ART AS CULTURE

An Introduction to the Anthropology of Art

SECOND EDITION

EVELYN PAYNE HATCHER

BERGIN & GARVEY
Westport, Connecticut • London

Library of Congress Cataloging-in-Publication Data

Hatcher, Evelyn Payne.
 Art as culture : an introduction to the anthropology of art /
Evelyn Payne Hatcher.—2nd ed.
 p. cm.
 Includes bibliographical references and index.
 ISBN 0–89789–628–9 (alk. paper)
 1. Art and anthropology. 2. Art and society. I. Title.
 N72.A56H38 1999
 701'.03—dc21 98–36738

British Library Cataloguing in Publication Data is available.

Library of Congress Catalog Card Number: 98–36738
ISBN: 0–89789–628–9

First published in 1999

Bergin & Garvey, 88 Post Road West, Westport, CT 06881
An imprint of Greenwood Publishing Group, Inc.

Printed in the United States of America

The paper used in this book complies with the
Permanent Paper Standard issued by the National
Information Standards Organization (Z39.48–1984).

10 9 8 7 6 5 4 3

Every reasonable effort has been made to trace the owners of copyright materials in this
book, but in some instances this has proven impossible. The author and publisher will be
glad to receive information leading to more complete acknowledgments in subsequent
printings of the book and in the meantime extend their apologies for any omissions.

Copyright Acknowledgments

The author and publisher gratefully acknowledge permission for use of the following
material:

Excerpts from *African Art in Cultural Perspective, An Introduction*, by William Bascom.
Copyright © 1973 by W. W. Norton & Company, Inc., New York, N.Y. Quotations used
by permission of the publisher.

Excerpts from "The Social Context of Art in New Ireland," by Phillip Lewis in *Fieldiana:
Anthropology*, vol. 58. Copyright © 1969. Used by permission of Field Museum of
Natural History, Chicago.

The artist Jerry Ingeman put aside his own work to help with research and drawing, and I am profoundly grateful.

Since the first edition appeared, I have lost my graphic designer, keyliner and proofreader, and so have to make do with a Mac computer. I have also lost a stimulating intellectual companion and beloved husband.

This edition, like the last, is dedicated to

Jack.

Contents

Preface

This book is not "really" about objects of art, or at least not *only* about objects of art. It is about the ideas people have had about art and the human condition in all its diversity. It is assumed that the reader is interested in such ideas, and would prefer not to have to memorize quantities of information before being considered ready to deal with them.

The purpose of the work is primarily to help provide a way for formulating questions concerning whatever aspect of the subject is of interest, at whatever level the reader wishes to pursue it. But, like the art that is the subject matter, it can be approached in a number of ways.

This book can be read rapidly as an overview addressed to the general reader who wants an idea of what the field is all about. It can be studied to get information on the arts and the people used as examples. For this purpose it is suggested that the main examples (boldface in Chapter 2 and the Ethnographic Index) are the ones on which to concentrate, a few at a time. If the reader wants to find out more about some particular society and style, the bibliography should provide leads.

The art objects and ethnographic examples used are just that: examples. They represent well known styles and cultures, so that further information about them is easily available. Samples of each style can be found in the nearest large museum, and full color portraits of them have been published in coffee table books and the like.

As a starting place for the further study of cultures, styles or ideas I have tried to provide good questions and leads to other works, and also a glossary that not only defines words as used in the text, but has notes on other usages. I have been told that this is very helpful for research in a field that overlaps several disciplines.

While the importance of process, of change, and of history is frequently stressed, accounts of the fascinating histories of each of the cultures used as examples are missing from these pages. A great many interesting art styles and life styles are not even mentioned. No one could possibly be more frustrated over these omissions than the author. Also it is distressing to ignore the perceptive subtleties of various disciplines and theories.

ix

But the time has come for a broad overview of the field and this can only be done by simplifying, by seeking the essence of ideas so that the nature of the grand panorama of forest can be seen. There is nothing like the effort to write for newcomers to the field to help clarify ideas. Specialists can judge the extent to which such simplifications reveal the essence or distort the picture.

This is a very exciting time for students of the relation of art to all the rest of culture, because of good field work interacting with new theoretical insights from many disciplines. Anthropologists and art historians not closely involved may not realize how rapidly or how profoundly the field is changing. Often work done as recently as the 1960's seems surprisingly naive both in ethnographic information and theoretical interpretation.

After the work of Boas and Kroeber and a few of their students early in the century, the arts were relatively neglected in anthropology. Such works as appeared until the 1960's were written for the most part by art historians and were based on artifacts in museums; information provided by field workers was incidental to other ethnographic work. More direct, in depth studies appeared in the 1970's mostly in articles emphasizing some one particular aspect and perspective. These have been illuminating, and have built up almost revolutionary understandings with far reaching implications. Now more complete art focussed, or art-including ethnographies are appearing, providing new breadth and depth. It is very fortunate that we have works as those of Biebuyck Ben-Amos, Ottenberg, Tuzin, Bricker and Glaze, to mention a few, not only for information on traditional contexts and functions, but for better understanding of process and change. Furthermore, through the illumination provided by such works, the earlier literature can be mined, and a wealth of possibilities opens up for the ethno-history of many art forms.

The statement at the end of Chapter 1 concerning the multiplicity of parameters of even a single art object is a condensed paradigm of the more general theoretical position of the author. Readers more particularly interested in the theoretical aspects of the subject in some depth may find the following of interest.

Theoretical Note

That a multiplicity of factors affect cultural forms and cultural norms is hardly a new perception, and that this multiplicity means that cultural forms are related in a number of ways to various aspects of their contexts is evident. Current work in a variety of fields is producing many new perspectives that reflect this multiplicity. Many models are to be found in the literature to convey various patterns of relationships that are seen as significant, and viewpoints, theories and methods are proliferating. In anthropology this has led to an overlapping with many other fields, and created for it a "crisis in disciplinary identity" (Honigman 1976), not a new problem to a discipline that has always sought to consider all aspects of human existence, and to relate numerous specialties to larger issues. As the concept of culture has become less powerful (being perceived more as a sensitizing idea than an explanatory principle) a flood of new perspectives is inevitable. However, the nature and implications of this mulitplicity have not yet been well recognized as a necessary step if new syntheses are to emerge, and the perceived need for wholistic anthropology is to be met.

It is disturbing to note how often one still finds insistence on "the *real* reason" or "the *real* issue" in scholarly works. It was not until the 1970 seminar on the Maya collapse that Mayanists started talking in terms of interrelated factors rather than disputing "real" causes. (See the concise statement in Culbert, 1974). This more sophisticated approach has not taken place in many other fields of study.

Multiplicity of interpretations reflect the staggering complexity of human affairs. The model and methods of physical science, while useful up to a point, proved to eventually be a block to the understanding of the biological level (Lewin 1982). Similarily, the models and methods of the physical plus the biological levels are useful up to a point for the understanding of socio-cultural phenomena, but the sheer complexity makes these insufficient. There has been an assumption that because these levels are basic, more complex levels are reducible to them, but they are better conceived as providing the boundaries and factors within which, and in relation to which, socio-cultural phenomena exist.

The perception of multiplicity and complexity, and consequently a willingness to accept the legitimacy of many theories and methods is not simply the mindless eclecticism attacked by Harris (1979). Attempts to put it all together in terms of one set of basic postulates or another, one paradigm or another, emic or etic, are a necessary and continuing human effort. But a decent respect for enormous complexity, for the difficulties of objectivity, and for Godel's Proof calls at this point for much effort to "seek complexity and order it" rather than making claims for all-inclusive explanations.

There is need to address this complexity by stripping the various models to the simplest possible terms in order to clarify the essentials. Using the format of an introductory text forces and tests this effort. By using the cognitive devices of 1) levels of complexity of phenomena, 2) levels of abstraction in analysis, and 3) the idea of multiple factors, vectors, or dimensions in any situation, one can perceive many theories and models as belonging in different categories, rather than as competing explanations. An ecological explanation does not rule out a socio-structural explanation, nor a processual explanation, nor a historical one, nor a cognitive one. Emic, relativistic explanations do not rule out etic substantive ones.

In sorting out these various levels and viewpoints, there is need to spell out the similarities and differences in the basic concepts that underly proliferating terminologies. When various levels, aspects and viewpoints are sorted out in very basic terms, relationships between these different perceptions can emerge. For many purposes the differences in the various conceptual tools (and the methods that go with them) are very important, but until the basic similarities are laid bare, the subtleties between different formulations of similar concepts make for confusion, misunderstanding, and unproductive controversy. This problem is addressed in the glossary for many important terms. The creative potential and stimulation of productive controversy are often lost in confusion over terminology, confusion as to the level of discourse, and the habit of either/or thinking.

It may seem paradoxical, but it is my view that the only way th achieve "wholistic anthropology" is through multiplicity, bringing the various sub-disciplines and theoretical perspectives to bear on a particular subject, as I have tried to do here.

About the Illustrations

The illustrations are all line drawings, primarily to keep down the price of the book. Of course they do not convey much of the esthetic quality of the art forms, but neither do they inject an irrelevant esthetic as some color photographs do. If photographs were to be used, they would be field photographs. The drawings do carry information and underscore the idea of first putting aside esthetic reactions and judgment. They have proved to be useful aids in learning to identify styles. One of the pleasures of teaching has been to have students return from some museum telling of the impact of the originals that they recognized and had learned about.

It will be noticed that a number of art works are repeated in different illustrations. This emphasizes the idea that any work has many aspects, brings out different comparisons, cuts down page turning and builds up recognition.

Most of the illustrations were drawn by the author. Where they are reproduced from published works, the source is acknowledged with the word "from"; those redrawn from other drawings or photographs are acknowledged with the word "after." Where possible, the location of the original is given, usually in a museum which the reader may have a chance to visit, but many museums have examples of these styles. The museums where the actual pieces are located are identified by abbreviations at the end of the captions; a key to these abbreviations is provided below. Where no museum or source identification is given, the original is in the author's collection, or, in some cases, as in the case of dancers and costumed figures, the actual drawing is a composite from several sources.

Museum Abbreviations: AMNH, American Museum of Natural History, New York; AS, Academia Sinica, Formosa; BM, The British Museum, London; BM/DP, Bali Museum, Den Pasar; BM/N, Benin Museum, Nigeria; BM/NY, The Brooklyn Museum, New York; CMAE, Cambridge Museum for Archeology and Ethnology, Cambridge, England; EPHMA, Evelyn Payne Hatcher Museum of Anthropology, St. Cloud, Minnesota; FM, Frankfurt Museum, Germany; FMNH, Field Museum of Natural History, Chicago; IM, Ife Museum, Nigeria; JM, Jos Museum, Nigeria; KIT, Koninklijk Instituut voor de Tropen, Amsterdam; MAI/HF, Museum of American Indian, Heye Foundation, New York; MAUBC, Museum of Anthropology, University of British Columbia, Vancouver; MH, Musee de l'Homme, Paris; MIA, Minneapolis Institute of Art, Minneapolis, Minnesota; MPA, Museum of Primitive Art, New York;

MV, Museum for Volkerkunde, Berlin; NMM, National Museum of Mexico, Mexico City; O, Ohio State Museum, Columbus, Ohio; PC, private collection; PM, Provincial Museum, Victoria, B.C.; PY, Peabody Museum of Natural History, Yale University, New Haven, Connecticut; RMZ, Reitburg Museum, Zurich; SMM, Science Museum of Minnesota, St. Paul, Minnesota; UM/UP, The University Museum, University of Pennsylvania, Philadelphia.

Acknowledgements

It is impossible to begin to acknowledge my debts for this endeavor without telling the story of my life, because I have drawn of so many parts of life to try to achieve a broad synthesis.

To my artist parents, Elsie Palmer Payne and Edgar A. Payne, I owe much of what I know and more of what I sense and feel about art. I also have to thank them for experiences in various cultural settings that go back before my memory.

A lot is due to the scientists I have known, especially the one I live with, and the many wide-ranging discussions that have gone on under our roof.

A few days in a class of Ralph L. Beals and I knew that anthropology was for me. Since then, I have had many fine anthropologists among my teachers, at U.C.L.A., Chicago, and Minnesota, some of whom I did not fully appreciate at the time, but all of whom affected my thinking, and therefore this book.

What has come to me through the printed page has sometimes been very exciting. Some influences are very evident: the names of A.F.C. Wallace, Warren d'Azevedo, Gregory Bateson and Roy Sieber among others are found scattered through these pages. Some names do not appear at all, yet the paragraphs on field theory in J.F. Brown's *Psychology and the Social Order* and much of Lazlo's *Introduction to Systems Philosophy* have had profound effect on the basic ideas.

For stimulating ideas and friendly arguments at various times I am grateful to Merle Sykora, Dorothy Billings, Doris Francis-Erhard, Herbert Goodrich and Dale Schwerdtfeger. Each of them also gave encouragment at crucial points.

This work owes a lot to E. Adamson Hoebel, Robert F. Spencer and Elden Johnson, who encouraged me to make the anthropology of art my specialty. Dr. Hoebel went through an early draft of this work and made many helpful suggestions.

The art historian, Rena Coen, whose scholarship I greatly admire, read a late draft and offered tactful suggestions concerning the terminology of art history.

Many students suffered through the early drafts of this work, and the ways they used and responded to it have been a most

direct influence. I wish I could list all of their names. Some that stand out are: Juliann Rule who drew some of the drawings in the technology chapter, Jerry Ingeman, Kristin Willete, JoAnn Christensen, and most recently Susan Baizerman who made many substantive and editorial suggestions.

Most of all I have to thank my typist, my photographer, my part time editor, my graphic designer, my proofreader and keyliner. Each of these is named J.B. Hatcher, and without all this help this book would still be a pile of manuscript and a heap of drawings.

My mother taught me to pay attention to basic principles in art and life; my father was an Impressionist. Meticulous scholarship was not part of my early conditioning. Whatever errors remain in this work, despite all of the efforts of all the persons whose training and help I acknowledge, are most certainly mine.

<div align="right">

E.H.
St. Cloud and
Minneapolis, 1984

</div>

The following copyright holders have very kindly given permission to quote short passages or reproduce illustrations:

The Field Museum of Natural History, for quotations from Phillip Lewis, "The Social Context of Art in New Ireland," from *Fieldiana:* Anthropology, vol. 58 (1969).

William Davenport, for quotations from "Sculpture of the Eastern Solomons," from *Expeditions*, vol. 10, no. 2 (Winter 1968).

The University of Michigan Press for quotations from Gary Witherspoon, *Language and Art in the Navajo Universe* (1977).

W.W. Norton and Company, for quotations from William Bascom, *African Art in Cultural Perspective: An Introduction* (1973).

Dover Publications, Inc., for the use of illustrations from Franz Boas, *Primitive Art* (1955 edition).

The American Society for Aesthetics, for quotations from James Fernandez "Principles of Opposition and Vitality in Fang Aesthetics" from *The Journal of Aesthetics and Art Criticism*, vol. XXV, no. 1 (fall 1966).

Introduction to the Second Edition

This book is written as an introduction for the use of persons new to the field. To do this I have tried to present the data, and the organizing of ideas in very basic form to look at many ways that what we call art is related to other aspects of culture and society. But in my view this is not being merely simplistic, because in the complexities of the contemporary world in a state of globalization where everything and everybody are interrelated with everything and everybody else, the complexities are overwhelming, and it is difficult to see such relationships.

So I consider this as a theoretical statement, even if put as clearly and simply as I can, because we are in a period when many are so preoccupied with the leaves on the trees that a look at the forest is called for.

Also, it seems to me that if one really understands a theory, it is possible to describe the essence of it in simple terms. This of course omits a great deal that a specialist would find significant, but leads the non-specialist to productive questions. In this edition I have not revised the original chapters but have added two new ones. These basically address the question as to whether what we have learned in smaller societies is useful for understanding larger ones, and how the approaches discussed in the original chapters relate to contemporary thinking. The Functionalist approach, for example, was a very useful one in bringing out many of the ways various aspects of society are related. Of course, it did not explain everything and new organizing ideas were needed. But in tracing out relationships questions were raised that led to other questions. So the examples used in most of the book are very simple sketches of the way art is related to other things in small societies. Such societies are not simple or "primitive", but have been studied because the observer had a chance to explore some of the relationships before globalization changed them.

What we have been calling "a culture" is a kind of construct of what we believe a certain number of people have in common. It is a rather static concept. There are a number of recent works that call to

our attention the variety of personalities and ideas that exist in any group of persons, and how they try to define their identities. Picton has addressed this problem. He says:

> "People live simultaneously in several dimensions of relationships, and the boundaries existing in one dimension will not and need not necessarily coincide with the boundaries within another." (p. 36) "The manner in which people are brought together in one dimension of their lives will not necessarily coincide with the pattern of unity and disjunction in others. In this sense particular boundaries will be created, maintained, embodied, subverted, and signified within and because of each particular dimension. These boundaries may or may not coincide, and there is no "law", beyond the consequences of particular histories, that insists that they must coincide. The result is (and we all know that this is true: the proposition is not restricted to the areas under discussion) that two people or groups of people can feel at one with one another when considering their relationship from one point of view, yet at odds when considering it from another. The question of identity thus becomes a complex process of negotiation through these multiple dimensions, with a result that is only very exceptionally unified." (p. 49) (Picton, 1991)

But he also says, in this significant article: "The continued use of words such as Yoruba and Ebira in this paper is a convenient shorthand, but should be understood as no more than a slipshod representation of the complexities of individual and social identity." (p. 36) Here is the nub of the problem. Even in an article specifically addressed to the complexities in a relatively small area, he has to resort to "slipshod shorthand" representations. We cannot deal with all the details, all the complexities, without some kind of categorization. But this is the kind of problem that has led anthropologists to deal with smaller entities, and the awareness of fragmentation at many levels, even the fragmentation of individual minds.

Humanistic anthropology and post-modernism of many kinds have become aspects for what I think is basically the admission if not the full recognition of the enormous complexities of human life and thought. In anthropology it comes with recognition of the inevitable part the observer plays, and considerable attention to "the Others" as

individuals. The key words in recent writing are often "self", "identity", and the subtleties of interpersonal behavior.

Post-Modernism in its various forms seeks to deal with the recognition of such complexities. But frequently the new formulations are a continuation of this century's preoccupation with the kind of reductionism than concentrates on the minimal elements of the situation, in this case on individuals and their feelings and responses. There is also sometimes a rather strident rejection of all the theories and organizing ideas that have gone before. Some of this arises from the lust for absolutes of "Western" culture, which expects such theories to be absolute truth. But if we do not ask if a way of organizing observations is the "real" truth, but instead ask what can we learn from this perspective, this way of looking at things, we can probably move to a deeper understanding.

My position is that as we develop new fine-grained ways of exploring our subject, we need to look at the theories of our predecessors, and attempt to make connections, not giving way to the Modernist habit, in art at least, of pretending our efforts are completely new, or to be valued for the sake of newness. This often leads to rephrasing an old organizing idea and thinking it is new because we give it a new label.

One of the questions of great significance today is how many such relationships are useful in trying to understand relationships in the contemporary globalized world. There are a number of approaches which attempt to study interrelations in some kind of a unit abstracted from the blooming buzzing confusion: systems theory, and paradigmatic theories of various kinds. But as Rappaport has pointed out:

> "Systemic analysis makes no prescription concerning the variables to be included in the analytic system. Their selection is a product of hypotheses concerning interrelations among the phenomena under investigation. . . . The dilemma is, simply, that the abstraction necessary to derive analytically tractable systems from the complexity of nature and culture puts the systemic formulations in danger of becoming unreal or unfalsifiable. This, of course, is not very different from the difficulties besetting all of science." (1984:364-5)

Much of "Western" discourse is phrased in terms of binary oppositions, as if everything falls into either/or categories. The current use of Manichaean dichotomy with regard to art versus science seems

incredibly naive and ethnocentric. My parents were artists, I married a scientist, and worked at Caltech. I have never seen art and science as that different.

All theories are useful for certain purposes - that is, for a better understanding of some aspects of what is going on, and to raise new questions. If we want to better understand process in the long term evolutionary sense, the various paradigmatic type theories can be seen as universality classes within the "principle of universality" having to do with changes over time and phase transitions that phycists and others are so excited about (Buchanen 1997). And Wallace described the stage when a new paradigm is needed in a way that sounds a lot like what we see about us today. (1970-pp 191-192) All this has to do with continuity and change in the arts, and the theories about periods of fluorescence discussed in *Art as Culture* on pages 162-164 and in chapters 9 and 10.

There are a number of very sophisticated studies written recently, and labeled Post Modern, that deal with various aspects of the problems of the relation of art to other human concerns. Some of these have to do with a close examination of the words that are used about art. Some have to do (Jameson 1991) with the emotions, the feeling, the tone of culture considered to be "reflected" in art. This is another version of the idea of a cultural personality which has been seen as much too simple, and is related to the problem of identity discussed by Picton. The fundamental questions raised by these kinds of psychological approaches are discussed in chapter 4. Treating art as a "reflection" of cultural or psychological phenomena is only a part of the matter (the idea of art as purely self-expression is a recent idea related to the emergence of art as a commodity when oil painting made works moveable). Considering art as communication, and part of ongoing discourses concerning social matters goes beyond the idea of art as mere reflection. Theories about such kinds of relationships are treated in Chapters 5 and 6.

I find an article by Born about music quite exciting, because she not only provides a fine grained analysis of her subject, but describes the modern/post-modern patterns in music in terms very much like the one I have described for the visual arts in chapter 10, although I have greatly simplified the subject.

> "Throughout this century, modernist discourse has been counterpointed by musical developments that have resisted the stark, negational character of modernism by encorporating aesthetic devices taboo to the modernists--developments

of what today we might call musical postmodernism and its early 20th-century precursors. Aesthetic devices brought into play include tonal or modal elements, repetition in form or rhythm, and the sounds of urban popular musics, non-Western musics, or earlier tonal musics (baroque, classical or romantic). . . . There is thus both structural unity and great diversity in musical postmodernism. It is important to grasp, finally, that despite the aesthetic reference to popular and non-Western musics common in certain postmodern musics, there nonetheless remain significant aesthetic differences between postmodernism and these 'other' musics -- a distance encapsulated in the very gestures of 'reference,' 'borrowing,' or 'incorporation.'. . . A further implication of the analysis presented here, then, is to contest the widely held postmodern culture theory which proposes that all such boundaries,--between high and low, art and popular musics--are now dissolved." (1997 pp 843-844)

This last point will be seen as related to what I call the dilemma of art museums in Chapter 10.

In a way, Post-Modernism in anthropology sounds a lot like the "stark negational character" of Modernism in its rejection of so much that has gone before, especially in any connection with science. But there are also some "Post-Modern" trends toward eclecticism, and efforts to try to put anthropology back together again. But the dominant tone seems to me to be more characteristic of the Modern period with an emphasis on a kind of reductionism that seeks to explore small elements.

Once our experiences get put into words, they also get put into categories. We cannot possibly handle all the stupendous amount of information that we might be getting every second unless we in some way lumped parts of it together, unless we related one bit to another and devised categories. These categories rest on our theories, our patterning of what we see, hear, smell, feel, read, etc. As we seek to encorporate the present day fine-grained studies into larger patterns, we need to see how they relate to patterns or systems that have yielded insights in the past.

The theoretical label for my approach is "field theory," meaning that all the vectors in the field affect any phenomenon. So what is attempted is an overview of all the factors that affect the arts; or put another way, I am raising questions about the relations of the arts to everything else in human societies.

Chapter 1

Contexts and Comparisons: The Anthropological Approach

People sometimes are content to look at an unfamiliar work of art simply to respond to its statement directly, but usually they are not content to stop there; they also want to know something about the work, and what the work is about. They ask "where did it come from?" "how was it made?" "who made it?" and "what does it mean?" And it is just these kinds of questions that interest anthropologists and art historians. Such questions involve not only specific information about the particular object, but broader questions about the relation of art to all other aspects of human life. Art is something that human beings do in a great many ways, for a great many reasons, and if one is curious about art or about people it is natural to ask questions about the whole process and the whole background or context of an art style. One question leads to another, and the more one learns about the background of any work of art, the more it seems related to the whole way of life of the people who made and used it. This in turn makes a work of art more interesting, more alive, and often more pleasing.

This means that the study of the visual arts as an anthropological study calls for considering art as an aspect of culture, and using the methods and theories that anthropologists have used to study other aspects of culture, taking into consideration a great many things instead of, or in addition to, one's own personal responses to particular art forms. It means that one needs to know where the art was made, who made it, what its use was, what its functions were, and what it meant to the people who made use of it. This is the study of art in its *cultural context.**

Culture in the anthropological sense means much more than the arts; it is conceived as the sum of all the learned, shared behavior of human beings: how they make a living, produce things, organize their societies, and use language and other

*Words that embody concepts important to the discussion are italicized when they are defined, usually when first used. The Glossary contains further definitions.

symbolic forms. Culture is the distinctively human means of survival. Each and every society has a more or less consistent way of life, *a culture*.

Anthropologists and art historians are presently going into the field, to places not yet industrialized, to find out how arts are made and used in the different cultures. They are coming back with accounts of the arts in such context, enriching our understanding through published works and new forms of exhibits. We can begin to see how art is made and used in social situations, many of them lively and exciting. When we study art in context, we find that many relationships seem to exist between art forms and all, or nearly all, of the other aspects of human life, and the visual form or style of the arts in a specific society.

We seek to compare the relationships and meanings from a variety of ethnographic contexts, to see if there are any regularities or generalizations that apply to all cultures, or whether certain kinds of art and certain relationships are characteristic of certain kinds of cultures. The *comparative method* is the anthropological equivalent of experiment, and so by making cross-cultural comparisons it may be possible to test the innumerable statements about the nature, functions and correlates of art that have been made in the context of the traditions of Western Civilization. It should also increase our understanding of the nature of art.

Furthermore, and this follows from the above, the study of art as culture calls for the consideration of a great variety of view points and theories from our own and other cultures. The anthropological study of art is not confined to the works of peoples with primitive technologies, but involves all cultures from any time and place. The traditional emphasis on "primitive art" has existed primarily because no one else was paying such attention to endangered species of art forms, other than those who have been interested in collecting it without the slightest regard for its cultural context. Unfortunately a purely esthetic appreciation is often linked to acquisitive greed. We need to compare not only the products, but the theories of artists—comparative *esthetics* or *"ethnoesthetics."*

Lastly, and this for some reason is not always understood, the analysis and intellectual study of visual forms and their human meanings to the peoples who made and used them by no means destroys one's ability to respond to the esthetic

appeal of any work. On the contrary, it vastly enhances one's perception and appreciation, deepens our feelings for other human beings, and enhances our humanity.

Socio-cultural complexity

For some time there has been a lot of effort put into the search for a substitute for the term "primitive art" without much success. The problem seems to be that, whatever the substitute, it tends to perpetuate the underlying, possibly unconscious, assumption that there is some fundamental distinction between "primitive" and "civilized" art. It is my position that the question as to what correlations exist between the level of complexity of society and the nature of art is a matter to be explored.

There have been various ways of classifying societies on the basis of complexity. The best known schema is that described, with examples, in Service (1963). Five levels are defined and labeled bands, tribes, chiefdoms, primitive states, and archaic or imperial civilizations; industrial civilizations would be a sixth level; the criteria used are basically economic and political. For the present purposes, we can use fewer levels, based on criteria most closely associated with the production and uses of art forms. These criteria are: (1) Technology, whether simple and direct, or more complex and indirect— that is, the use of materials partially fabricated or prepared by others than the final artist-craftsman, (2) The degree of specialization of craftsmen, and (3) the units of the society that are symbolically important in the art forms. In all complex societies, or more accurately in all societies in proportion to the degree of complexity, there are sub-groups and crosscutting groups that often have characteristic art forms and styles. At the simplest level there may be differences in men's and women's art; and in more complex ones there may be peasant art, folk art, temple art, palace art, provincial art, cult art, elite art, etc. The cultural boundaries may be unclear; for example, a religious association and its art forms may extend across a number of political and linguistic boundaries. Nevertheless it is often useful to consider societies and cultures as entities.

Anthropological study has often focused on small, less complex societies, and often assumed that they and their cultures form independent systems because the inter-relationships of various aspects of human life can be better understood in small systems than in large ones. One can call

them "simple" in a relative sense; the term seems ironic when one seeks to understand the symbolic systems of the Navajo, for example. Technology may be simple in terms of artifacts, but extensive if one considers the technical knowledge of botany, zoology, astronomy, and ecology that is involved in daily life, as in the case of the aboriginal Australians.

Tribes

This being said, I include in the first level peoples with very direct technologies, peoples who for the most part make their artifacts from materials in the immediate environment. This includes both "bands" and "tribes" in Service's terminology. Where a label is needed, the term *tribal* is used for both. In these societies, every person knows the basic techniques of crafts-manship appropriate to his sex, although some may be more proficient. The social focus is on a kinship group such as a clan or lineage. Where there are important persons, "big men," they are closely identified with their lineages or clans. The symbolic integration of the society is achieved by the ceremonial relationships among the icons within the system; art forms dramatize these relationships.

The classic examples of peoples with simple direct technologies and small numbers of persons in daily interaction are the Australian Aboriginies. The hunters and gatherers of Arnhemland will be used as an example of the art context at this level. The predominate art form is the ceremonial cycle, with

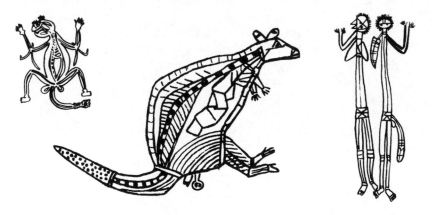

Figure 1.01. Arnhemland, Australia; figures from bark paintings. Bark paintings are often used in ceremonies to illustrate the sacred myths. (after Elkin, Berndt and Berndt).

ritual, dancing, mime, and song dramatizing the sacred myths. The media used are: (1) body decoration with paint, feathers, leaves, etc.; (2) space layouts and earth drawings, symbolically shaping the sacred areas; (3) "props" in the form of carved and painted wood and bark, decorated often with the same materials as human bodies, and (4) paintings on bark and on rock walls.

Kingdoms

The second level of complexity, often in the form of *chiefdoms* or *kingdoms* involves less direct technology, often with trade in tools and materials, and with greater specialization in craftsmanship. There will be full-time professionals and there may be organizations in the form of guilds or castes for craftsmen. Metalworking is sometimes found, with techniques that are not known to all, and sometimes considered to be so esoteric as to have a mystic aura.

At this level there is more specialization in the uses of art as well as in making it. While there are still great festivals, there are more art forms that are preserved in shrines and royal compounds and the homes of the elite. Artifacts made in more durable materials such as stone and metal are often kept in more permanent and durable structures, and handed down from generation to generation. Symbols of the whole society become more important in integration. These symbols are often both religious and political, and may center on a king, chief, or high priest. As the whole society is too large to act out the relationships among its parts, the visual and visible symbols of common loyalties are very important.

As an example of a culture at this level of complexity is the kingdom of Ashanti in Ghana. The Ashanti are the best known of the many art producing peoples of this region, perhaps because the use of gold and gold-leaf makes the art spectacular, and the political importance of the Ashanti at the time of colonization made them a focus of interest to Europeans. Their art forms include: little brass weights in a great variety of forms, made by the lost wax techniques and used for weighing gold dust; golden insignia and jewelry worn by "royals" as badges of office; staffs carried by important officials, carved of wood and covered with gold leaf; a variety of handsome textiles made by a number of techniques; and bronze vessels and carved wooden figurines used in shrines. Ashanti culture involved a close integration of the aspects of life we would separate into

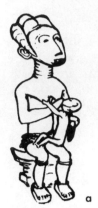 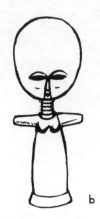 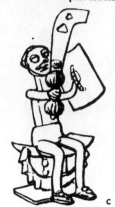

Figure 1.02. Ashanti, West Africa. a, carved wood figurine; mother and child. Such figurines are put in shrines as part of a symbolic assemblage. b. carved wood figurine; this type, called Akuaba, is carried by women who desire children. c, small brass weight in the form of a chief on a ceremonial stool holding the emblems of a warrior; used to weigh gold dust. (a, PC; c, after Kyerematen).

categories of kinship, political organization, and religion. The visual symbols that helped to achieve this were usually symbols of the ancestors, and the panoply of the "royals" was worn on the many ceremonial occasions. Kings, queen mothers, chiefs and their ancestors were responsible for, and symbolic of, the people as a whole.

Preindustrial Civilizations

On the third level, preindustrial civilizations are marked by being large scale societies with great social stratification, full-time professional craftsmen, extensive trade, and monumental architecture. Political elites and priestly hierarchies may command a great deal of labor that is lavished on fine crafts-manship and great monuments. Writing and record keeping are often in artistic form. Religious symbolism may be very differently perceived by the elite and by the folk, and the provincial, peasant, and ethnic variations of the great styles may be clearly distinguished. But empires come and go, and the civilizations they foster and spread may outlast them. Hence the cultural attributes of civilizations are not always closely associated with large political units.

The example of preindustrial civilization used here is that of Bali, because the prodigious art productivity of people in the villages of this small island is relevant to many questions

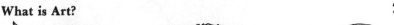

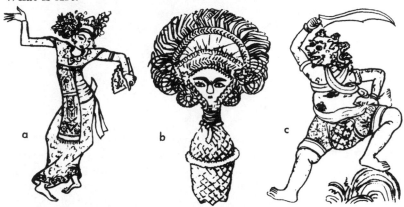

Figure 1.03. Bali, Indonesia. a, Legong dancer wearing elaborate textiles and a gold headdress. b, basketry figurine, used as part of an offering; an icon of Dewi Sri, the rice goddess. c, figure from a wall painting. (c, after Ramseyer).

concerning the place of art in people's lives, and so has been much studied and written about. Art forms of a richness that is usually associated with the elites of preindustrial civilizations have long been a traditional part of the lives of peasant villagers. One cannot single out any art form characteristic of Bali, but rather one visualizes an incessant art activity: gamelan orchestras, dance dramas, bodies elegantly arrayed in rich textiles, shadow puppets performing ancient Hindu epics, and elaborate ritual offerings of food, flowers, and fibers against a background of ornately carved stone temples. When examining the way of life of traditional Bali, we can understand what is meant by the proposition that culture itself is an art form.

It is interesting to note that in all the discussions about the use of the term "primitive" with regard to art, and with all the suggested substitutes, very little has been said about where the crucial dividing line is to be drawn in any dichotomous terminology. While four stages can obviously be divided down the middle to make two, there is a great deal of difference between the concept of a continuum divided into grades for convenience, and that of a dichotomy with all the implications of contrast and opposition.

What is Art?

In the field known as "primitive art" discussion since 1970 has shifted from considerations of the word "primitive" to the

word "art". The new focus is on whether the usage of the word is ethnocentric or not, and whether it should be applied to activities of peoples who do not have such a word, as well as how it should be defined. Confusion here lies in the fact that art is not a phenomenon but a concept. Being a concept it has no objective referent, and so one cannot say what it is or is not, but only what the user means by the term.

That many languages do not have a word that can be translated "art" and may or may not have a related concept, only means that the conceptual system of that society does not include the word, and may or may not include the concept. This does not invalidate the use of the term for cultural products of that society for comparative purposes. Many peoples do not have words for "economics" or "chromosomes" or "religion", but this does not invalidate these categories. Once the idea of such a category exists it tends to become powerful in our minds and is used.

In studying the art of a particular culture it would be ideal if we could determine the way the people themselves distinguish artistic work from the purely utilitarian. While many peoples do not have a term that can be literally translated by the word "art", the concept may be imbedded in the language in some other form. However, what we call art may be looked at very differently and judged by very different standards in other cultures.

In actual modern usage, the word "art" is no longer limited to sculpture and painting, but is very broadly defined, and includes textiles, body painting, happenings, and whatever, so that the narrow definitions of the past do not limit the cross-cultural view as they once did.

But there are still many problems when we seek to apply the idea of "art" cross-culturally, especially as there are many definitions and only a very broad agreement within the Western cultural tradition. Some of these problems have been given considerable attention; interesting discussions are to be found, for example, by Sieber and others in d'Azevedo (1973c) and in Maquet (1971). Recognizing these problems, it is still necessary to provide some kind of working definition here.

While the concept of art in industrial civilizations has broadened to an extraordinary degree in terms of medium and content, it has, at least implicitly, narrowed in terms of use, function, and meaning, a narrowing of the relation of art to its context. This is the concept of art as being purely for esthetic

contemplation, art for art's sake, pure art, and the necessity of the uselessness of an object to be called "art". It is not a very useful concept for cross-cultural studies, even if one believes that such purity of motivations exists.

So the concept must be broad in both respects, and even broad enough to include different cultural viewpoints. Herskovits' definition is "any embellishment of ordinary living that is achieved with competence and has describable form" (1948: 380). Maquet (1971: 8) defines esthetic aspect or quality as the noninstrumental features—i.e., nonutilitarian, Herskovits' "embellishment"—making no judgments as to the excellence of these features. This means a definition very close to the idea that art is the esthetic dimension of any human activity.

The first component of art, then, is the purely *esthetic*. When we think of art as the production of a human being, it is not difficult to differentiate an esthetic sensibility of the artist from his craftsmanship, or from the various meanings he may be seeking to convey. Because people differ so much as to what they like, there has been some discussion as to the relativity of esthetic response, but the assumption behind many writings is that some persons are born with greater sensitivity to esthetic qualities, and that this sensitivity can be further trained by experience in the arts. It is further assumed that there are universal esthetic standards, although we know very little about what is universally valued and what is culturally determined. Concentration on the esthetic aspects of the art forms of other peoples has tended to be evaluative in our terms, and to seek to point out the esthetic qualities of exotic works. Art museums want the best to display, for example, and they display pieces individually to show the esthetic qualities of the work to the best advantage.

Books that serve essentially the same functions as art museums tend to approach the subject similarily. They seek to get the viewer or reader to better appreciate these forms of art, but sometimes the statements concerning what these forms meant to the makers are based more on imagination than on ethnographic knowledge. The viewing of exotic art from a purely esthetic perspective has had a profound influence on the European arts of the XXth century.

While the esthetic aspect may be the defining one, it is usual to think of art, either as an activity or an object, as having several other components or aspects more obviously related to

the cultural context. These other two components may be called craftsmanship and meaning. These three may vary in their proportions to the extent that one or another may be negligible, and they are not independent—good craftsmanship, for example, has esthetic appeal for its own sake—but it is useful to think of them as separate. Various students of art have emphasized one or another of these aspects, so this formulation may clarify the nature of the various contributions to the field of study.

Craftsmanship is compounded of (1) knowledge, (2) physical skill, and (3) effort, in the sense of human energy expended. In other words, the technique of the artist. The techniques of the artists are part of the technology of the culture, and some studies of the arts of nonindustrialized societies have concentrated on this aspect almost entirely, as, for example, D'Harcourt (1962) does on Peruvian textiles. The word "arts" is often used in the sense of technics, for crafts or the industrial arts. Whiteford (1970) uses the word in this sense in his book in Indian Arts. One theory as to the origin of art suggested that the visual arts arose from the esthetic feeling aroused by the rhythmic motions of good craftsmanship. (See Boas 1927).

The third component is *meaning*. Visual arts may communicate a number of kinds of meanings, and there have been a number of attempts to name and describe them. Such categories are especially useful for seeking to understand art forms from a

Figure 1.04. Fang, Africa. a and c, wood carvings used on reliquaries relating the deceased to the clan ancestors. b, carved wood dance mask; portrays a forest spirit. (a, c, MPA; b, MH).

culture that is unfamiliar, because they provide a way of formulating questions that lead to greater understanding.

(1) the first category of meaning lies in representation, the subject, the image, of a form in nature, largely regardless of the degree of exactness of realism—a highly stylized bear, that is hard for a person from another culture to recognize, still represents a bear. The Bambara carving is an image of a male antelope. The subject of the Solomons carving is a male human with fish; the Fang statuettes are images of male and female human beings.

(2) A second category of meaning (Symbolic I) is what the art represents beyond the immediate visual statement—not just any old bear, but the Hamm's bear, or a bear named Joe. It is not far from traditional use to call this the *iconographic* level. For example, the same Solomons carving is an *icon* of Wakewakemanu, a deity who controls schools of bonito fish, and the Fang carving is an icon of an ancestor of the clan. Often there are a number of features to indicate the special nature of what is represented—i.e., a woman represented is seen as the Virgin Mary because she wears a blue cloak and a halo. The central Balinese figure is an icon of the rice goddess. These symbols are specific to the culture. Representation on these first two levels is sometimes called the content of the work, the subject and symbolic associations, as opposed to formal structure or composition.

(3) The third category of meaning we can call *interpretation* (Symbolic II). This could be called a theoretical level because meaning is interpreted in terms of a particular theoretical symbolic system. This deeper, broader level of meaning is sometimes called *iconology*. The Fang carving is a symbol of the clan itself—of the

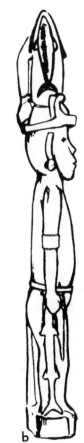

Figure 1.05. Wood carvings. a, Bambara, Africa. b, Solomon Islands, Melanesia (b, UM/MP).

ongoing life of the clan, and for Fang Elders, of the Life Force. Included here, in addition to iconology, is interpretation by persons from other cultures.

(4) A fourth category of meaning is *metaphor*, where some relationship or quality of the visual form is analogous to some relationship or quality in human experience. The qualities are often formal ones—spatial relationships, lines, color, etc., rather than any kind of representation or content. The formal quality is often called style as distinguished from content. In our examples, in the case of the Fang statuette, Fernandez (1966) has shown that the Fang regard balanced opposition as necessary to achieve vitality, so that we can conclude that the bilateral symmetry is a metaphor for this tension.

(5) Another aspect of meaning, and one that probably operates at all of the above levels, is the sense of mystery or significance created by *ambiguity*. It may be in content; the Fang statuette combines characteristics of an old man with proportions appropriate to an infant. Ambiguity may lie in the differences between the messages conveyed by different levels, the form-meaning contradicting the icon, for example.

Lewis (1969) points out that the social *context* of the art is not merely a background to it, but provides another level of meaning, a social meaning for the participants, as the social meaning of the opening of an art exhibition in our culture has almost nothing to do with the nature of the objects on display. Art is important in creating the atmosphere of special occasions such as calendrical rituals and festivities, not only by symbolism, but by simply heightening emotion and so the significance of the event. With or without symbolism on a number of levels, art objects gain much of their importance and effect from being part of, or souvenirs of, meaningful and satisfying events.

The Nature of "Context"

When it comes to cultural context, a distinction is sometimes made between the use of a work of art and its function. *Use* involves the treatment of the object in the purely physical sense, what one can see. *Function*, on the other hand, is more interpretive and more abstract. It involves the analysis of how the art "works" in some context. Usually this means either the

psychological context—how it works for the individual or in social context; the social function is usually conceived as being how the art works to "hold society together". The interpretations of function are usually made by an outside observer, and are not always the same as the *purposes* as they are conceived by the makers and users.

Fig. 1.05 shows a carving from the Solomon Islands. These are *used* as house posts in a canoe house. Their *function* is to contribute to the sacred atmosphere in this place, which is also the sacred men's house, and by the shared meaning it symbolizes, to reinforce the social bonds and psychological security of the men who gather there. In terms of *meaning*, it is an *image* representing a male human figure with fish, the *subject*. Iconographically, this figure is a portrayal of Wakewakemanu, a deity who, with others, controls the appearance of schools of bonito and tuna; when displeased he can cause sickness and death by using garfish as arrows. He is sometimes generous, and sometimes dangerous, and so on the level of our *interpretation* he is a symbol of the unpredictability of natural forces that bring valuable fish and dangerous sharks. The *purpose* of having his statue is the canoe house is to please him.

The distinction between a work of art and its context is by no means as clear as one would think, especially in the less complex societies. We are used to thinking of a work of art as an object made by an artist in his studio and transported to a viewing place. We consider the object as a kind of self-contained entity, as indeed it often is. However, the majority of the art forms that we see in museums and art books that have come from Native America, or Africa, or Oceania, are objects that were once part of a larger artistic whole from which they have been extracted. The most obvious example of this is a mask that was part of the artistic whole that included the costume, the movements of the wearer, the music, and indeed, the whole performance. Such a performance may last for days and involve a great deal of art work; it may even, as among the Pueblos, be part of a year long ceremonial cycle. In a sense, just to look at a mask as a work of art by itself inevitably imposes our own cultural standards. So it is necessary to recognize that we need to try to piece together and imagine the artistic context as well as the cultural one if we are to attain a deeper sense of the import than the piece available to us provides. Even then, it is almost impossible to define the artistic whole. Perhaps we

would do better to regard these pieces as fragments from the life-style of a people.

The cultural tradition that has given rise to the study of comparative art is one that stresses art as object, as artifact far more than as event, as action, as process. We have collected far more than we have observed. Artifacts of many kinds can have esthetic qualities that can result in their being labeled art. For a variety of reasons, the chief one being durability, the objects most often so labeled and put into museums and collections are of certain limited kinds, and judgments as to the artistic output and creativity of peoples are based on these few forms. It is as if one were to hang up the ass-head mask from a performance of the *Midsummer Night's Dream;* an interesting piece, perhaps, but hardly the artistic whole.

Definitions from other cultures often do not make a sharp distinction between visual arts and the performing arts, and the words they use may concern the act rather than the thing. DeCarbo found that in Northern Ghana the concept was embodied in a word that means "one who performs particular activities artfully" and so he uses the term "artistry, or the practice of art" in describing the esthetic activities of this region. Witherspoon (1977: 151) says:

> "In the Western world beauty as a quality of things to be perceived is, in essence, static; that is, it is something to be observed and preserved. To the Navajo, however, beauty is an essential condition of man's life and is dynamic. It is not in things so much as it is in the dynamic relationship among things and between man and things. Man experiences beauty by creating it. For the Anglo observer of Navajo sandpaintings, it has always been a source of some bewilderment and frustration that the Navajo 'destroy' these sandpaintings in less time than they take to create them. To avoid this overt destruction of beauty and to preserve its artistic value, the Anglo observer always wants to take a photograph of the sandpainting, but the Navajo sees no sense and some danger in that. To the Navajo, the artistic or esthetic value of the sandpainting is found in its creation, not in its preservation. Its ritual value is in its symbolic or representational power and in its use as a vehicle or conception. Once it has served that purpose, it no longer has any ritual value."

The work of art known as a Navajo sandpainting (or to be exact drypainting because of the use of materials other than sand), is part of a ceremonial occasion that may last as long as

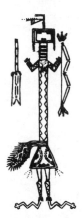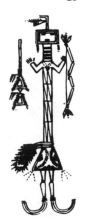

Figure 1.06. Navajo, North America. a and c, figures from sand-paintings. b, layout of a large sandpainting. The act of painting is part of a ceremony, a form of ephemeral art. (a, b, c after Newcomb and Reichard).

nine days and nights. Such a ceremony is in charge of a priest, the *Chanter*, and is "sung over" a particular individual, often as a curing rite, but also to bring blessings to all present. The patient's relatives are there, as are all in the neighborhood who can come. Social harmony is important, as well as ritual exactness. The Chanter provides the general directions and a long sequence of prayers, songs, and ritual acts, and directs the making of the sandpainting on the floor of the hogan. He does not usually strew the sand himself, but instructs the men who do. The making of a painting is a ritual act in a complex of ritual acts including prayers and songs, prayer sticks, and the use of various medicines applied to and consumed by the patient. The painting is a kind of altar, and when it is finished the patient sits on it to absorb the power from it. Each ceremony is related to one of the chapters in the story of the mythological past, and the paintings used illustrate events in the lives of the Holy Ones. A single painting out of this context is a fragment of the ritual, and therefore a fragment of the artistic whole.

One can regard all of culture as a kind of artistic creation, but we can also distinguish the more esthetic, the more symbolic aspects from the physical routines of daily life. In most cultures, ceremonial-festival occasions are the most important art wholes, and many individual contributions are made to them. Much of this collective work is emphemeral, but some artifacts remain as souvenirs and works of art in their own right. Even where there are enduring shrines, temples, and

palaces, they gain much of their importance because they are used as settings for ritual dramas. The arts of the Arn-hemlanders, the Ashanti, and the Balinese as well as the Navajo are all closely identified with ceremonial-festival events.

Style and Styles

Many fragments of the larger events which have survived and which we see as art in museums embody so much of the ethos of a people that we sense a significance we cannot interpret. The first understanding that comes to us is through recognition. Because the styles are so different we can learn to recognize objects as belonging to the tradition of a particular people, and so receive a part of their vision and view point. The Arnhemlanders, the Navajo, the Kwakiutl, the Ashanti, the Balinese, and the New Ireland and Solomons Islanders, whose art is used repeatedly as examples in the pages that follow, will in time communicate more directly as we come to greet their works with recognition.

The word *"style"* is sometimes used to mean the formal, ab-stract qualities as distinguished from content, but usually also includes the way the representational elements are treated. For example, the ways eyes and eyebrows are portrayed when the human figure is the subject is a part of style that is often very helpful in identification.

The problem of defining "a style", however, presents dif-ficulties; an individual artist has his style, there can be period styles, subcultural styles, styles in different media, culture area styles, and so on. To talk about a "style" is to talk about a classification that has been made for the convenience of observers. Such a classification can be made on the basis of a number of criteria, using a variety of labels: the style of an individual, or a period, of a culture, of a medium, of the formal qualities. The concept of style rests primarily on observable features; therefore, in visual arts there should be some kind of visible resemblences among objects classified as belonging to the same style. Objects made by the same people do not necessarily belong to the same style unless there is such a resemblence. The sandpaintings of the Navajo belong to a clearly recongnizable style, but the rugs from that area (except for those based on sandpaintings) are very different in appearance. One cannot, then, properly speak of a Navajo style without further designation.

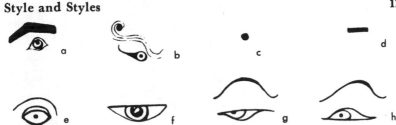

Figure 1.07. Stylistic conventions for representing eyes. a, Kwakiutl. b, Sepik River. c, Arnhemland. d, Navajo. e, Yoruba. f, New Ireland. g, Bali, female. h, Bali, male.

A style may be so widespread as to cut across cultural boundaries, and it is then usually called by the name of a group with which it is associated, such as a cult group, or, especially in the archeological context, the name of the place where it was first found.

Visual forms, as has frequently been pointed out, are impossible to fully describe in words, yet a great deal of ink has been used in the effort to do so. Words can be very useful in helping the viewer to learn to see, but they cannot substitute for seeing. They can only call attention to certain qualities, and, because there are so many elements and factors in any art style, words describing one or some of them, if taken too seriously, can lead to errors of identification and of interpretation. Terms that have been applied to certain periods and styles in the art history of Europe, such as "Gothic," "Baroque" and "Cubism," have sometimes been applied to arts of non-European peoples. By and large, however, these transplanted terms are more confusing than helpful, and can even be misleading. What is being said, usually, is "this reminds me of the European Gothic because of its vertical lines" or "this is reminiscent of the Baroque because it is ornate." The descriptive terms (vertical, ornate) would be more appropriate, as they do not imply all the other qualities of the European styles.

In art books and museums every effort is made to show not only the best work in a particular style, but the most typical, that is to say, having as many as possible of the qualities found in that style. But all of these qualities do not appear in every work—the illustration above shows typical eyes, but not all art works in these styles portray eyes in this fashion. A style is more than the sum of elements. Qualities or details described in words are clues that lead to seeing the whole configuration that is a style.

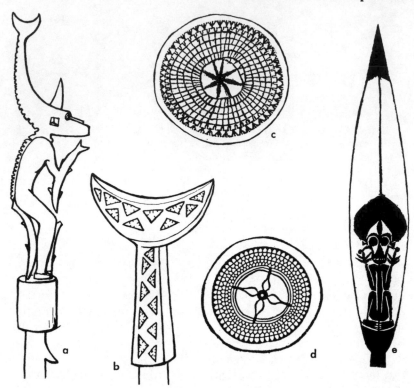

Figure 1.08. Fish as subjects and the use of shell inlay are both typical of Solomons woodcarving, but they are not always found in the same objects, and other media show different stylistic features. a, carved wood fishing float; b, canoe handle with shell inlay, both from Eastern Solomons; c, ornaments cut out of turtle shell, the "Kapkaps" that share a similar style in several Melanesian regions; c, from the Solomons, d, from New Ireland; e, painted canoe paddle blade from another region of the Solomons. (all FMNH).

For all the complexities, for all the problems, (or perhaps because of them) we humans need words, labels, for the configurations we perceive, and many of us take considerable pride and satisfaction from wandering through a museum and greeting art objects by name.

Kroeber (1948: 329) says ". . . . for things to be done well they must be done definitely, and definite results can be achieved only through some special method, technique, manner or plan of operations. Such a particular method or manner is called a *style* in all the arts." In asking about the relations of art to

various other aspects of a culture, we are asking how this technique, manner, or plan of operation is related to techniques, manners, and plans of operation in the life-style, and how these are related to environmental circumstances, and a people's strategies for survival in these circumstances. If all the suggestions concerning what is expressed in art are true, then all these things should be reflected in a people's styles. At the heart of the inquiry into the cultural nature of art is the question as to what factors in the total situation affect the visible forms that we observe.

Use affects form, and so the style of the art object, in the broad sense of style, is in part dependent on the use for which it is made. Some uses are very restrictive, and some permit a great deal of latitude, but there is no tangible art form that is made without conciousness of some kind of use. There are degrees to which objects are utilitarian, and in some forms the "limitation of possibilities" means that objects made for a certain use will resemble each other regardless of the part of the world in which they are made. For example, canoe paddles may differ in decoration, but in basic form there are limited number of possible shapes if they are to do the job. Canoes themselves offer more possibilities and can be made of a greater variety of materials, but this variability too has clear cut limits.

In recent artistic terminology, a "functional" style is one that achieves esthetic elegance by being well designed for use, not for its function in the sense that word is defined above. The Micronesian co-conut grater is an example of such esthetic elegance; it is completely un-decorated.

The "definite manner" that results in the style of what we see in the visible object or event is influenced by a number of influences on the artist. The important anthropological question with regard to style is how do the various aspects of the context

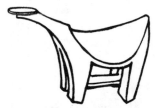

Figure 1.09. Micronesia. Coconut grating stool carved from a solid block of wood with a shell grater. (AMNH).

within which the artist works affect the the product, the visible form. The chapters that follow examine various aspects of cultural context, the variety of influences that affect the situation and the artist, and the ways these factors have been seen by various observers as determining form. These include:

1. the physical environment within which the artist works,
2. the medium in which the craftsman works, his materials and techniques,
3. the personality of the artist and his role in society,
4. the uses and functions of the art froms in the society,
5. the nature of the visual language the artists use,
6. the visual forms to which the artist has been exposed in the history of his own people and those with whom they have been in contact, and
7. the nature of the esthetic canons by which the creative process is guided and judged.

How all this works is not very well understood, so we are dealing with a variety of explanations and theories that have been put forth and which have illuminated the nature of art in certain instances. I shall try to summarize these various insights, with examples as to how they apply. I do not see any necessity of adopting any of these positions as ultimate Truth. They all add to our understanding. Some seem to be more applicable in certain ways at certain times, but it is not impossible that all these factors can operate to some degree in all creative situations.

Every artifact was made in a specific environment, of certain materials with specific tools and techniques; the maker or makers had their own personalities and motivations, and they operated within the context of a society; the art form is related to others in time and space; each says something; and every artifact has some degree of esthetic worth, depending on the criteria applied to it.

Further Reading

The works mentioned at the end of each chapter have been selected from the bibliography as being useful and accessible as starting places for fuller exploration of the topic in that chapter. The following are general works:

Anderson 1979; Biebuyuk 1969; Boas 1927; Forge 1973; Jopling 1971; Maquet 1971; Otten 1971.

Chapter 2

Where? The Geographical Dimension

The first concern with geography is a matter of identification: labeling a recognizable style in order to know where objects were made and used is necessary to be able to discuss what they may have meant in context. One learns to do this by stages. Certain styles are very distinctive, for example the wood-carving styles of the Northwest Coast of North America. Usually there are stylistic features characteristic of a whole culture area, and these are learned by familiarity with examples. Increasing knowledge and study means finer and finer discrimination—the sub-area, the ethnic group, tribe or state, and eventually a village, school, or individual artist. This is true of the arts at all levels of complexity. Also, of course, identification is a matter of time as well as space, even down to the periods in the work of an individual.

The matter of identification is made difficult for the student by the fact that the labeling in books and museums is not standardized—sometimes geographical names are used, sometimes the names of ethnic groups. For example, there are a number of examples of art forms from the **Sepik*** River area of New Guinea. When we look at the ethnographic literature, we find the names that are featured are Iatmul, Mundugumor, Arapesh, Abelam, Tchambuli, etc., and it takes careful attention to note the geographical location in these accounts. In the literature of art, the provenance of an artwork is likely to be given as "Yuat river, Sepik River region," and we wonder which tribal group produced it, particularly in view of the differences in personality and ethos that have been ascribed to each by Mead (1935). For this reason, both geographic and ethnic terms are provided for the examples here.

Neither styles nor cultures are as neatly bounded as students and scholars would like. Artists, works of art, and artistic ideas

*Each of the peoples mentioned anywhere in the text will be found in the Ethnographic Index and Notes; the 14 used most frequently are printed in **boldface** in this chapter and in that index.

all travel, and have traveled probably as long as there have been people, so that sometimes stylistic areas crosscut geographical and ethnic ones.

As a general rule, but by no means a hard and fast one, we can say that the simpler the socio-cultural system—or to be more accurate, the smaller the system, the more localized or "geographical" are the stylistic variations. Conversely, the larger the system, the more "sociological" are the styles, that is to say, in large social systems they are associated with classes and occupational groups rather than regions. Even in large systems, however, there are centers that one can place geographically from which the styles diffuse. There also seem to be nuclear areas in regions with smaller societies, but in this case the regional variation is more marked.

Anthropologists have found it useful to talk in terms of *culture areas*, regions of the world that usually have similar environments and adaptions to those environments in terms of lifestyle, or culture. In some regions the fit between culture and geographical regions seems to be very close; in others, such as Africa, cultural types crosscut regional boundaries in various ways. On the whole, art style regions fit reasonably well with the culture areas, and some way of grouping the material geographically is necessary. Naturally, there are seldom precise boundaries, whatever we draw on maps, nor would all authorities agree on the classifications. In each of the areas described below, there are many similarities in the culture and art forms, and within them lie the finer points of comparison that illuminate the various correlates of style. A few ethnic names are given as examples in the text and on the maps. It is to be remembered that there are many, many, other peoples in each area, equally skilled, though perhaps not so widely known. The culture area concept was first applied to native North America, where it works out rather well, so we will start there.

North America

In most of North America before the conquest, hunting and wild plant foods were important everywhere, even in the many areas where crops were grown. Heavy dependence on crops was probably limited to the arid area and where human populations had built up along the Mississippi River. People conceived themselves as very much part of the natural world,

but with a special role to play in it. Often this role included world renewal ceremonies, as in first fruit ceremonies and animal dance rituals to help renew the energy of the universe and increase the food resources. The natural world was permeated with the supernatural, which humans sought to be in tune with and control by ritual knowledge. In their ceremonies the Iroquois, for example, gave thanks both for and *to* the maize, the maple, and the deer. In many areas, individuals sought Sacred Power by making contact with a Guardian Spirit, often in animal form. The specific form these concepts took varied with habitat and subsistence patterns.

Arctic

Every schoolchild is familiar with some facts about the Eskimo and their life in the arctic wastes, although the severity of the life is hard to really comprehend. The men fished, hunted sea animals on the coasts, and caribou in the interior. The available materials were animal products, and survival meant skill in working these materials. Groups were small and kin

Figure 2.01. Eskimo, Arctic. a. ivory carving of a walrus; human face indicates the spirit. b. engraved tusk showing a walrus hunt. (a, b, from Naylor, retouched).

based, with specialization almost entirely by sex. Religion was oriented to the spirit world of the animals that were the sources of life. The great skill of the women in working furs was often used to embellish clothes in handsome patterns. Small ivory carvings are the best known art form. Masks of wood and hide were made in Alaska, and stone carvings are recent.

Sub-Arctic

Across most of what is now Canada there lies an area of tundra and conifer forests with cold winters and short summers. Here widely scattered bands of hunters lived self-reliant lives. The materials for their scant belongings included an extensive use of rawhide and bark. They probably invented the showshoe and the tobaggan, but there is not much visual embellishment; people put their esthetic efforts into tales of the spirit world and into music, except for birchbark containers, quillwork, and small religious carvings in wood. The Algonkian people live in the eastern part of this area.

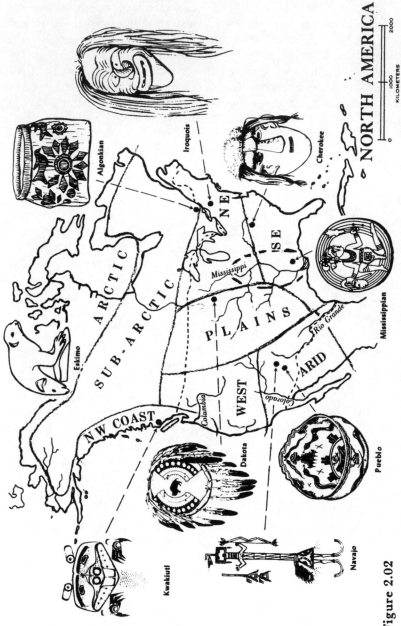

NORTH AMERICA

0 1000 2000
KILOMETERS

Figure 2.02

Northwest Coast

This is one of the few temperate areas in the world where hunting and gathering societies persisted into recent times. Warmed by the Japanese current, conifer forests cover the mountain slopes to the jagged coastline. It is a land of plenty for people with well developed techniques for fishing, sea mammal hunting, and the preserving of food. Here wood-working was a highly developed skill among the men, and the women wove a variety of mats and baskets. The **Kwakuitl** and the Haida inhabit this area. People lived together in villages of large plank houses, and traveled between villages in their seaworthy canoes, fighting and visiting and performing spectacular ceremonies. The social organization, while never centralized politically, was fairly complex with a heirarchy of status, status that was validated by the public ceremonial giving of accumulated wealth, the famous potlatch. Best known art forms are "totem" poles carved of cedar, masks and containers of wood, Chilkat blankets, and basketry.

Figure 2.03. Kwakuitl, Northwest Coast. a. horn spoon. b. carved painted wooden mask; a raven. c. carved wooden feast dish; a seal. d. house front painting; a bear. e. carved wooden mask; a mosquito. (a, b, c, e MAUBC; d from Boas 1927).

Among the people of the Northwest Coast of North America, the salmon was an important source of food; it, like many maritime resources, appeared in great quantities, and then disappeared again. When the salmon swam up the stream to spawn, their dead bodies often floated back down to the sea, but innumerable salmon appeared from the sea again the next

season. The **Kwakiutl** and others conceived this in terms of salmon spirits who lived in the sea and who clothed themselves in fish form and sacrificed themselves, but could reanimate their bodies if the bones were returned to them. This interpretation of natural phenomena is seen as related to one of the main themes of religion and art; transformation from flesh to spirit, and from death to life.

Western

Put together for simplicity as "West" on the map, this area is made up of three regions; the chief similarity lies in the fact that in all of them the Precolumbian inhabitants were hunters and gatherers who lived in small bands, and adapted to a variety of local habitats. The southern part of the area could be included in Arid America, but we are following the common usage in designating the three regions as Plateau, Great Basin, and California.

The Plateau area was in many ways similar to the sub-arctic, with variations depending on local resources, such as the salmon rivers. The known art form from this area is basketry, especially the "soft" forms known as "cornhusk bags".

California populations were denser in the valleys and sparser in the desert and mountain regions, but the groups remained small, not given to social stratification or warfare. In much of California the acorns provided a staple food that could be stored in baskets against the leaner periods. In the drier parts of the area, sandpainting was often a part of the ceremonies; small carvings were also made. The Pomo of Northern California are the most famous basketmakers.

In the deserts of the Basin, people lived in small family groups, sometimes meeting with other groups for rabbit drives and dancing. The best known craft in the whole area is that of basketry, made by women. The men displayed much creativity in the ephemeral arts of ceremony and dance.

Arid America

The dry region that extends widely over the southerly part of the western United States and the northern part of Mexico was an area of many cultural similarities in Precolumbian times. Kirchhoff (1954) considers the main distinction to be between the Oasis farmers and the Desert gatherers. However, most of the literature uses current boundaries dividing the area into the Southwest and Northern Mexico areas.

The Southwest

There is a great variety in the landscape: mountain zones with forested slopes, an extensive plateau area dotted with cedar and juniper, and the lower desert of cactus and sage. Of the peoples of this area, the best known are the people of the Pueblos of the oases, including Zuni and Hopi, the **Navajo** of the plateau region, and the Pima and Papago of the desert. Rain is associated with well-being, and figures largely in the symbolism of all these peoples. Snakes are associated with lightning and so with rain; cloud symbols take varied shapes; the fertility of maize and of humans depends on many things, but all are related to the sacred waters.

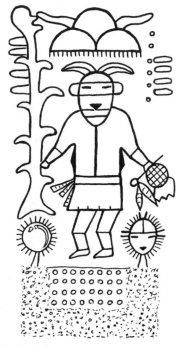

Fig. 2.04. Hopi, Pueblo, Southwest. Painted cloth panel; clouds, rain, seed, maize etc. (FMNH).

Pueblos had fairly complex cultures, although socially on a tribal level, and in some ways they show relationships to the civilizations of Mesoamerica. Farming was the basis of subsistence, and weaving and pottery have been long known. These Pueblos were organized into highly integrated communities with clans and cult groups, and a theocratic structure. Elaborate calendrical ceremonies involved much artistic activity; the well known "Katchina dolls" of the Hopi represent the masked dancers in these ceremonies, and the dancers represent the supernaturals.

The **Navajo** are relative newcomers to the area. They learned farming and pottery making from the Pueblos, and later became shepherds, weavers and silversmiths. They live in scattered settlements and gather together for ceremonials that focus on curing.

The Desert peoples foraged wildly, but also grew some crops where conditions permitted, and made pottery in addition to their finely woven baskets.

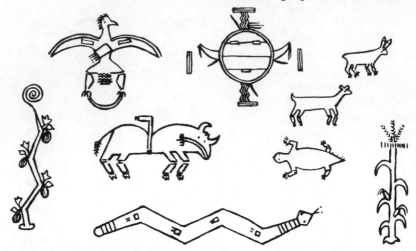

Figure 2.05. Navajo, Southwest. Figures from sandpaintings; flora and fauna. (after Newcomb and Reichard).

Northern Mexico

This area includes not only the desert near the border, but the Sierra Madre mountain region. Readers may be familiar with the Huichol who are now famous for their yarn paintings.

Prairies and Plains

These grassland areas with trees along the watercourses have cold winters and hot summers, the land becomes drier from east to west, and in Precolumbian times the villages of earth lodges along the streams became smaller from east to west. The people farmed and went out onto the grasslands to hunt. Complex ceremonial organizations, with elaborate rituals were the chief esthetic expression.

The nomadic culture that we associate with the Plains was one that had incorporated the horse (from the Spanish via Mexico) into the traditional pattern of hunting expeditions, creating a whole new life-style that flourished for about a century. Peoples from different areas and traditions adopted this pattern. Food came mostly from the bison, with some meat of the antelope and the deer. The latter also provided material for clothing; buffalo hide, which is quite astonishingly thick and heavy, was used for tipis and blankets.

A few people remained sedentary, and continued to grow maize, beans and squash in the river bottoms, to hold their traditional ceremonies and trade with the nomads.

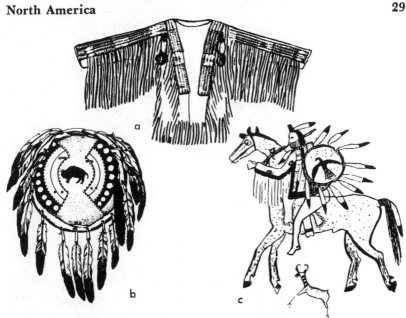

Figure 2.06. Dakota, Plains. a. buckskin shirt, decorated with fringe and quillwork embroidery. b. rawhide shield; shields carry symbols of spirit protectors. c. drawing of a warrior on horseback, in the style used to paint records of exploits on tipis and robes; artist is Running Antelope. (a, MAI; b,c, from Naylor).

Craftsmanship for the horse nomads focused upon hidework, including the high development of the teepee. Clothing, containers and shields were all made of hides. A variety of decorative techniques embellished all these items; quillwork, painting, beads, fringe and feathers. Work in other materials was limited to small, portable items such as catlinite pipes. All of these arts were used to enhance the great annual religious event, the Sun Dance, and other ceremonial celebrations. The Dakota, who once farmed on the edge of the Mississippian area, exemplify the adaptation to nomadic culture.

Mississippian

The culture areas shown by solid lines on the map are those convenionally used to mark off culturally similar regions as they were found after contact with Europeans. In Precolumbian times, however, archeological evidence indicates that the valleys of the Mississippi and those of its tributaries formed a most important culture area (indicated by the dashed

lines). This culture was clearly in a formative period of civilization comparable to those of other great river valley civilizations of the world. That its development was slower was probably due to the fact that the natural resources of the surrounding areas were so rich that the populations were not concentrated, and intensive farming had not become necessary. Throughout the area farming was combined with hunting to provide food, and trade in obsidian, copper, mica and other precious materials was extensive.

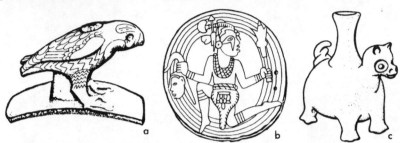

Figure 2.07. Mississippian. a. stone pipe; hawk. b. incised shell gorget showing warrior with trophy head. c. Ceramic effigy pot; some of these effigy pots are in the form of trophy heads. (a, O; b, c, MAI).

In the core area ceremonial centers with enormous mounds on which wooden temples were built bear witness to the growth of theocratic kingdoms. Ethnographic evidence tells us something of what these cultures must have been like, for the remnants of such a kingdom was maintained by the Natchez until direct contact with Europeans was made. Others probably dissolved as European diseases, particularly smallpox and measles, decimated the populations before the arrival of the conquerors themselves.

The last phase of this culture was marked by art forms that suggest a widespread cult, the Southern Death Cult, with a buzzard motif and other death symbols, very comparable to the Chavín of South America with its feline motif, and to the Olmec of Mesoamerica with its were-jaguar.

Southeast

This area provides an environment of mountains, forests and rivers, well watered, with hot summers and mild winters. Social organization was characterized by warlike matrilineal kingdoms with palisaded villages and towns. The ceremonial organization was complex, with temples, specialist priests and

an elaborate cycle of festivals. The calendrical festivals and the names of the months reflected the foods that were important at the various times of the year. There were many artistic achievements in basketry, feather work, stone, wood, clay and copper. In archeological context, this area is most closely related to the Mississippian. Examples are the Natchez and Cherokee.

Northeast and Great Lakes Region

In the more southerly part of this area the women grew the native American staples, corn, beans and squash, but further north the growing season is shorter and the rainfall less plentiful, and there was no farming. In the western part, wild rice substituted for corn. In all areas the men hunted and fished. Where there was farming, there were settled villages, but the gathering peoples lived in smaller, more mobile groups. Well developed crafts in baskets, birchbark, finger weaving, quill and beadwork and pottery were mostly women's arts. That there was probably also extensive wood carving done by men is known from the few religious forms that have survived and the "False Fase" masks of the Iroquois. The Chippewa are the best known of the gathering peoples.

Mesoamerica

Mesoamerica is the region between the Arid America on the north and the Circum-Caribbean area. It is a region of very great geographical variation. Lying in a tropical zone, the variations in terrain and elevation give climatic regions that range from very dry to very wet, and from tropical heat to the chill of the mountains, although nowhere colder than temperate zones. As these variations occur within fairly short distances, trade has long been important, not merely in durable goods, but in foodstuffs. Mesoamerica is an area that bears witness to the theory that necessity is the mother of the invention of farming. After the ice age, game became increasingly scarce, and bit by bit, from 7,000 B.C. on, plants were domesticated in this region until by the time of European discovery a great number of crops had been developed. In this area maize was first grown, and the Precolumbian civilizations grew up with the development of intensive preindustrial agricultural techniques. In the long history of this civilization, several regions developed characteristic styles in a variety of

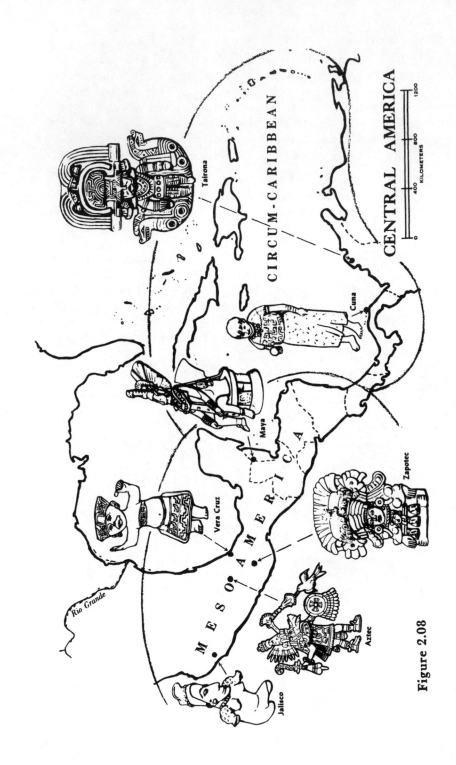

Figure 2.08

media. The tropical areas of the coast of Vera Cruz, and of the lowland **Maya**, the dry uplands of the valley of Mexico, and the fertile valley of Oaxaca offer a variety of habitats in which art traditions went through a number of periods which rose and fell as did the states within which they were an expression.

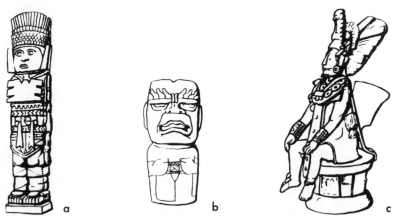

Figure 2.09. Mesoamerica. a. monumental stone pillar, Toltec, Valley of Mexico; b. carved jade ceremonial axe, Olmec, Gulf Coast; c. Clay figurine, Jaina, Classic Maya. (a, c, NMM; b, BM).

Mesoamerican pantheons had gods who were specialized, various ones being in charge of rain, fire, childbirth, death, etc., but they were not simply anthropomorphically conceived. They had a bewildering number of aspects and personas, and were involved in a complex symbolism related to the cardinal directions and cycles of time. For the most part one kept in harmony with the wishes of the gods by knowledge of the ordering of events as revealed by astrology, but one also sought their aid by means of sacrifice. It was not only that they sometimes deigned to hear the pleas of humans, but gods needed the sacrifices to maintain their vitality, so that they in turn could provide the rains and the food humans need to sustain life.

Circum-Caribbean

The Circum-Caribbean area, including Central America and the northern fringe of South America, was in Precolumbian times an area of slash and burn cultivation, with some intensive techniques, and hunting and fishing. The societies were organized into chieftanships with stratified societies of nobles, commoners and slaves. With this the religious concepts

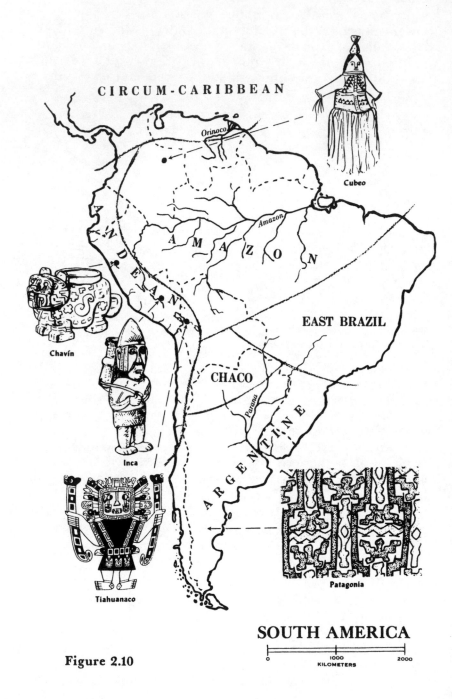

CIRCUM-CARIBBEAN

Orinoco

Cubeo

A M A Z O N

Amazon

A N D E A N

Chavín

EAST BRAZIL

Inca

CHACO

Paraná

A R G E N T I N E

Tiahuanaco

Patagonia

Figure 2.10

SOUTH AMERICA

0 1000 2000
KILOMETERS

included priestly as well as shamanistic specialists. From the pottery and goldwork that have been preserved, we deduce that craftsmanship must have been highly specialized. There is, however, little evidence of monumental structures. Tairona is an example of the Precolumbian cultures of the Circum-Caribbean area. This area is now dotted with a number of folk cultures that include many elements of traditional cultures from native America, African, East Indian and European traditions, and combinations thereof. There are some isolated areas, but in many, folk arts grade into tourist art. The **Cuna** people provide us with an example where the history of some of their art forms is known from the days of the preconquest kingdoms to the tribal-to-folk-to-tourist forms of more recent times.

South America

The **Andean** area is marked by enormous variation in ecological zones due to the steep rise and great altitude of the Andes Mountains. The area ranges from the costal strip to the very high mountains, and from the tropic of northern lowlands to the frigid mountain tops and the temperate south.

Early civilization developed along the watercourses that cut through the deserts of the costal strip and the canyons above. Populations were concentrated along these river valleys, and intensive farming practices developed. Fishing was important for protein food, and small scale trade up and down the valleys was always lively. Similar developments occurred in mountain valleys, with a variety of food crops adapted to different zones. Maize was a staple at lower altitudes, and potatoes in the higher ones; cotton was grown for textiles in the lowlands, and the llama and alpaca provided wool in the highlands. Ceremonial centers were in time linked by common beliefs spread by cults such as the Chavín cult. Periods of political consolidation came and went, and eventually climaxed in the extensive empire of the Inca. With these evolutionary developments came a very high degree of craftsmanship in large constructions, in pottery, in textiles, and in metalwork, although iron for metal tools was not included.

To the highlanders, the majestic mountains were in themselves divine; on the bodies of these mountains grew the potatoes that were the staff of life for most people. The rulers, descendants of the Sun, brought the good rich maize from the lowlands, and had terraces and irrigation works built so that it

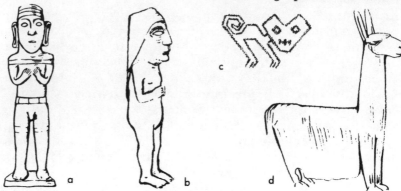

Figure 2.11. Andean a. and b. male and female votary figurines in gold and silver; they would have been clothed in fine textiles. c. feline from a textile; d. silver llama. (a, MV; b, d, AMNH).

would grow in the highlands. It was a sacred plant, and the rulers directed the ceremonies necessary to its growth.

In the present day, in addition to the Spanish colonial heritage, there are folk arts, especially in dance, music and textiles, that combine tradition in various ways, subject to the limitations imposed by extreme poverty. The history of these arts is very little known, as attention has focused on the elite arts of the past that are so impressive.

The Amazon Basin is the world's largest area of tropical forest. It is not a jungle, as the vegetation is not thick at ground level except in areas of secondary growth. It is an area of huge trees of varied kinds, and a lively world of plants, birds and small animals in the tree tops. In this area the Indians live in scattered settlements cultivating tropical crops, such as the native manioc, by slash and burn methods; they also hunt and fish. Travel is by canoe on the rivers. The climate is very even, warm and wet. Social organization is of a tribal type, often matrilineal. Religion centers around curing ceremonies and passage rites, with shamans as part-time religious specialists. Best known art forms are mostly in the form of adornment of the body, including bark-cloth masks and costumes for ceremonies. An example from this area is the Cubeo.

One could hardly expect similar world views of peoples who lived in such different worlds as the Andes and the Amazon. To the many peoples who live in the vast Amazon area, the world consists of rivers and rain-forest to the everyday senses, but behind this lies the greater reality which can be seen by the shamans when they take hallucigenic drugs in a proper ritual

manner. There is great beauty in this unseen world, but danger, too, and the spirit ones may cooperate with human allies to bring illness and death to enemies.

Other areas of South America were sparsely inhabited in preconquest times by hunters and gatherers. Little is to be found of their arts in collections, and it is probable that their forms were mostly ephemeral.

Oceania

Oceania is a term used to describe all the islands of the Pacific Ocean in the South Seas. Sometimes Indonesia is included, and sometimes it is classed with Southeast Asia. Australia may also be considered separately.

Australia

Australia is a continent about the size of the United States. Until modern times it has always been the most isolated of all land masses, with no mammalian population until humans and their dogs made their way into it during the last ice age. For about ten thousand years thereafter the Australian aboriginal peoples led a hunting and gathering life, changing slowly, but adapting their way of life closely to the land. The eastern and southwestern edges of the continent are temperate and well watered; the north is tropical with alternate rainy and dry seasons. Otherwise much of this vast area is dry scrub or desert.

The entire continent was dotted with small bands of people, each with a homeland territory within which to move in search of food, each very much part of the ecosystem. These people spoke a number of different languages, and there were a number of cultural variations within the basic pattern, but everywhere the beliefs were closely tied to the home territory, and each cultural system was highly integrated in the sense that the concepts of the natural, the supernatural, and the human formed a single consistent conceptual framework to guide behavior; life had a kind of wholeness unknown in areas of rapid change.

Technology was very direct, tools and artifacts very few, but the knowledge of the habitat and its resources impressively complete. Each feature of the landscape, each living species, plant or animal, had its place in the conceptual system, how it came to be in the Dreaming, how it behaved, and how it fitted into the social structure of humans. Humans performed their

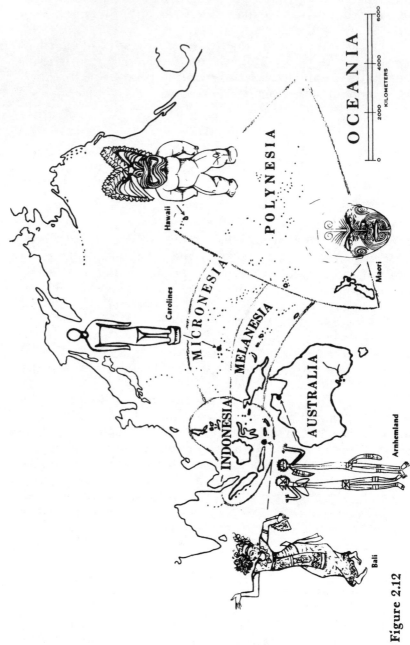

Figure 2.12

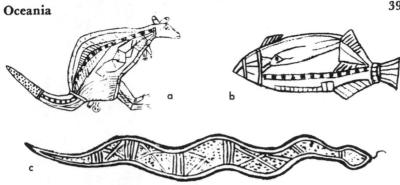

Figure 2.13. Arnhemland, Australia. a. kangaroo, important as food and in belief system. This is sometimes called the "X-ray" style. b. fish. c. the great python, a major figure in the origin myths; associated with sacred pools and water in general. (Details from various bark paintings).

ritual parts in this continuing drama. The concept of the Dreaming was not so much of the Dreamtime and its "origin myths" but a supernatural dimension of life, always present and knitting time together. Art forms reflect man's place in nature.

Representative groups are those of **Arnhemland** in the north, and a central desert people, the Walbiri.

Polynesia

Polynesia covers a wider area than any other culture area, but not much of it is land. The word means "many islands" and they lie in tropical and subtropical areas, on each side of the equator, and the largest, New Zealand, is temperate in climate. There are volcanic islands, with good rainfall and much vegetation, and tiny coral atolls with very little land. Fishing and the growing of various root crops and coconut are the food producing activities. Societies were chiefdoms, with sacred hereditary chiefs and kings. Geneologies were importantly included in the elaborate mythology, and supernatural power, "mana", was inherited, as well as achieved. There was considerable specialization, especially in woodworking, a skill needed for the sophisticated canoes as well as housebuilding and carving. Fine woven mats and painted bark cloth (tapa), netting and featherwork were also visual forms of artistic effort. Wood and stone carving were once probably extensive; only a little has survived the period of the zealous destruction of "heathen idols". Hawaii is in Polynesia, as is New Zealand, home of the Maori.

The mythology of the Polynesians tell of the great voyages of the ancestors and of the gods of the seas and the winds, and how islands were brought out of the sea. In such an island world, land is a small part of the universe, a precious part for human beings, but, as in the world view of the Hawaiians, "land and sea were complementary to each other, and only together could they form a complete setting for human existance". (Buck 1938: 266).

Micronesia

The hundreds of small islands of Micronesia are scattered in clusters over thousands of miles of ocean. The Micronesians navigated their canoes freely over this vast area, and their navigational charts made of bamboo strips with shells to represent islands can be considered works of art. The cultures of these peoples in many ways resembled those of the Polynesians, but trade was more extensive. Oliver says: Nearly every place produced a specialty—fine mats or unique dyes or special shell ornaments—and exchanged it for something unusual from another place." (1951: 79).

Fishing and gardening provided food; land was scarce and a source of wealth. It was usually owned by kin groups in amounts that varied with the rank of the lineage. High ranking

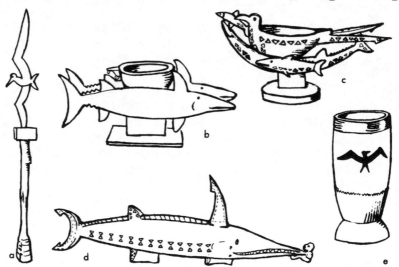

Figure 2.14. Solomons, Melanesia. Wood carvings, black with shell inlay. a. fishing float; b. and c. ritual communion bowls, d. casket; e. household mortar. Note fish, sharks, frigate birds. (all UM/UP)

chiefs had great authority in additional to ritual duties. Religion centered about the spirits of the ancestors. The Caroline Islands are in Micronesia.

Melanesia

This is an island environment of tropical climate with both volcanic and coral islands. Gardening and fishing were the main sources of food, with pigs playing an important part as feast food. The organization was mainly tribal, with status being achievable by the accumulation of pigs and control of pigs as capital. Status was validate by feats. Feuds and headhunting were common. Religious observances centered around ancestors and the spirits that control food resources. Within this general pattern, however, there is great cultural diversity. Many different languages are spoken, due to past migrations of many peoples. There is considerable variation in habitat, particularly between the coastal and inland regions. This is an area best known for an impressive variety of wood carving styles, including those of the **Solomons** and **New Ireland**.

New Guinea

New Guinea belongs in Melanesia because of the degree of cultural similarity, but is often considered separately simply because it is so large, and within the general pattern, quite diverse. Stylistic areas are clearly distinguishable. It is a very large island, about 2,500 km. long. It is tropical, but climate varies with altitude from the humid tropical coast to snow capped mountains. Technology is very direct, and metal was not known until this century. Slash and burn horticulture is the basic food producing method; sweet potatoes, yams and sago are staples, pigs provide protein, wealth, ceremonial feasts and prestige. Social organization was tribal in type, and the local unit a village or hamlet. Ephemeral ceremonial art was elaborate, and usually centered on a "men's house" where carvings, trophies and ritual materials were kept. Beliefs were intricately connected with ancestral spirits and the power to be derived from headhunting.

Figure 2.15. Sepik Region, New Guinea. Carved wood canoe prow in the form of a crocodile. (MPA).

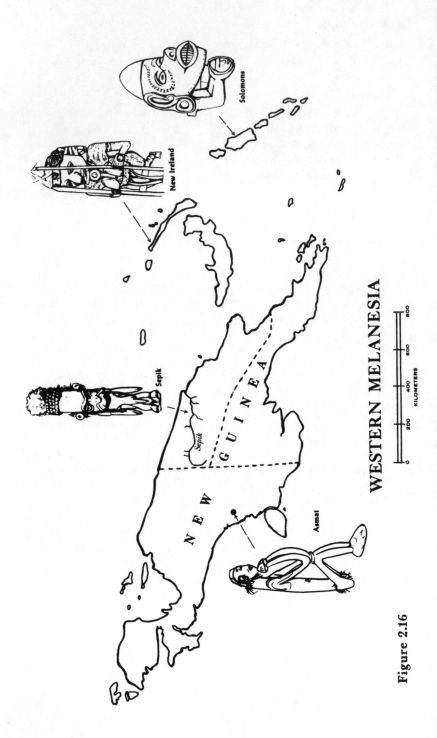

WESTERN MELANESIA

Figure 2.16

The relation of peoples to their homelands is close. Schifflin (1976) tells of the emotions expressed in mourning ceremonies for places associated with the deceased, and Rappaport has interpreted the customs of one people as a "ritually regulated ecosystem." In their belief systems, New Guinea peoples often equate themselves with other biological species in seeking metaphors to express their feelings about themselves. The Asmat, for example, identify with praying mantises who are headhunters like themselves. Two of the areas famous for art are the **Sepik** river and Asmat areas.

Indonesia (Malaysia)

The culture area called Indonesia or Malaysia is a tropical area with a long and complicated history. In the interior are tribal peoples who are slash and burn farmers growing hill (dry) rice. Nearer the coasts cultures show many influences from Asia at various periods; here the main crop is wet rice grown on terraced hillsides. In this large area peoples have put together the many influences that have come from different civilizations of mainland Asia at various times, and from Europe and America in recent times, combining these influences in many ways to create distinctive cultural forms.

Bali is a small island that assimilated influences from India, and remained Hindu when the neighboring Java was

Figure 2.17. Bali, Indonesia. Carved wood, polychromed. a. mythical bird, Garuda; b. mythical lion, Singa. (b, **KIT**).

converted to Islam. The Balinese have interpreted Hinduism in the light of their own traditions, and see the high center of the island as the home of the gods. In addition to the construction of numerous temples of tufa and limestone, the Balinese have ingenious artistic uses for all kinds of natural woods and fibers, palm leaves and bamboo, and also import gold, silk and other materials.

Africa

Dividing the huge continent of Africa into culture areas cannot be done neatly; the map must be recognized as a more or less convenient approximation. Futhermore, the new nation states will in time make this seem as obsolete as the areas of Native America. And yet, because both are based on natural zones, such areas may have a certain amount of meaning for a long time to come.

Variation in habitat is great in Africa, and the traditional adaptation was very close. There are many cultures and many languages, and many complex histories. But when compared to other regions of the world, Africa south of the Sahara shares many qualities that give all these diverse cultures a unity that Maquet calls "Africanity". The qualities rest on some shared basic postulates with deep meaning. The concept of the Life Force, or Vital Force, for example, is similar in its abstractness to the concepts of Sacred Power of the American Indians, and that of Mana of the Polynesians, but it is qualitatively different, and differently approached. As Maquet puts it, "The African sees himself. . . as part of the great stream of life that transcends his own self." (1972: 63). This attitude means on the one hand an effort to cooperate with rather than to master nature, and on the other a great sense of belonging to and depending on the ongoing line of the family, of which the self is but a single link. It is this sense of ongoing human life that is embodied in the ancestor figures rather than the individuality Westerners express and look for in art.

North Africa is considered to be the Islamic culture sphere, related to the near East. Archeological effort is bringing to light more of the complex cultural history of the region, and its relations to sub-Saharan Africa. It includes the area along the Mediterranean coast with Egypt, and most of the Sahara desert. The Sahara is one of the most arid regions in the world, and the few peoples who inhabit the area are nomadic, Islamic, and produce little that is usually classed with the visual arts,

although a broader definition reveals a number of visual esthetic forms. In the literature on African art this region is best known for the great number of pre-historic rock paintings, especially in the Tassali region, that reflect the long history of the region from the days when it was far more habitable.

West Africa

South of the Sahara stretches a belt of grassland with patches of trees. This is traditionally called the Sudan, a name now used by the nation in the eastern part of the region. The area of the western Sudan, the Sahel, is an area of small grain farmers and pastoralists. Here the great Medieval kingdoms rose and fell, and the Niger river forms the great highway. It is an area that has become increasingly arid during the past 500 years, due to climatic factors and population pressure, hence the increasing poverty since the days of the great kingdoms. Islamic influences have been strong. The most famous art forms come from peoples such as the Bambara and the Dogon in the form of wood carving, but we are coming to recognize the artistic value of other media, particularly architectural forms.

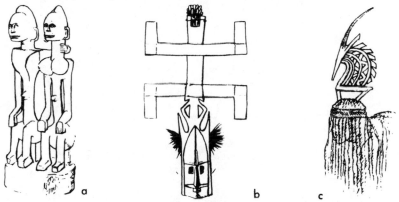

Figure 2.18. Western Sudan. a. Dogon primordial couple, carved wood. b. Dogon mask. c. Bambara antelope. (a, RMZ; b, MH).

The southern part of the West Africa region becomes gradually wetter as it approaches the coast. The people are primarily farmers, although many are also town dwellers. The coastal region, called the Guinea Coast, is a tropical rain forest area where heavy rains alternate with a dry season, when winds blow from over the Sahara. Tropical root crops are grown near the coast, and grains in the drier areas, together with a number of garden crops. Metalworkers often belonged to a separate

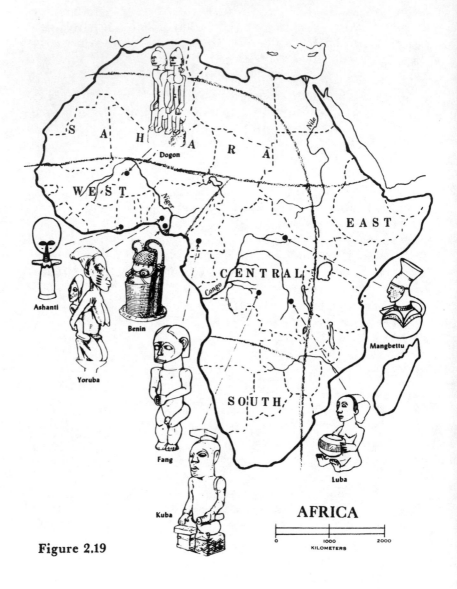

Figure 2.19

AFRICA

0 1000 2000
KILOMETERS

caste; good carvers, potters, and weavers could become specialists. Trade with the regions to the north has been extensive for many centuries; European slaving and trade began in the 16th century. This was an area of many ethnic groups, organized in many ways in groups, cults, associations, kingdoms, with great variation in size and level of complexity. Dancing was probably a most basic art form, but the area is famous for the variety of wood carving, bronze and brass casting, gold work, and textiles. The **Ashanti** of Ghana and the **Yoruba** of Nigeria are the people especially well known for their arts. **Benin** bronzes are also famous. These peoples are now part of the modern nation states of Ghana and Nigeria.

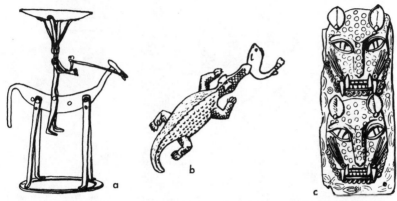

Figure 2.20. West Africa. a. Yoruba, iron lamp for a shrine; b. Ashanti gold sword ornament; c. Benin, bronze plaque with leopard heads. (a, after Bascom 1969a; b, after Cole and Ross; c, FM).

Their arts are changing, but they are very much alive. Many other peoples in the Niger river drainage area have produced a number of art forms; woodcarving is the best known.

Central Africa

The northern part is the Sahel, sometimes called the Eastern Sudan culture area. It is very arid and supports people dependent on pastoralism and grain crops.

In the vast Congo region only a small part of the area is rain forest, although it is all tropical. The rest is covered with dry forest, savannah and grassland. The peoples are usually slash and burn farmers, and the concentrations of population have been less than on the Guinea Coast. In terms of socio-cultural complexity, tribes and kingdoms were both found. Living with very direct technologies, the relation to nature is very

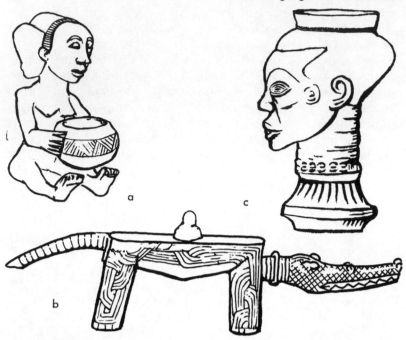

Figure 2.21. Central Africa. a. Luba wood figurine; b. Kuba divination board in the form of a crocodile; c. Kuba carved wood cup. (a, UM/UP; b, PC; c, after Paulme).

close; knowledge of the habitat is intensive, and rich symbolic systems are modeled on the properties of animals and plants, although, as the art shows, humans most significantly embody the Vital Force. Wood and ivory carving and raffia cloth are the famous art products of the area. The Kuba, the Luba, the **Fang,** and the Mangbettu are located in this region.

South African

This area, with a Mediterranean climate on the coast, and arid land in the interior, was at the time of colonization the home of the Bushmen and related peoples. These hunters and gatherers probably once roamed widely over the grasslands of Africa before the spread of the farmers and pastoralists. Rock paintings found far beyond their recent habitat are attributed to the Bushmen.

East Africa

Along the entire eastern side of Africa, up to the east Horn, lies a band of savannah and grassland, fairly sparsely pop-

ulated by cattle herders who depend greatly on grain for food, but regarded cattle as of supreme importance. Ethnographic accounts describe tribal societies and small kingdoms, and archeology bears witness to former greater kingdoms and extensive trade with India, China and the Islamic world. As with most primarily pastoral peoples, the visual arts are not spectacular; emphasis is put on music and dancing and oral literature. The Zulu of the south, whose latter day beadwork is elaborate, and the Masai of Kenya are peoples of this area.

The eastern Sudan is for the most part extraordinarily flat, with extreme wet and dry seasons. The people are cattle herders, with gardens for grain and vegetables, and organized by the segmentary lineage system without centralized government. The visual arts were not stressed, but a great many of the hand made objects for everyday use are of high esthetic quality.

The Eastern Horn is really desert, inhabited by Islamicised camel and goat herders with a strong tradition of oral literature.

Ethiopia is an upland and mountainous region with great cultural diversity, which is best known for maintaining the traditional art forms of the Coptic Christians.

Art and Environment

In addition to the basic necessity of knowing the place of origin of art works, geography is of importance for two kinds of questions that have interested students of art. One has to do with the traveling or diffusion of styles or elements of style; this will be considered under the heading "Whence" in Chapter 7. The other is the matter of the relationships between style and physical enviroment. Some of the possible relationships are fairly obvious, while others are more a matter of speculation; some are very direct, others subtle and indirect.

The most obvious and direct relationship or art styles with habitat lies in the use of materials. In all but the most industrialized societies, art is not separated from craftsmanship, and the technology reflects adaptions to the environment. This can be seen very clearly in the societies with direct technologies. People living close to nature develop skills in working with materials available to them, and with skill goes the tendency to work the material in esthetic ways. The hide work of the Plains Indians, the wood carving of the Northwest Coast, the birchbark of the sub-Arctic, and the

featherwork of New Guinea are examples. The relationship is not so simple where societies have become more complex and command the resources to import materials from other areas, and sometimes peoples show off their skills by doing something with a material that has been considered "impossible". Still there is a tendency for the people closest to the resources to have developed the higher skills, and for artists to work with a material to bring out rather than to deny its qualities. Therefore, some of the qualities in a style are inherent in the material from which the artifacts are fashioned, and this is related to geographical factors.

Another fairly clear relationship that exists between art and environment lies in the content, the images that are represented. Animals especially impress themselves on people's minds and are important in their art forms and in their symbols. Eskimo polar bears and Australian kangaroos are obvious examples. Real animals are very much a part of people's lives in various ways, and sometimes the symbolism that is built up around them persists and changes even though the animals are no longer so directly important. The Bambara antelope is apparently a survival from the days when the Bambara were hunters, and it has changed in meaning to continue in importance as a patron of farming.

Looking closely at the forms that are represented in a particular area, one realizes that not all species of flora and fauna are found in the art forms, and the question arises as to why a people select certain forms to be significent. To answer this involves us not only in an attempt to understand their symbolic systems, but the relation of such systems to their daily lives. For example, the frigate bird is a common motif in Melanesia, and Davenport (1968) has shown how this bird is associated with the valued, unpredictable bonito fish controlled by the dieties in the cosmological-ecological system of the Solomon Islands. Hopi art forms exist in a context of ceremony that is attuned to maintaining life in a highly arid land, and can hardly be understood without an appreciation of the way the storm clouds come from the mountains.

As art forms are often expressive of belief systems, and belief systems tend to be concerned with the chief problems and dangers of life, visual symbols are likely to be parts of systems that relate to adaption and survival in a given habitat, although the way the visible forms relate through the belief system to that habitat is not always obvious.

The abstract shapes and qualities of the visual world—the form qualities—have been seen as influencing the artist's products, although many authorities have pointed out that the individual artist's vision is more shaped by art than direct observation. Still, the environment may have shaped the cultural view, and hence the art to which the individual was exposed. Direct environmental experience as well as artistic tradition probably affects the perception of space depth in two dimensional works. The famous example of Turnbull's Pygmy friend Kenge who went out onto the plains from his forest home and insisted that the distant buffalo must be very small, suggests that this may be common to forest dwelling peoples. If this is the case, then other environments may well affect ways of perceiving form, and, of course, the forms that are produced. Fraser mentions several of the suggested relationships:

> "In Melanesia, with its plunging defiles, sluggish rivers, and craggy mountains, art seems to parallel in its violence and contrasts the harsh shapes of the land-scape. . . . The world of the Micronesian artist of the Pacific atolls is, so to speak, thindrawn and linear—atoll art often has such characteristics." (Fraser 1962: 17).

It has been suggested that in forested areas people produce curvilinear organic art forms, while in open areas the art tends to be geometric, with straight lines. Sir Herbert Read has gone so far as to say that peoples from bare areas do not produce organic forms at all. In North America, indeed, quill and later bead embroideries from the woodland areas are more often of organic forms executed with curved lines, while Indian women of the Plains more often used straight lined geometric figures. On the other hand, the arts of the Eskimo show great sensitivity to organic form, although there are no trees at all, and Plains males painted figurative forms.

It has also been suggested that peoples from tropical forest areas tend to produce ornate forms, with full or crowded spatial arrangements. Peoples who are accustomed to the great open spaces, on the other hand, reflect this in their formal arrangements by focusing on a single element, or a few elements either free-standing or on an unbounded surface.

A more factual observation regarding habitat and art form is that made by Willett with regard to prehistoric African art. He offers no theories, but points out that differences in materials

and conditions of preservation do not account completely for the observed difference:

> ". . . the general distribution of the rock art. . . is, for the most part, outside the area of the distribution of the sculpture. It seems likely that these artists of the open savannas expressed themselves in paint and line, whereas the peoples of the West African forests and woodlands and of the Congo Basin preferred sculptural expression." (1971: 65).

Of all the arts, architecture is most closely related to the habitat because of the nature of the protection needed and the material available. But architectural forms have an effect on other artistic expression. Mud and plastered walls are tempting areas for mural painting; wooden posts are there to carve.

A frequent subject of the artist is the human figure; artists portray themselves and their neighbors, and visualize the supernaturals in something like human form. In a great many cases, the physical type is readily apparent, in others it has been altered in some way for expressive, symbolic or stylistic purposes, and it is less obviously reflective of the literal reality. Representative landscapes and plant forms are relatively rare outside of the artistic traditions of the more complex civilizations, but where they exist the images may be quite realistic. Sometimes they are more representational than a stranger to the area might suppose.

Of course a people's stylistic ideas affect all their cultural forms, so that the cultural environment as well as the natural one influences the artistic products we see. In terms of content, for example, the way people treat and decorate their bodies will be reflected in their representations. Many renderings of human beings that seem to us highly stylized are actually very representational; much of the exotic quality is due to the art that has been applied to the human subjects themselves rather than to their portraits. A striking example is that of the Mangbettu of the Northern Congo region with their elongated skulls and distinctive hair style. A most complex situation is found in the case of

Fig. 2.22. Mang-bettu pot. (RMZ)

Japanese landscapes, where many qualities of Japanese prints turn out to be quite representational. But the Japanese have

greatly modified much of their landscape in terms of their esthetic ideas. The relation between art and environment is not all one way.

In addition to the direct effects of materials and the visual stimuli, some students have postulated that climate and geography have an effect on personality, and this in turn shapes the world view and the art forms. Relations of this kind between culture and environment are not very amenable to testing. One can, however, look for any qualities that may be correlated with types of environment and climate, regardless of how the influence operates through individuals.

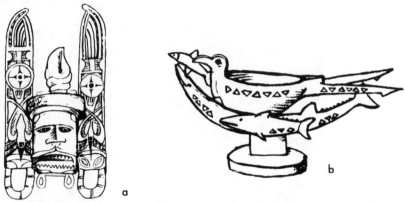

Figure 2.23. a. New Ireland; b. Solomons. Similar environments, different styles. Birds, fish and humans are the usual subjects in both regions, but Solomon carvings are very clear forms, black with shell inlay. New Ireland pieces are intricately carved and covered with fine lines in black, white and red paint that tends to obscure the subjects. (a, FMNH; b, UM/UP).

The current tendency is to consider environmental factors in terms of small scale ecological systems rather than geographical areas or climatic types. In the Solomon Island example, the environment affects the art form in terms of the materials used—wood and shell; in the subject matter—the use of fish, shark and frigate bird motifs; and in terms of iconographical meaning—the great ecological significance of the huge schools of bonito that appear unpredictably, heralded by sea birds, and surrounded by sharks, which is reflected in the belief system. It is not apparent whether there is any direct influence of this environment on the formal stylistic qualities of the art. There is a similarity of content in the art of the **Solomons** and that of **New Ireland**, but the formal qualities are

very different. This may be due to the fact that the relationship of the New Irelanders to the sea is no longer very important, so the formal qualities bear more relation to some other factor, such as the social situation.

To perceive the relation of a people's symbolic forms to the environment in which they live, we need to understand the problems and dangers of that environment. The question "From whence comes death?" can illuminate the way the religious ideas of a people are structured. One need not deny spiritual awareness, or take a materialistic position, to recognize that the Unknown, the Invisible, is defined in terms of metaphors and images that reflect responses to fears and hopes in the physical world.

The visible form tends to reflect, in some way, the environment in which it is created. The most obvious factors that affect the style, (in the broad sense of the word), are the visible forms and inhabitants of the artist's world which are the models for his images, and the materials he has to work with. With the technological means which his environment and culture provides, he shapes the material to express his world, which is also shaped by his culture.

Further Reading

General: Anton et al. 1979; Christensen 1955; N.Y. Graphic Society 1974; Wingert 1962.

Americas: Dockstader 1973; Keleman 1969.

North America and Mesoamerica: Feder n.d.; Feest, 1980; Spencer, Jennings et al 1977; Whiteford 1970.

South America: Dockstader 1967; Emmerich 1965; Lothrop 1961; Stewart and Faron 1959.

Oceania: Alkire 1977; Buehler, Barrow and Mountford 1962; Gittinger 1979; Holt 1967; Linton and Wingert 1946; Poignant 1967; Schmitz n.d.

Africa: Bascom 1973; Maquet 1972a; Sieber 1972, 1980; Willett 1971.

Periodicals: African Arts, American Indian Arts.

Chapter 3

How? The Technological Means

In this chapter we consider the artist primarily as a crafts-
man. In the broad sense of the word art, ". . . the arts of a
people are the skills and techniques they employ in making
their tools, implements, and ornaments" (Whiteford 1970: 5) as
well as their symbolic statements. Making the distinction
between artists and craftsmen often implies a strong value
judgment in favor of the former, and tends to obscure our
understanding of the arts in various cultural contexts. Some
craftsmen have more esthetic sensibility than others, are more
creative in that they are always recombining the elements of
form and technique, and we may consider the results more
artistic in some cases than in others, but all arts involve
craftsmanship. It is arbitrary to draw a line between "arts" and
"crafts"; a work of art is considered by the observer to be of
higher esthetic quality, and usually to be more meaningful
than a craft object, but this is a matter of degree.

The description of crafts in this chapter includes several
aspects: 1) the actual technique by which various materials are
worked, 2) the degree of specialization that is usually associated
with the various crafts and 3) the type of persons who are likely
to work in a certain craft in societies of various levels of com-
plexity.

The degree of specialization of the artist is roughly correlated
with the complexity of the society in which he works. Thus in
many very small societies, "everyone is an artist", in the sense of
making things by hand, and no one is a full time professional.
Nevertheless, it seems to be the case that some persons specialize
to some degree because of their personal interests and capa-
bilities. The person drawn to one art form or another will
tend to do it in his spare time, and to pay more attention to the
similar work of others. While the selection of a person for
particular artistic tasks may be largely a matter of social
position—as relationship to the deceased in Arnhemland
funeral rites—it usually happens that there are several persons
in the right relationship, so that the work is to some degree

apportioned according to skill. In complex societies there may be many full time professionals. Between those extremes the pattern is one of recognized specialists who are usually paid in some form for their work, but who also engage in subsistence activities such as farming or fishing.

But these categories are very inexact and grade into one another. For example, an old woman in a hunting and gathering band may in fact spend most of her time making baskets for younger ones to use, and so in effect earns her living by her profession. Recent studies have shown a remarkable number of traditional artists in Africa whose primary vocation is their art, although according to political criteria their societies were at a tribal level. We tend, too, to overlook the great amount of creativity that goes into the work of part-time artists and craftsmen in complex societies, concentrating as we do on elite products.

Many creative forms are not made by professionals at any level of socio-cultural complexity. These often ephemeral arts are usually in terms of techniques that are based on skills known to everyone of the appropriate sex. In more complex societies they form much of the "folk art". There are active processes of creativity at work among all peoples, if we can achieve sufficient objectivity to include media and canons that we are not accustomed to classify as art.

The folk artist is likely to be an amateur, creating by embellishing the useful things of life far beyond necessity, and a great deal of creativity goes into the breaks in the daily grind; the festive occasions, calendrical festivals and rites of passage. Folk art may also be defined as the work of specialists and professionals providing craft articles that can be bought by the person of humble means. It is this latter that tends to disappear in industrialized societies. The time involved in hand-craftsmanship means either that the maker cannot improve her condition beyond the subsistence level, or only the affluent can afford her creations.

Greater socio-cultural complexity is, however, closely tied to an increase in the number of techniques used by people, and the division of labor for greater specialization of occupation. While increase in socio-culture complexity may be related to increased technological sophistication and specialization, the increase does not apply to every craft; it does mean that more crafts that may be treated artistically are added.

Complexity also means that the artist-craftsman has a less direct relationship with the natural sources of his tools and materials; other people provide him with these in some kind of an exchange system. In small societies with direct technologies, the craftsman usually makes or inherits his tools. The material too is a matter of differences in specialization in procurement. The metal worker is less likely to mine his ore than the basket maker is to gather her own fibers. The potter who uses a wheel is more likely to have someone else to dig and prepare his clay than the woman who coils her pots.

Even where the technical devices remain simple, increased specialization comes about with increase in socio-political complexity, so that the masters of Peruvian weaving did not themselves shear the wool of the alpaca as Navajo women do with sheep, nor, probably, did they gather and process all of their dye materials. Pre-industrial civilizations produced the most magnificent, elaborate examples of craftsmanship known, such as Peruvian and Oriental textiles, the royal jewels of all empires, and the hand hewn stonework of the monumental architecture and sculpture of the ancient world, the intricate work of bronze casting, cloisonné, and fine ceramic wares. The high level of craftsmanship of these hand-made forms does not mean that everyone who worked on them was an artist or a craftsman, because even without factory organization or power tools, many persons often did "grunt" labor for master craftsmen who designed and/or directed the work.

In industrial civilizations, specialization has continued the divorce of art from craftsmanship, to the point where in a few remaining media that are considered crafts, some persons seek to make their works so useless that they can be called Art. Artists usually buy their traditional tools and materials ready-made, except for a few self-concious experiments in primitivism, which are soon discarded as too time consuming. However, some work directly with modern technological processes.

Technique, the tools and operations that the craftsman employs, may be put for convenience under several broad headings that more or less correspond to the way people in a number of societies classify occupations without subdividing too minutely. There are: hide work, fiber work, carving, modelling, painting and metalwork. The basic processes of each are described below with a few examples. The variations and elaborations are too many to consider here.

Hide Work

The technique of skin working is used by either men or women, depending on the culture. The skill is naturally most important among the hunting societies in Northern latitudes. In addition to the use of rawhide, there are three basic kinds of processes for curing hides (from large animals) and skins (from small ones). These are: 1) animal—the oil process or chamoising; 2) the vegetable process or tanning proper; and 3) the mineral or chemical process now also called tanning (formerly tawing). All American Indians used the oil process, not only for buckskin, but for all hide curing. In West Africa the typical leather is vegetable tanned goatskin, called morocco leather. Modern leathers, such as those used for the hand tooled leatherwork of Mexico, are chemically tanned.

Figure 3.01. Rawhide. a-e, steps in making a rawhide shield, Dakota. Drums are made in a similar fashion. a. scraping the hide, flesh and hair are removed; b. scrapers made of bone, sinew and flint; c. shrinking and thickening the hide with heat; d and e, cutting and attaching the hide to a willow hoop; f. Dakota Sundance figure—rawhide cutout with feather; g. a Dakota rawhide shield, painted; h. Balinese shadow puppet made of parchment, which is finely thinned and smoothed rawhide; design is both punch cut and painted; i. Navajo rawhide mask, with feathers. (f, MAI/HF; g, PY; i, BM/NY).

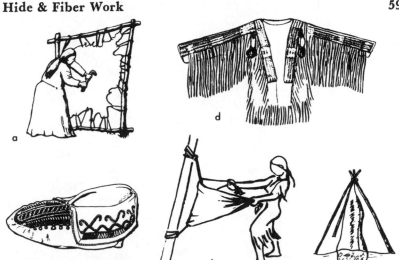

Figure 3.02. Buckskin. a. scraping; b. working the skin to soften after soaking with animal oils; c. smoking to improve color and preserve skin; d. Dakota buckskin shirt decorated with fringe and quillwork; e. Iroquois moccasin decorated with moosehair embroidery. (d, MAI/HF; e, from Naylor).

Once the skin is prepared, it can often be decorated by a number of techniques. For example, rawhide is often painted; the Dakota and other Plains tribes used rawhide shields and drums painted in representational-symbolic fashion by men, and containers—"parfleches"—painted with geometrical designs by women. Hopi and Navajo men made helmet masks of painted and decorated rawhide.

Soft-tanned leather (buckskin) was widely used for garments and skin tents in the circumpolar region and in the North American plains. Well prepared buckskin is esthetically attractive even without adornment. But it can be decorated in a number of ways—painting, fringing, appliqué and various types of embroidery. Decorative patchwork, especially for clothing, was done in fur in the circumpolar regions; even fishskins were worked and decorated by painting in Siberia. Quillwork was a North American invention unknown elsewhere.

Fiber Work

There are many techniques employing fibers, and many kinds of vegetable and animal fibers are used. Fibers can be used simply by being hung, as in "grass skirts" and in many areas

such fiber costumes are often used by dancers. A basic division is between spun and unspun fibers. Unspun fibers may be stuck or pounded together after being soaked, which is called felting; bark cloth, felt and paper are made in this way. Unspun fibers, either soft or stiff may be woven together to make baskets, mats, bags and the like. Spun fibers, usually twisted on a spindle, are woven into textiles either with the fingers (perhaps using some kind of a device to hold the threads such as a "warp-weight loom") or on a true loom, or they may be tied and twisted together using aids such as crochet hooks and knitting needles. Some examples, with figure numbers:

	felted	finger woven	loom woven	knitted, netted, etc.
unspun	Cubeo bark cloth (3.04)	Pomo basket (3.03)	Kuba raffia cloth (3.04)	
spun		Kwakiutl cape (3.05)	Navajo rug (3.06)	African knitted costume (3.04)

Basketry and matting

Weaving of baskets is done with a great variety of fibers, and some of them are quite soft, so that the difference between baskets and textiles is not softness, but that the fibers of textiles have usually been spun. Basketry techniques are of three main classes: plaiting, twining and coiling. In plaiting, sometimes called simple basketweave, two sets of elements pass over and under each other. In plain plaiting this produces a checkerboard effect. This can be varied by varying the number of elements so that one goes over two and under one, and the like, producing diagonal effects called twill plaiting. When stiff rods are used so that the weft elements are bent around them, wicker plaiting, or more commonly, wickerwork, is the name used.

Twined baskets are rather like wickerwork in that there are stiff warps, but they are more complicated in that the wefts twine around each other in various ways as well as over and under warps. The third technique, coiling, (sometimes called sewn baskets), is done by coiling fibers around themselves, sewing each coil to the previous one; new material is added to the coiled material as needed. Typology is based on whether rods or bundles of fibers are used in the coils, and the kinds of stitches used to hold the coils together. Basketry decoration consists usually of patterns made by variations in the colors of

the fibers to make patterns in the course of the weaving, but decorative elements such as beads and feathers can be woven in or added later.

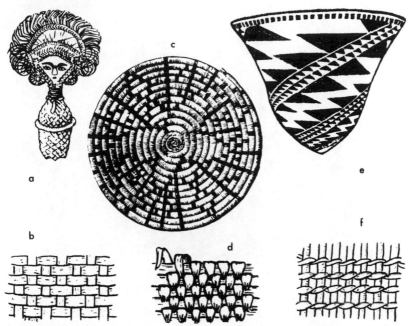

Figure 3.03. Basket weaves. a. Balinese basketry figurine with plaited base; b. plaiting, simple "basket weave" or plain weave; c. Hopi coiled tray; d. coiling or sewing; e. Pomo twined burden basket; f. twining, the wefts are twisted together. These basic types of weaves are also found in fabrics. (c, from James; e, AMNH).

Basketry and mat weaving are often, but by no means universally, women's arts. I have the impression that basketry is very often an art produced by older women rather than younger ones. Sometimes one reads about the dying art of basketry that is practised by older women, and a generation or more later, the same plaint is voiced about the same people—the young having become old and taken it up. Elsie Allen, the Pomo basketmaker, did not herself take up the art seriously until she was 62 (Allen 1972). Perhaps it is most usually learned in childhood and resumed in the later, less active years.

In societies with more complex, indirect technologies, baskets are often replaced for many uses by clay and metal pots, cardboard boxes and the like. Yet baskets persist in the home and marketplace because they are light, attractive and

unbreakable. The making of baskets has never been mechanized, and remains a folk art and cottage industry.

Woven mats were once very important, both practically and symbolically. With many peoples they were sometimes of a fineness approaching cloth so that they were worn as clothing. Polynesia is particularly known for such mats. Beautiful woven mats and raffia cloth were important house furnishings in the Congo area.

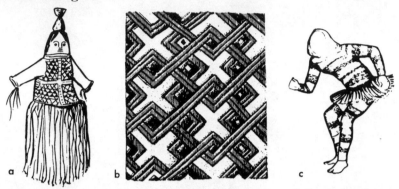

Figure 3.04. Uses of fibers. a. Cubeo bark cloth mask-costume, painted; b. Kuba cut-pile raffia cloth—"Kasai velvet" made with unspun raffia on a slanted upright loom; c. African dancer in a knitted body suit and raffia fiber skirt (mask not shown). (a, FMNH; b, from Boas).

Netting and similar openwork techniques involving the knotting together of spun fibers are very important in small societies at all levels. In Africa netting and knitting, often done by men, is an important technique in the preparation of costumes for the masked dancers, covering the wearer almost completely, and serving as a foundation for decorations. In South America, hammock making is a well developed craft, with the products both useful and attractive—variations and elaborations such as crochet and macreme are widespread folk art in complex societies.

Textiles

Weaving of cloth is rarely the work of the complete amateur, as it requires a considerable amount of technical knowledge and skill, together with the time to achieve results. The weaver may be either male or female; sometimes there are both male and female weavers in the same society, although they use different kinds of looms, as among the Ashanti. There are several instances of neighboring groups in which the men are

the weavers in one and the women in the other, as in the case of the Hopi/Navajo of the Southwest. Among the Kuba, women make fine mats in the form of raffia cloth, including the famous Kasai velvet. Among their neighbors, the men weave raffia cloth and were astonished to learn that women could do so.

Devices to assist in holding and manipulating the thread vary in complexity; a basic distinction is that between guiding each thread over and under, sometimes called finger weaving, and having a device for lifting a whole row of strung threads (warp) at once, making a space (shed) through which cross threads (weft) can be thrust. The latter is a true loom. Finger

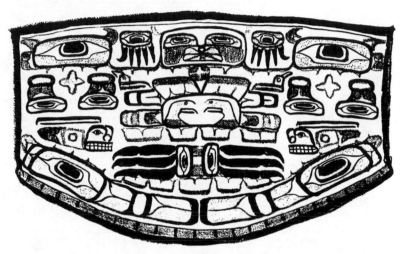

Figure 3.05. Fingerwoven cape (Chilkat Blanket). "Chilkat Blankets" are named for the band of Tlingit Indians who wove most of them; they were an important article of trade on the Northwest Coast. The usual fibers are cedar bark and mountain goat wool fingerwoven in a twined weave. This rare Kwakiutl example is woven of sheep's wool. (After Hawthorn).

weaving "looms" merely hold the warp. Northwest Coast capes or "blankets" are made on a frame from which the warp is hung with weights tied to the bottom ends; the designs were finger-woven by twining. Women wove geometrical patterns, carrying the design in their heads, but if a cape with symbolic designs was to be done, a pattern board was painted by a man. The Kwakuitl also made everyday rain capes from unspun cedar bark.

The widely used belt loom, and the upright loom used by the Navajo and some West African women, are true looms, as are

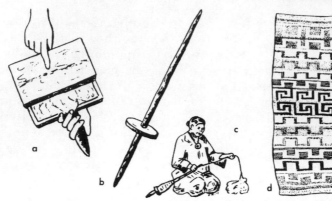

Figure 3.06. Carding and spinning wool for a Navajo rug. a. carding wool to comb out and align fibers; b. spindle with spindle whorl; c. Navajo woman spinning; d. Navajo rug, woven on an upright loom with hand spun wool fibers, using a tapestry weave. This is a weft faced fabric. (d, EPHMA).

the narrow men's looms of West Africa in which the sheds are controlled by pedals or toe holds. Men's cloths, such as Ashanti Kente cloth, are made by sewing narrow strips together to a-chieve an intricate design.

The weaves that can be accomplished are many. A simple classification has to do with threads that are visible. If only the warps show, as in many sashes made on a narrow belt loom, it is a warp-face fabric, and if the warp threads are hidden by the wefts, as in the "tapestry weave" of Navajo rugs, it is a weft-faced fabric. "Plain weave" is one over and one under for the full width of the cloth. "Twill," as in basketry, produces di-agonal effects. Beyond such basics, the possibilities of how many over and how many under are almost infinite.

Navajo women are a well known example of specialists. The materials they used are wool, hand carded and spun, dyed in small batches, and woven on an upright loom. The Navajo weaver shears her sheep, cards her wool (a sort of combing process that straightens out the fibers) and spins her yarn with the aid of a spindle. The Navajo loom is a frame made of poles with a continuous warp strung in a figure eight between them. Everything except the carding implements is made from local materials by the weaver herself; the technology is very direct.

Using backstrap looms, the ancient Peruvians carried the art to its greatest elaboration. The weavers for the elite were often full time professionals, and their products were of very great

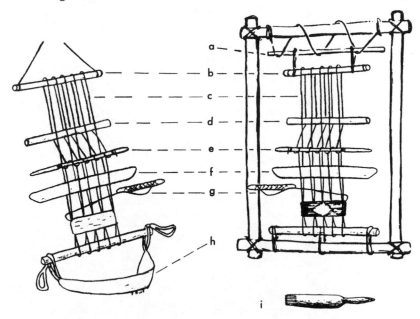

Figure 3.07. Backstrap and Upright looms. Schematic drawings to show basic elements; a. tension bar; b. warp bar; c. warp threads; d. shed rod; e. heddle; f. batten; g. weft thread; h. backstrap; i. weaver's comb.

ritual, symbolic and economic importance. They produced an astonishing variety of weaves, often of great intricacy and elaborateness of design, a profusion stimulated by the high significance of the textiles as an expression of rank. The techniques of the ancient Andeans have been described in some detail in various publications; the classic work is D'Harcourt (1962).

Weaving is a medium where freedom in form-quality is achieved only with a very high degree of craftsmanship and the expenditure of much time. That is to say, weaving patterns tend to be in straight lines; stripes and plaids are basic. Such basic weaving styles are widespread and not easy to identify from style alone. More complex works, however, are as distinctive as painting. Cotton and silk can be spun to smaller threads than wool, and this affects the intricacy of the finished design. Embroidery can be done in connection with weaving, or after the cloth is removed from the loom.

Fabrics can be decorated in a great number of ways in addition to designs that are woven in. They can be painted or

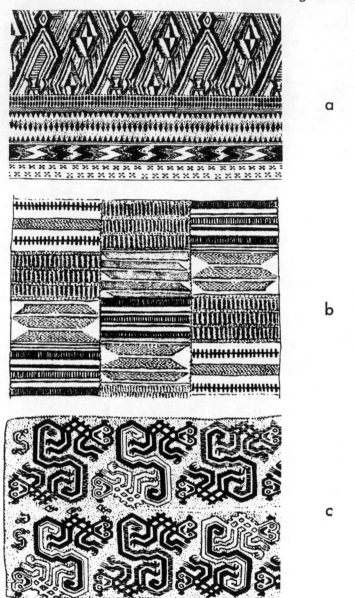

Figure 3.08. Styles and techniques in textiles. a. a detail of Mayan woman's blouse (huipil) woven on a backstrap loom; b. Ashanti Kente cloth, detail of a man's toga, woven on a narrow loom with foot treadles, the strips swen together to make the full cloth piece; c. Andean embroidery on plain weave. These sketches show some of the characteristic types of repetition and variation.

dyed after weaving; paints stay on the surface, and dyes penetrate the fibers. In either case, the designs may be applied with brushes or stamps. Dyeing can also be done by controlling the areas to take the dye; tying or sewing up areas into tight bunches, or by using a resist (wax or starch) painted, stamped or stencilled before dyeing. Wax resist, batik, is used for intricate multi-colored designs in Indonesia. In West Africa starch is widely used for resist, and indigo as a dye; tie-dye there becomes quite intricate when the fabric is stitched together instead of tied. The ikat process is a resist process in which batches of thread are tied at planned places and dyed before weaving.

Featherwork as a craft is often included with fibers; as a material feathers are everywhere useful for lightness and the brilliance of color, so they are especially important in adornment for special occasions. Featherwork techniques include attachment to various kinds of textiles—nets, cloth, etc., binding onto rods, etc., and glued flat to make feather mosaics. Shellwork, in addition to the making of beads, pendants and the like, is often used to ornament fiber products. Of these extensive esthetic uses of fiber, the forms most available to us because they are most collectible, are baskets and woven cloth.

In the civilizations of the New World, textiles have a long and rich tradition marked by very fine craftsmanship using simple looms. In a few places such as the Maya highlands and Otovala in Ecuador the tradition has been continued. Compared to this long history, developments in textile arts in Africa are recent, and marked by an exuberant experimentation and great variety. In Indonesia, textile arts are richly developed, especially the techniques of ikat and batik. Elsewhere in Oceania the weaving of cloth with spun thread was unknown, although mats and bark cloth (tapa) were very fine in Polynesia.

Weaving is by its nature a very repetitive process, and artistic quality is achieved by the kinds of variation that are introduced, and there are characteristic methods of varying the repetitive elements in different areas. It is the author's impression, for example, that Mayan weavers achieve variation primarily by contrasting patterns in successive bands; the Andean method is by reversals and multiple rhythms, and the West African weavers use deliberate irregularities in the way the elements are repeated.

Carving

Carving is usually classified according to the material carved; wood, stone, bone, ivory, etc. The techniques used with hand tools do not differ widely for these different media—the main factor being the hardness of the material; some stones are softer and more easily carved than some woods. When the material is hard, drilling, abrading with sand and the use of hammer and chisel are most common; otherwise the chief tools are adzes and knives. In Indonesia, however, fine carving is done with small steel chisels.

Woodcarving is nearly always a man's art. In the societies well known for this art, males customarily are the craftsmen in wood in order to make many of the tools, weapons and utensils of daily life, but in a number of societies the more difficult work is done by specialists, and of these specialists some carvers are known as artists.

Bascom has given us an account of the working methods of the Yoruba master carver, Duga, which can be summarized as follows:

> "Like other carvers, Duga selected and collected his own materials for his paints and his own wood," using kinds of rubber trees for most carving, and the harder African oak for utilitarian containers and Ifa diving trays. Duga also carved in bone and ivory. "Duga used the traditional tools of the Yoruba carver. A small adze is used to block out the rough form of the object and a narrow adze to carve it almost to the finished state. . . The blades of both adzes could be removed from their forked handles and used as chisels. . . In working with a knife Duga often used his legs as a vise, and in using an adze he turned the figure round and round, rightside up and upside down, viewing it from many angles and literally in its three dimensions." (Bascom 1973b: 72).

> "Yoruba carvings are often polychrome, and Duga's work was no exception. The chewed end of a splinter of wood served as his brush. He worked with a palette of nine colors which were normally matte, but could be made glossy with the addition of a gum resembling gum arabic." (Ibid: 70, 71).

About the wood sculpture of the Solomon Islands, Davenport (1968: 401) tells us:

> "It has been seventy-five years or more since blades of stone and shell have been used, but the tools that carvers

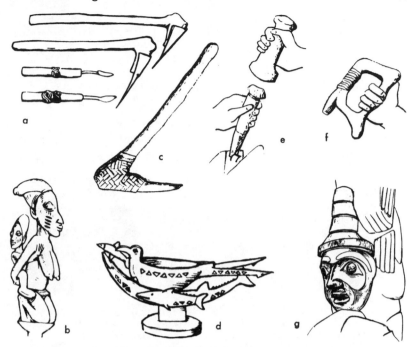

Figure 3.09. Wood carving a. Yoruba carver's tool kit with forged iron blades; b. Yoruba carved wood staff; c. adze, Sepik River, stone, wood and palm fibers; d. Solomon Islands ceremonial dish of blackened wood with shell inlay; e. chisel and stone maul, Kwakiutl; f. D-shaped adze, Kwakiutl; g. detail from a Kwakiutl totem pole. (a, PC; c, UM/UP; e, MAUBC).

use today are the simplest possible. Adzes, the blades for which are made from any kind of scrap iron, ground down to the correct shape on a volcanic stone. . . . are the all purpose tool. With a kit of adzes of several shapes and sizes a good craftsman can do almost anything. Aside from the adze a nail or a bit of stiff wire serves as a drill point or punch, a salvaged screwdriver. . . . or a flattened spike serves as a chisel or gouge. Few men have even a good pocket knife, and many have only a sharpened table knife or some kind of small iron blade for whittling. . . . surfaces are finished by scraping them with broken glass and rubbing them with pumice stone. . . . Paint is nearly always applied to sculpture. Black is achieved by mixing powdered charcoal with the sap of a certain tree. . . . white is from lime obtained by burning coral, the terra cotta is from a red earth.

"Shell inlay, which against black surfaces is almost the hallmark of sculpture from the British Solomons, comes

from two kinds of shell. The small, angular mother-of-pearl is cut from the paper thin shell of the nautiluses that drift ashore. . . and disks of conus shell that require a great deal of labor and are now valuable heirlooms that are reused. The shell is held in cuts by a tree pulp putty which is blackened at the same time as the rest of the work.''

In addition to the techniques of carving, inlay and painting which are common to most woodcarvers, the sculptors of the Northwest Coast of North America used techniques for shaping wood by steaming and bending.

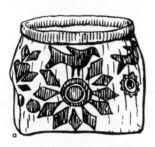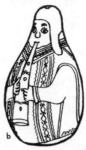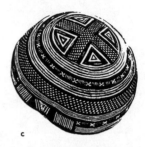

Figure 3.10. Use of wood-like materials. a. Algonkian birch bark container, scraped to leave design; b. Peruvian gourd figurine, areas darkened by burning (pyroengraving) and incised design; c. West African calabash (gourd). The dark can be painted or burned, the light carved or engraved. (a, MAI/HF c, PC).

Gourds and bark are widely used for containers, and shaped and embellished in various ways that are related to woodcarving. Gourds (calabashes) are widely used in Africa, dyed with indigo and incised or with designs burnt on. Birchbark containers were important in the northern regions of North America, with scraped and engraved designs revealing the color of the underlayer. Bark containers were often also decorated with stitchery such as porcupine quill embroidery.

The carving of stone without the use of metal involves techniques that seem incredibly difficult, especially if the stone is hard. Soapstone, limestone and catlinite are easily carved when fresh, but harden when exposed to air. The main ingredient in the technology of many impressive prehistoric stone works in hard stone is time, and by realizing the man hours that went into these works we see our own impatience thrown into relief.

"The pre-Columbian sculptor had great feeling for his material. The Aztec carver used trachyte, serpentine and other rugged stones of the region. For the Maya, limestone

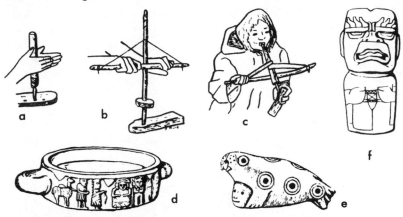

Figure 3.11. Drilling and stone carving. a. hand drill, this technique can be used with sand or with a stone point; b. pump drill; c. Eskimo man using pump drill; d. Inca stone dish, shaped with stone hammer, drilled and ground with sand; e. Eskimo carving in ivory, the characteristic dot and circle motif is drilled; f. Mesoamerican ceremonial axe of jade, a very hard substance requiring much skilled patience; it is well polished. (d, f, BM; e, from Naylor).

was at hand, which was tractable when quarried and hardened on exposure to air; it also provided the material for stuccowork. Carving in jade, bone, wood and even shell testify to the plastic talent of these peoples.

"The tools and techniques of the pre-Columbian sculptor were highly ingenious. Tubular and solid drills were used, rotated on bowstrings, to define circles or parts of circles, or to start a pierced or hollowed out section. Deep cutting and grooving were done with hard stone and even hardwood tools, with the use of various abrasives, and the fine incising was accomplished with implements of jade, quartz, flint and possibly obsidian." (Kelemen 1969: 69)

Aside from the well-known forms of wood, stone, bone and ivory where carving is the main technique, a number of materials may be carved. Modeled clay, when it has become "leather hard" may be carved and pots are sometimes decorated in this way; the cleaning up of a molded clay form by cutting and scraping are technically a kind of carving, as is incised decoration. Scarification of the human hide is carving and the elaborate tatooing of the Maori involved rather deep cutting.

Modeling

Modeling is an additive technique for shaping forms out of soft substances that are then hardened by air drying or firing.

When they are hardened, or partially hardened, they can also be carved. Resin, stucco, clay and wax were the most usual materials before the use of cement and synthetic plastics. Resins are used for their adhesive as well as their plastic qualities, and are often found in masks. Stucco, which is usually simply lime plaster from heated limestone, is modeled and applied to architectural structures where available, as in the Maya area. Wax is especially important for modeling forms to be cast by the lost wax process. But clay is by far the most widely used of all plastic materials.

In the long term, fired clay is the most enduring of all art materials except stone and gold, although it breaks more easily in use. The durability and abundance of potsherds from past cultures makes pottery one of the best records of cultural change available to the archeologist. Further, clay is often modeled or painted in representational forms that provide much information about the past.

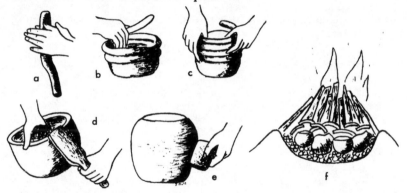

Figure 3.12. Hand formed earthenware pottery. a, b, c. steps in making a pot by the coiling method; if pot is large, the lower part is partly dried before further building. d. the paddle method, clay is added in lumps rather than coils. e. stones of various shapes and properties are used for smoothing, scraping or polishing. f. the air-dried pots, covered with old shards are fired in an open fire, sometimes, as in this illustration, in a pit.

The technique of clay working requires finding clay deposits, then grinding, cleaning, wetting and tempering the clay before beginning to form the desired shapes. Clay is a very free medium, in that it can be manipulated in a great many ways. The most widespread of forms made from clay are containers: pots. Small pots can be formed by pinching; larger ones are usually made by building up coils into the desired shape, or "throwing" on a wheel. Clay may also be shaped in or

on a mold, or built up by "paddle and anvil" techniques. Where pots are shaped by hand, the potters are usually women, part-time specialists. The use of the potter's wheel was confined to Eurasia in Precolumbian times, and was usually the full time work of males.

Unfired clay can be modeled and carved; it is often used for architectural forms and decoration, and if protected from rain, it may last some years. Pots, to hold liquids, must be hardened by firing. Various degrees of hardness can be achieved with different clays and different degrees of heat. The kinds of pots made in areas with which we are concerned here are fired at relatively low temperatures, and are called earthenware or terracotta. Earthenware is usually fired in an open fire, covered with potsherds to protect the surface from direct flames. Red clay comes out terracotta color (red) if the air circulated around it freely in the firing, but if the fire is smothered with dung or some such kind of substance, this clay becomes black. A kiln is

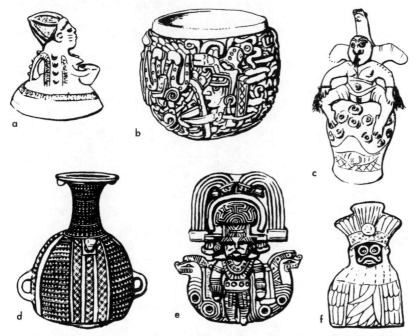

Figure 3.13. Techniques and styles in clay. a. Yoruba pot lid modeled by Àbátàn; b.Maya bowl carved when clay was "leather hard"; c. Sepik River roof ornament with clay applique, painted; d.Inca pot, polished and painted in several colors before firing; e. South American blackware ocarina (whistle) carved and incised; f. Mesoamerican figurine formed in a press mold and painted. (a, After Thompson; b, d, e, MAI/HF; c, MV; F, NMM).

needed to get the higher temperatures needed to produce stoneware and porcelain, which were the high class wares of the preindustrial societies of Europe and Asia, and which continue to be so in the industrial world.

Surface treatments are numerous: polishing, corrugating, slipping, painting, carving, applique and glazing are the principle forms. Pots made by hand and fired in open fires are not glazed, that is to say, they have not been covered with any of the coatings of certain minerals that melt in firing, and serve both as a decoration and to make pots more completely waterproof. Sometimes such minerals were used as paint for designs and sometimes a very high polish superficially resembles a glaze in appearance. Unglazed earthenware is always more or less porous.

Techniques for forming and decorating pots can be combined in a variety of ways. The various techniques and the terminology for describing them are not always clearly distinguished. Appliqué, for example, is a matter of sticking on bits of clay; these can be simply rolls or daubs, but can be modeled before or after application. In Bali ornate roof ornaments are made by attaching a number of decorations made in press molds to the basic pot-like form before firing. The craft of pot making is not clearly distinguishable from the art of sculpture in clay, as the examples in Fig. 3.13 show.

Ethnographic information on the modeling of clay sculpture is very scant compared to that on wood carving. There are enough references to women sculptors in clay in Africa (the Mangbettu, the Ashanti, for example) and in Mexico to raise the question as to how much of the ceramic sculpture found in archeological context was made by women—it seems probable that this was the case wherever fired clay is a woman's medium. Thompson (1969) has done a study of a Yoruba potter-sculpture Àbátàn. An account of her artistic development and place in her culture opens up the understanding of this widespread form of art, and the contribution of female artists to religious art, especially where the more conspicuous religious symbols are in other media.

Painting

Painting, an artistic specialization in the European a.id Asiatic civilizations, is relatively rare as a special or separate form, such as easel painting, in the majority of cultures, although bark paintings are made by the Australians of Arn-

Figure 3.14. Painting a. Navajo method of painting with sand; there is great variation in skill and accuracy, as the painters are not specialists; b. Kwakiutl stone palette; c. pointed stick for working paint into hides with fine lines, Plains; d. Pueblo yucca fiber brush for pottery painting; e. hollow bone air brush, Plains; f. turtle shell paint dish, Plains; g. bone brush for filling in large areas in hide painting, Plains.

hemland, and ceremonial shields and other painted objects hung on the Tambaran cult houses of the Sepik River Area can be so considered. Mural painting on walls goes back at least to the cave paintings of the Upper Paleolithic, and is widely distributed, but only preserved where sheltered. As long as the walls last, paintings may be repainted, or painted over with new works. The mud walls of African houses, for example, are frequently repaired and redecorated.

Paint is, of course, often applied to objects that are carved, molded, or woven. Yoruba and other African carvings in wood are frequently painted; stone carvings, including the sculptures of the Maya and of ancient Greece were painted. Painting on pottery with earth colors is widespread on earthenware, and becomes permanent with firing.

The most common pigments used by peoples with direct technologies are charcoal and the earth colors, red and yellow oxides, and white kaolin. These are mixed with water and possibly some kind of vegetable gum, or, like the cave paintings of the European Upper Paleolithic period, blended with animal fat to make an oil paint. Brushes are often made from chewed twigs or fibrous stems, although some peoples make excellent ones of animal hairs. Techniques of application are basically similar everywhere. Technological knowledge has expanded mostly in the direction of a greater number of hues, such as the blue of the Bonampak murals of the Maya.

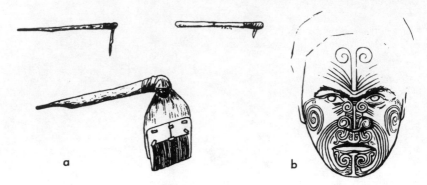

Figure 3.15. Tattooing. a. Polynesian tattooing tools; b. facial tattoo of
the Maori Chief Rauperaha.

Body painting is almost universal and the technique and
materials are not too different from those used on wood and
stone. Tattooing, a more permanent form of painting, goes
under the skin. Painting on non-human hides requires re-
peated strokes and often pressure to make the design firm and
lasting.

Drypainting, with sand or other materials on a horizontal
surface, is a widely scattered technique, and was probably more
widespread in the past. In Mesoamerica today elaborate designs
of dyed sawdust are made in the streets over which a religious
procession will pass. Once, it is said, the paintings were made
of flower petals. Navajo drypaintings are made on the ground,
usually on the floor of a hogan. The background is natural
earth color, preferably a pinkish tan brought in for the occasion
and smoothed with a weaving batten. The sand used for
painting is prepared in seven basic colors and no others are
used. The colors are not mixed together. They are applied
directly by being strewn with the fingers, and experienced
painters can make long narrow lines of even width and regular
shape, areas of smooth solid color, and very small details. The
One-Sung-Over sits on the painting, absorbing its power, and
the sand is taken away and returned to the earth.

Metal Work

When we consider the techniques for working metal by pre-
industrial processes, the chief distinction to be made is between
the metals that have a lower melting point, such as copper,
silver, gold, and their alloys, and iron, which requires a con-
siderably higher temperature. Copper frequently occurs

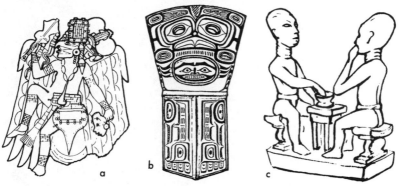

Figure 3.16. Uses of sheet metal. a. Mississippian engraved copper sheet; b. Kwakiutl copper, painted ridges in repoussé; c. Ashanti staff, gold leaf glued to carved wood. (a, from Naylor; b, from Boas; c, after Cole and Ross).

naturally in quite pure form, called native copper, and can be pounded into shape. However, it becomes very brittle when thus cold-worked, and must be heated (annealed) to permit extensive working. All the copper artifacts of native North America were made by this method. Gold occurs naturally in pure form, as does silver, and they are frequently associated with copper deposits. All three melt at about the same temperature. Gold is obtained by panning, and melted and pounded into sheets, which can be cut and shaped. Working of gold in the Andean region started with such sheets, and pushing or pounding designs, usually from the back of the piece (repousse), continued to be a much used form down to Inca times. It is particularly useful for headdresses and large ornaments because it can be thin enough to be quite light. Very thin sheets can be used to cover other materials, such as wood carvings.

In the Ashanti area, gold is panned from river gravel by the women of a family; the young men and boys melt the gold dust into small lumps over charcoal with the aid of bellows. A lump is beaten on an anvil to form a thin sheet much thicker than our commercial gold leaf. It is then glued by strips into a wood carving, being carefully smoothed into the design.

Copper can also be extracted from ores by heating with charcoal. Several metals occur in combination, and this leads to accidental alloys, but metals are also deliberately combined. Bronze is an alloy of copper and tin, and brass is an alloy of copper and zinc, properly speaking, but in many pieces both

tin and zinc are present, so the distinction is not a clear one. In the Andean area gold was often combined with silver and copper and was also plated over these metals. Once melted, any metal can be shaped into a mold. Simple molds can be made of sand, stone or fired clay. Mold-made pieces can be further shaped by hammering, and the surfaces can be stamped, incised, inlaid with stones, etc.

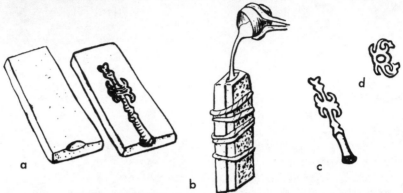

Figure 3.17. Navajo silver casting. a. shape is cut in tuff (a light stone from volcanic ash); b. molten silver poured into mold; c. the casting with sprue attached; d. casting heated and bent to from bracelet. It will be finished by filing and polishing.

The casting of complex pieces presents difficulties, as air pockets tend to be trapped and leave holes in the casting. A stone or clay mold must be made in many pieces to allow the metal to push air out the cracks and so fill the spaces completely. The lost wax (cire perdu) method offers the solution to these difficulties. In addition to solving the air pocket problem, this process can preserve details if fine clay is put next to the wax. Because the technique can reproduce almost any shape or surface decoration, the styles of ancient Mesoamerica and Peru, of West Africa, and of Indonesia are distinctively expressed. Wherever they are known, gold, silver, copper and a variety of their alloys have provided material for elite tastes in art, and as a lost wax mold could be used only once, each piece has the additional value of being unique.

Iron ore is widespread, but its use depends on knowledge of bellows and a furnace to reach the necessary heat for smelting to get the metal from the ore. This can be done on a small scale, and ironworking was widespread in Africa by 100 A.D., and south of the Sahara preceded the use of other metals. On the other hand, ironworking was unknown in the New World in

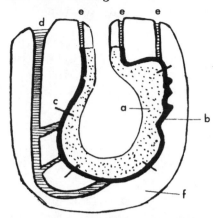

Figure 3.18. Cross-sectional diagram of lost wax casting mold. For a large and hollow piece, a hollow core, a, is first made of clay and covered with wax; b. This wax can be modeled, added to, or carved to provide very fine detail. Pins, c, of metal are inserted to hold the core in place. Sprues, d, and e, of wax are attached. The whole is then covered with clay, f, called the investment, and is baked. The wax melts, and is poured out of the sprues. Molten metal is poured into the investment through the main sprue, d, taking the place of the lost wax. The mold is broken to remove the piece, and the sprues, now metal, are filed off. (For a smaller work no core is used, and the finished piece is solid metal). g is a Benin bronze head made by this lost wax process. (g, BM/N).

Precolumbian times even in the areas where work with other metals was highly developed. African blacksmiths in recent times use scrap iron rather than smelting ore, but the craft is still of great importance. African blacksmiths forge tools and ceremonial objects and also often work in other metals. The best known art works in iron are the iron staffs made by Yoruba

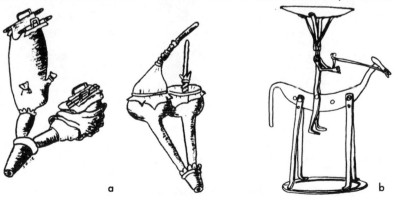

Figure 3.19. Ironwork. a. two types of African piston bellows; b. Yoruba forged iron sculpture. (b, after Bascom).

smiths for use by certain cults. Iron is associated with medicine and with war.

Metal working is usually a man's craft, although in smaller work such as jewelry men are often helped by their womenfolk in finishing and polishing, as is done by the Navajo. Metal-workers are specialists or full time professionals, and in Africa smiths are often a separate caste.

Mixed Media

In the European tradition the trend toward specialization has meant a kind of purity of medium for several centuries. Sculpture, for example, whether of stone, metal or wood was not painted, clothed or decorated with other substances. A sculpture so adorned lost its status as fine art and became a quaint example of folk art. Societies with less specialization have no such taboos. All kinds of materials are combined; human figures are dressed and adorned, either for special occasions or for as long as the adornments last. Many of the carved or modeled objects we admire in museums were once clothed and decorated, sometimes to the point of being completely hidden.

The techniques for combining substances and decorating basic forms are many and various. Painting has already been discussed. Fibers, woven and unwoven, are used with carvings. In the ephemeral arts particularly, many techniques using fibers, feathers and flowers provide brilliant color to works that in museums seem drab. Even field photographs in black and white look grim and grubby without the vitality of color.

Great structures of lashed bamboo, basketry and bark cloth, decorated with leaves and flowers like a Rose Parade float are raised and carried in Sepik River and other Melanesian ceremonies. Similar usages are found in the great dramas of the Northwest Coast of North America, where decorated cedarbark costumes covered the masked dancers.

Textiles and beadwork are more enduring, but these, too, are often colorful works that are kept for special occasions and used in combination with other media to celebrate the day. In Africa, where dance is at the core of artistic expression, many media are used in costuming and in some areas textiles have great symbolic meaning as well as brilliant esthetic effect. The form of the dance itself is designed to bring out both of these aspects.

For example, a medium that is often combined with other media is beadwork. Beads are combined with fibers in a number

of ways, and can be used on hides and other materials, and used in jewelry, sometimes in combination with metalwork. Beads are made by direct technology from stone, bone, shells and seeds, and glass beads received in trade are often the first items incorporated into art forms. Quillwork is a distinctive Native American variant; various techniques of quillwork are described in Whiteford (1970). Beads of semi-precious stones were important status markers in ancient West Africa, and certain beaded objects the perogative of kings. Thompson (1972: 229) describes the making of a Yoruba crown:

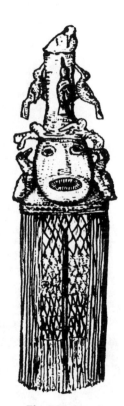

"Bead embroidery is practiced at a number of centers, especially at Efon-Alaye, Ile-Ife, Oyo, Ilesha, Abeokuta and Iperu-Remo. The men who work in this tradition must be extremely skilled. Their task entails the stringing together of beads to form a strand of a single color, and the tacking of these strands (length and color determined by design) to the surface of the crown until the visible portion of the object has been completely covered.

"The bead embroiderer begins with the making of a wicker-work or cardboard frame. At Efon-Alaye, one of the leading centers of the crown-making industry, the shape of the frame is an almost perfect cone. The cone towers over all other forms of the Yoruba headgear. The embroiderer or his helper stretches wet, starched, unbleached muslin or stiffened cotton over the frame, providing the base for the embroidery, and allows the object to dry in the sun. A frontal face, a Janus design, or a circular band of frontal faces are often molded in relief over the lower portion of the frame, with shaped pieces of cloth dipped in wet starch. The actual embroidering then follows, after a choice of surface pattern."

Fig. 3.20. Yoruba beadwork crown. (MIA).

When one considers the artistic whole to be the king in all his robes and regalia, or, further, the whole as production of the ceremonial event, many craftsmen and many media are involved.

Stagecraft

To get a glimpse of how techniques were combined for artistic ends in actual use, stagecraft should be included as a technical form. The Kwakiutl provide perhaps the best known example, but many similar devices were used elsewhere.

> "The dancing house in which the Tokuit dancers were going to perform was vacated and carefully guarded several days before the initiation. Underground passages were dug, down which the dancer could disappear. A system of kelp speaking tubes was installed. Elaborate gear was brought to the house, such as false bottomed chests in which the dancer could be concealed while apparently being consumed by fire. . . . During the dances various tricks were employed to create convincing illusions. An apparent beheading used portrait carvings and bladders filled with seal blood. The fire thrower handled burning embers in leather gloves with wooden palms skillfully put on by his attendants." (Hawthorn 1967: 41-2).

Strings from the rooftop manipulated puppets and other special effects; the lightning was controlled by the fire tenders using grease as well as wood. In short, craftsmanship included far more than the production of a single artifact.

Summary

The relationship between material and technique is very intricate and subtle. The more advanced the technical means controlled by the craftsman, the more he can bend the material to his will, and the less he will have to be influenced by the hardness of the stone or the limitations of his pigments. He may still choose to be very sensitive to his material, as in the use of the natural variations in color of jade. He may also display his mastery as by making delicate lace-like shapes in stone that seem to deny or transcend the nature of the material.

While one can value work made by hand, it is sometimes very difficult to distinguish objectively, in terms of quality, a more advanced, even mechanized production from a purely hand made one. One can tell a coil made pot—if well done—from a wheel made one, but not necessarily whether the wheel was foot or motor driven. Aniline dyes are not necessarily garish. From the point of view of the craftsman, introduction of new tools or other technical means are ways for him to achieve as good or better results with less time and energy. One would think that only when speed is valued above quality would the effects be

conspicuously bad. However, when the craftsmanship presents few technical problems to absorb the attention of the artist, the resultant straining for esthetic effect may give the work that conspicuous but undefinable quality of self-consciousness that is characteristic of so much recent art.

The techniques used by craftsmen in producing their arts involve them with their social contexts in a number of ways. Art as artifacts are physical objects that require tools and materials, and are economic objects in exchange systems. The craftsman's role varies with so many factors in the social context that very few generalizations can be made without distorting the facts.

Craft specialization is often not only by age, sex and status, even in tribal societies, but by community. Because art objects are also artifacts, they have long had economic functions in systems of exchange that have links over wide areas. Communities specialize in crafts based on local resources and local skills. Esthetic quality also is a matter of making things attractive for purposes of economic exchange, whether this takes the form of gift exchange, barter or sale.

One of the frequent generalizations about artist-craftsmen, especially in tribal societies, is that men, being involved in the public ceremonial and political aspects of life produce art—art with many levels of meaning, or fine art, while women are concerned with domestic craftsmanship and produce repetitive designs. In many societies there is some truth in this statement, but acceptance of it has resulted in overlooking many works of women that are of high esthetic quality, by a) ignoring techniques that are regarded as mere female accomplishments, such as embroidery, and by b) ignoring the fact that forms with many levels of meaning, such as clay sculpture were often made by women. Increasing specialization tends to result in the shift of crafts to the male sphere, as women's primary responsibilities often rule out full time professionalization; full industrialization has taken most crafts out of the home, but they remain as hobbies, i.e., folk art.

Technique, or craftsmanship, is the means by which artistic ends are achieved. In some theories as to the origin of art (reviewed by Boas, 1927) the rhythm of motion of the craftsman working in a well mastered technique gives rise to esthetic pleasure that is the very foundation of art. Knowledge of techniques and their usual effects are aids to identification,

understanding and appreciation of the forms we see, for the techniques applied to the material bring the design into being. Technique is the direct method, the definite way of doing something by which style is achieved. To say that the medium is the message as McLuhan has done, calls attention to the importance of the medium as *part* of the message.

Further Reading

General: Newman 1974, 1977; Spier 1970; Weltfish 1953; Whiteford 1970.

Hides: Morrow 1975.

Weaving: Bjerregaard 1977; Emery 1966; D'Harcourt 1962; Jopling 1977; O'Neale 1945; Reichard 1936.

Pottery: Bunzel 1930; Fontana et al 1962; Foster 1955; Fagg and Picton 1970.

Basketry: James 1909; Mason 1904; Miles and Bovis 1969; Navajo School 1903.

Metal: Benson 1979; Adair 1944.

Figure 3.21. Items from Kwakiutl ceremonies. a, e, rattles; b, painting such as might have been used as a backdrop or curtain; c, Hamatsu dancer; d, mask. (from Boas).

Chapter 4

Who? The Psychological Perspective

When art has been approached from the psychological point of view, four concepts have been central: perception, creativity, personality and the psychological functions of art. The anthropological questions relating to these concepts have to do with the ways in which perception, creativity, personality and functions are similar in different cultural contexts, and the ways in which they are specific to each cultural setting. Most of the answers to these questions have so far been impressionistic and conjectural, but there is gradually building up a body of information by which we can test and reformulate the various theories. However, by taking the comparative viewpoint, it becomes necessary from the start to re-examine some assumptions and re-define some of the terms based on these assumptions. The great emphasis on individuality and progress in the cultural values of Western society has meant that psychological questions have centered on the artist, and on innovation, but in cross-cultural perspective the questions are broader.

Perception

A psychological question that has been asked that relates to visual forms and modal personalities is whether visual productions are culturally distinct by virtue of the fact that things appear different to different peoples, and what is the extent and nature of these differences in perception. To do this, it is important to distinguish between different meanings that have been given to the word *perception*, which can mean:

 1) physiological perception—perception in the narrow sense of what sensory organs can and do respond to,

 2) how people organize and describe these physiological perceptions, and

 3) what meanings they give to what they see.

1. Perception in sense one, being a matter of physics and physiology appear to be very much alike for all members of the human species. Slight variations due to differences in experience with one kind of perceptive quality or another is

found by careful experiments. For example, Segall, Campbell and Herskovits (1966) report the results of investigators in many parts of the world who presented to a number of people a variety of linear images in the form of certain standard illusions as to which line is longer. Statistically significant differences emerged for the different figures, correlated with whether people were used to a "carpentered world", i.e. whether they were used to two dimensional representations of reality, and whether their environments were marked by broad horizontal vistas. There was no correlation with racial type. That the differences were not large and the discriminations fairly subtle, suggests that on this level differences in perception exist, as one would expect, but are small compared to the way people think about and communicate their perceptions. To use another example, color is perceived similarly by all normally sighted persons in this sense. A bright red-orange is highly visible and stimulating, a soft grey-green the reverse.

However, much of what is perceived even in this basic, physiological sense is subject to selection determined by how one has learned to organize and interpret what he sees.

2. As to how people describe and systematize their perceptions, color provides a very good example. There are a number of studies showing that peoples have very different lists of color names, and some are much longer than others. The Navajo do not terminologically distinguish blue from green, for example. It has also been shown that the better a verbal description one has for a color, the better he can remember a precise hue. As to differences in how people organize and think about color, the best example probably comes from contemporary sub-cultures. Persons dealing with color in the form of pigments think of white as the absence of color, and the primary hues as red, yellow and blue. Persons who deal with colored light think of white as the combination of color, black as the absence of color, and magneta, yellow and cyan as the primary hues.

3. As to the interpretations people give to what is perceived, the feelings that are associated with perceptions, color again provides an example: there is considerable variation as to the symbolic meaning of various hues. While bright red may be universally physiologically perceived as being exciting—i.e., causing arousal, the symbolic meaning varies with context. In China, red has long been associated with joy and used for festive occasions; in Navajo drypainting "red is the color of

danger, war and sorcery, as well as their safeguards." (Reichard 1950: 197); in the Luscher color test the basic meaning of the red has to do with passion and vitality because: "It speeds up the pulse, raises the blood pressure, and increases the respiration rate." (Scott 1969: 60).

A fundamental way that all levels of perception operate has to do with what captures attention—whether what we see or hear says "Look out!" or "Relax, no problem." Studies on the nature of attention, of arousal, suggest ways that art can affect the viewer. The idea of arousal rest on physiological human similarities, and yet also takes into account the differences provided by different environments and life experiences. Berlyne's experiments, for example, show that the human organism responds by arousal to what is not clear, what does not make sense, what is not familiar. In his experimental materials are pictures of birds with elephant heads, incomplete designs and the like. On the other hand, his subjects tend to report that familiar creatures, realistically drawn, and regular patterns are more pleasing. This kind of alertness to the strange and unexplained as compared to the familiar (and therefore presumably safe) has obvious biological survival value.

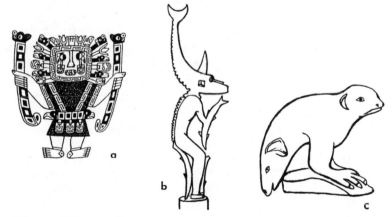

Figure 4.01. a. figure from a Tiahuanaco pot, Andean area; b. Solomons fishing float. c. Eskimo soapstone carving. (a, AMNH; b, FMNH).

Much of the grotesque, the incongruous, the shocking and the unbeautiful found in art forms is for the purpose of arousal, and heightens the experience of special events. Sometimes one suspects that the artist creates such a form for direct effect and a symbolic interpretation is provided later. Ambiguity, discussed

more fully under "meaning", relates to this aspect of perception.

Cognitive and symbolic systems, (how peoples conceive the cosmos as being ordered, how they classify experience, and what they perceive as "natural" or "weird") have recently been given more attention in anthropology than other psychological perspectives. See Chapters 5 and 6 below.

This contrast between the strange, the unfamiliar and the possibly threatening on the one hand, and the regular, known, understandable on the other should be very familiar to readers of books on art. The vocabularies in which this contrast is expressed are many, including Classical/Romantic, Harmony/Vitality, Rage for Chaos/Yearning for Order. Among others, Beam (1958: 144) has claimed that art always involves both tension and harmony, no matter which is emphasized, and without both, and both under control, it is not art. He summarizes neatly in a diagram:

Uncontrolled	Controlled		Controlled	Uncontrolled
deadness	Repose	versus	Vitality	wildness
obviousness	Finiteness	versus	Infinity	nebulousness
monotony	Order	versus	Variety	chaos

Many interpretations and analyses of art and art styles come out with something very like this idea as the bottom line. Bateson (1967) takes a single recent Balinese painting through various levels of meaning—the subject is a funeral ceremony; he gives a sexual interpretation of the forms (not perceived by the artist); and finally says "the crux of the picture is the interwoven contrast between the serene and the turbulent." (p. 141).

Similarly, Witherspoon finds this concept in Navajo philosophy (and art) in a way that makes human creativity particularly significant: "Thus life must be regenerated, movement rejuvenated, order restored, and beauty renewed and recreated. This never ending process goes from active to static and static to active." (1977: 201).

The basic human experience of arousal and relaxation, activity and repose, while apparently simple, is applied and elaborated in a quite astonishing variety of formulations.

> "The idea of the constant and unceasing interaction of the
> Yin and the Yang, of Tao in operation, is equivalent to
> Ch'i yun (the circulation of the Vital Force). An

expression of it in painting is the term *yuan chin* (far-near, perspective). The movement out of the void of far distance forward into the clarity of middle distance and foreground, and back again, is analogous to the cycle of coming out of Tao and returning. The tension and balance set up by far and near, obscure and clear, unseen and seen, are *yin* and *yang*." (Sze 1959: 107).

Creativity

Stereotypes that were to be found in the literature about the primitive artist repeating traditional forms are becoming a thing of the past as the field workers report actual observations. However, the attempt to formulate a terminology that is freer of ethnocentric bias continues to be a problem, partly because the tendency to equate innovation with creativity and esthetic excellence suggests a false dichotomy between "traditional tribal art" and "innovative civilized art". As with other inventions, the rate of innovation per capita is probably not that different. In order to study the relationships between the artist and the society in cross-cultural perspective, some definitions may be useful in avoiding ethnocentric pre-judgment.

A distinction has to be made between an individual invention and a social one. That is to say, there are repeated cases in which a person created something new, as far as he was concerned, but someone else has done it before him, or other persons did not regard his invention as being very novel. Perhaps a majority of people have had the experience of "inventing the wheel" in a small way. At any rate, innovation is a matter both of the degree of originality and the extent of social acceptance. The degree of innovation perceived in art is proportional to the familiarity of the observer with the style. The artist in our society regards each small innovation in his work as tremendously important; his immediate audience is equally sensitive to change. On the other hand, a person not familiar with a particular cultural tradition may not see any newness at all, and indeed, all the works in an unfamiliar style tend to look much alike—very little of the variation is observed.

The amount of innovation perceived by the artist and his immediate audience also depends on whether, and how much,

innovation and newness are valued in a particular art form in a particular culture. In some cases the artists will emphasize the symbolic requirements and say that the work is "exactly like" other ones, although an analyst can see considerable variation. On the other hand, an artist in our society will claim great uniqueness for a work that, to a person used to looking at a variety of styles, may look very much like hundreds of others exhibited that decade.

All kinds of thoughts and images, day-dreams and drug trips go on in people's heads. These are, at best, ideas, perhaps very novel ideas. Barnett (1953) calls them "mental configurations." We might call them inspirations if they inspire action. What I am calling *creativity* involves making something that other persons can see, hear, smell or taste; i.e., perceive. This requires energy—the 99% perspiration that is traditionally said to be combined with the 1% inspiration to make a work of genius. Unless a person can in some way create form to make his idea manifest, we do not have creativity, we do not have art. Such a creation is new and unique in that it did not exist before. It is not necessarily novel—it need not be in the social sense an invention or innovation.

A creative individual puts a lot of energy into making something that did not exist before, but creativity differs from productivity alone in that each creation involves a recombination of elements in a unique form. The recombination may, indeed, be very subtle, as when a musician creates a personal interpretation of someone else's composition. He is an artist whether or not he invents a novelty. Creation in this sense can, at least conceptually, be reasonably independent of the degree of skill in craftsmanship or the quality of esthetic sensibility. In this sense, then, it is the uniqueness that is diagnostic of creativity, resting on a recombination analogous to the recombination of genes in the biological individual, and we reserve the term *innovation* for a marked change, analogous to a mutation, involving a completely new element or organizing principle.

Creativity and Ritual

The creativity possible in ritual arts, where innovation is not appropriate, is evidenced by the variations we can see in some of the products used in ritual situations. Thus the figures of the Rice Goddess that appear in so many Balinese forms—woven, cut out of palm leaf or paper, made of sugar or wood, are always

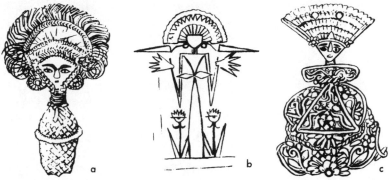

Figure 4.02. Balinese Rice Goddess Figurines, used in many forms as part of offerings to the gods that are often artistically elaborated. a. basketry. b. from a palm leaf panel. c. rice paste. (b, c, after Ramseyer).

recognizable but involve much creativity in technique and the way elements are combined.

Navajo sandpaintings are required to be ritually correct, and not, definitely not, innovative. Yet because each situation in which the ritual that includes the paintings has a particular combination of conditions to be met, the Chanter must choose an appropriate combination of elements. His problem is not perceived as an esthetic one, and he often does not himself strew the pigments, but he must compose in a creative way for the particular circumstances. At the very least, he must decide whether the work is to be large and complex or small and simple, depending on the number of painters and the size of the hogan—thus the "same" painting can have different forms:

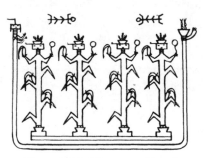

Figure 4.03. The same Navajo sandpainting in two forms.

Navajo ritual requirements are extraordinarily complex, and depend on a number of principles of relationship which leave

room for different interpretations as to which is the more important in a given situation. Color combinations and sequences, for example, depend on various relations and interrelations of sex, direction, danger, protection and other ritual elements of the situation. Furthermore, there may be choice of materials or devices that are symbolically equivalent, giving rise to substitutions and change; glass can be used as crystal, coral as redstone. It is probable that much of the elaboration of Navajo drypainting came about by the substitution of drawn or painted symbols for symbolic objects, such as are found in connection with the simpler drypaintings of Pueblo altars. So, much creativity is involved in works that are ritually "the same".

If creativity were mostly a matter of newness, of novelty, one could not recognize the excellence of a work of art without knowing where that work fitted into a historical sequence that identified what was new at that time.

Cultural Differences in Creativity

There still remains, however, the question as to whether some societies foster creativity and creative personalities more than others—whether artistic productivity and/or innovation are higher in some cultures than in others. At first glance these differences would seem too obvious for discussion, and the only question is what factors make for more creative personalities. Further consideration, and further exploration of the ethnographic material, however, makes us wonder about this, because so much of our evaluation rests upon ethnocentric selection of what constitutes art and creativity. It is entirely possible that there is a similar proportion of creativity and esthetic concern per capita in any society, but that it is channeled by the circumstances of life and interpretations of culture into channels we do not usually recognize as art, or that there are art forms so ephemeral that we have no adequate records. This possibility alerts field workers to the esthetic dimension of all activities (d'Azevedo 1958). The current opinion, however, is that:

> "The amount of creative expression that is permitted or expected may differ from one society to another, from one period to another, from one craft to another, from one genre to another, and even from one part of a carving to another." (Bascom 1969b: 111).

As to why such variability exists, there are theories ranging from the idea that very few creative persons are born into the world, being created by virtue or heredity or divine intervention or whatever. On the other extreme, one can assume that all persons are naturally creative, but that circumstances and society inhibit this quality in a great many persons. It is, of course, possible to reconcile these two views by considering various degrees of natural potential, and various degrees of encouragement in the socio-cultural setting.

The anthropological question has to do with the aspects of a culture that promote or discourage creativity or innovation. The example of Bali is very interesting in this regard, because the energy devoted to artistic pursuits is so high—a civilization in which "everyone is an artist". Yet this is a conservative culture in which marked innovation was not the rule. Based on her experiences in Bali and other cultures, Mead (1940, 1959) offers a hypothesis concerning one of the factors that tends to promote creativity. This is an early "symbolic elaboration of experience", especially in the formalization of a number of roles and statuses in which the child is successively placed, before he is lumped with a larger children's group. When this kind of experience is combined with exposure to many valued symbolic activities he early tends to manipulate, and so combine creatively the many symbolic elements at his disposal. Some descriptions of Balinese character have mentioned the tendency to use artistic symbolic situations to a point that seems like escapism to an outsider. Other theories relate the degree of creativity to social rather than psychological factors—i.e., that innovation will be encouraged where symbols of social identity are needed.

Who is an artist?

The definition of an *artist* which emerges from other definitions used here is: a craftsman (male or female) who by creative recombination and/or innovation makes an artifact (tangible or intangible, i.e. statue or song) that has a high esthetic component. This would include the ability to direct others in the actual production. Whether or not the people have a word meaning "art" or "artist", the selection of and attitudes towards persons who fit this definition is widespread enough to suggest the concept is cross-culturally meaningful.

Who were the artists whose efforts were regarded as special in their own societies, and how were they identified? In the

previous chapter it has been shown that certain crafts tend to be performed by certain classes or people. How does this fit with the statements that "in primitive society every man is an artist" or "in all societies, artists are self-selected"? How much chance does a creative person have to become an artist in those societies that prescribe who shall practice the various crafts?

The ascription of certain crafts to certain classes of persons, as males or females, old or young, persons born with a caul or born into a certain caste, of proper kinship position, etc., would seem, to our notions of individual choice, to be in contradiction to the idea that artists are self-selected. But the limitation on choice is only a limitation on medium. Many artists, even in our specialized society, can work in a variety of media, and indeed, their choice is often a matter of opportunity. Where the medium is prescribed, as for example clay often is for women, the self selection is a matter of whether one makes a few useful pots, or whether one makes objects of high esthetic quality, with all the commitment that such effort implies.

The elements of motivation, opportunity to learn the craftsmanship, and recognition of ability by other members of the society are shown in the case of Àbátàn, a Yoruba sculptor

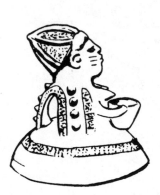

in clay whose life and work was studied by Thompson (1969). Abatan is considered a master of mud sculpture, pottery and praise poetry. In her youth she was a widely acclaimed dancer. Her mother and maternal grandmother were both potters, and Abatan started picking up the craft from her mother. There was no formal instruction, no lessons, but by helping and observing, she gradually learned. By the time she was twenty she could make seven

Fig. 4.04. Ritual pot lid by Àbátàn. (after Thompson).

named types of pots, learning the simple utilitarian types first. She was in her thirties before she was commissioned to make the vessel with the figurative lid that has considerable ritual importance for use in domestic shrines. It is the figurine on these pot lids that give her her reputation as an artist.

In societies with direct technologies, the most usual situation is where the basic skill of a craft are known to all persons of the appropriate sex, but where a few make the effort to learn to use these skills more creatively. Davenport's account of persons becoming artists in the Solomons is probably typical:

> "Who becomes a carver in the Western Solomons is determined mostly by interest and aptitude. There are neither hereditary positions for artists nor hereditary groups of artisans. Anyone [male] who has an interest and ability may become a sculptor. . . . All men in this society are skilled woodworkers, and carvers are not necessarily better than ordinary craftsmen in the use of their tools. All men, too, are familiar with the traditional motifs and designs used in carving. High interest, then, is the first prerequisite for becoming a carver.

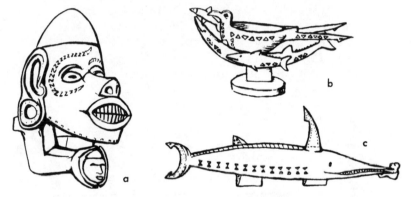

Figure 4.05. Solomon carving. (a, FMNH; b, c, UM/UP).

> "Beyond this, the necessary talents are the same indefinable aesthetic characteristics that seem to distinguish the artist from the non artist in our society." (Davenport 1968: 400).

> "If a man can build a good house, construct a sound utility canoe, cut efficient and aesthetically pleasing canoe paddles, carve minor and major sculpture well, and perform also the tedious operation by means of which the delicate geometric patterns are cut into all children's faces, then he may be spoken of as a 'talented man'. . . .

> "Excellence in several skills must also be achieved by a woman before she is rated a 'talented woman'. The feminine skills required are mastery of the forms of plaiting appropriate for fans, baskets and fine mats as well as the delicate art of tattooing." (Davenport 1968: 404).

Both of these examples show the importance of 1) personal motivation, 2) opportunity, and 3) acceptance of ability by others, which all seem to be important factors in most if not all situations. Cases where the status of artist is determined by some supernatural sanction such as an accident of birth seem to be rather unusual. Divination, dreams and other less tangible signs are more usual. Mead, however, has described a case where the status of artist was determined by accident of birth. She found that among the Mundugumor babies were destined to arts and crafts if they were born with the umbilical cord around their necks. While they had free choice as to whether they actually pursued such a calling, without such an initial sign they would never be successful. Females were to be basket-makers. Males were to be artists. They might be carvers of the tall wooden shields, or the spear decorations, or the crocodile river spirit figurines that were at the ends of the sacred flutes. Or, for the yam feast, they might be the painters of the complex designs on the very large triangles that were raised for the celebration. They would carry on what she called "the fine tight tradition of Mundugumor art." (Mead, 1935: 124).

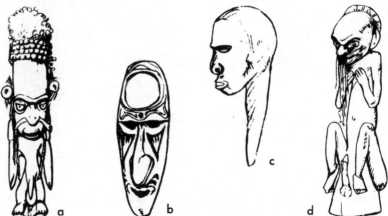

Figure 4.06. Mundugumor carvings. (a, after Poignant; b,c, after Fraser; d, CMAE).

She answers in part the question as to what happens to artistically motivated persons who are not born to the status. Apparently here they can act as helpers if they are willing to do a lot of the work without getting the credit for it. This may well be the case in other societies where craft specialization is inherited. It may also be that there are a number of arts open

to the amateur in these societies. A question she does not answer is how many persons so born and also interested in being artists are necessary to continue "the fine tight tradition of Mundugumor art."

The case where crafts are assigned to hereditary guilds or castes would seem to be especially limiting in terms of opportunity and acceptance. In some parts of Africa the blacksmiths form a separate caste. Sometimes the men of this caste are also the wood carvers, and the women are the potters. This does not mean that all individuals in the caste practice the craft, much less that they are all artists.

What do you do in such societies if you have artistic leanings but are not a member of a specialized group? One simply expresses oneself in the other arts that are not so restricted; dance and drama, ritual, personal adornment, needlework and festive decoration. Folk art in other media arise alongside of the specialization of crafts.

Personality

There are several questions with regard to personality. One has to do with the artistic temperament, how alike all artists are, and how different the artist is from others in his society; another concerns how his work relates to the personality type characteristic of his society.

If art is considered a form of self-expression, a projection of the psychological patterning of the individual that is called personality, then the similarity of a number of productions that is called a style would be due to similarity of the artists who work in that style. A cultural style, in this perspective, comes about because similarities in child rearing and other circumstances make for similarities of personality in members of the society, a "national character" or a "modal personality", shared by artists and viewers alike. When one reads ethnographic descriptions that emphasize personality qualities, such as Mead's "Sex and Temperament", and then sees the art forms produced by the people described, there is a feeling of congruence between the two. Her work describes three Sepik River societies that share many similarities of culture, yet foster very different male and female personality types. While the theories of modal personality and art as projection are now considered inadequate as complete explanations, this approach still offers many interesting

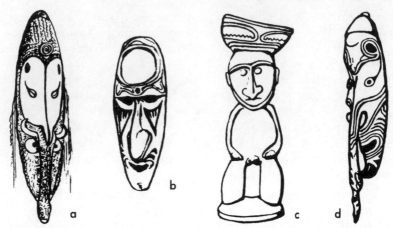

Figure 4.07. Sepik River personalities. a. Iatmul. b. Mundugumor. c.
Arapesh. d. Tchambuli. (a, after Bateson; b, d, after Fraser; c, after Mead).

insights and even possibilities for reformulating the culture
and personality problem.

There have been a few exploratory studies that have analyzed
artistic productions from the psychological point of view by
applying the interpretations of visual forms that have been
developed in clinical settings, such as the Rorschach "ink blot"
test, the Machover "Draw-a-Man" and the like. In 1949 Wallace
used a collection of these interpretations to formulate a psy-
chological profile of the ancient Maya from the drawings in the
codices.

Several other studies used essentially the same technique, but
concentrated on a few psychological and artistic characteristics
in a variety of cultures to see if any correlations could be
established between certain aspects of art and certain per-
sonality traits or child rearing practices. In a well known study
by Barry (1957) eleven art variables were assumed to be
measures of complexity, and these, together with an overall
impression of complexity, were used to rate a sampling of art
from 30 societies. A positive correlation was found between
complexity and the severity of socialization of children.

In my study of the formal qualities of Navajo art, I found that
the hypothesis that this art form reflects modal personality was
not born out. I analyzed a number of drypaintings by the
methods used for the clinical study of drawings, and the
characteristics that emerged were not those described by nu-
merous observers of Navajo personality. However, I did not

consider the representational qualities of the human figures.

The term "self-image," when applied to the human figures from various cultures, suggest a relation to the modal personality or ideal personality to be found in the cultural setting. This is usually thought of as an unconscious projection—the configuration of one's deep images of what humans, male and female, are like. But it can also be a matter of manipulation, especially in cross-cultural context, presenting the image that the artists would like outsiders to have.

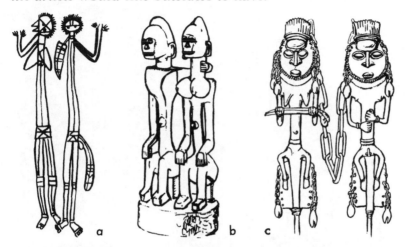

Figure 4.08. Holy Pairs. a. Arnhemland bark painting. b. Dogon wood carving. c. Yoruba bronze. (a, after Berndt and Berndt; b, RMZ; c, after Fagg et al).

On an intuitive level, one feels that human figures made by the artist of a society tell us something about themselves, which is why I have used human figures where possible to illustrate art styles. Something of a people's idea of what it means to be a human being may come through in their representation of the Founder couple—or Holy Pair, just as some of the people's world views can be found in their creation myths.

But self images are multiple, and include the image of one's fears, the images of one's dreams, and the images of one's roles. Knowing something of the lives of the people who present these images, and seeing the variety of forms they make, we can better interpret the "selves" being shown. Sometimes the facial expression of anthropomorphic images communicate to the viewer a feeling for emotional quality which one attributes to the makers. The faces of Hopi and Navajo masks usually have a

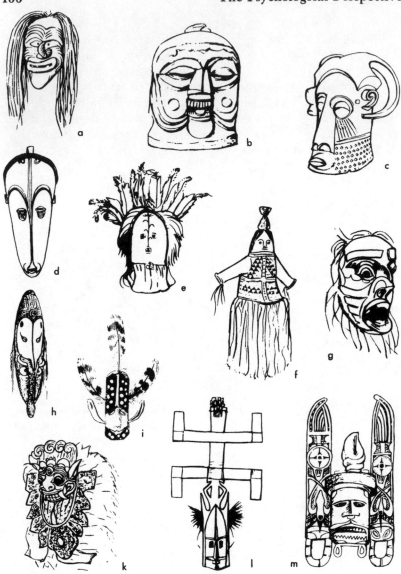

Figure 4.09. Masks. a. "Haduigona": Iroquois, used in healing ceremony. b. Egungun: Yoruba, ethnic satire. c. "Bomba": Kuba, a secret society mask. d. Ngil society: Fang, forest spirit. e. "Talking god": Navajo, Yei-be-chai ceremony. f. Tawu (tree bark mask): Cubeo, from a mourning ceremony. g. "Sneezer": Kwakiutl, comic relief. h. "Mwai": Iatmul, Sepik River, ancestral spirit. i. Alaskan Eskimo shaman's mask. k. "Barong": Bali, the witch's adversary. l. Kanaga: Dogon, bird spirit. m. "Nitkulega": New Ireland, malanggan.

remote, reserved, controlled quality very different from the highly dramatic intensity of the Kwakiutl masks. However, masks by their nature present such diverse and complex personas that one can hardly expect to understand the meaning of the emotions expressed without knowing the dramas of which they were a part, and how these emotions are interpreted by the viewers. So one needs the whole cast of characters, and the script as well, to get a picture of a people's idea of the roles that personalities play.

A very direct effect of art on personality lies in the way the arts provide examples of how people should and should not act. Dramas, clowns and satirical dances mime bad behavior, sometimes in general, and sometimes with recognizable transgressors. Art also presents models of what human beings ought to be, and human beings seek to present themselves as art tells them they should be; some peoples also recognize that such acting can lead to becoming.

The study by Gerbrands (1967) of *Wow-ipits* (carvers) in the Asmat area directly addressed the question as to whether artists were recognized in the society on the basis of esthetic excellence, and he also studied the personalities of the artists. He found that while this is a very small scale society, with limited resources and a direct technology, and while kinship status was important in the assignment to carve specific forms, the carver was recognized as an artist, and that each wow-ipits had a personality and a manner of working very different from his fellow wow-ipits. The variations in personality are also marked in the accounts of Solomon Island carvers by Davenport. These personality differences and ways of working made the products recognizably different. The extent to which personalities can be inferred from artistic productions remains an open question.

The Artistic Personality

The paradox of regarding the artists as a deviant type of personality, and at the same time assuming that the projections of the artist reflect the modal personalities of the culture may turn out not to be so paradoxical if reexamined in other terms. As Radin first pointed out, there seem to be in all societies certain personality types that provide specialists even where the division of labor is not formalized. The mystic, the skeptic, the

politician, the artist, the philosopher, the practical person and the administrator seem to be found as types or as variously assorted predelictions for which roles are often found. At the same time, as Mead emphasized in her famous *Sex and Temperament* certain kinds of personalities are favored and other personality types or tendencies are disvalued in certain cultural settings, so that the observer has a strong sense of characteristic or modal personality. If we think of the artist as a person who finds esthetic means of symbolically resolving problems of conflicts in a form that communicates to others, we can see how his unusual way of responding to the situation may express what others feel. An artist may indeed be a person who is particularly sensitive to the problems or contradictions of his culture, and in that sense reflects the "type anxiety". If his artistic solutions are congruent with those of others, his work will be accepted as art, not just personal aberration, and so represent the characteristic kinds of solutions that fit the cultural pattern. The extent to which innovative, as distinct from creative, efforts are valued will depend on the felt need for new solutions.

When we ask if there is, cross-culturally, an artistic temperament or personality, we are asking if there is a correlation between the degree of creativity and esthetic concern in the work of a craftsman and his behavior in other ways.

If there is a process of self-selection of artists—which of course must be validated by recognition to become a role—it suggests there is some kind of personality configuration characteristic of artists in all societies that sets them on this path. Without making any assumptions as to whether these characteristics are the result of biological heredity, childhood experiences, divine intervention, or some combination of them, the comparison of accounts of artists in a variety of cultural settings suggests some regularities. At present there are too few such accounts for any definite conclusions, except the obvious characteristics of high motivation and esthetic sensibility. Observations suggest also that there is a high correlation between degree of creativity and the degree of concentration, or even obsession, of the artist when planning or executing his work.

Bateson has said: "If there be any basic human characteristic which makes men prone to struggle, it would seem to be this hope of release from tension through total involvement."

(1949: 111). Accounts and even photographs of artists at work in a variety of cultural settings show this intensity to be widespread, and is probably an important psychological function for the artist. To the extent that the viewers can become involved, art can perform this same psychological function for them.

A study that brings out the subtleties of the psychological, social, situational and cultural factors in the making of an artist among one of the peoples of West Africa has been done by d'Azevedo (1973a and b). In this case the cultural perceptions of the personality type that goes with the role of "artist" results in myths that lead some "deviant" personalities into artistic pursuits, aided by a special relationship with a tutelary spirit—a demanding personal muse. It is this spirit that insists on the intensity, the obsession, that is characteristic of artistic activity.

Such studies of artists as we have from other cultures also suggest that except for these directly related traits, artists may vary widely in personality. A very complicated relation must exist between the cultural patterns and personality patterns to determine which types in which situations are regarded as "normal" and which "deviant." There is a suspicion that where the artist is expected to be far out he will take advantage of the freedom from convention in the expected or permitted ways. However, some societies apparently provide the necessary conditions for artistic concentration within the normal patterns of behavior. (Goodale and Koss, 1971). It would seem probable, though, that the very best artists are the ones most obsessed with their creative efforts, and are therefore persons who do not always perform other roles successfully.

Psychological Functions of Art

The view that art is self-expression alone does not explain why the artist goes to so much disciplined effort, or why people are willing to support his efforts. Theories that attempt to explain the functions of art call for explanation of how it works for the consumers as well as the producers. In this sense a theory of psychological functions includes socio-psychological functions. Such theories differ from sociological explanation chiefly by being expressed in psychological terminology.

There are a number of views concerning the psychological factors that are most important in leading to artistic creativity, and with each of these different interpretations goes a different theory as to how the psychological needs of individuals arti-

culate with social functioning and cultural styles. However, these different perspectives are largely matters of emphasis, and are not difficult to combine in a general way if one is not an ardent disciple of some school of psychology.

The position in depth psychology, of whatever stripe, is that the arts are used to express symbolically whatever cannot for some reason be satisfied directly. This can take the form of wish-fulfillment, like the Freudian interpretation of dreams, where fears can be turned into dragons that may be slain, and one can find one's prince or princess. In this view, art expresses not only what is repressed, but what for whatever reason has not been directly achieved in reality. The artist satisfies the needs of other persons if his needs are similar to theirs and he can help by forming images that satisfy these needs in fantasy. As such expressions are symbols of what is desired, they tend to be closely related to cultural ideals and hence to values.

The forms that images and symbols take may be considered part of the "collective unconscious," formed by similar life experiences common to the human condition, or culture specific with underlying similarities of theme. From this point of view, the study of art focuses on symbolism, on the meaning of symbols in the analyst's frame of reference. Cultural differences are considered in terms of the dominant themes, desires, fears and values.

One view is that the most important motivation for art lies in the need for mastery, and is related to hostility and aggression; to destruction and retribution tied to the basic primordial drama of patricide. Muensterberger says:

> "We have seen the widespread connection between
> death (often actual murder) and the making of an image.
> The idea of an 'ancestral image' or the 'ancestral mask'
> has been recognized by field workers for a long time. There
> is the obvious and acute relationship between oedipal
> strivings and the making of these objects. . . . Destruction
> and creation go hand in hand. Through this interaction of
> destructive and restitutive tendencies, the artist is able to
> channelize his impulses and gain mastery over his
> aggression." (Muensterberger 1951: 371-389).

This approach stresses art as a male occupation and is applied to the fine arts, especially representation of the human figure and various kinds of phallic symbols. It is also linked with castration fears and with envy of female procreativity. The latter view is supported by Tuzin's observations of the Plains

Arapesh of the Sepik River. Here a myth recounts how a spirit taught a woman how to give birth—and this spirit came from a housepost carved by the husband. ". . . the event implicitly arrogates to men the procreative powers of women. Art and ritual are the means by which they accomplish this." (Tuzin 1980).

Figure 4.10. Aggression and death. a. Mississippian "Death Cult" shell ornament. b. Sepik region decorated skull. (a, MAI; b, FMNH).

Exactly what is meant by mastery of males over their aggressions is not clear; certainly head-hunting and highly artistic ceremonies are clearly related in New Guinea; art does not function as a substitute for violence.

The main problem with these theories is that they seem to fit some socio-cultural situations but not others, and so cannot be universals in any determining sense.

It is not necessary to accept the implication of male superiority in the arts to see that these kinds of formulations can provide insight into some of the facets of the psychological dimension. Consistent with the theory of a male-destructive-creative artistic effort, and female nuturing-growing-creative effort would be the emphasis on subtractive (cutting away) arts of wood carving and stone carving as male arts, with additive forms such as weaving and the making of baskets, pots and clay modeling as female ones. The division is not universal, but prevails in many cases.

Devereux broadens the Freudian approach by considering cultural variation. He maintains that art is communication of a very special kind, highly structured yet always changing. His theories are perhaps best summarized in his own words:

"Having demonstrated that art provides a safety valve for the expression of that which is tabooed, we must next

seek to define the tabooed subjects that find expression in art. The subjects belong to three main layers:

1) The generally human taboos: Incest, in-group murder, etc.

2) The culture specific taboos: sex in puritanical society, avariciousness in Mohave society, cowardice in Plains Indian society, etc.

3) The idiosyncratically (neurotically) tabooed: Repressed wishes, etc. It is hardly necessary to add that the nature of idiosyncratically tabooed wishes depends to an appreciable extent also upon the dictates of the individual's cultural milieu." (Devereux 1961: 206).

"Dynamically speaking, the anthropologist studying art functions as a genuine student of culture and personality when he investigates:

1) The types of tabooed materials that society views as the 'proper' subject of art. . . .

2) The rules of the game for expressing tabooed impulses—the subterfuges that enable one to be crude and yet rated as a poet.

3) The technical skills needed for complying with the rules of the artistic game. . . .

4) Changes in the content of the ethnic unconscious and in the rules for changing the forbidden into art.

This manner of investigating art is clearly cultural in scope and yet provides massive information about the psychological climate of the culture: about its nuclear areas of conflict and typical defenses." (Devereux 1961: 209).

A related view is that art is a kind of catharsis, releasing accumulated tensions. The Cubeo combine art forms with alcohol and drugs to build a psychologically intense situation that in this frame of reference has the psychological function of catharsis. The focus is a funeral ceremony, with a series of masked dances with varieties of emotional expression from grief and solemnity to hilarity and sexual excitement.

In addition to the feeling that sacrifice should bring reciprocal rewards from the gods, artistically elaborated ceremonies involving human sacrifice probably performed some of the same psychological functions of catharsis as horror and disaster movies do. Whatever the theoretical explanation, it is clear that art somehow helps human beings cope with the trauma of death. Beauty and art forms have been part of funeral ceremonies since Neanderthal times. This universal human problem is met everywhere with symbolic solutions to satisfy

the mind and esthetic solutions to release the emotions. Some of these solutions seem very bizarre, but trying to understand how they work in context reveals a lot about the psychological functions of art, and the way people express their feelings about death tells us a lot about how they deal with the problems of life. In *The Sorrow of the Lonely and the Burning of the Dancers* Schiffelin provides an insight into the way one group in New Guinea deals with death—and with life—through creative activity.

The Balinese by all accounts achieve emotional satisfaction from participation in the creation of elaborate patterns—in social life, in ceremony, in continual joint artistic activity. The building up of emotional climaxes is disvalued (Bateson 1949). Strong emotion is, however, expressed as part of artistic pattern. The masks especially show this; whether of supernatural figures, like the witch who is the personification of fear, or the human characters in a comedy, emotion is shown in intense form, although the whole drama does not reach a climax in triumph or tragedy. Psychologically, the Balinese art provides for psychological satisfaction both in the form of an ordering (harmony) that reassures, and for a controlled expression of emotion, providing an outlet. It does not usually provide the release of high climax, a "catharsis" seen in intense form in the case of the Cubeo. The theory of the function of art to express what is taboo in the society is born out in the case of the Balinese. While the conflict is handled in daily life by avoidance, aggression and violence are found in the art forms

Figure 4.11. Expression of emotion in Balinese art. a, b, d, masks worn by actors. c. Rangda the witch who is both fearful and an expression of fear. e. Man with kris, an aggressive symbol which appears in many art forms. (a, b, d, after Ramseyer).

and the kris (a kind of sword) is esthetically elaborated and symbolically important.

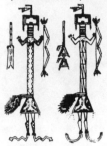

Fig. 4.12. Navajo sandpainting.

The ritual art of the Navajo, of which dry-painting is a part, has very different psychological functions. The focus of the ceremony is curing, psychological as well as physical, and the art form at all levels of meaning, including the contextual, stresses vitality that is ordered, controlled and harmonized to help directly achieve health, goodness, beauty and harmony. Expressions of passion and conflict are not to be found. The only "release" is a release from anxiety.

Kardiner suggested that the "secondary institutions," i.e. all the symbolic forms including the arts and religion are formed by the projections characteristic of the "basic personality" in the society. These secondary institutions help shape personality also. He did not elaborate on this, placing most of his emphasis on the socialization process. Mead, however, explores the process among the Balinese:

> ". . . man may shape his culture, as the Balinese have done, so that there is a symbolic answer for every need which is patterned in the growing child. The young child may be taught to know terror and frustration, bitterness of rejection and cruel loneliness of spirit very young, and yet grow up to be a gay and light-footed adult because, for every tension of the threads which have been twisted or double-woven in the delicate mesh of the child's spirit, the culture has a symbolic relaxation ready." (1940: 346).

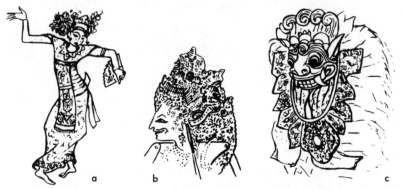

Figure 4.13. Bali dramatic forms. a. Legong dancer. b. shadow puppet. c. the Barong, mythical beast who opposes the witch in a dance drama.

"These childhood fears and agonies are sharp and poignant; left to fester unexpressed, they might easily lead to maladjustment, to deep unhappiness, and perhaps, in the rare and gifted individual, to some artistic expression. But in Bali they are not left to fester but are given continuous expression in the traditional art forms. At festivals the witch mask is brought out; in the shadow play the same drama is enacted; in the dance forms, in the religious trance, in the children's mimetic play, the fear of the witch is relived, but never completely exorcised—for, another week, the play goes on with the same spectators, the same actors, so as to give satisfaction to a people whose common childhood experience is being re-enacted, to lend contentment to their faces and unrestrained gaiety to their laughter." (1940: 345).

Art can also be seen as an outlet for the high degree of sexuality of human beings which, for a variety of reasons, can seldom be unrestrained and completely satisfied directly. But art forms often stimulate expression rather than act as substitutes for it, so the psychological mechanisms are unclear.

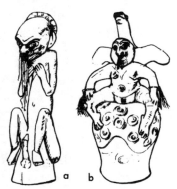

Fig. 4.14. Sepik River roof ornaments. a. wood. b. clay. (a, CMAE; b. MV).

The whole field of erotic art has only just been admitted to respectability for study, and very little is known of its uses, its functions, or the extent of such subject matter in various cultures. It is even difficult to accurately define erotic art as a category because of the differences in cultural perceptions. While portrayal of the sex act itself is clear enough, there are great cultural differences concerning the degree and kind on nudity, gesture, etc., that are considered erotically arousing. Symbolic interpretation varies widely too, as where the sex act symbolizes spiritual bliss, or the prominent phallus of an African figurine symbolizes ancestorhood. The best known art forms where sexual intercourse is the subject, outside of European and Oriental art, are found among the ceramics of the Andean region. It is not known how these were interpreted. As for more subtle relationships between erotic feelings and such abstract qualities as rhythm and color, we have only subjective impressions.

Artistic Problems and Psycho-social Problems

An important psychological function of art is entertainment, an escape from the problems of life; art is not only a safety valve, but is non-threatening. Paradoxically this can make it possible for art to be used in the solution of real problems by solving artistic ones.

Peckham (1965) offers the psycho-biological theory that the function of art, like play, is as a kind of safe rehearsal for coping with configurations that are disturbing, that achieve arousal in Berlyne's sense. In this view it is not the solution, the balance stressed by Beam that is the real function of art, but the un-settling, the "rage for chaos". This position tends to be close to that of Devereux, in that art functions to express and expose problems.

The views of Kavolis, Kubler and others, that art offers not just beauty and repose, or just excitement and chaos or even a balance of the two, but a kind of resolution or solution, are also psychological theories. Artistic solutions often provide sym-bolic or metaphorical statements of relationships which present stimulating analogies. A new symbolic solution is achieved by an individual out of his own psychological needs, yet is perceived by others as meaningful in the social situation so that it is accepted as an innovation. This view of artistic innovation seems to be similar to that described by Wallace in revitalization movements; instead of a prophet and vision we have an artist and his inspiration; in both cases there is a reformulation and a new symbolic synthesis.

The problem solving approach is not really very far from the Jungian view, in which the unconscious uses the archetypical symbols found everywhere in the human mind to form individual recombinations that have to do with a person's psychological dilemmas. Jungians point out that in many societies, artists say their ideas come to them in dreams. The difference between the Jungian and the Freudian views is that the former regard symbols as more fluid, more variable in meaning, more creatively used by individuals than do the latter.

Bateson's formulation puts the relation of conscious and unconscious in a still larger frame of reference. Art is a way of integrating the selective, verbal, analytical purposive part of the mind with the more primitive intuitive unconscious that is not simply what is denied or repressed, but includes the basic

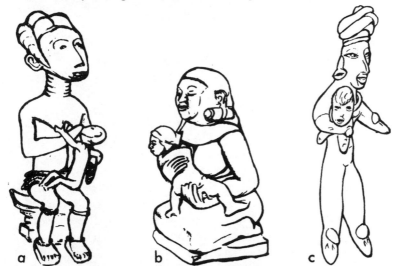

Figure 4.15. Universal Archetype. Mother and child figures are especially characteristic of Africa, but they are also found elsewhere. a. wood carving, Ashanti. b. stone carving, Bali. c. clay, pre-classic Mexico. (a, PC; b, BMIOP; c, NMM).

biological wisdom, the body-intuitions of the race, and does not set the self off sharply from the universe that surrounds it. Not, of course, that every work of art does all these things, but that the art process aids in communication at these levels. The psychological function of art is then not simply to provide a safety valve, but is a process by which wholeness is achieved; not simply an ego-trip for the self, but a search for deeper relationships beyond the prison of self. This is similar to the humanistic view that by the qualities of arousal, by making people feel more alive, art helps in the search for meaning and purpose in life. The psychological functions of art include the esthetic pleasure that somehow helps human beings, aware as they are of tragedy and frustration, pain and death, to feel that life is worth living. In Berenson's memorable words, art is life-enhancing.

Theories of art as a problem solving method, aside from the esthetic function of life-enhancement, do not deal with whether the solutions presented are good or bad. The newer cognitive studies have revealed the importance of analogy in human thought; thus art forms can be significant in problem solving. Art forms make no statements about truth or falsity as in formal logic.

Summary

An important thing to be learned from the cross-cultural study of artists, their personalities, their roles, their degree of freedom and their conservatisms and innovations, is the nature of the relationship of the individual to his society and to his culture. When looked at in this perspective, assuming the artist is a romantic rebel becomes as shallow a stereotype as assuming the primitive artist is mindlessly expressing the traditional group consciousness. Motivation, esthetic sensitivity and pre-occupation seem everywhere to mark the creative person, and individuality in this sense is important. To be accepted to perform the role means a relationship with other persons to fulfill their needs. Art has psychological function for the viewer as well as for the artist, or in another frame of reference, art has social functions that the artist performs if his efforts are to be supported.

Depending to some extent on the degree of freedom allowed by use, by the material, the technique and the demands of cultural norms, the craftsman leaves evidence of his personal style, his personality, on the work. The characteristic ways of meeting technical and artistic problems, which field observers have found to vary with individuals, leave their marks in the formal qualities of the object, even if the artist does not sign it with some favorite motif. In free media such as clay modeling and some kinds of drawing and painting, the artist may also project himself by unconscious bodily movements. These individual qualities, as well as the innovations of interpretation and characteristic recombinations of elements affect the product so that there are personal as well as cultural and regional styles.

Further Reading

Artists: Bascom 1973b; Bunzel 1930; d'Azevedo 1973; Fagg 1969; Gerbrands 1967; Holm 1974.

Theory: Devereux 1961; Jung 1964; Kris 1952; Munsterberger 1951; Peckham 1967.

Function: Bateson and Mead 1942; Schiefflin 1976; Turner 1968; Wallace 1956.

Chapter 5

Why? Social Contexts and Social Functions

The "why" of this chapter has to do with why art is a matter of culture, supported by society and of importance to it rather than a purely personal concern. Art is assumed to function to help hold society together, but there are differing viewpoints as to how this is accomplished. The main positions are:

I. Art helps hold society together because of its psychological functions—essentially it acts as a safety valve, channeling discontent, disruption, and excess energy. The meanings of the forms have to do with psychological tensions, anxieties and frustrations because of taboos, conflicts and other points of tension in the culture. Art is life enhancing, making individuals feel more in harmony with everything, and so with each other. Happy persons are easier to get along with than unhappy ones.

II. Art helps to hold society together by the esthetic pleasure it provides, especially when people are gathered in large groups. It is a form of pleasure bond, important in encouraging the feeling of togetherness, *"communitas"*. Meaning is derived very largely by association—contextual meaning. The relation between (art) form and (social) function is not necessarily very significant, i.e., it is not the symbols that are important, but just the esthetic pleasure from the surroundings.

III. Art helps hold society together because it reflects and reinforces the relationships deemed proper in that society; art symbols are collective representations which by their form and content are shaped by and help shape the social order.

While different theories emphasize one or another of these positions, there is no reason why art cannot function in all of these ways, even simultaneously. Especially as there is more than one kind of "togetherness". The concept of "communitas" mentioned above is useful in this context; Turner contrasts the unifying emotion of communitas to the organized unity of the structure:

"It is as though there are here two major 'models' for
human interrelatedness, juxtaposed and alternating. The
first is society as a structured, differentiated, and often
hiererchial system of political-legal-economic positions
with many types of evaluation, separating men in terms of
'more' or 'less'. The second, which emerges recognizably
in the liminal period, is of society as an unstructured or
rudimentarily structured and relatively undifferentiated
comitatus, community, or even communion of equal
individuals who submit together to the general authority
of ritual elders. . . . communitas." (1969: 96).

These two modes, structure and communitas, I conceive as
operating, often more or less simultaneously, in all
ceremonial-festival occasions, and suggest that it may be useful
to examine the proposition that different art media, and
different qualities in various media symbolize the structure or
engender a sense of communitas. There are additional ways
that social integration is conceived, but these two seem
particularly useful with regard to art. But even though
symbolic forms are important in maintaining society,
especially when it is conceived as an organic whole, we cannot
maintain that they always work, that each society is a
smoothly functioning entity, existing in isolation. This being
so, a full understanding of the social functions of art must
include situations of competition, conflict, violence and war,
but such functions have not been explored to any significant
extent.

I. Psychological Means to Social Ends

Psychological functions have been discussed in the last
chapter. In addition it should be evident that the chaneling of
energy and emotion into art, as is done in a Balinese village,
provides an outlet for energies and emotions that might
otherwise be expended in competition and conflict. Fur-
thermore, by providing role models that help shape the self
image of individuals into recognizable personality types, art
aids social interaction by helping people to know what to
expect in the behavior of other persons.

But a little reflection and observation will show that psycho-
logical functions and social functions are not necessarily
congruent. And, just as the artist, preoccupied with his art, may
fail in his responsibilities to other persons, so art forms can
serve as an escape for viewers and patrons, and the arts serve to
help avoid rather than face social responsibilities.

II. Art as Social Setting

It is often difficult for persons who value art highly to accept the idea that art frequently functions as a decorative adjunct to events that are primarily social. But art is not just the province of the esthetically sensitive, for their appreciation and contemplation. Art can be important to social occasions, even though it may not be the main concern of most of the participants, who have very little interest either in contemplating it for esthetic effect or in interpreting the meaning. It may indeed be possible that in many situations meaning at any level except contextual is unimportant to the social function of the arts. New Ireland provides us with an example where much of the symbolic meaning has been lost, yet the contextual meaning is still of great importance.

> "Instead of caring about subject matter, those persons involved with malanggan and its art are consciously interested in details of the social context, such as who the patron is, who is being honored, the recent transmissions of the rights to stage the ceremony and have the specific image carved, etc. In other words, the social context is a kind of connotational meaning which engages the interest of the patrons, carvers and viewers, and as such is quite amenable to study. The art, imbued with contextual meaning, may thus be viewed as being highly symbolic of the social context as such, in addition to and at the same time as it refers to subject matter. In this way, the art conveys to all viewers connotations of social importance, identities of patrons, of honored dead and initiates, expenditures of resources and food-stuffs and money, not by the actual forms of the art object, but by virtue of associations with these matters in the ceremonials. This steeping of the art with social value by association with socio-ceremonial matters is similar to imbuing the patron with prestige, which he gets by association with socially valued activity and resources. At the same time, also, the art itself, consisting of expensive objects, the product of labor, expenditure of money and foodstuffs lends to the ceremonies much value. As a visual focal point in the ceremonies, and in its role as repository of reference to supernatural beings and forces, the art serves as tangible evidence of the presence of such power to all viewers."
> (Lewis 1969: 171).

And from the New Yorker (Dec. 20, 1976, p. 29):

> "That evening, in the main hall of the Metropolitan [Museum], the huge stone urns held white lilacs that not

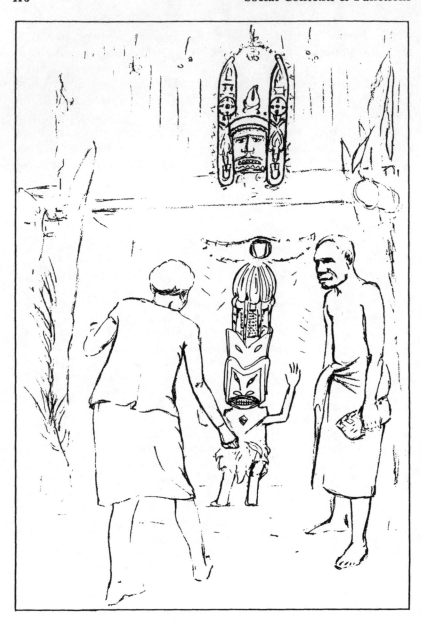

Figure 5.01. New Ireland. The patron and a visitor at one of the malaggan displays in the initiates enclosure. (after a field photograph by Phillip Lewis. See Lewis 1969).

only looked fresh but were. They smelled like spring anywhere. The crowd was enormous. Six hundred and fifty people had come to a dinner being held in the Fountain Restaurant, and well over a thousand had come for a reception that started at ten o' clock. Jacqueline Onassis was the chairman for both events, which were to benefit the Costume Institute. In the main hall the band played, the young and those who felt young gyrated. Everyone said the exhibit, downstairs, was going to be a huge success, but mostly people walked around and looked at each other and said they would go to see it on a day when it would not be so crowded."

New Irelanders, too, are interested in the feasting, the dancing, and the important people. A really big affair brings people from 30 miles around, with gifts for relatives, new apparel, fees for the show and goods to sell. The organizer starts months ahead, perhaps years. Preparations include the growing of foodstuff, the making of craft items, rehearsals of local dance teams. The event is a stimulus to the economy over a wide area. Throughout Melanesia the pig feast is necessary for making the reputation of a Big Man, and results in this kind of wider socio-economic integration; the social functions are more alike than the symbolic forms. The big New Ireland ceremony is ritualistically a memorial service for the dead of a particular matrilineal clan, given at intervals of some years when an important person in the clan has died. Thus it involves a sense of the succession of rank from one generation to another. The entrepreneur tries to get people to add on their ceremonies and other events to the occasion, and in various areas certain additions become traditional; in Lesu boys are initiated as part of the series of events. *Malanggan* figures, shown at the climax ceremonies, are individually named and owned, and can be bought, sold or traded. But it is not the specific artifact, the art object, that is owned, but a kind of copyright on the named figure with its necessary attributes. The owner commissions a carver to make his figure in accordance with his specifications. After the festival, the carvings are often allowed to rot.

Art as pleasure-giving and social-bonding is tied into the social structure because at all levels of complexity an individual who can give a lot of people pleasure by a really big social event, enlivened by various art forms, gains prestige. The patron is important because he can mobilize the necessary economic resources and organizational skills. Even where a small society collectively expresses itself in a traditional

manner through collective action, as among the native Australians, the elders who organize the event increase their importance. Interestingly enough, it seems to be rare for the best artists to be the best organizers, and vice versa.

Not only the festival itself, but the preparations for such an event seem to be bonding. Even the quarrelsome, aggressive Mundugamor of the Sepik area in New Guinea are reported by Mead to have been very sociable when preparing the art necessary to a large ceremony.

She reports that during a quiescent period between raids, a big man might decide to give such a ceremony, and that there would then be a truce to the quarreling within the community; the pattern was that there must be no disturbance during this period, such as spear throwing or wife stealing. Women would be busy laying in a good supply of yams or other food, and cooking special meals for the men who were preparing the ceremonial materials.

There might be an elaborately painted crocodile nearly twenty feet long, made of bark, or even a larger bark triangle raised against the coconut trees and also elaborately painted. It is thought that these large paintings were inspired by the facades of the Tambaran Houses made by some of the other peoples of the Middle Sepik region. (See p. 240). Smaller items such as shields and spears for the dance would need to be refurbished, or new ones carved. And sometimes new flute figures were carved, and decorated with little crocheted garments, hair, shell, fur and feathers. All this work was under the general supervision of the master artist, ignoring the leading head hunter.

With the truce there was the greatest of good spirits. Flute music started the day, and the various groups sat around crocheting, painting, carving or stringing shells. At noon women prepared great heaping dishes of food, with lots of fish and sago grubs. Thus for several weeks the normal mistrust between everyone, which usually resulted in a hesitation even to turn one's back on another man, was submerged, although some undoubtedly schemed for advantage all the time.

It was not until the dances and the feast were over that the more usual hostility and suspicion showed itself again, and people were as quarrelsome as ever. The only other time people cooperated and were cheerful was in preparing for a head hunting raid, against some other tribe.

All this suggests that art as an activity helps engender the kind of integration that comes from shared happy or intense experience, the sense of "communitas".

Figure 5.02. Social and symbolic spaces. a and b. diagrams of dance grounds, Arnhemland; dots represent initiates, squares are brush shelters. a. is for ceremony acting out a dual social division; b. represents the body of the Fertility Mother, symbol of the whole society. c. Kwakiutl house; for ceremonies the rear platform becomes a stage. d. Ashanti shrine house. In all these spaces, dancing is the important symbolic activity; high status persons have special insignia and places of honor, but are not spatially separated from their people. (a,b, after Berndt and Berndt; c, from Boas; d, after Swithenbank).

There is another way in which art forms, in a very broad sense, influence the interactions among people. This is the way culturally shaped environments, settlement patterns and structures affect people. Mead has said "organizing space is a way of organizing people." Even when symbolic meanings are not attributed to these forms by the persons who make and use them, they affect the social order in a number of ways, and great value is attached to customary spatial forms of settlements, dwelling and sacred places. Artistic and architectural skills and efforts are lavished on the settings for the great social ceremonies. In pre-industrial civilizations we can see this very clearly, as great efforts are made to provide monumental symbols and spaces for unifying ceremonies—Tikal and other centers of the Maya, Cuzco of the Inca—and the Processional Way to the Acropolis in Athens. These planned spaces

physically direct the movements of the people, and so affect who meets whom, in addition to whatever symbolic meaning is given to the shapes of the spaces or any of the art forms displayed.

Figure 5.03. Social and symbolic spaces in hierarchial societies. a. plan of an Egyptian temple at Edfu; spaces are ranked. b. Balinese shrine in a temple area, a purely symbolic structure, the number of roofs indicates the rank of the deity. c. plan of a Balinese temple; the highest courtyard contains the shrines; it is higher and more holy than the other courtyards, but all the people go there. (a, after Grillo, b,c, after Ramseyer).

Large gatherings usually involve not only ceremonies, but festivals and fairs. Gifts may be exchanged; souvenirs may be acquired, all sorts of objects may be bought and sold. And art forms not only shape and embellish social gatherings, but are often articles of exchange; as at the malanggan gatherings, where the "copyright" for a particular form of carving passes to another owner. As artifact, art functions to extend social interactions far beyond the local community, again regardless of any symbolic meaning attached to the forms.

III. Art as Symbol of Society

Social function is most usually discussed in term of symbols, of collective representations. The relation of visual forms to the social function of such symbols has been conceived in various ways and expressed in a variety of terminologies. It is a field that is still largely in a speculative stage, full of possibilities for exploration. In the main, persons whose focus has been on tribal societies have tended to emphasize the way art reflects existing society and maintains tradition, while persons whose interest is on the industrialized and industrializing world have

emphasized the role of art and artists in promoting social change.

A device that seems useful for categorizing the ways that art functions symbolically with regard to the social order distinguishes the symbols of society conceived as a whole, as a single entity, from those of society as a structure or pattern of statuses. We can also make a distinction between loyalty to a set of people and that to a set of ideas or beliefs. It will be recognized that this is a very artificial division; art forms can, and often do, relate to society in all these ways at once. We can picture this formulation thus:

	synthesizing symbol	patterning symbols
of social organization	A	B
of cultural beliefs	C	D

A and B can be conceived as relating to society as a "causal-functional" system; to the way people interact with each other in organized ways through roles that go with their kinship, political and economic statuses; a society.

C and D can be seen as having more to do with the "logico-esthetic" system, the iconology, and relate to the ways people are united by common ideas and values; the "society" referred to is less likely to be a political entity and more likely to be a matter of shared world view, of shared religious beliefs, a culture.

People who share the same ideas and world view, expressed and united by a similar style, may still kill each other off in conflict over who shall possess the insignia of rank, wealth and power. However, where there is such common understandings, violence will be limited in certain conventionalized, even ritualized, ways. Individuals, even those who hold the positions of power and rank are seldom powerful enough to challenge or greatly change the expressive symbols C and D without repercussions, although new insignia may be added. The Golden Stool of the Ashanti, understood by the British to be a type A throne, functions also as a religious type C symbol, and so when a colonial governor said he was going to *sit* on it, a sacrilege, revolt broke out. Vietnam protesters indicated their feelings by disrespectful treatments of the U. S. flag, to them a symbol of the structure (the "establishment")—these were shocking acts for those who regard that flag as a sacred symbol of an ideal.

A. Symbolic Labels for Social Entities

Category A, then, involves basically the idea of one symbol, or a complex of symbols, that stands for a whole society, often a corporate group or political entity. Visual symbolic forms help make concrete the abstract set of loyalties, giving a label with which to identify. In our societies such labels and emblems are very consciously chosen when a new college or professional team is formed. It has been pointed out that no professional football team is called the Pussycats, but it is even more unthinkable that they would have no totemic symbol at all. Although such symbols stand for the organized social entity, the structure, the establishment, the sense of loyalty to that entity, the feeling that "we are one people" means that in times of high emotion, such as war, the symbol arouses an atmosphere of communitas.

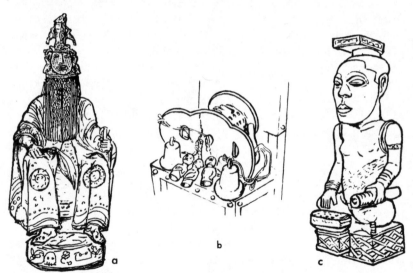

Figure 5.05 Society symbolized. a. Yoruba king in full regalia. b. The Golden Stool of the Ashanti. c. Statuette of King Shyaam aMbul aNgoong. Kuba b. after Kyerematen; c.BM)

The symbols that stand for the society include *totemic* animals and ancestors as symbols of kin group; in more centralized societies the ruler is often the symbol. Such basic symbols are made tangible in art forms. The symbols may be elaborated into whole complexes, and embellished with decoration, but the basic function is to "stand for" some

organized collection of people. In kingdoms, for example, a considerable panoply forms a complex around the main symbols, which is properly speaking the office—the Kingship rather than a particular person; thus "the Throne" or "the Crown" represents the basic symbol. While he holds office, the person who wears the crown is the living symbol animating the panoply. In the case of a Yoruba king, his face is hidden by the veil that is part of the crown. Thompson describes an elaborate iconography of the beaded crowns worn by the kings of Yoruba city states. His interpretation, summarized, is as follows:

> "Traditional crowns. . . . must include (1) a beaded fringe veil. . . . for state occasions when the king incarnates divine powers and it is dangerous to stare at his naked face, (2) frontal faces rendered in relief or partial relief, and (3) beaded birds rendered in the round. . . . He is both impregnated with godhead and subjected to the morally watchful gaze of the gods. His own face has vanished and the countenances of his ancestors have become his own at a higher level of vision. Thus the meaning of the frontal face on the beaded crown seems to be: the union of the living king with the deified royal dead." (1972: passim).

He says further, that the birds are, at one level, symbols of the king and his counselors, and at a deeper level imply his mysterious and ambiguous power to use magical aggression, and to defend against such aggression by others. The veil can be interpreted to mean that it is the Kingship as a symbol that is important, not the individual human being.

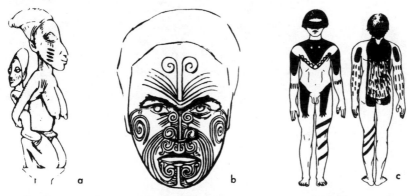

Figure 5.05. Permanent and temporary status. a. Yoruba, carving showing tribal scarification. b. Maori, tattooing indicates rank. c. Kwakiutl, body painting for a boys' dance. (a, PC; c, from Boas).

B. Symbolic Labels Indicating the Social Order

The most obvious way in which the structure of society is indicated by art forms is through the variety of insignia surrounding, worn by, or actually made part of individuals. Statement of the social order by the individual showing his place in it is found in all societies; status, rank, occupation and locality are all displayed. In some societies the indications are so precise that individuals can usually be placed on sight, as in the India described in Kipling's *Kim*.

Paulme (1973: 16) points out that in Africa ethnic identification requires indelible forms that are not easily counterfeited; thus scarification is used. Her point is probably widely applicable: permanent forms such as scarification and tattooing are most usual as marks of unchanging status, and temporary forms such as body paint and ornaments are insignia of some more temporary status.

Dress and adornment indicate, often in great detail, an individual's place in the life cycle—child or adult, male or female, married or unmarried, etc. Such symbols indicate position in the social structure, and signal to other people how to behave towards the wearers. These kinds of status markers, as with those of rank, can be very overt and explicit, or very subtle and even subliminal.

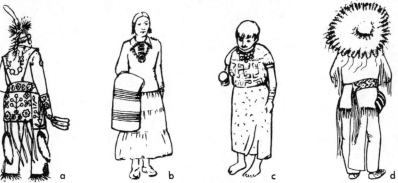

Figure 5.06. Contemporary ethnic identification. a. Chippewa. b. Navajo. c. Cuna. d. Dakota.

Ethnic identification is often symbolized by hair and clothing styles, and even today when many people have abandoned such garb most of the time in favor of manufactured clothes, the heirlooms are brought out and worn on festive occasions, and new costumes are made.

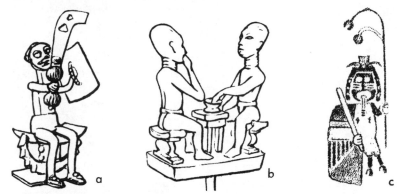

Figure 5.07. Symbols of office. a. Ashanti goldweight representing a chief. b. Ashanti staff of a chief's spokesman. c. Andean figure from a textile. (a, after Kyerematen; b, after Cole and Ross; c, after D'Harcourt).

Visual symbols of office are particularly important where the society is too large for each person to be known to all others, but are also widespread in quite small ones to indicate changes in roles. Ashanti "Spokesmen" carry staffs; warriors carry weapons, shields and insignia; priests everywhere wear distinctive garb. These labels show who does what job.

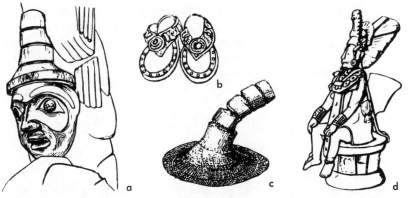

Figure 5.08. Symbols of rank. a. Kwakiutl detail of a totem pole, showing a chief. b. Ashanti sandals with gold ornaments. c. Kwakiutl basketry hat, height indicating rank. d. Maya clay figurine; even without knowing the precise iconography of the regalia, high rank is recognizable. (a, c, after Hawthorn; d, NMM).

Rank can be indicated very precisely as in the Chinese court in the Manchu dynasty, when court dress prescribed the bird or animal embroidered front and back for each rank, and minute details of colors, buttons, etc. Rank can also be stated by the

degree of opulence. In either case, a great deal of fine craftsmanship goes into providing status symbols for the elite.

Sumptuary laws may specify garments and ornaments limited to the upper class. For example, the wearing of gold and silver and of the finest textiles were perogatives of the Inca nobility. The insignia was not as specific as that for the Chinese, however, as evidenced by the information that the Inca had new garments to wear every day, and gave them away as a mark of favor.

Not all aspects of dress reflect differences in status. Alikeness in dress directly expresses communitas and equality. An example of a rather obvious and specific statement of a group feeling lies in the concept of dressing alike, not as imposed by structure as in the case of a group like a king's guard, but freely chosen by persons in an egalitarian group, such as a club, to express their solidarity. This occurs widely in West Africa, where the weaving or printing of a special cloth may be commissioned for a celebration.

The social order can be indicated in other ways than by personal insignia. One obvious way is the positioning of persons in space to symbolize their social relations. Seating protocol is important, as in Kwakiutl ceremonies; sacred and other spaces are laid out with regard to social positioning. All kinds of possessions can become prestige items. Further, it even becomes meaningful to have high class tastes in art, and to sponsor art-embellished events.

C. Symbols that Synthesize Ideas and Sentiments

Symbols of a culture may have great power because of the sentiments and beliefs that people attach to them.

> ". . . meanings can only be 'stored' in symbols: a cross, a crescent, or a feathered serpent. Such religious symbols, dramatized in rituals or related myths, are felt somehow to sum up, for those for whom they are resonant, what is known about the way the world is, the quality of the emotional life it supports, and the way one ought to behave while in it. Sacred symbols thus relate an ontology and a cosmology to an aesthetics and a morality: their peculiar power comes from their presumed ability to identify fact with value at the most fundamental level, to give to what is otherwise merely actual, a comprehensive normative import." (Geertz 1957: 326).

Such synthesizing symbols may seem completely arbitrary to outsiders, but may be also based on the natural symbols of life:

the human body, the great tree, Father Sun (or Sky), and
Mother Earth. The more dynamic basic symbols may have
simplified abstracted shorthand visual forms such as crosses,
circles, starts, triangles and the like. Basic symbols may also be
elaborated and embellished, or surrounded by decorations and
subsidiary symbols.

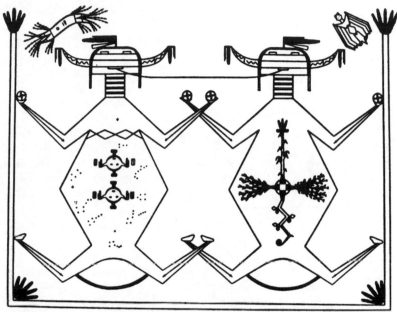

Figure 5.09. Natural symbols. Father Sky and Mother Earth, Navajo
sandpainting. (from Newcomb and Reichard).

Behind the symbols lies the model (the definition, the
paradigm) of the way the world (reality—the universe) *is*, and
therefore how society is conceived. "A culture" can be thought
of as the shared model of reality in the heads of the members of
society. A synthesizing symbol stands for this model and for all
the basic postulates that are embedded in it, as well as the values
that are derived from it. Such a model is analogous to a
mathematical system, like plane geometry, and can be thought
of as a problem-solving system. When the users of the system
run into problems that it does not solve satisfactorily, and it is
no longer perceived as all encompassing (and the symbol no
longer "resonant"), new models are sought that can make sense
of both the old system and the perceived contradictions. Thus,
when the old model of the solar system with earth as a flat plane
with a dome over it no longer fit the known facts, not only was a

new model of the solar system developed and the universe en-
larged, but the whole view of reality had to be changed—God
had to be conceived on a larger more abstract scale. In a time of
troubles, creative individuals in all fields "play" with new
models and when one seems to work new symbols develop to
evoke it. The clearest and most impressive cases are those of a
prophet with vision who offers a new paradigm that eventually
becomes a religion (Wallace, 1956, 1978).

Art forms are important in this process in reinforcing the
basic symbols and fundamental patterns, and adapting them to
changing times, as well as in exploring new symbols and new
visual metaphors when they seem needed.

D. The Patterning of Values

Art can relate to the structure of society by visual forms that
in some way reflect that structure not simply by labeling, as
with insignia, but by communicating common values and
patterns that reflect the basic postulates concerning what life is
all about and how things, including society, are or should be
structured.

> "In cases such as these [the Maori, the Northwest Coast
> Indians, and Victorian England], the value seems to be
> attached to size and complexity and elaboration for its
> own sake; also there is a tendency to produce decorated
> versions of everyday objects which are not only flam-
> boyant but technically useless. The adjective
> 'ostentatious' sums up the whole complex. From this
> point of view these primitive art styles from the Pacific
> area have much that was characteristic of the artistic taste
> of mid-nineteenth-century England.

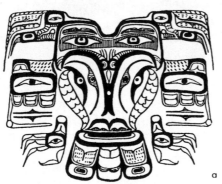

Figure 5.10. Ostentation hypothesis. a. Kwakiutl. b. Victorian. (a, from
Boas; b, Dover pictorial archives).

> "I believe that such correspondences are not altogether accidental. The resemblances in artistic taste reflect common moral values, in this case the moral values of the socially ambitious. For as in Victorian England, the primitive societies of British Columbia and New Zealand were characterized by notions of a class hierarchy coupled with much social competition." (Leach 1916: 37).

In most of the efforts to relate art styles to social structure, there is the recognition that there must be some way that art helps to relate the individual to the group. A term that implies this relationship without going into psychological theory is the term "value", as used by Leach above. Sieber puts this approach very succinctly:

> "From this point of view. . . there is a level at which the social function of the arts is constant. The arts at any time or place, in reflecting cultural values, evolve what might be called the value image that culture has of itself. The image can become objectified (perhaps reified is a better word) so that it stands as a symbolic reinforcement of the values it reflects." (Sieber 1962: 205).

Thus the Fang value balanced opposition as a means of achieving vitality and harmony in social relations and in symbolic forms, and the Navajo value the orderly arrangement of many elements, not opposed, but going in the same direction without interfering with each other.

The relationship of esthetic canons to the "existential postulates" as well as the "normative postulates" (values) of people actively living in real societies is rich, subtle and complex. Studies that result from field work, such as those of

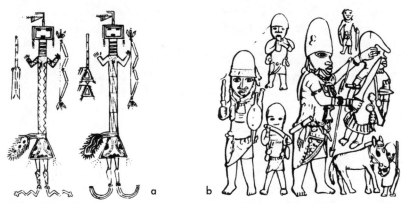

Figure 5.11. "Social perspective." a. Navajo. b. Benin. (a, after Reichard; b, after Pitt-Rivers).

Turner, Thompson, Tuzin and Glaze, have revealed some of this richness.

Some of the hypotheses so far advanced have to do with egalitarianism and hierarchy. Hierarchical societies not only tend to use "social perspective" by making important persons larger than others, but tend to make abstract units of unequal size. The more egalitarian the society, the more equal units and figures tend to be. Another hypothesis is that emphasis on rank and dominance may be correlated with the overlapping of forms, while in societies with great respect for individual autonomy, figures do not "interfere" with each other.

 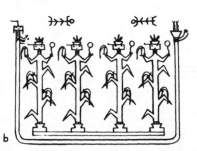

Figure 5.12. Dominance and autonomy hypothesis. a. Bali; sketch of a typical recent painting with overlapping forms, modified by the unifying effect of marked rhythmic repetition. b. Navajo; layout of a sandpainting; the figures and units do not touch each other. (a, after a painting by I. B. Njana).

Although he does not use this terminology, Mundt (1952: 197, 213) suggests that visual rhythms, like aural ones, have a social meaning related to communitas rather than structure.

According to some writers relationship between visual forms and social structures is not a causal one. According to Maquet (1971) it is a matter of coherence, equivalence or parallelism — "a relationship of consistency based on a nonrational logic." However, there is an element of causality if visual forms and social structures reinforce each other by congruent configurations. There is also an implied causality in the idea that art forms can be trial balloons providing new patterns of relationship that can be seen as analogies. As has been emphasized in recent studies in cognition, people think more by analogy than by formal, "rational" logic, so if any thinking affects social behavior, visual forms can do so.

This tantalizing kind of relationship has been discussed at some length, notable by Kavolis (1968), and systematic inves-

tigation of the many hypotheses are beginning to appear; the field is full of possibilities. Such an effort is made in *Visual Metaphors* (Hatcher, 1974).

Art and Social Process

There are an almost infinite number of possibilities for the ways artistic modes can go together to reflect, mold and enhance the social life of human beings. Glimpses of how art forms functioned in social contexts helps us to sense the relevance of such forms, the meanings they have aside from mere escape from the hard realities of life.

For example, how did the rich art traditions of the Kwakiutl function for these competitive, combative, prideful people? Descriptions of the society have been puzzling. How could a Kwakiutl village survive as a community without unifying political forms? The enormous pride of each of the kin groups centered on the chief and his great house would hardly seem to permit more than one such organization in a community. The only exception to continued rivalry and warfare would be temporary alliances, often achieved by marriage. But each village did have more than one Great House, and existed as a community for all the rivalries. I suggest this was largely achieved by the highly artistic, dramatic activities of the ceremonial season.

While many of the symbolic forms were perogatives of kin groups, the ceremony fitted these icons into the larger artistic unity of the whole festive-ceremonial occasion. The vivid enactment of death and return to life of a dancer in the Winter ceremonies of the Kwakiutl must have resulted in shared excitement based on the psychological impact. The physical togetherness of the social event was heightened by the emotional psychological effects of art as well as by the esthetic ones. Furthermore, even as visual icons were symbolizing the structure of the separate groups, the rhythm of the music was uniting all present. All joined in the drumming with sticks (batons) passed out to the audience; all joined in communal meals; there must have been moments, especially after many hours of these activities when the feeling of communitas was strong. Shared rhythm is probably always the most direct means for achieving the sense of togetherness. At the same time, the social structure is evidenced in the display of the crests of the various kin groups, and the symbols of the importance of the leader of each.

If one considers the festival-ceremonial event as an artistic whole, the interweaving of the three aspects (the structure—proclaiming icons; the value sharing style; and the emotional-togetherness enhancement of food and rhythm) produces a unified statement of the rich complexity of social life.

Ceremonial-festival occasions usually include all the aspects and have all the functions discussed above. Among the Ashanti, as elsewhere, such events provided escape from the daily routine, a chance for special decorations and special clothes, a chance to mingle with others in an atmosphere enhanced by art in various forms. The King (or the local chief) and his court appeared in fine handwoven togas with their insignia of office, each proclaiming rank, and making the structure visible. The structure symbolizing icons documented the legality of the establishment. The Ashanti style, clear and brilliant, stated the values and proud identity of these people of the "Gold Coast." Through all the events ran the uniting rhythm of the drums.

Some ceremonial occasions are not festive. Thus the symbols of society are most potent when they serve to unite the Us against the Not-Us. Then the traditional unifying and synthesizing symbols are most evident, structural emblems

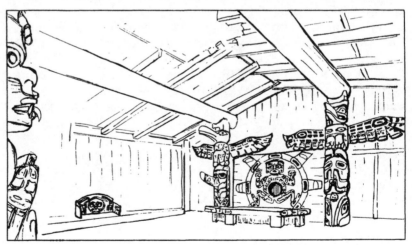

Figure 5.13. Interior of a Kwakiutl house. Between the house posts, carved with the owner's crests, a painted wooden screen hides the preparations of the dancers; sometimes the dancers emerge through the hole in the middle. (This house has been rebuilt within the Provincial Museum, Victoria, B. C.).

glorify valor; the rhythms of the drums and the esthetics of the social contexts are changed and show less variety.

No one in the world today should need to be told that symbolic forms, visual and otherwise, are used in propaganda wars as people compete to promote their definitions of reality; this is not a new phenomenon, although expanded by new media.

In appealing to group unity, art symbols also rally people to opposition, conflict and violence. If they express traditional values, they also challenge those values with new forms that reflect other ways of looking at social relations. It would seem probable, if the kinds of interpretation discussed in this chapter are meaningful, that icons, as symbols of specific groups or power holders, are more often involved with power struggles and rebellions (in Gluckman's sense of throw the rascals out) where the structure is not changed, and that stylistic formal changes are to be expected where real changes in social forms are desired. Whole peoples who speak the same tongue and have very similar cultures may slay each other when they get a chance, nevertheless there may be shared understandings of ways that warfare should be carried out, and limitations of various kinds—these may also be expressed by the artistic patterns. If artistic meanings include visual statements as to how the social world should be ordered, they probably also include the preferred styles for dealing with conflict and disorder.

A very clear example of limited conflict and violence within an area of similar culture understandings can be found in the head hunting wars of New Guinea. Head hunting was enormously important to the status of males, and skulls were a necessary part of the artistic and symbolic embellishment of the Men's House. But encounters usually ended when a life was taken and the winners could celebrate with elaborate ceremonies, involving an expenditure of energy on artistic activity at least as great as that expended on warfare. The vivid and moving scene described by Bateson in *Naven*, where the defeated called to the victors as they went off in their canoes: "Go then, go now to your beautiful ceremonies" makes one wonder even about the relation of aggression and creativity. There is a glimpse of the possibility that the warfare can be regarded as part of the whole artistic creation in which social forms serve artistic ends rather than vice versa.

If art does, indeed, perform any or all of the social functions that have been claimed for it by virtue of what it communicates, by its style, rather than simple association, one would expect the function to in some way affect the style. Just as use, material, technique, and the personality of the artist may influence the visible form, so too the social function. The relation of art to society, in this view, is not only a matter of icons, but also of formal organization of spatial relationships, a kind of diagram of the natural order and the social order, and so a guide as to how to behave. Both harmony and opposition are involved.

As art performs such a great variety of social functions, and as function is so closely related to meaning, one can consider all art as a form of communication. The study of art as communication makes it possible to understand how all the various theories as to the function of art, even those that seem contradictory, can be accepted as valid if visual meaning, like speech, depends on the contexts in which it is used.

Further Reading

Bateson 1958; Biebuyuk 1973; Douglas 1975; Fraser 1968; Glaze 1981; Kavolis 1965, 1972; Ottenburg 1975; Rogers 1970; Turner 1968, 1969, 1974; Tuzin 1980; Wallace 1956.

Chapter 6

"What. . .?" Art as Communication

If art has all the functions attributed to it, it must do so by some kind of communication from artist to viewer. And, if art is a form of communication, why should it not communicate whatever there is to say? Why should it be limited to what is taboo, or to values, or even to feelings?

There are two related dichotomies that have been widely accepted; one is the distinction between the visual and the verbal in terms of the intellectual quality of the latter, and the other a distinction between "feeling" and "thought". These are of course, useful distinctions on some levels, but such a dichotomy leads to considering our brains simply as rather inferior computers, and in reaction to this, anti-intellectualism. On the one hand a loss of a sense of the significance of life, of purpose and motivation; and on the other a loss of the common sense necessary to maintain it. If we conceive of visual forms as having at the same time both cognitive and emotional qualities, we are on our way not only to being better able to understand the works of other peoples, but in conceptually putting human beings together again. In exploring the nature of communications aspects of visual forms, however, it seems necessary to put aside judgments about esthetic quality. In other words, to pay attention to what is being said, without reference to how beautifully it is said. What is said can be both intellectual and emotional.

When we talk about art as communication we are especially concerned with how the visual (or otherwise perceptible) form that is presented to the senses conveys some kind of import by means of the form itself. While the context in which the art appears is important to full understanding, art does not communicate unless the form of the work has some meaning by itself.

Verbal, visual and other communication "codes"

We can conceive the event, the situation in which the viewer comes in contact with art, as one kind of communicative transaction involving a number of channels ("media"). Thus in a conversation, communication is by words, tone, etc., in the

voice; gestures and body languages, and facial expression. These can be analytically separated into codes for the sake of understanding the systems of meaning expressed through each. The speaker is to some degree conscious of what he is communicating by these codes, and the listener is to some degrees conscious of what is being communicated by each. They are not, however, necessarily conscious of the same aspects of the message in the total communication transaction. In a social event such as a Navajo ceremonial we can also conceive the communication going on as being transmitted through a number of channels with different codes or systems. What is being said in words, in paintings, in gift exchange, in music, in ritual, in dance and mime, may all add up to a very rich total communication, but each channel can be viewed as having its own system. Verbal and visual communications seldom occur separately. Even the printed page, the most verbal of all media, has its visual aspects. Most of us quail at the sight of many pages of solid type without illustrations, diagrams, variations of type face or other visual messages.

How closely the various channels of communication are linked seems to vary from culture to culture. Some peoples do not seem to relate their visual forms to verbal ones. Elaborate visual forms are meaningful in themselves, or by virtue of their

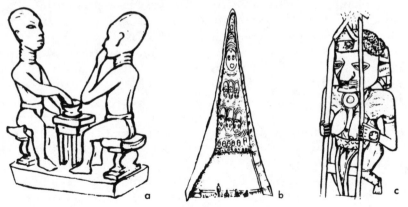

Figure 6.01. Visual forms with and without clear verbal associations. a. Ashanti carving illustrating the proverb "The food is for the man who owns it, not for the man who is hungry," referring to the powers of the chief. b. a Sepik River (Abelam) men's cult house painted in a way that Forge finds communicates consistent meaningful relationships which the Abelam do not verbalize. c. detail from a New Ireland malanggan, another visual form for which verbal iconography is not known. (a, after Cole and Ross; b, after Forge; c, MIA).

contexts, and are not seen as related to a mythology. Lewis and Billings both report frustration in trying to elicit verbalization concerning the meaning of malanggan figures in New Ireland, for example. Forge (1965) points out that among the Abelam of New Guinea the visual forms speak for themselves; the meanings are not expressed in words and there are no associated myths. On the other hand, it has been noted by several observers that all Ashanti visual art forms are closely tied to verbal ones. All have verbal referents and are named, and usually refer to stories and proverbs. Often visual forms, such as gold weights and the finials of spokesmen's staffs, are very clear and representational as to subject; they are illustrations of the proverbial sayings. Ambiguity only exists in that there may be several proverbs with different meanings concerning the subject.

Where the relationship is close, as here, verbal techniques of analysis provide very illuminating studies of the art forms; a componential analysis of Ashanti words about art (Warren and Andrews, 1977) is an important contribution to understanding the meaning of art in that society. It tells us a lot about what these people value in their art forms and so about their values in general.

A direct study of the meaning of visual forms is that of Munn (1973) reporting her fieldwork among the Walbiri of central Australia. The women of this group make drawings in the sand as on a blackboard, a running set of illustrations to accompany the story telling. The relations between the visual and verbal codes is apparently close, although they complement each other. Incidentally, this account is also very interesting in that it is one of the few studies of an ephemeral art form, drawing on the ground, that has probably long been a widespread and common form of human communication. Her studies show, furthermore, that a basic vocabulary of visual elements is used not only in the secular story illustration, but in body painting and sacred arts—a very meaningful "code."

When we consider visual arts as one channel of communication within the framework of an event (such as a ceremonial gathering) in which there are a number of channels, the meaning of the total situation may be basically clear, and we can see what aspects of the whole are communicated by the different channels. Furthermore, the total meaning provides us with a check on interpretations of the various codes.

One can consider the subjects, the symbols on the icono-
graphic level, and the form-qualities as separate codes, each
communicating a message in a given transaction. But to receive
the messages embodied in each code in a specific event, one
must at some level be aware of the way each code works, that is,
the coding system. It is in this sense that we can compare visual
communication to linguistic communication, comparing the
actual art works to utterances, to speech, and a cultural style to
a language. Both the sender and the receiver must be familiar
with the basic system, the "language" of each code. It seems
probable that, as suggested in Chapter 5, codes differ as to the
kind of message which they best convey, and the kind of
thinking that is done with them.

Visual communication differs from verbal communication,
not in being more a matter of feeling, or of the unconscious, but
in being more a matter of how things are related to each other
than how things can be distinguished from each other. In other
words, the verbal aspect of the mind is concerned with analysis,
the visual-kinesthetic aspect more with synthesis, with pat-
terns. Nothing is more distinctively human than language, and
dualisms are very significant in human thought. But the
tendency to either/or thinking involves a number of very
uncomfortable oppositions which call for resolution. Very
often it is by visual forms that people try to find solutions,
resolutions, to put the world together again, to find harmony
rather than conflict.

When we look at visual forms that already exist, and try to
figure out what is being said, when we seek to analyze the visual
using words, we often do so by making distinctions in terms of
binary oppositions or polar opposites. The structuralist form
of analysis is based on an opposition theory that comes out of
the effort to make distinctions, and so emphasizes the either/or
sorting process as the basic organizing principle of human
thought.

Fraser (1974) has put together a number of interpretations of
African art in terms of some basic dualisms; a kind of analysis
that can be very illuminating. However, because of the great
number of qualities that can be seen in any art form and
analyzed as oppositional, only a careful consideration of the
cultural context can give any assurance that the dimensions
selected are the significant ones to the makers. It is all too easy
to pounce on subjects or qualities that are significant to the
analyst.

Structuralist analysis fits the Fang case very well. Fernandez has so well documented many situations in which the Fang use symmetrically balanced social and symbolic forms and perceive them as solutions, that one is convinced of the meanings he gives us. This is not always the case. The problem is the enormous number of polar dimensions that the analytic mind can discover in any visual form.

Not all distinctions are dualistic, however. In talking about art, art historians and students of art have found it useful to distinguish the subject matter, iconography, and formal (abstract) qualities. When we consider how visual forms communicate, we can use such distinctions to set up categories which we can postulate may act as separate "codes" or at least as systems analogous to the phonetic, phonemic and other categories of language. Comparisons with verbal systems of communication and with the way languages are studied, provide a number of useful analogies. However, because of the differences between the visual and the verbal, these can only be of a general nature. The verbal-minded often translate what they see into words, then assume that what applies to the words applies to the visual form itself.

One analogy with verbal forms that we can use involves the use of the terms "etic" and "emic" which derive from linguistic analysis. All the sounds made by the human vocal apparatus and used in speech have been listed and recorded in the phonetic alphabet. Speakers of any one language use a set of these—a phon*etic* system. However, only certain sounds within that set are really meaningful; the rest are permissable variations of no significance. The meaningful set of sounds of a particular language is call the phon*emic* system. Similarily for visual forms, we can define terms that apply to all forms in one category wherever they are found, an "*etic*" system, so that we can make comparisons. We can also consider the set of forms used in a particular culture, and how these forms, and their meanings, are involved in the cultural, "*emic*" system. For example, bilateral symmetry is a form-quality that can be objectively defined and widely observed as part of an etic set of describable formal qualities. The way this quality fits into Fang culture is part of an emic system of meaningful forms.

A fascinating question with regard to meaning in the visual arts has to do with whether there are subjects and form-qualities that have similar universal meanings. If so, which

ones? Which ones have only very specific meanings, unique to each culture? In other words, to what extent, and in what way is art "a universal language"? For example, we find lions and tigers and jaguars and leopards as subjects frequently used in various art styles. Putting them together in a category called predatory felines, they seem to have a widespread meaning as power symbols. On the level of form-quality, overlapping forms may possibly be a universal metaphor for rank or dominance. Only by a continual comparison of emic meanings in terms of elements that have etic definitions can we learn some answers to these questions.

Categories of Meaning

In Chapter 1 the categories of meaning discussed below were briefly defined. For comparative, etic, purposes they could be considered as separate codes in order to explore the idea that in each category there are embedded some universal visual meanings, some of the "deep structure" of the human mind. By analytically separating them we can learn to perceive more of the meanings in what we see.

Subject or Content

The first category of meaning is the representational level, what is imitated or portrayed—the subject. Maquet defines this as what is recognizable; Panofsky calls this primary subject matter. In practice determining this is by no means simple when we consider the multiplicity of cultural conventions. Consider a scale of the degree of realism. At one end there are rather highly accurate replicas, like good waxworks, which are convincing to the point of a complete illusion of reality, as anyone who has spoken to a waxworks guard will, if not too embarrassed, testify. I have never heard of anyone so brash as to push cultural relativism to the point of claiming that a waxwork human figure would not be recognized as the image of a human being by anyone regardless of his cultural conditioning. So at this level of representation we have universal understanding. As the scale moves from this end, there is a great variety of conventionalizations and cultural interpretations of reality, and, of course, of what aspects of reality to represent. Many subjects are recognizable, and even look very obvious once we have learned to see them by having them pointed out, but seldom otherwise. At the far end of the scale it is hard to determine whether a named motif is considered repre-

sentational to the makers and users, or whether this is just a name attached for convenience because of some vague association, or because an outsider insisted on having a name. (See Boas, 1927). So the category of representational forms merges gradually into the abstract, arbitrarily symbolic, and vaguely analogous.

Figure 6.02. Navajo drypainting (sandpainting), "The House of Many Points." Some subjects—anthropomorphic figures, plants and a bird—are recognizable without knowledge of symbolism. (from Reichard).

The subjects in the Navajo drypaintings shown in Fig. 6.02 are five anthropomorphic figures, a bird, and four plant forms (tobacco, corn, bean and squash), the sun, the moon, some rainbows and lightning. The human figures, plants and the bird are easily recognizable, but the others must be labeled for

us. That the central circle "represents" a mountain seems utterly unrelated to any kind of realism; it is a purely symbolic mountain.

Traditional art forms in literate and especially industrial societies have lost so much of their importance as a means of conveying news, information, and instruction that it is hard for us to realize how important images are in pre-industrial and pre-literate societies to convey information; before photography and TV the visual travel reports such as those of Catlin and the bird paintings of Audubon served this purpose. The recreation of historic events in waxworks, painted stone, clay or wood is widespread. There is a photograph of a mud sculpture representing the execution of a criminal in Beier (1963) that is of just this nature. Visual forms that communicate largely by content, that is by what is represented and its iconographic meaning, are well exemplified by the bronze plaques that were a record of history in the palace of the kings of Benin. The forms were often analogous to a painting of the signing of the Declaration of Independence, even though the specific form of the social contracts of the society were not in the form of written documents, but largely in the visual forms of regalia and ceremony.

To the archeologist, the representational quality of images provides one of the most important sources of information about the lives of long-gone peoples, information that is often otherwise unavailable. The representations were also sources

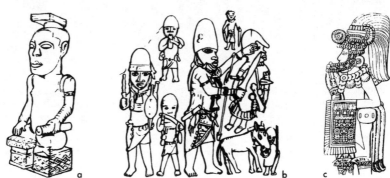

Figure 6.03 Historical records: a. Kuba king; statuettes are part of the record of successive reigns, kept also verbally with chonological accuracy. This is king Shyaam aMbul aNgoong. b.Benin bronze plaque recording a military victory. c. Mayan record of a messenger dressed in characteristic Valley of Mexico style, with Tlaloc shown on the textile over his arm. (a.BM; b, after Pitt-Rivers; c. Stela 31, Tikal)

of information in the times they were made, as records of
important events.

In addition to the informational meaning of images,
anthropolical interpretations of art forms in terms of content
are usually of two kinds: one is analysis of the art corpus from a
culture to find the category of forms favored—human or
animal, male or female, etc., on the assumption that this has
meaning in terms of some theory, such as Freudian psychology
or Structural analysis. There must be reasons for what is selected
from the environment to portray in art. The other approach is
to consider the ways in which the forms depart for exact
realism, as this may be significant in terms of understanding
how people view themselves and their world. This approach
also involves an analysis based on the analyzer's theory. It is
related to the interpretation of form-meaning. However, it is
sometimes overlooked that the visual reality in the artist's
world may be significantly different in many respects from that
of the analyst. To take a simple example, psychoanalytic inter-
pretation of drawings of the human figure maintains that
elongated figures indicate a concern for health beyond the
normal. To apply such an interpretation it is necessary to take
into consideration whether the drawing has been produced by a
Masai, one of the tall, thin, peoples of East Africa, or by an
Eskimo, who is likely to be short and stocky.

Icons

This category of meaning is a matter of the meaning of a
form that everybody sharing a culture knows, but an outsider
has to be told. Panofsky calls it conventional subject matter. An
icon is an arbitrary symbol in the sense that Morris (1946) uses
the term "symbol" in distinction to a "sign". At this level art is
in no way a universal language. One can only know the
meaning of an icon by being given its label in words by
someone who knows the iconographic system of which it is a
part. Among the persons who share this system, there will be
of course, differences in knowledge, both of the number of
icons that are included, and the myths in which they are incor-
porated, but by and large there is not likely to be anything very
mysterious or esoteric except where the group that shares the
symbolic system is itself apart and secret from the rest of the
society.

Some of the elaborate iconography of the Yoruba is described
by Bascom:

"For example, *Eshu* or Elegba, the divine messenger who carries sacrifices to Olorun, is fed through a natural piece of laterite. His worshippers use carved wood heads on pedestals or pairs of anthropomorphic figurines to which strings of cowries are attached, dance wands topped by a figure with a long topknot of hair which can be hooked over the shoulder, and wooden fans. Most Yoruba carvings are polychrome, but Eshu's are made of blackened wood.

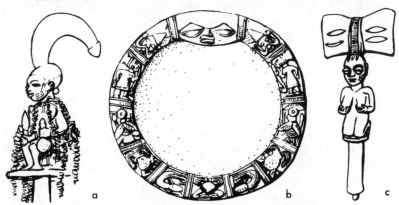

Figure 6.04. Yoruba iconography. a. Eshu, the messenger diety, the only diety represented in human form. b. tray used in Ifa divination. Ifa was give the power to speak for the gods by Olorum, the High God, the controller of destiny. The face on the tray is Eshu. c. dance staff representing a devotee of the cult of Shango, the thundergod. (a, after Wescott; b, MH; c, after Thompson).

"*Ifa*, the god of divination, is fed through the sixteen palm nuts which are manipulated in divination. They may be kept in a carved wooden bowl or in a smaller, more elaborate container of wood or brass. The diviner marks the *Ifa* figures in wood dust on a carved wooden tray with a bell carved in wood or ivory or cast in brass. His worshippers are distinguished by alternating tan and green beads.

"*Shango*, a god of thunder, is fed through prehistoric stone celts which he is believed to hurl from the sky. His initiates wear red and white beads, and *bata* drums are used for his dances. A gourd rattle, frequently decorated with incised designs or covered with leather, is shaken while prayers are offered to *Shango*. Initiates are shaved while seated on an inverted mortar decorated with relief carvings of his rattle, thunderstones, or a ram, which is his favorite sacrificial animal. His priests carry appliqué

shoulder bags, or wear appliqué panels which whirl out
from the waist when they dance. A carved dance wand
(*oshe Shango*) may be owned by any worshipper and is
held by a priest while dancing." (Bascom, 1973a: 88).

The iconographic system of a people is often expressed
rather completely in their mythology, but this iconography may
or may not be extensively represented in the visual art forms.
Sometimes very important personages are not so portrayed,
although others frequently are. Among the Yoruba gods only
Eshu is represented by an anthropomorphic image; among the
Navajo, Changing Woman rarely appears in drypaintings.
Visual art does not simply illustrate mythology; it comple-
ments it. It is also possible for the visual expression to
be more extensive or elaborate than the verbal ones. In any case,
at this level we have the dramatus personae of symbolic life and
all the more explicit forms of symbolism recognized by the
people.

Figure 6.05. Icons of mythological personages. a. the war god Ku,
Hawaii. b. the rain god Tlaloc, Valley of Mexico. c. Dewi Sri, goddess of
rice and harvests, Bali. (a, BM; b, NMM).

Of course, when we as outsiders learn the label of, for
example, a statuette of Eshu, the messenger of the gods who is
unpredictable in part because of his amorous adventures, or
learn that the anthropomorphic figures in the Navajo dry-
painting are the twins who slew the monster of evil, we have a
slightly greater knowledge about the forms. But when a person
brought up in the culture sees such a figure, he has associations
with all of the complex mythology with its embodied values
and feelings, even if he is not party to the deeper interpretations
of the elders and philosophers of his people.

Navajo iconography is very complex indeed, both in its verbal and its visual forms. A partial, simplified account of the Navajo drypainting "The House-of-Many-Points" by Miguelito gives a glimpse of this complexity:

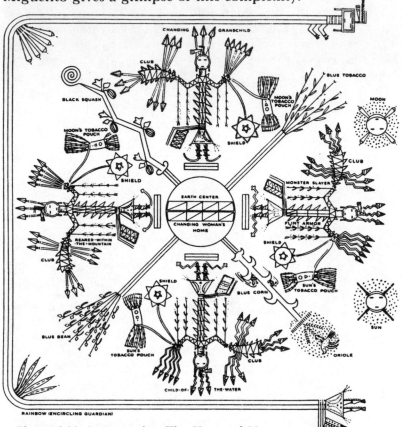

Figure 6.06. Iconography. The House of Many Points, Navajo. (from Reichard).

"The black center represents the center mountain of the mythological universe. The black-blue subdivision is the house of Changing Woman fortified by the powerful flint of her children, the twin War Gods. . . Changing Woman had charge of moisture and from her mountain home domesticated plants arise, all blue except the black squash. The corn has an oriole on its tip. . . The red object in the left hand of each figure represents a tobacco pouch elaborately embroidered in porcupine quills. The blue circle is the sun, the blue triangular object near it, his tobacco pipe with a bit of tobacco in black at the

mouthpiece, a white line indicating a smoke on the bowl. Monster Slayer, the black figure, and the blue Child-of-the-water carry the Sun's pouch. The yellow figure, Reared-within-the-mountain, and Changing Grandchild who is pink, carry the Moon's tobacco pouch. . . The Sun and the Moon are the eastern guardians. . . the Rainbow is the encircling guardian. . . " (Excerpted from Reichard, 1939).

Interpretation

It may seem difficult to draw a distinction between the iconographic level of symbolism and the interpretative level, but I think they can be operationally distinguished. If, given the name of an icon, one asks what it means or symbolizes, one often gets a great variety of answers, which is not the case at the iconographic level.

In the interpretative category I include both emic and etic interpretations of meaning. Any Freudian will tell you what the image of a snake symbolizes, whether or not he knows anything about the iconographic systems of the society that produced the image. Furthermore, within the culture itself, there are likely to be a variety of answers. This is, of course, particularly true of plural, changing, complex societies, but even in the simplest societies interpretation of the symbolic meaning of icons will vary. What the children know, what the women know, what new initiates know, and what the old men know are usually different kinds of symbolic interpretation. Very probably there are in all societies skeptics and devotees, mystics and philosophers. There are those for whom the images *are* deities, those for whom the images are symbols of deities, and those for whom the dieties themselves are symbols of the Great Truths. When Griaule sought to find the meaning of Dogon art, only a small group of elders knew the "true" symbolism.

One aspect of this category is "iconology," the term used by art historians for the broader, deeper "intrinsic" meanings that lie behind the art forms and are shared by members of a society. This is closely related to the concept of world view, as discussed under "Art as a Symbol of Society" above. However, such deeper, broader meanings may be variously conceived by persons within the society even if in general they share a common cosmology and world view.

An interesting aspect of age-graded societies is the correspondence between the levels of meaning and of symbolic forms and the age grades. With movement through the grades, the meanings become deeper and more abstract, in a way that cor-

responds to the developmental sequence of the life cycle. (Tuzin, 1980; Glaze, 1981). In many cases, however, only some elders of a philosophical, mystical bent reach the highest grade and the deepest meanings. Even in societies without formal age grades, differences in the level of understanding are usual— Santa Claus is a literal belief to a little child, a symbol of unselfish love to elders. Some persons, of course, never abandon their literal interpretations for abstract spiritual ones, but this is less likely to happen in systems set up to ritually reveal, step by step, deeper meanings behind the symbols.

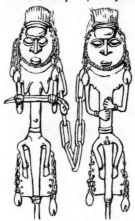

The Yoruba have a secret society of highly ranked elders who share a concern for the unity of life at a profound level. the society acts as a kind of high court, and seeks to resolve conflicts.

"The sacred emblems of the society, the *edan*, are placed on those spots where the relationships among men have been broken and blood spilled. Expressing the unity of male and female, they possess the power of reconciling and adjudicating differences among persons and atoning for the violation of the earth." (Pemberton 1982; 186).

Figure 6.07. Yoruba bronze *edan*. (after Fagg, Pemberton, Holcombe).

Individual differences are found in all societies. Interpretation depends on a number of factors: place in the life cycle, indoctrination (cultural and sub-cultural), and personality.

"Among the Navajos there are a number of men and women who take a special interest in why things are the way they are, and why people behave the way they do. Such people often develop extensive and complex theories and philosophies to explain the events and things they question. Such theories are not only not shared with or known by the general population but usually differ somewhat significantly from each other. The people are the Navajo Aristotles, Freuds, Webers and Darwins. Just as is true for such people as Jung and Freud, Weber and Marx, Plato and Aristotle, the theories of the Navajo intellectuals, however different on the surface, are all found to be based on similar assumptions about the nature and operation of reality." (Witherspoon 1977: 8).

One might call this the level of theoretical symbolism, the meaning as interpreted in accordance with some theoretical formulation as to the nature of things. Thus the meaning of symbolic forms can be given by the philosophers among the Dogon according to their system, or by the Doctors of Philosophy in some university according to theirs. According to the Christian philosophy of those Europeans who first came in contact with African or Oceanic art, these were works of the devil, symbols of evil. Thus it would be proper, when talking about what an art object symbolizes at this level, to always include the theoretical framework of the interpretation, i.e., "According to Dogon theologists. . . " or "According to the Oxford school of social anthropology. . . "

For example, the symbolic meaning of the Yoruba deity Eshu has been analyzed by several scholars. A psychoanalytic interpretation has been done by Wescott (1962) who interprets Eshu iconography in terms of sexuality. Indeed, many of Eshu's cult objects are rather explicitly sexual, and the stories about him in the mythological abound in sexual episodes. Wescott finds sexual symbolism not only in these explicit facts, but in many other visual features, such as the long top-knot of hair. In this frame of reference the "real" function and meaning of this symbolic form, with all its artistic manifestations, has to do with some kind of conflicts in Yoruba cultural-psychological patterning concerning sexuality—possible anxiety concerning male potency.

In a Western philosophical frame of reference, Eshu "really" symbolizes the indeterminancy principle, for Eshu is the messenger, and he often fouls things up, and this explains why the best laid plans of good people who obey the social and ritual requirements do not go as they should, and life is so chancy. That Eshu has much to do with sex is simply because sexual urges are often a factor in throwing an orderly pattern of life into disarray. In the stories about Eshu, it is often such urges that lead him aside from his task. In Structuralist analysis, he is the opposite of Ifa, the God of Fate and prediction. I do not know what the "real" symbolism of Eshu is for the inner priesthood of his worshipers.

The religious symbolic system of a people, as it is known at this level by the specialists or adepts, the elders, is a life-long study. The iconography and symbolism of the Navajo, for example, has been studied by a number of outsiders and is recorded in some very large books that are by no means

complete. Any effort to master such systems, especially in a time measured in years rather than decades, inevitably means that one must organize and simplify, and make explicit what is felt or implicit. This means forcing the system into one's own frame of reference, one's own kind of ordering, which is why one so seldom reads works on symbolism that are very convincing unless the writer has spent considerable time in the field and thereby adjusted his viewpoint or focus reasonably closely to that of the symbol users. And unless the visual symbols are part of the description, these deeper meanings can only be approximated. Sometimes, however, words and visual forms together do give one a sense of what is so deeply felt by people of an alien culture.

Philosophers and scholars tend to be either "lumpers" or "splitters" and there seems to be an alternation of interpretations as one corrects the other. This is very evident in the interpretation of symbolic forms. After a period when the "New Ethnology" and Existentialist philosophy made the most of the uniqueness of culture and experiences, there has come a renewed interest in what used to be called "the psychic unity of mankind." The Jungians Campbell and Eliade have emphasized universal themes and archetypes in mythology and religion, respectively. These are impressive and fascinating works. However, interpreters tend to get carried away by their vision and see meanings for which there is no evidence. For example, there is absolutely no information to allow us to infer that an octopus painting on a pot from ancient Crete can be interpreted in the same way as an octopus under a lotus in a Buddhist work from Japan (Campbell 1974: 228-230). From a scholarly, scientific point of view, such formulations provide hypotheses for investigation; from a humanistic point of view, they enlarge our understanding and are an inspiring corrective to the narrowness of some religions, but it should be remembered they are only theoretical interpretations.

The problem with many theories of universal meaning is that interpretation is made in too specific a form. There are a great variety of symbolic meanings given to a circle, but when one seeks to generalize from them, to find a higher level of abstraction, the idea of wholeness, of an entity, emerges. Similarly, when we seek to compare the symbolism of ceremonial events in different cultural contexts, a very general, very basic message may be found in all, although the specific symbols are very different indeed.

On one level of interpretation, varieties of symbolic expression that are fantastically diverse seem to have universal significance. This comes out particularly clearly in the case of elaborate funeral and commemorative rites for the dead (e.g., the brilliant funeral displays on the Sepik River or in Bali). In New Ireland the memorial malaggan is combined with the initiation of the boys; the Cubeo finish their memorial rites with sexual license; the Kwakiutl chief raises a pole to his deceased predecessor and proclaims his own importance, and commemoration of the Ashanti ancestors includes dancing in the streets; the Balinese burn intricate offerings. In all of these there seems to be not only the somewhat neutral statement that life must go on, but a positive affirmation in the triumph of life over death, or more accurately, a celebration of life in the face of the inevitability of death.

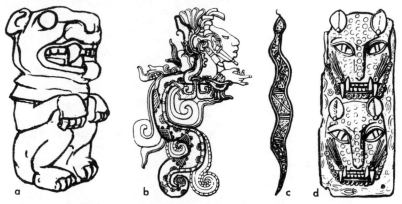

Figure 6.08. Widely used symbols: the powerful feline and the ambiguous serpent. a. Mayan stone jaguar; b. Mayan stone relief; c. Australian bark painting; d. Benin bronze leopards. (a, SCMM; b, site of Yaxchilan; d, FM).

Some symbols may have a universal, basic, meaning; others are more culture specific. The big cats seem to be used universally as power symbols, but, on the other hand, the serpent has a variety of interpretations; in Freudian symbolism, a phallic symbol; in Biblical, a symbol of evil, in some parts of the Congo, a symbol of death. To some people in Arnhemland the Great Python was important in the creation of the land, and controls the wealth, to others the Rainbow serpent is one form of the Fertility Mother; the Navajo equate snakes with lightning and arrows because of the way they move; in Western tradition the snake is a symbol of healing, and sometimes of

Christ and sometimes of the Devil. In West Africa a snake can
be a power symbol much like a leopard. These various
meanings—and shades of meaning—are probably overlapping
in many symbolic systems, and a potent form for expressing
ambiguity—and mystery.

When one looks at the content of the art works such as the
Navajo drypaintings, it is revealing to see the way the univer-
sals, such as male and female, birth and death, sex and food, are
treated. It is also instructive to note which of these universal
concerns is omitted. This has to do with the purposes and the
functions of the "code". For example, sex and death do not
appear in Navajo drypaintings. If one were to make psy-
chological interpretations on the basis of the paintings
alone, one might conclude that the people were very sexually
repressed, and unconcerned about death, which is not the case.
The arts may reflect human preoccupations, but not all of them
at one time.

Metaphors

Metaphors are a matter of seeing one thing as resembling
another in some way; an analogy. Metaphors are so common in
everyday speech that we do not notice them: "What color is it,
plum or peach?" The idea of bigness seems to be a common
metaphor for important or powerful, so in visual forms the
king is shown bigger than the people who surround him. The
metaphors suggested by the formal qualities of visual art are
not always obvious, and the possibilities in these qualities are
intriguing.

By the formal qualities of a work, as distinguished from
content, is meant the style in the narrow sense. This is the non-
representational understructure that includes the spatial
arrangement of the elements used, the kind and degree of
symmetry, the colors used, the nature of lines, etc., in short the
way the purely artistic problems are solved. The term "form-
quality" applies to a minimum unit of this aspect of style.

In both iconography and interpretation a form-quality may
be included and given a rather specific meaning. For example,
a circle, which, as a metaphor, is said to give a general feeling of
wholeness, in Jungian symbolism is regarded as an icon of the
whole self. In many iconographies, a circle is the symbol of the
sun. For the Dakota, the circle is *the* synthesizing symbol. In
ancient Mexico, two circles could represent Tlaloc, the Rain
God.

The distinction between symbol as icon and metaphor is often useful in reconciling differences of interpretation. For example, William Fagg has interpreted the representation or use of horns in African and other sculpture as an expression of growth embodied in curves of constantly increasing radius. Willett points out that horns have a variety of other meanings in various contexts. It is perfectly possible that form-meaning—metaphor—is implicit whereas the iconic meaning is more explicit. Indeed, they may even sometimes be different, thus providing ambiguity. Straight horns could be iconographically similar to curved ones, but metaphorically different.

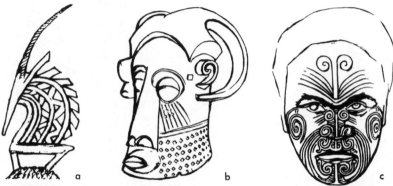

Figure 6.09. Metaphors and symbols, curves of growth. a. the Bambara antelope is danced for success with crops, and so may be a symbol of growth. b. Kuba mask; the horns are ambiguous. c. Maori tattooing; spirals are characteristic of Maori art, but are not given explicit meaning. (b, PC; c, after Ebin).

There is a good deal of evidence as to the physiological similarities of the human organism with regard to the perception of form-qualities. How much similarity exists as to the nature of the meaning, the "form-meaning" that different peoples assign to these qualities, is a matter on which we have but little information. Many basic similarities on interpretation of specific form-qualities may be obscured by variations in which ones people consider most important, and by secondary or derived interpretations.

As representational forms merge into non-representational forms by degrees, so units of non-representational form, simple figures such as circles and triangles, that may have iconographic meaning, are not easily distinguished from the qualities of form; "form-qualities" that are part of any visual

art. In interpretation, the symbolism of various simple figures, as interpreted by various theorists, is closely related to the interpretation of various form-qualities that I call metaphors rather than icons. The nature of meaning of such form-qualities is also a matter of different systems of interpretation. The best known and most clearly formulated of such systems is that of depth psychology as incorporated in such projective tests as Rorschach, Machover and Luscher. But there are some explicit statements in the works of students of art.

Figure 6.10. Reaching for Heaven. The use of towers and pyramids is widespread in sacred structure—the upward thrust is said to communicate aspiration. a. Bali; b. Sepik region; c. Maya.

That there may be interpretations of form-meaning, as distinct from specific inconographic or symbolic meaning, in other cultural systems seems implicit in some of the studies of qualities that are esthetically valued in various cultures. Information on this is gradually appearing in various field studies. For example, in Fernandez's work on Fang esthetics, we find the following:

> "There should be balance in the figure, and the proportions of opposite members whether legs or arms or eyes or breasts should display that. Without this balance of opposite members, it is said—and this is the important comment—the figure would not be a real one. . . it would have no life or vitality within it. . . I must confess that those features that seemed to have what *we* would call movement or vitality were not those selected by my informants. They generally picked those whose presentation and posture were stolid, formal, even—and perhaps this is the best word—suppressed.
>
> "This whole idea that vitality is obtained through the balance of opposite members in the statue was a clue of

some importance in my understanding of Fang culture."
(Fernandez 1966: 362-3).

It is notable that *visual* forms are used to reconcile the oppositions by combining them into a unified entity.

If the elements of visual communication are much the same for all human beings, why is art not a universal language? The answer to this is that the possible combinations are so complex, and, apparently, the human mind has to select less than all the possible number of elements to combine into systems that are manageable.

Selection and combination of form-qualities constitutes an emic system, and, in the narrow sense of the word, make up the style of a work. The example which best clarifies the nature of this process is the use by a painter of a set of hues selected from the enormous variety available in the modern world; this is known as a palette. Similarily when an artist consistently favors heavy bold outlines, or rectangular forms, or highly polished surfaces, he is making choices that are selected out of the total ranges of possibilities, and the selections of particular styles make up the set of forms of that style. A definite style is as much a matter of what is left out as what is included. Character-istic ways of relating elements to each other are basic to each stylistic system.

The meanings of form-qualities have usually been inter-preted with regard to their import in particular works, but an examination of many such interpretations shows that *color* is often considered to be the carrier of emotion, and *line* of analysis, cognition and control. The *spatial relationships* are seen as related to social relationships—the individual with his environment, the organization of social life, and the relations of humans to the world of supernaturals. The composition, or organization of the whole, by combining and harmonizing all these elements, "solves the problem" of whatever confusion or conflict of discordant forms are felt to be significant. Each style, by selection of form-qualities, and their combinations, achieves vitality by expressing sources of tension and possible resolution. The system of formal qualities in an art style, if all this is so, should reflect or communicate the ethos or feeling-tone of a culture, and the world view of the people and even the characteristic problems and their solutions. Form-meanings are rarely verbalized, and much of their virtue may well lie in the expression of relationships that are not easily verbalized.

In *Visual Metaphors* I have defined form-qualities of two-dimensional works, and collected a number of interpretations—(form-meanings) that have been attributed to these qualities—the metaphorical senses in which they have been used. Witherspoon (1977) finds my analysis of Navajo drypainting using such interpretations to be consistent with his interpretation of Navajo culture based on extensive field experience and his analysis of the language. These interpretations, applied specifically to the form-qualities of the painting "The House-of-Many-Points" illustrated above, can be summarized in the following analysis:

In the painting (as distinct from the drawing made from it) the center is solid black and dominates the whole. There is no ambiguity of figure and ground. The full but not crowded layout indicates vitality. The spacing of the figures without touching or overlapping may be related to the Navajo respect for individual autonomy; that they are the same size suggests egalitarian values. The careful attention to small details is said to relate to overcoming anxiety. The symmetry and repetition have been suggested as related to the emphasis on unanimity and community harmony. The great emphasis on line suggests emphasis on intellect and on control. The precision and delicacy of lines suggests strength through knowledge rather than force; the predominance of straight lines over curved lines suggests strength, and the points are considered aggressive. The encircling lines suggest control. The motion is conveyed outward from the center, and is also somewhat circular, but movement is harmonious, controlled but never opposed; the motion is ordered, not turbulent, suggesting tension and vitality but no conflict.

Ambiguity

When the primary purpose of a visual form is to communicate information on the cognitive level, the esthetic aspect is reduced largely to making the production neat and well laid out so that it will be clear. Ambiguity is to be avoided; clarity is of the essence. Many forms that have a high esthetic component, however, tend to be ambiguous, unclear or contradictory in one way or another. Peckham considers this the essence of art, on which its primary functions depend. He says:

"Art, as an adaptive mechanism, is reinforcement of the ability to be aware of the disparity between behavioral

pattern and the demands consequent upon the interaction with the environment. Art is a rehearsal for those real situations in which it is vital for our survival to endure congnitive tension, to refuse the comforts of validation by affective congruence when such validation is inappropriate because vital interests are at stake; art is the reinforcement of the capacity to endure disorientation so that a real and significant problem may emerge. Art is the exposure to the tensions and problems of a false world so that man may endure exposing himself to the tensions and problems of the real world." (Peckham 1965: 314).

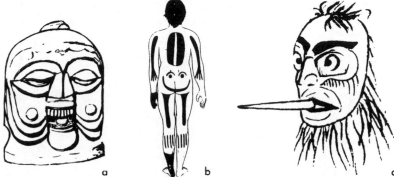

a b c

Figure 6.11. Ambiguity, humorous and satirical. a. Yoruba satirical mask. Much of the ambiguity here is on the esthetic level; the mask breaks some of the Yoruba canons (see chapter 8) but follows others so that it is both ugly and handsome. b. boy, painted for frog dance, Kwakiutl. Imagine the ambiguous effect when the boy is jumping about in a squatting position with his head down! c. Mosquito mask, Kwakiutl; for a human size dancing "mosquito." (a, after Thompson; b, from Boas; c, after Hawthorn).

This all-out approach is at variance with most interpretations which say that the tensions and problems should be balanced and resolved in works of art. It certainly excludes from the domain of art all that is classical and serene, and many traditional arts of the folk that tend to minimize ambiguity. Ambiguity is found in many art forms in one manner or another, and the study of the types of ambiguity that are or are not permitted in art tradition might yield insightful clues to cultural viewpoints. When things are strange, they capture attention, and so are important in long and sometimes boring ceremonies. Sometimes they can grip one with a sense of mystery and even terror; sometimes they relieve the monotony or solemnity by making everybody laugh. A kind of ambiguity that makes people laugh is incongruity. Many art forms deliberately use incongruity to be humorous or satirical.

Furthermore, there can be little puzzles and mysteries that are fun to solve, double meanings that are fun to discover. Thus many visual puns, incongruities, and exaggerations found in art forms are life-enhancing without in the least being scary or solemn, or related to serious tensions. Ambiguity is not always a matter of great art or great truths.

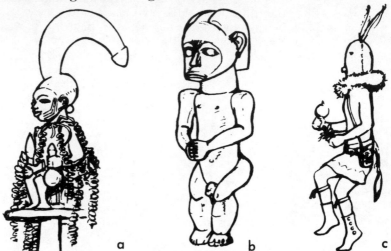

Figure 6.12. Ambiguity, sacred and symbolic. a. Yoruba; carving of Eshu. b. Fang ancestor figure. c. Navajo Yei-be-chai dancer. (a, after Wescott; b, MPA).

But ambiguity is important where deep basic human meanings are to be communicated. If for no other reason, people must make mysteries because the great truths, baldly stated, are always so banal and obvious. The inner sense of their significance does not come easily, and it is not easily transmitted.

"... for those not instructed in reading meanings into forms, there is always a certain vagueness, nebulosity and ambiguity involved in these Lega artworks. Indeed it may be deliberately so intended, for many of these works are destined for use in the esoteric contexts of cults, initiations and so on. The objects must be mysterious for the non-initiates, and they must retain something of their transcendent mystery even for the initiates." (Biebuyck 1969a: 12).

Ambiguity increases the variety of interpretations of the symbolic II level. Perhaps the more kinds of interpretation possible, the more profound the sense of mystery evident in

religious art. This mystery and ambiguity calls for solution, achieved in art by solving the "artistic problem."

An example of ambiguity of image is found in many African figurines that combine infantile proportions of the body with mature features such as beards. Iconographically they are often ancestor figures. Fernandez discusses the meaning of this in Fang culture:

> "If one looks closely at these statues, one finds that the great majority of them have infantile or childlike features. The obvious feature is the protruding stomach and umbilical rupture which figure so largely in many statues. The umbilical rupture is primarily characteristic of infants and children, less characteristic of the strengthend stomach walls of adults. . . Finally, the porportions of the statue—the large torso, the big head, and the flexed, disproportionately small legs are definitely infantile in character. Now the opposition contained here lies in the fact that the statue presents both an infantile and ancestral aspect. While the Fang argue that the statues represent age, the ancestors, and their august powers in their descendants' affairs, they also recognize the infantile qualities of the figures themselves.
>
> "There are, of course, cosmological and theological explanations for this juxtaposition of contradictory qualities in the statues. Among them is the fact that the newborn are felt to be especially close to the ancestors and are only gradually weaned away by ritual and time to human status. Another explanation for the infantile quality lies in the primary concern of the ancestral cult in fertility and increase. . . More important than that, I would argue however, is the fact that these contradictory qualities in the ancestor figure give it a vitality for the Fang that it would not possess if the *eyima* simply figures an aged person or an infant." (Fernandez 1966: 365-6).

There is ambiguity in the figures of Eshu. The phallic form is usually less explicit than in this illustration, and appears to be a hair style. There is, of course, ambiguity in its position. Furthermore, the cowrie shells with which the figures are usually hung were a form of money, but also, because of their shape, they are widely considered symbols of female sexuality. Ambiguity with regard to sexual themes is widespread, and may not only be due to taboo, but to the fact that "maybe's" are often more erotically stimulating than direct statements.

One of the most potent of ambiguities lies in the interplay of symbols of "structure" and participation in "communitas" in

the larger artistic whole of festive-ceremonial occasions, as in the example of the Kwakiutl, or of the king of the Ashanti, adorned and surrouned by symbols of power, dancing with his people to the beat of the drums.

Often the mystery resides in an ambiguity not visually expressed in a single work, but known through the iconography. An apparently simple portrayal of a snake in an Arnhemland painting may be an icon of the Fertility Mother in her Rainbow-Snake form, whereas in other paintings she is shown as a human being.

Psychoanalytic works interpret ambiguity as having to do with the disguise of taboo subjects. More recently the anthropological study of symbolism has centered on a cognitive approach related to the study of ethnoscience, the way people classify the phenomena of the natural world; for example, things that swim, things that fly, things that run on the earth. All peoples classify, and their classification both reflects and forms their view of the natural order of things. As Mary Douglas has pointed out, things that do not fit into the classes of the natural order are weird, like bats. Such things may be taboo, may be sources of supernatural power, they are mixed and impure: sources of danger. This is, of course, closely related to what is known about psychological arousal; we are alert and nervous about things we cannot fit into what is expected, natural, understood. What does not fall into place is a potential source of danger, and is perhaps dangerously powerful.

Most of the work of this kind has centered on the iconography, but can be applied to ambiguity at any level. We are offered explanations on the emotional, perceptual and cognitive levels as to why ambiguity not only conveys a sense of mystery but incites the kind of arousal that suggest significance.

Sometimes ambiguity is a matter of actual contradiction. This is the kind of thing Devereux is talking about when he says one of the functions of art is to sneak in taboo ideas, Peckham can call chaos, and that Kavolis can call a search for new solutions. One of the codes of meaning can carry traditional forms so that the work can be defined as art, while another can run counter to the values implicit in the traditional code.

Restricted Codes and Multiple Codes

Visual productions can communicate in a variety of ways, on a number of levels or codes. A work of art must have esthetic quality to some degree, and form, with the metaphoric meanings that form conveys, but it may or may not embody any of the other codes. Some art forms have relatively little to "say"—they are in communication terms "restricted codes." This is not to say that they may not have high esthetic quality, nor that they may not strike the viewer as significant form, but that they do not have representations, iconographic labels, or deep symbolism. Craft works are in these terms abstract works of art. Navajo weaving, except for some attempts at putting religious subjects into this form, is an abstract art, admired for craftsmanship and esthetic effect, but devoid of other than form-meanings. Navajo drypaintings, on the other hand, communicate on all levels. Religious art frequently has multiple codes. The more the levels, the more possibilities for ambiguity, for mystery, and for depth.

Figure 6.13. Symbolism of geometric forms. a. interlocked or interwoven motifs are common in Kuba art forms and are given various names but no symbolic meaning. b. Navajo silver "naja"; neither the shape nor the arrows have significance. c. Bali; this icon symbolizes the cardinal points, each with its guardian diety and associated color, and their ruler at the center; the whole symbolizes the orderly universe, the cosmos. (a, BM; c, after Ramseyer).

Looking at an object sitting isolated in a museum, one cannot tell how much meaning was felt by the people who viewed it in its original setting. Some of the works that we tend to think of as crafts that are made to be used, perhaps with abstract "purely decorative" design, may have had several levels of meaning of deep significance. Textiles, especially when they are worn rather than hung on a wall, are often considered in our culture as just crafts, without the power of communicating anything much beyond the sex and wealth of

the wearer. In West Africa, and in most pre-industrial civiliza-
tions, textiles have, or had, great significance, and elaborate
iconographic meanings. In other cases, the reverse is true, and
we keep inquiring about symbols until (especially if we are
potential purchasers) someone invents a name and a meaning
to keep us happy. Simple figures like crosses, circles and
crescents, may be differently weighted in significance in
different settings within a culture. A form that has rich
significance in one situation, such as a Navajo drypainting,
may be just a design in another setting, as on a Navajo bracelet
made for sale.

The categories of meaning that I am using here are meant as
a way of calling attention to the nature of meaning as it applies
to the visual arts. But if meaning has all this richness, embodies
all these levels, it must form fairly complex systems within
cultural contexts. To examine how these systems work in
detail, we must explore the ways they work in toto.

Art as Feedback

Society is "held together" by patterns of interaction among
its members, making up the social structure. When it all works
well, it has what Geertz has called "causal-functional integra-
tion." A culture, too, may be more or less integrated, but the
relationships within it are of a different kind; "logico-esthetic
integration." Individuals also have patterns of more or less
consistent motivations; psychological or "personality inte-
gration"—having it together. Some peoples seem to have
social, cultural and psychological patterns that are congruent,
that all go together in a unified *configuration*. What is meant
by congruent is basically that one aspect can be translated into
another. It seems congruent that one bows to a person of higher
status, that one classifies a number of items in hierarchial
order, that art forms show elements piled up on top of one
another, that one is comfortable knowing one's place. It is the
nature of relationships that are basic, relationships that are
built up into social, mental and motivational patterns. In cases
of disruption and change, the social, symbolic and psycho-
logical patterns of relationships often no longer seem
congruent.

Although they do not always use the terminology, form-
ulations that put together the social, psychological and
symbolic forms in terms of how they function through time,

often use the basic concepts of systems theory, and thus explain the process by which the congruent configurations are achieved. Implicit in such theories is the idea that art "works" by communicating.

Kavolis in his study of the question as to why certain periods in history seem to have been more productive in terms of art, says:

> "Art may be conceived as one of the symbolic factors which promote the integration of social experience and cultural symbols with private emotion. When a state of relative equilibrium in the social system is disturbed, private emotions tend to become disconnected from social conditions. . . and cultural symbols, and art is more needed as a means of again bringing social conditions, cultural traditions, and individual emotions into a 'meaningful' relationship with each other." (Kavolis 1972: 138).

If art has this kind of relation to the psychological and social systems, then it can act to establish or re-establish equilibrium. Communication is a kind of feedback.

In systems terminology, art in promoting integration is acting as a deviation-counteracting mechanism with respect to that aspect of the system having to do with the congruence of three aspects of human existance—the "individual emotions" or psychological aspect, the social conditions, and the cultural or symbolic aspect. In so doing, what is changed can be any of the three. Many students of art in the Western tradition emphasize the importance of art in promoting social change, and even consider this to be its principle social function, and so decry any form that seem to express the traditional. (These are often the same persons who disapprove of change in "primitive" art.) But if the three sub-systems are to be brought into working alignment, the function can just as well be the effect on an individual whose patterns are out of adjustment with the socio-cultural whole.

We do not need to consider the functions of art different in time of relative equilibrium, when the three systems are workably congruent, from the times of change that Kavolis says call for artistic innovation. In the context of an upset in the integration of an individual, the art forms of ritual can function to achieve a psychological equilibrium within the context of a condition of relative social and cultural integration. Many descriptions of folk psychotherapy could be described as artistic performances to achieve equilibrium, but

the effect is primarily that of reintegrating the individual into the society rather than changing the society. The visual art aspects of such a ritual can be creatively put toward this end, as in the example of a Navajo drypainting in the context of the healing ceremony.

If the social and psychological patterns are congruent and satisfactory, innovative symbolic patterns and relationships will not be acceptable, and new art forms will not emerge; the artist will receive social support only if his patterns are within the traditional norms—that is, his feedback will be negative for the new and strange.

In other words, if an individual's patterns of motivations, of behavior, are not consistent with those perceived as proper by others, traditional symbolic forms, religious, ritual, artistic, verbal, may be invoked in various ways to communicate to him ways to bring his psychological patterns into alignment with those around him.

In such a case, there can be much creativity in recombination (this has been called involution), and in imparting freshness. But there will not be major innovations, no paradigmatic shifts. The system may be a slowly moving equilibrium.

If the patterning of social relationships is perceived as frustrating, artists will seek new solutions—propose new patterns. For example, if a state of balanced bilateral opposition is not working very well, a dominant third element may be seen as a solution, and this may increase acceptance of social forms with this new pattern. Thus the visual form, by analogy, offers a new idea which can be applicable to social forms. In some periods innovations are rejected by audiences, while in other times and in other contexts, novelty is valued. In Bali, new dances may come and go as fads, and older forms persist or reimerge. Probably the periods of great innovation depend more on social acceptance than on the number of geniuses born. Accpetance of innovation, of new solutions, depends on the felt need for new relationships.

Sometimes the solutions of a system are so successful that the total situation is changed with the regard to the environment of the system, and the elaboration of traditional forms makes for increasing problems—a "deviation amplification system" such as that described as an explanation of what happened to the Maya (Culbert 1974). In this case the lack of a new definition of the situation can be disasterous.

Summary

People seek to find answers to their problems and to get ahead in accordance with their ideas of what the world is like (definition of reality, existential postulates) and how people ought to behave (values, normative postulates). Even though there is much variation in individual thoughts and actions there is in a society enough agreement as to the way life is patterned to allow for both prediction and manipulation. In times when this doesn't seem to work, people experiment with new solutions. It is at times like this that social movements arise based on definite statements as to the basic problem and its solution. If the proposed way of looking at things is different and fundemental enough, it will change people's perceptions of the way the world works and how people should behave; a new paradigm. Artists and students of art in our culture tend to give art an important place in changing old patterns. Historically paradigmatic shifts seem to have more often been religious in nature, with art forms functioning to communicate and so help create the new vision. Conceiving a social system, or an event such as a malanggan gathering, as a system with an almost infinite number of communications continuously going on, we can always find similarities of relationships in various forms which we can perceive as patterns. These patterns, embodied in a variety of codes, are continuously giving information to the participants concerning the appropriateness of their actions and words, the feedback reinforcing in many ways the old and in some ways the new simultaneously and continually.

But if part of the function of art is to not be obviously serious, if many of the codes—words, music and visible forms—are to act as trial balloons, then as communication much that is produced is probably hot air, and just adds to the atmosphere. Over-interpretations miss the implications of the idea that art can function better in some ways if it is not taken too seriously!

Considering art as communication means looking at art as a dynamic, ongoing process, a creative process which is part of human living. As Schieffelin says:

"Symbols do not just 'stand for' something else. They constantly and actively 'bring things into meaning.' This happens because symbolic activity brings objects and concepts into new and different kinds of relationships in a

larger system of meaning, formulating and organizing
them in new ways according to a few simple procedures.
This 'rendering into meaning' is the symbolic process by
which human consciousness continually works reality
into intelligible forms.'' (Schieffelin 1976: 2).

When we consider the past, we often have art forms surviving
from the turbulence of past events, and ask ourselves what part
they played in their original contexts, and what they can tell us
concerning the nature of socio-cultural changes.

Further Reading

Arnheim 1971; Bateson 1967; Dondis 1973; Douglas 1975;
Fraser 1974; Forge 1965, 1973; Hatcher 1974; Munn 1973a,
1973b; Turner 1967; Tuzin 1980; Wass and Eicher 1980.

Chapter 7

When and Whence? The Time Dimension

In the previous chapters we have considered various factors that affect art, that affect style, and, of course, each of these is related to the way styles change. Environmental changes alter the problems of living, the visual surroundings, and the available materials. Changes in technology, from whatever source, mean new tools, new materials, new processes. The effects of particular personalities, geniuses, may be debated, but it seems clear that all kinds of change may make for psychological stresses that often result in new symbolic and artistic solutions. Social change can be considered evolutionary as new levels of socio-cultural complexity emerge, and historical as changes in society come about through contacts between different peoples. Any of these types of change may be related to changes in symbolic systems, with different icons or with new meanings for old icons and in the structures of verbal, visual and musical communication systems.

All the approaches and theories in anthropology concerning the nature and causes of cultural change and cultural persistence are applicable to the study of change and tradition in art styles. There are three basic approaches to changes through time, which to some extent derive their difference in viewpoint from their differences in the time scale considered: 1) The evolutionary approach involves a concern with long term trends and with the regularities or laws of change; 2) The historical approach involves primarily an investigation into the changes that have occured at a particular time (or at least within centuries rather than millenia); and 3) the acculturation approach, concerned with what can be observed among living peoples, with the main focus on the effect of complex, industrial societies on more traditional ones. Simplistically put, the evolutionist emphasizes the similarities in cultural dynamics, and the historicist stresses what is unique, but of course they both seek specific facts and broad regularities. In method, the evolutionist deduces change from the evidence of

societies of the past and present at various levels of complexity, while the historicist seeks to build up laws of culture process from information on what happened in particular instances. Either can be speulative or rigorous. Observed current change can be fitted into either approach and any of the various explanations.

For examples, while the evolutionary approach would tend to compare the stages of development of complexity in Mesoamerican, Andean, and other civilizations, the historical approach would put the matter in terms of the histories of the Maya, the Aztecs, their influences on each other, and also possible influences from and to the various cultures of the Andean region. The historically minded tend to put emphasis on diffusion, the developmentally minded tend to consider the source of innovation relatively unimportant. When looking at the contemporary situation, art historians, who are interested in people to better understand art, tend to emphasize diffusion, while anthropologists, who regard art as a help in understanding people, tend to look at the matter more functionally. In other words, the art historian is more interested in what was adopted into a society, and where it came from, while the anthropologist is more interested in why (or why not) people selected certain innovations. Such differences in viewpoint are by no means mutually exclusive; they depend on and enrich each other.

Evolutionary Change

The nature of evolutionary change in the arts has tended to be a puzzle since the concept of evolution became important in anthropological thinking. First efforts at applying this idea were speculation on the origins of art and on universal stages in style. Some saw art emerging from the regularities and rhythms of craftsmanship, and so from geometric form to representational ones. Some saw an emergence from accidental resemblences, as animal forms perceived in rock formations; geometric forms came from the representational ones. Boas (1927) showed that on a historical scale, either of these trends could occur, so such trends were unlikely to be inevitable in a long term sense.

There was at the same time a tendency to consider that increased skill in rendering visual realism was evolutionary progress in the arts, but the modern art movement with its

recognition of esthetic value in expressive distortion, and the new appreciation of the tribal arts made this view seem absurd. Furthermore, it was discovered that "primitive" artists, such as the carvers of the Northwest Coast of North America, could carve figures of startling realism if they chose, showing that their stylistic conventions were not the result of ineptness, but of choice.

Current Approaches

Current views of the evolutionary changes in the arts focus on the many correlates of the degree of complexity of the socio-cultural matrix. Some of these correlates are referred to in the various chapters of this book. The use of the evolutionary framework does not in itself call for theoretical positions concerning cause and effect in culture change. However, evolutionary theories tend to place emphasis on techno-economic adaptions as the fundamental force for change affecting the society and the cultural forms: art forms reflect these basic changes, and the individual is only a vehicle. Marxist versions of this evolutionary viewpoint tend to stress a dichotomy between the art statements of the haves and those of have-nots, and that artistic statements affect the rate of the inevitable change.

The idea of an Avant-Garde, because of its extreme emphasis on individualism, seems totally opposed to Marxist views, but involves similar assumptions about change. The underlying assumption, embodied in the phrase itself, is one of progress, and indeed that change is progress. There is an implication that the new and novel are of value simply because they are new. The curious combination of elitism and Marxism in such works as that of Greenberg (1961) rest on assumptions of this general nature. The concept of cultural evolution used is that progress follows inevitable steps, and that the individual can speed the rate of change (which is laudable), or impede it (which is reprehensible). This is a rather different view than that of the processes of biological evolution, because biological innovations (mutations) are for the most part lethal or short lived, and are subject to the test of functional utility within a specific environment. Proliferation of mutations is important in periods of stress to produce the few that are adaptive. If we are to use a biological analogy, then, it is necessary not only to produce innovations, but to select the ones with the best adaptive potential for the species.

In looking at art from any evolutionary perspective, much must be inferred from what is known of cultures at different levels of complexity in the very recent past, because so little is preserved in the archeological record. Various attempts to

Figure 7.01. Representational and geometrical sequences within short periods on a historical time scale. a. Frigate bird and crocodile motif from New Guinea; b. figurative and "geometical" designs in Polynesian ornament. (both from Boas, 1927).

understand the evolution of art, or for that matter, all of cultural (and even biological) evolution, have been marked by simplistic conceptual models which show very clearly how difficult it is for even the best human brains to encompass the magnitude of the evolutionary picture. This is brought out very clearly in the case of art. Boas showed that many sequences could and have happened in relatively short periods of time. What he did not make explicit is that, even assuming as short a history as 500 centuries as the period in which human beings have been capable of some kind of artistic expression, there is room for an enormous number of such sequences and episodes; a great many centuries in which human beings probably danced and sang, performed rituals, told stories, improvised costumes, wove baskets and created forms in a variety of perishable materials. It is a rarity to find art works more than a century old

from such artistically prolific areas as Africa and New Guinea. For how many centuries have new forms emerged in a variety of ways out of other forms, passed, decayed, and disappeared? Except where fired clay and stone were used, the enduring samples of art forms from the past must be a very small fraction of 1%. Even works in stone do not always last—we have very few of the Greek sculptures which are so basic to the European tradition.

Munro, in *Evolution in the Arts,* has pointed out that the chief effects of cultural evolution result from increase in specialization. That increase in complexity has an effect on style by specialization of craftsmanship and by difference in symbolization seems apparent. Few students of art today would claim much overall progress for humanity in terms of esthetic quality, but certain trends that depend on technology are very clear.

It is from the techniques employed and from the increase in artifacts that last that we get our best ideas of evolutionary change as shown by the archeological record. Technology is cumulative, and so craftsmen do not abandon techniques such as clay modeling and wood and stone carving; in such techniques new forms are the result of more persons combining and coordinating their efforts to produce larger, more permanent works. Artifacts made by new techniques such as metal working are added to the cultural inventory.

Evolutionary Stages in Archeological Perspective

However, the study of evolutionary sequences in terms of levels of complexity presents a number of interesting problems. Much of the archeological contribution of the nature of the evolutionary process rests in comparisons of the origins and growth of civilization in its various forms in various places. The similarities in the use of art at various stages, such as the elaborate burials of certain periods, and the similarities and differences in iconography and formal qualities of style have been an important part of these studies.

The longest stage of the human past, when peoples lived entirely by hunting and gathering, has left very little art in the record, except for rock art, such as the Upper Paleolithic cave paintings of Europe, scattered petroglyphs, and some small carvings in bone, ivory, and stone. One cannot infer, however, that the people were too brutish to spend much effort on art, or too close to starvation to do so, because the evidence from

surviving hunting and gathering peoples suggests that their ephemeral arts may have been highly elaborated.

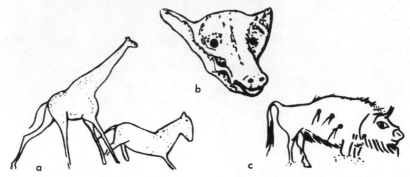

Figure 7.02. Arts of Stone Age Hunters. a. rock painting, Africa; b. carved bone, Mesoamerica; c. cavewall engraving, Europe. (a, after Bandi et al; b, NMM; c, after Burkitt).

With the advent of fired clay, the record becomes fuller. It was once thought that pottery necessarily implied a settled way of life based on farming, but archeological information from several areas suggests that food storage rather than food cultivation is the associated technique. While the people of the Northwest Coast of North America used wooden containers rather than pots, we can get from their lifestyle a glimpse of the possibilities of food collecting in a rich environment. The earliest known pottery comes from the Jomon period in Japan, as early as 10,000 B.C., long before there is any evidence of cultivation in that region. With pottery containers, clay

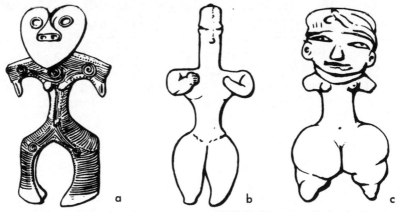

Figure 7.03. Clay Figurines. a. Japan, Middle Jomon period; b. Greece, Neolithic; c. Mexico, late Formative. (a,b, after Clark; c, MAI/HF).

figurines are often found. The majority, especially the earlier forms in each area, are female, and have been called "mother goddesses," "fertility figures," "pretty ladies," etc., but their use and meanings are not really known.

Long term evolutionary trends have been marked by increasingly large scale socio-economic systems with wider and wider circles of trade of goods, of peoples, and of ideas. There have also been larger and larger units of political organization, with redistribution of goods from power centers, and the use of resources in such centers to support the arts. In pre-industrial civilizations, this has meant that craftsmanship requiring astonishing degrees of skill and labor is associated with kings, courts, capital cities and ceremonial centers. It is very difficult

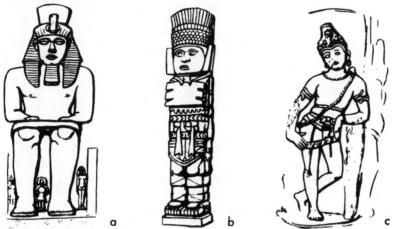

Figure 7.04. Stone sculptures from monumental constructions. a. colossal figure of Rameses II, Egypt. b. Toltec pillar in the form of a warrior, Mexico. c. guardian diety of a temple in Pattadakal, India. (a, at Thebes; b, at Tula; c, after Goetz).

to assemble the resources necessary for highly professional craftsmanship, imported materials, and large constructions without the role of some kind of elite to control or allocate such resources. Long term trends have been punctuated by the rise and fall of particular empires and civilizations, and the nature of such cycles is a concern of the historical approach to the problems of culture change.

Historical Sequences

The historical approach has revolved around several interrelated problems: 1) Tracing the changes in a particular

stylistic tradition through time; 2) Searching for regularities in the histories of all traditions for laws of stylistic sequence; 3) Tracing the effects of stylistic traditions of each other; and 4) Accounting for periods of artistic productivity. These four problems have been studied with reference to facts in various time scales, from the artistic concern with the work of a single artist to the entire artistic output of a civilization over a period of thousands of years.

Stylistic Traditions and Time Sequences

In some historical views a style is a kind of entity that has a life history almost like that of a biological organism. Styles are born, grow old, and die, and each stage of this life cycle has qualities characteristic of all styles at a similar stage. This model is often reflected in terminology—Archaic, Classic, Baroque, and the like. Often such stylistic life histories are closely identified with the life histories of civilizations in which they occurred, the civilizations being similarly regarded as entities having patterns of growth, climax, decline, and death. Kroeber, following the traditional historical model, notes:

> ". . . the comparability of stages of growth evident in so many unconnected art styles. There is crude stiffness or ineptitude at the emergence; an archaic phase with form developing into definiteness but still rigid; then the freeing from archaism, followed by a rapid culmination of the style with full achievement of the potentialities for plasticity inherent in it, after which there may come a straining for effect, overexpressionism, or again ultra-realism, or a flamboyant rococo or overornamentation; if indeed repetitive atrophy of form. has not preceded these latter." (1957: 35-6).

This model can include a number of views as to how art and the rest of human life are related, but the relationship is usually assumed to be close. In Kubler's formulation, the relation between art and other aspects of culture is conceived as being very loose. He rejects the biological metaphor, and uses a concept of "form-class" instead of using the term "style." Form-classes are analogous to philosophical ideas that have exercised human minds for longer or shorter periods at various times and places in human history. They appear, develop, and disappear, but they may reappear at other times and places. Each will have a specific sequence in a particular time and place, and Kubler's analysis resembles the biological metaphor in that he distinguishes characteristic qualities in earlier and

later solutions within a sequence. The nature of these sequences has to do with the potentials of the formal qualities of the form class, more than with any other kinds of ideas, or with an invariant sequence analogous to birth, growth, decline and death. He places more value on the innovation than on mature or classic realization, and talks of exhausting the possibilities of the solution.

When one looks at historic sequences of art, there arises the problem of defining the entity to call a style. For example, if one were to talk of a Nigerian style of modeling, one might consider the Nok figures as archaic, the Ife as classic, and Benin

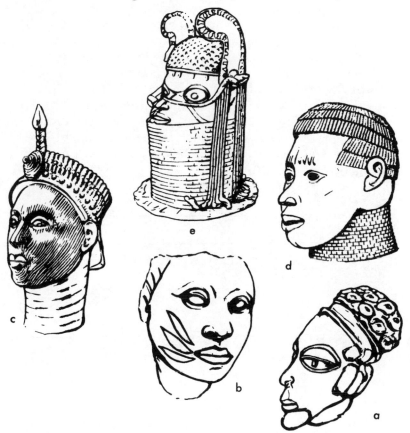

Figure 7.05. Heads modeled at various periods of Nigerian history. a. Terracotta, about 500 B.C., late Nok period. b. Terracotta, and c, bronze, "Classic" period (XII to XIV centuries) from Ife, the ritually central Yoruba city. d. Bronze, Benin early period (XIV century). e. Bronze, Benin late period (XIX century). (a, JM; b, IM; c,d,e, BM).

as post-classic. On the other hand, if one considers Benin
bronzes by themselves, one can identify archaic, classic, ba-
roque, and decadent phases in that tradition. There can also
be a difference of opinion as to the high point of a stylistic
sequence—does one prefer the classic realism of Ife or the
stylization of Benin?

Some confusion also exists because the terminology
employed for sequential stages is also used to label stylistic
qualities, and so the same word may mean very different things.
For example, the period called Classic by Mayanists because it
was the high point of Maya civilization, was a period in which
the stone carvings were highly elaborate, and not at all
"classic" in the sense of serene and elegant simplicity such as
that of the Ife heads.

Whether conceived as styles or form-classes, and whether or
not the connections of art forms with socio-cultural forms are
many or few, the question as to the nature and operation of
such sequences remains open and intriguing. On a visual level,
descriptions of the qualities that distinguish stages in the
development of styles, or formal sequences, remain to be
worked out and demonstrated to be, or not to be, universals.

Sequences and Seriation

Archeologists have, of course, unearthed a great many

Figure 7.06. Seriation. The assumption that style elements follow a normal
distribution curve through time was tested very effectively using New
England tombstones which are dated (after Deetz 1967).

artifacts that provide us with numbers of sequences of art styles through time in various places. The styles, even when not representational, provide information on the geographical extent of culture and cultural sequences. For example, one can chart the history of a style or of some stylistic feature simply in terms of its growing, maximum and declining popularity as shown by the number of pieces in existence at successive points in time. Because it is usual for a feature or motif to follow a normal distribution curve through time as it waxes and wanes in popularity, it is possible to infer a temporal sequence from the distribution of stylistic traits to be found in a number of artifacts at a site. This is the technique known as seriation. With this technique relative dating can be established. By defining some collection of stylistic qualities and motifs as a style, larger sequences can be established.

There are available a number of areas where changes in style through time are known, and a number of specific sequences of change are well documented. One of the first things a student of art history or archeology needs is at least a general knowledge of styles not only by location, but by time period. And indeed, even a casual tourist or museum visitor gains much from some familiarity with the styles of various areas and periods.

Our understanding of the past is continually being increased by more information, especially through archeology, and from the subtle changes in perspective and interpretation that come from new approaches.

A current anthropological approach is in terms of systems theory, with civilizations considered as populations and their cultures as adaptive strategies. Thus they can be studied "without recourse to traditional subjective and often moralistic interpretations such as 'decadence'." (Butzer 1980). The place of art in systems models has not yet been explored in any depth, although certain lines of inquiry have been suggested, as indicated at the end of Chapter 6. (also, Rappaport 1967).

If culture is the adaptive strategy of a society, and its art communicates patterns of relationship that are part of such a strategy, art is important in maintaining or changing adaptive behavior. In some views, great shifts in basic conceptual models (paradigms) of reality are crucial points in human history. People who accept such new models work out the problems of living in terms of these paradigms until the possibilities of this approach are exhausted (Wallace 1978).

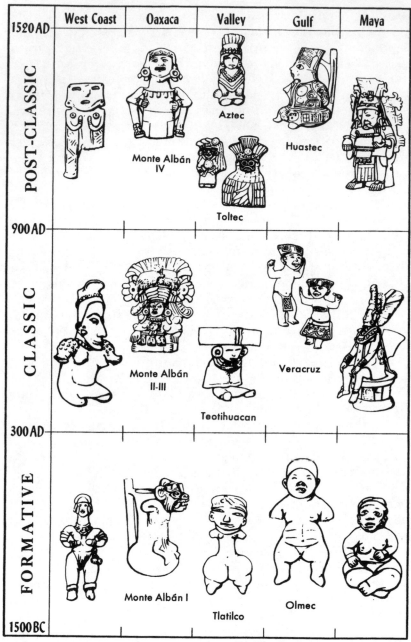

Figure. 7.07. Principal Regions and Periods of Mesoamerica, illustrated with ceramic figurines. These random samples are not necessarily representative of particular sequences.

This idea, (the paradigmatic theory) about socio-cultural systems, is closely analogous to Kubler's view of purely artistic innovations:

> "Early solutions (Promorphic) are technically simple, energetically inexpensive, expressively clear. Late solutions (Neomorphic) are costly, difficult, intricate, recondite and animated. Early solutions are integral in relation to the problem they resolve. Late ones are partial in being addressed more to details of function or expression than to the totality of the same problem." (1962: 55-6).

Is this just a matter of analogy? Or, is the "systemic age" of a civilization related to the "systemic age" of its art forms? Or, are art forms related only to lesser problems?

Diffusion

Tracing art styles through time and tracing them through space are, of course, closely related approaches. In anthropological terms the tracing through time is tradition, and the tracing through space diffusion.

Stylistic traditions within an area may be very distinct, like those of the Gulf Coast, the Valley of Mexico, and the Mayan regions in Mesoamerica, but they are related to each other and have long influenced each other; they bear a family resemblence although each has its own personality. The diffusion of stylistic traits through such an area, together with other bits of evidence, provide the clues from which history is reconstructed. Diffusion between more distant areas provides less evidence, and interpretations are subject to more controversy.

There was a time, in the last century, when these aspects of change were conceived as diametrically opposed explanations. The diffusionists argued that innovation arose only in one or a few places, usually Egypt or the Middle East. The proponents of independent invention tended to believe that each society or area went through evolutionary stages independently, inventing as they went because of developmental imperatives, and the psychic unity of the human race.

Anthropologists no longer consider the diffusion vs independent invention controversy of any theoretical significance but the issue is very much alive in practice because of various inferences based on stylistic resemblences in the realm of art interpretation. In cultural context, the study of the

influence of cultures and styles of one area on those of another
are an important part of history and art history. The effect of
the spread of Buddhism on the culture and art of China, or the
exchange in art between Asia and Europe are very important. A
real problem arises, however, when on the basis of stylistic
resemblence alone, diffusion is inferred, and on the basis of
only this, whole theories of contact up to and including
transplanted civilizations are advanced. Even without ela-
borate structures of inference, the persistent tendency to
infer repeated diffusion of art forms and motifs from a few
centers of high civilization conveys the impression that the
peoples who made and used these art forms elsewhere lacked
creativity and the ability to develop their own styles.

The historicists had four basic criteria for determining if
traits had been diffused; the criteria are probabilistic, of course.

 1. *Space.* Were the similar traits distributed among
cultures that were near enough to each other so that in-
formation could have easily been passed from one to the
other? If so, the possibility of diffusion is strengthened. If not,
the other probabilities would need to be very high. Some
explanation and evidence of contact are called for.

 2. *Time.* The possibility of diffusion as an explan-
ation for similarities is strengthened if the cultures involved
were not only close spatially, but existed at the same time.
If not, some evidence of the existence of the trait in the
intervening time is needed.

 3. *Complexity.* The case for diffusion as an explana-
ation for trait similarities is strengthened if the traits are
complex. The more complex a trait the less the chance of
independent invention; the simpler a trait the more likely it
ocurred to a number of persons at different times and places.
Even a simple trait can be analyzed into a number of qualities
of form; the more of these qualities that are alike or very
similar, the greater the probability of diffusion; the fewer the
number of qualities, the less chance for diffusion, even if the
similarity among the few traits is striking.

 4. *Similarity of form, meaning, and function.* The
probability that similarity of culture traits in different societies
is due to diffusion is increased if the traits are similar in form,
and have similar functions in society. The probability of
diffusion is less to the extent that any of these differ from one
cultural setting to another.

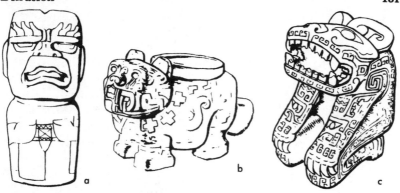

Figure 7.08. Carved stone objects. a. Olmec were-jaguar; b. Chavín puma; c. Shang China tiger. Are the similarities due to subject matter, material, or to contacts between peoples? (a, BM; b, UM/UP; c, AS).

Similarity of form is not, after all, necessarily due to borrowing, for if technology, function, meaning and sequence affect style, then similarities of style can result from these factors. It would seem probable, for example, that similarities in Maori and Northwest Coast woodworking have more to do with habitat and materials than with hypothetical migration, and pyramids are a physical necessity if one is to build large structures up towards heaven without the use of structural steel.

There is also a problem of sampling. For example, many thousands of examples of pots from various periods have been found in East Asia, and many thousands have been found in the New World. It is not difficult to find pieces that resemble each other from opposite sides of the Pacific Ocean. But drawing inferences from stylistic criteria calls for some consideration of the percentage of pots that show stylistic resemblances, as well as the number of form qualities that are similar, in order to evaluate the probability of coincidence, of chance resemblance. This is not to say that such borrowings have not ocurred, but that one cannot accept the evidences of a few similar artifacts as proof.

Historical linguists have found that two languages can have as high as 5% of words similar in form and meaning without being related to each other genetically or by contact. This type of criterion could be applied to art forms if a descriptive teminology existed to quantify stylistic qualities.

Rather than tracing the diffusion of styles and motifs, anthropological interest has turned to the consideration of

what innovations have been incorporated into a cultural tradition when many other available ones have not. Objects and how-to knowledge travel readily over enormous distances, but people seem to adopt inventions and ideas if they fulfill a need of some kind; artists were no more passive borrowers in the past than they are now. Sometimes it is astonishing how much of the distinctive ethos of a people is retained and expressed in art in the face of many kinds of contacts, innovations, and influence. Much, of course, depends on the kinds of contacts that bring new elements. A fishing boat blown off course, or a wandering traveler provide minimum contact, and are not likely to bring much in the way of artifact with them. Traders and missionaries have more effect, full scale conquest is pretty drastic, and still more drastic is the replacement of one people by another. Furthermore, the kind of persons and what they bring affects the kinds of changes that are likely to take place. Where a religious cult converts a number of persons we see changes in the iconography, and if the religions are different enough, changes in the formal qualities of style that I have suggested imply different metaphoric formulations. Trading contacts will mean that actual objects are transported. Relative wealth and power affect the direction of flow, yet even the conquered may come to strongly shape the cultural forms, and thus "conquer their conquerers."

Florescent Periods

Accounting for periods of artistic productivity is a highly speculative occupation, and those who have attempted it have used data largely from Western civilization. Such speculations give rise to stimulating theory; judging productivity, however, is difficult. We are always working only with what has endured, a matter of the nature of the materials, location, and climate; whether preservation was important to the makers and users; and how subsequent peoples evaluated, and so kept and recorded, or discarded and did not record what they saw.

Where periods of high creativity are assumed to have existed, explanations are: 1) genetic, in that a number of persons of genius happen to be born at a particular time; 2) the nature of socio-cultural change means that there are periods of growth, florescence, and decline in culture—the life cycle analogy mentioned above; or 3) art has functions that are important under certain social conditions, and hence artists become very

active when such conditions are present—a functional theory such as that by Kavolis mentioned in Chapter 5. Thus the question is closely related to whether some cultures are more creative than others.

In periods of much cultural contact and rapid change old patterns break down and new solutions are sought. This means that old styles often lose their vitality because they are no longer relevant, and are declining, both in quantity and quality. But such a period may also be a period of great creativity in the sense of many experiments. Only a few of these experiments may become dominant, accepted forms and be retained and developed. In retrospect we can trace the "life history" of such a style. When a great style is being born it may be one of many mutant or abortive originations amidst the debris of the older ones. Creativity, measured by innovation is one thing; productivity, often associated with some kind of affluent elite to support the arts, is another. A great style appears to reflect a period when the paradigms, the solutions, and the patterns, seemed clear to a people. We have tended to concentrate on such styles and such periods. But in order to better understand the role of art in human affairs, and the nature of cultural change, we need to put together and reformulate all of the viewpoints in the light of what we can see around us and recover from the past.

The current challenge is to find ways to understand the processes of change, the complexities of the always shifting, crosscutting networks of interaction that characterize human affairs. Studies of the arts in the field in all parts of the world have become more numerous and are making a variety of contributions. For example, studies (by Herskovits and more recently by Thompson) of the current art styles and life styles that show past diffusion to the New World from Africa are interesting not only for revealing what has happened, but for increasing our understanding of how things happen. Observation of what is happening all over the world at the present time is not a mere matter of recording the destruction of traditional arts, but an exploration of the very lively processes of innovation and change.

Contemporary Changes

All the conditions, all the factors that have affected art in traditional settings affect the changes that are taking place.

More people live in urban environments, but their environments require adjustment, too, and present images to the eye, and spaces to be shaped and adorned. New technological processes and materials invite experimentation. Individuals face new choices, with increased individualism and increased alienation, hence new freedom for innovation, and increased emphasis on short-term rewards. New social organizations, new economic forces, means not only new patrons but new symbolic forms. People communicate more often across linguistic and cultural boundaries.

Change is bewilderingly rapid, and the first reaction, to those interested in the arts of small societies, is to try to save artifacts and information that are disappearing, and only secondarily to study the processes of change. But the present is continually becoming the past, and the importance of observing what is happening while it is happening has become increasingly evident. Often, trying to recover the past, people discover the present, and vice versa.

The Distant Past and Ongoing Present

There are a number of ways in which knowledge of the present illuminates the past, and also a number of ways in which the past contributes to and helps us understand the present.

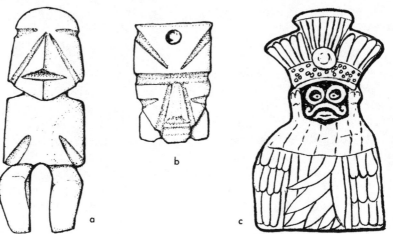

Figure 7.09. Production methods for pilgrim and tourist art. a. small pre-Columbian jadeite figurine, Mexico. b. contemporary alabaster key chain ornament, Mexico. a and b are both carved with straight, filed grooves. c. ceramic figurine of Tlaloc made in a simple press mold and painted, Mexico, pre-Columbian. (a, c, NMM).

Our current technological revolution makes it seem that all current changes are unprecedented, but looked at more objectively, we can see that a lot of what is going on can be compared with the past: the Neolithic revolution, the introduction of metal tools, previous cycles of conquest, increased trade, religious conversions, and past effects of increased complexity. Tribal arts have in the past become folk arts and new arts have been patronized by new elites. Pilgrims are tourists, and souvenir art is not new. Devices used to speed up production, such as molds, give similar formal qualities to works from many times and places. Consideration of how current processes are similar to past ones, and in what ways they require entirely new solutions is a challenging endeavor.

One interesting and complex aspect of the interest in the old has been the trade in antiquities, the digging up of old pieces for sale. This upsets archeologists and scholars very much, because without knowledge of exactly where and with what the object was found (the archeological context) we learn practically nothing. In addition to illegal trade in antiquities, there is, of course, a trade in fake antiquities.

Imitations of past styles take a number of forms. There are museum replicas which may be exact, but many are considerably adapted to modern use. There are many of these

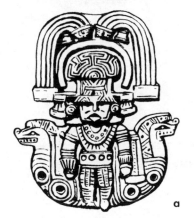 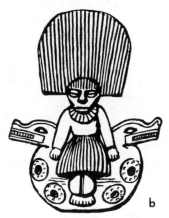

Figure 7.10. Modern revival of the distant past. a. Carved clay blackware ocharina, Tairona, Santa Marta, Columbia (1200-1532AD); b. Souvenir blackware ocharina made by people who presently live in the area, on the model of the archeological finds; these people are not descendants of the original makers, who were exterminated at the time of the conquest. (a, MAI/HF).

that are of fine quality, and some that are not, but they are all honestly represented.

There are also replicas, made from old molds, and copies made by local craftsmen, and these find more buyers if represented as antiques. Some copies are essentially works of art with merely a time-lag as to when they are done; except for the mystique of age, they do not differ from the work of the past. Further, there are a number of places where the styles are in genuine revival rather than copies of the past; copying serves as a training ground for artists. There are some very interesting and sometimes fine works made in the style of ancient artifacts by living people, sometimes inspired, or at least encouraged by the work of anthropologists. Such is the San Ildefonso Pueblo blackware (Mariaware) and the Hopi pottery associated with the Nampeyo family. In south America as in Asia there are several centers of such work.

To the anthropologist all the complexities of current change are important for what they reveal about process, how individuals and societies continually change and adapt, and how they do not change. Visual art forms have the potential for being particularly useful for this study because they are tangible and a number of them survive from the past. For the art historian, the present offers a vast number of links which lead backward in tangled but unbroken chains in terms of style, technique, and motifs that are fascinating to follow. But many theoretical and scholarly considerations rest on the direct study of particular histories, accounts of real people making and using, selling and buying art, with all their varied ideas and motivations, cultures, and personalities.

Sometimes a study will reveal how the past affects the present in unexpected and subtle ways. Bricker (1981) has given us an illuminating study tracing how the persistence of some ideas of the ancient Maya can be inferred from the symbolism of contemporary ritual/festival events performed by contemporary Mayan people. Ancient ideas seem to explain a strange collection of diverse forms and symbols accumulated during the past centuries.

Processes of Change

Because art has so many different dimensions, there are a great many ways in which it can change. Each art style has a different history of change as a result of the impact of the industrial revolution and contact with other peoples.

Wherever we look, and whatever artistic activity we observe, a number of points of view can be taken, and a number of factors enter into the situation. The observations of Carpenter (1972) on the impact of technological items such as cameras and tape recorders on the world view and self-image of formerly isolated peoples makes us realize how completely the contexts that shaped the traditional arts are altered. Such direct observations of the moments of technological impact help us understand cultural process, whether we find the result tragic, funny or hopeful, or all of the above.

One can consider changes in terms of the effects of technology, or the effect of religions such as Christianity or Islam (Bravmann 1944), or of economic changes such as the loss of royal patronage and the importance of foreigners as patrons (Ben Amos 1975), and so on. All such things may change styles.

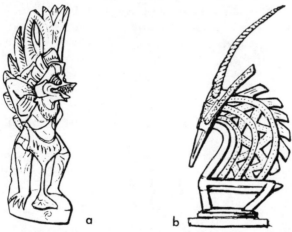

Figure 7.11. Traditional icons that have new meanings. a. Garuda, now an emblem of the nation of Indonesia; b. Bambara antelope, now an emblem of the nation of Mali.

In terms of *meaning*, change can take a number of forms. Traditional styles can be used to communicate a new symbolic system—thus Yoruba woodcarving can portray Christian iconography. Or an entirely new iconography and art style may be adopted, and the alien forms interpreted in terms of the traditional beliefs, as in the folk Catholicism of the Maya. An interesting effect is where the basic social functioning of an icon persists, even though its meaning changes. For example, the Bambara antelope and the Balinese garuda have become national rather than religious symbols.

Art made for local use, that expresses loyalties and local values and is therefore functional in the sense of social function, still exists even if it is changing. It also becomes less vigorous, as the demands of the outside world requires so much attention, time and energy. The Malanggan is still important to the New Irelanders, but they must also devote themselves to the Christian churches, to road maintenance and to work for money. New forms of entertainment entice the young. Similar forces operate in all recently tribal societies. The process has to a degree happened before with the growth of civilizations: tribal art becomes folk art.

The traditional basic myths may be abandoned as truth but retained as folktale, and the iconography remains a very important part of the culture; Holy days become holidays. This seems to be happening in Yorubaland, as the majority have embraced either Christianity or Islam, but many traditional forms continue and are meaningful to everyone. In the European tradition, Cupid persists as a well-known symbol after almost two thousand years of Christianity, and is more visible than St. Valentine. Who knows what St. Valentine looked like?

Some forms characteristic of the culture of a whole people become folk art which persists, although largely abandoned by elites. Many folk arts persist unobserved even in industrial societies; the amount of needlework in contemporary America in enormous. New materials are adapted to folk uses, as in the case of Christmas ornaments. New folk art forms will probably emerge in developing societies whenever poverty is not extreme.

Traditional arts, often after a period of decline, are sometimes revived as sources of ethnic pride. Kwakiutl art, for example, has been revived as a living tradition. Anthropologists and art historians sometimes play a role in the revival of ethnic arts by preserving artifacts and accounts of techniques, so that when people decide to return to their roots, these resources are available. Archeological finds are also a source of ideas, to the descendents of the makers and to others.

Stylistic Trends

There are many different kinds of changes in the art forms and styles that are being produced, but a few trends seem clear:

There is sometimes a *freezing* and standardizing of traditional forms. This often happens in response to the demands of

outsiders for authentic traditional works, especially for the tourist and the export market. Copies of fine pieces from those in local museums are made in some quantity. Some works, such as the Bambara antelope, can be done with little loss of quality; other forms cannot. Navajo silversmiths complain that buyers want the same old things when they are interested in creating new ones.

There is often a *simplification* of traditional forms. This can result from desire to shorten the work, to make articles that are more portable, cheaper and more saleable.

The model of art as a kind of communication, analogous to language, illuminates the simplification effect of contact on style, and the functions of tourist art.

> ". . . both tourist arts and pidgin languages originate and function in situations of contact between mutually unintelligable communicative systems. The changes which result are not arbitrary but reflect the needs of the new situation." (Ben-Amos 1977: 129).

Pidgin languages, using elements from very different systems, are very simplified, restricted languages, limited as to what they can communicate. Tourist art also has this restricted quality. In time some pidgin languages become fully developed; this has happened with Swahili and NeoMelanesian. Sometimes

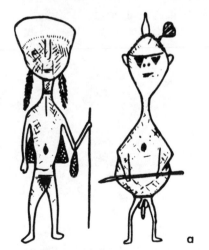
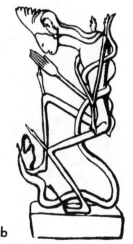

Figure 7.12. Effects of western contact on traditional styles. a. increased realism—Arnhemland bark painting; b. even a sophisticated Balinese artist is influenced by the appeal of the exotic—wood carving by I.B. Njana, ca. 1936. (a, after Berndt and Berndt; b, after Holt).

fully developed art styles also emerge from the contact situation. In doing so, they can become a kind of lingua franca extending across cultural boundaries, or to be more precise, serve to communicate in the new social situations that involve persons of different backgrounds, and bring them together.

There are also some more specific changes in style in response to the market. Two trends of this kind are fairly common: Increased *realism* of representation, perhaps due to exposure to photographs and European art as well as buyer's tastes; and new kinds of *distortion* appealing to a desire for the weird and exotic. Such ideas can also affect ongoing functional art; d'Azevedo tells of a West African carver who incorporated some new ideas saying that if they were not accepted by his local patrons, they could be sold to tourists.

The exaggerated value now placed on functional art in the market place, especially with regard to African art, leads inevitably to *faking signs of use*. Tourists will also buy pieces with mistakes if these pieces look primitive or old.

There are also variants, *adaptions* of local crafts developed deliberately as souvenir items. Sometimes these ideas are provided by outsiders, sometimes by local artisans. The popular thornwood carvings of the Yoruba are an example of this latter; they are also examples of increased realism.

The effects of using *new techniques and materials* are seen everywhere. When metal hand tools became available to Northwest Coast carvers there was a florescence of carving. Now silkscreen printing is flourishing. When aniline dyes were

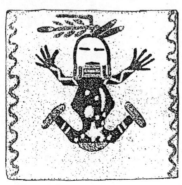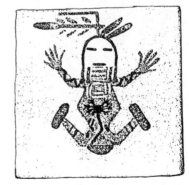

Figure 7.13. Two small permanent Navajo sandpaintings, Father Sky and Mother Earth, popular as souvenir items. (see Fig. 5.09). These personages have often been used as wall paintings in trains and hotels because they are understandable to "Anglos."

introduced to the Navajo, the result was the "riotous aniline" period. Mud sculpture has become cement sculpture in Ghana. Ashanti Kente cloth came into its glory with the introduction of silk; now rayon is often used. New materials and tools are often welcomed, experimented with, incorporated, or discarded. The results are not predictably good or bad. Technological innovation, especially in the form of white glue, made it possible to make permanent paintings with sand, and these are popular souvenirs of Navajo country. Some Navajo artists are developing this medium as a fine art form. (Parezo, 1983).

A *revitalization* or renaissance in art styles sometimes is very much involved with a resurgence of ethnic pride or new religious expressions. In such cases, styles are not "frozen", but develop in response to functional needs. Ethnic pride includes recognition by outsiders and art is a potent means of getting such recognition. Art also helps support revitalization in economic terms, and makes renewed festival-ceremonial events possible. There may be many events and articles for tourists that are phoney, but even these may have functional importance, as when a tourist oriented pow-wow sparks the interests of the participants in traditional music and costumes.

Tourist Art

As has been said, we have been so busy collecting and trying to get disappearing information on traditional arts in their functional contexts (a fairly recent endeavor) that art made for sale to strangers had been largely ignored. But now, although the surface has barely been scratched, a number of interesting accounts of contemporary artistic activity have been published. These are not only important to the theorist, but add greatly to the enjoyment of the collector or even the casual viewer. A collection of such accounts has been edited by Graburn (1976) together with his illuminating introductory essay. Here we can just touch on some of the trends, with a few examples and illustrations.

There is a more or less generally accepted continuum from the cheap, ugly, poorly made objects to works of high esthetic quality and fine craftsmanship that are very expensive. Grayburn calls works at the higher end of the scale "commercial fine art". By commercial he means for sale to outsiders rather than for local use; the latter he calls "functional art." Artifacts on the lower end of the scale he designates "souvenir

art." The range between can be called "tourist art." No precise lines can be drawn between these categories, as so many factors and subjective judgments are involved. As seen in the market, commercial fine art is defined by price, with all of the factors that go to determining price in the fine arts. These include, in addition to the esthetic judgment of the people in the business, a "name brand" in terms of ethnic label, sometimes a famous name in terms of the maker, and sheer fad or fashion. In this frame of reference, what was at one time considered tourist art can become fine art. The triumph of the collector is to acquire at a reasonable price a piece of tourist art that later becomes recognized as fine art.

Art made for sale to outsiders is distinguished from "functional" art that has its use in the cultural context of the makers. This terminology should not be taken to mean, however, that the activity and even the style (as well as the money received) has not had an important place in the society. The role of weaving for the Navajo and silk screen printing for the Kwakiutl are cases in point.

There is now an increasing public interest in a number of changing "folk" and "tourist" arts. One reason for this is the opening up of our minds so that we realize that many pieces are esthetically worthy of attention, and another is that the ongoing histories and cultural contexts of these changing forms are so interesting.

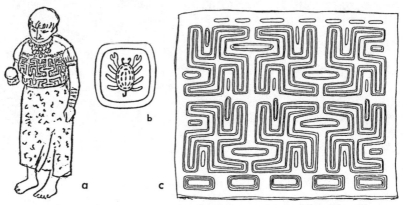

Figure 7.14. The molas made by the Cuna women of San Blas, Panama, show a complete range—functional, fine art, tourist, and souvenir. The technique is a complex form of applique using imported materials. a. Cuna woman in ethnic dress; b. souvenir "mola" patch (9 cm); c. a geometric type mola, once functional and sold to tourists when old and faded.

Tracing the histories of various ethnic arts in recent times is a very lively form of art history. For example, Cuna women, whose ancestors may have been the makers of Coclé pottery, make applique pieces called molas from purchased cotton material. Earlier designs were mostly geometric and resemble the body painting that is traditional in the area. Later designs are often figurative, and reflect events not only in the world of Cuna, but the larger world—adapted from pictures in magazines and the like. Molas were purchased by tourists, and recently many are made especially for sale. In short, a history of an art that has moved from "tribal" to "folk art" to "tourist art". Some of the pieces are now being seriously considered as fine art. An unexpected incident is the letter written by Cuna women to the New York Times refuting the story that they were being taught by a Peace Corpsman to make molas on the sewing machine. They already knew how to use sewing machines, and no one could make a proper mola in such a fashion. The role of the mola as an artistic expression of ethnic identity is well understood and valued by the people themselves.

The current history of ethnic arts is by no means entirely a matter of decay. Often forms that have become accepted as fine art emerge from the contact situation. San Ildefonso blackware, Navajo blankets and silver, modern Eskimo sculpture and prints, Haida argillite carving, Balinese paintings, Peruvian pyro-engraving, and some African carving styles, for example, are widely esteemed—and command high prices. there is of course, great variation in quality with such styles. The better artists tend to become professionals, the poorer ones turn out pieces quickly. Of course there are also professional artists trained in modern schools who draw on ethnic traditions.

From the point of view of the makers, the artists, the main criterion is craftsmanship; one can and must charge a higher price for something that takes more time and effort. But if one can only sell pot-boilers, one makes pot-boilers in order to eat. There are a number of instances where the same craftsman makes fine art objects, tourist art, and souvenir art with full consciousness of the return for his time in each type. Functional arts and the various grades of art for sale can not only co-exist, but are often made by the same individuals. The craftsman who decorate gourds in Huancayo, Peru, quite deliberately produce three grades of gourds for sale, and other gourds are used locally

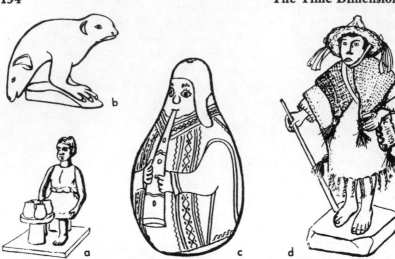

Figure 7.15. Forms developed for sale to outsiders. a. Yoruba thornwood carving (7 cm) using dark and light woods, said to be the most popular form of souvenir in Nigeria; b. Traditionally the Eskimo carved only very tiny figurative forms of ivory and soapstone; this is a recent soapstone figure 9 cm high; c. Peru; decorated gourds have been used for centuries as containers, the sculptural forms are a Peace Corpsman suggestion; d. Highland Maya, a display doll made with traditional techniques of carving and weaving.

as containers. (Boyer 1976). Cuna molas are made in all grades and are both functional and commercial.

When there is little information to go on except from the art forms themselves, we can see influences of one style on another. Observing living artists, we can see how they select from the variety of visual forms, the responses of buyers, the suggestions of well wishers. We can also observe their frustrations when new ideas and new forms do not sell.

The lowering of quality that results when the patrons of art are strangers with money, rather than local patrons, does not come about just because of the money. It comes about as the result of a different kind of dialogue between artist and patron. If the art deteriorates in quality, it is because the buyers do not know good quality and do not want to pay for it. It also comes about because neither artists nor patrons understand the esthetics of the other, and lack respect for the other's taste. To take a simple example, tourists and collectors like things to look old even if they know they are not, so Navajo silver and West African brass are preferred with a "patina." Navajos and

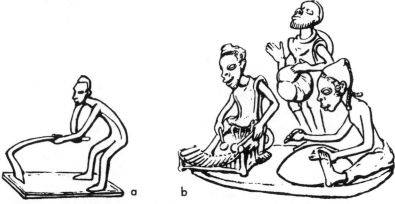

Figure 7.16. Contemporary West African brass casting. a. Small brass figurine (5 cm high); a bit of souvenir art in terms of size and price, but comparable in quality to some esteemed gold weights from the past; b. Musicians (15 cm high); lost wax casting from Ghana (Ashanti?). This piece was thickly covered with black paint, presumably on the assumption that this is what tourists would like.

Africans, on the other hand, like these works clean and gleaming, as we like our own silverware.

Authenticity

The question as to what is genuine or authentic and what is spurious or fake is an important one with regard to all contemporary ethnic and changing arts, and it is by no means a simple problem, particularly as people differ in the ways they use these terms. Some persons, when speaking of tribal arts particularly, regard a work as fake if it was made for sale rather than for tribal use in the traditional way. This label is very unfair to folk artists who would seem to have just as much right as the graduates of art school—and probably even greater need—to put their works on sale. Why should they be expected to forever copy the styles of their ancestors and then be criticised because the style loses vitality? A fake is something that is claimed to be something that it is not, and an authentic piece is just what it is claimed to be. This definition may be simple, but it does not mean that it is always easy to find out if a piece is what it is claimed to be, and one has to be fairly knowledgeable and thoughtful to consider what the words of the claim mean. If all that is claimed is that something is hand-carved in Africa, that is all it has to be to be authentic. Whether or not it is old or new, good or bad, is not the question. The fact that excellence,

high esthetic quality, is often called "true" or "authentic," and that poor quality often called "false" serves to confuse the issue.

What is lost in works made for sale is not always craftsmanship. One can get Navajo tapestries more perfectly woven than anything in the past, if one is willing to pay for them. What is often lost is the quality of intensity found when the meanings are profound and believed in by artists and patrons. But this quality never existed in each and every work, so quality is not assured because something was used within the social context of the maker. There have always been plenty of routine productions in any tradition. Use can be faked, quality cannot. Recognition of quality comes with developing familiarity with a particular medium, such as weaving, or a particular cultural style.

Souvenir art is a form of folk art, in the sense that neither the makers nor the patrons are the elite of the societies. When we consider art only in terms of the decay of the traditional forms and assume that the only alternative is the acceptance of the international styles taught in art schools, we are overlooking the esthetic needs of ordinary people, and this means undervaluing not only the ordinary people, but the importance of the mysterious domain of the esthetic in human affairs.

It is challenging to everyone's eye for quality to find good work regardless of categories or labels. For example, there are carvings made in "bush factories" in Africa. These are made, usually as copies of a model, by anyone with sufficient skill in handling tools, and sold in quantity to exporters for the novelty trade. They are authentic African carvings. Most of them are neither good representations or artistically interesting. Yet every once in a while one sees one that stands out among its fellows, an "affecting presence" that somehow, for all that it is classified with the lowest form of tourist art, has that mysterious appeal we call esthetic quality.

Why should this quality be felt by a person so far, in space and culture, from the makers? Or, for that matter, why should a useless statuette appeal to anyone?

Further Reading

Ben-Amos 1975, 1980; Biebuyek 1973; Boas 1927; Carpenter 1973b; Dick-Read 1964; Eyo 1977; Feest 1980; Grayburn 1976; Kroeber 1957, 1984; Kubler 1962; Mount 1973; Munro 1963; Wallace 1978 (Appendix).

Chapter 8

The Esthetic Mystery

Esthetic quality, the most essential ingredient of art, has been left until the last. The esthetic response is a very personal thing, yet there are cultural standards. Some people have thrown in the sponge and said that matters of esthetics are completely relative, yet they discuss art with the implicit assumption of universal esthetic values.

One of the reasons for leaving the consideration of esthetics until the last is that I consider that the study of art from the anthropoligical point of view calls for doing just that, putting aside considerations of esthetic excellence until one has looked at a work or a style from every other point of view. Even if one's concern is primarily appreciation, one does not come to it by being told "You *ought* to like that," but by withholding judgment, or to be more accurate, setting aside one's inevitable initial reaction, and first considering the work from a number of viewpoints. By defining art so very broadly in the beginning, I have opened up the possibilities of regarding perhaps the great majority of human things as art, and by this very inclusiveness forced a kind of relativism as each person is forced to select from this vast mass of material what he considers worthy of artistic contemplation. The alternative is to abdicate and only accept what the Tastemakers decree is art by placing on display objects so labeled.

This broad view, considering the esthetic dimension of many activities and many kinds of artifacts is part of the present openness, part of the rejection of ethnocentric and snobbish ideas about fine arts (d'Azevedo 1958). Carried to extremes such a view can lead to a sentimental enthusiasm for anything "hand crafted." By and large, however, the process of discovering the beauty of everyday objects enlarges and refines esthetic perception. (Sieber 1980).

When we use the word esthetic we are referring to the pleasurable response to what is beautiful, in nature and art. When applied to art, it has become unfashionable to refer to beauty, because art is not always a representation of what is beautiful in nature, and so the term confuses people. So we turn to the other great human values, the "good" and the "true,"

and use these for the evaluative terms for art. Also, perhaps, this is because art is not only meant to be pretty, but at its best seeks to combine Good and the True and the Beautiful, to speak of the quality of life. We feel that art should do this, which is not to say that it necessarily does so. Like any other form of communication, it can convey what is evil, false, and ugly, but part of the esthetic mystery is the feeling that the beautiful should somehow relate to goodness and truth.

The matter of esthetics alone is a matter of evaluation—a matter of degree of this kind of pleasurable response that is evoked by something we perceive. Some thinkers refer to esthetic qualities as a lure, an attention getter, as the flower is colorful and provides nectar to lure the bee, so that the flower's species may be perpetuated. For that matter beauty can be regarded as analogous to the pleasures of sex that lure animals to reproduce. To assign such pleasures instrumental biological roles does not explain why the "lures" are so attractive, so life-enhancing for the individual, nor, for that matter, do such "explanations" diminish the ultimate mystery of life itself.

The mysterious need of human beings for esthetic experience has never been explained. The role of this need in human affairs has been treated as incidental. When we look at the archeological and ethnographic record, and reassess the importance of trade, however, a new possibility emerges. As soon as the barest physical needs are met, and sometimes even before, some kind of esthetic satisfaction is commonly sought.

Trade, whether in the Sepik River area or in the pre-Columbian Mississippian or between ancient China and ancient Rome, is not in essentials, but in "luxury goods"—that is to say, pretty things. It is customary to say that the wielders of power, from big men to god-King emperors, organize the making and importation of luxury goods to enhance their prestige and extend their power. But how can the possession and control of beautiful things bring prestige unless they are considered highly desirable in themselves? How can you show off with something if other people do not admire it? As far as the other assigned motivation, that people deal in art objects just for money, how can there be any profit in such things if they are not widely valued for themselves? As soon as people get power or money they use them to embellish their lives.

This being so, we must consider the possibility that one of the motivations towards the wealth and power or even modest

success and affluence is the desire for esthetic experiences in the form of events or possessions. This makes the mysterious esthetic urge one of the important causative factors in human history.

Technological knowledge followed, not led, trade in copper, gold, silver, silk, jade, glass, pottery over the trade routes of the ancient world. Metals were long known and used for ornament before they were used as tools and weapons. Further, having enlarged our definition of art and the esthetic experience, we see the same priorities on a smaller scale and among humble persons as well as the rich and powerful. Even at the lowest level of simply making, creating, a purely utilitarian object, there is some thought of an esthetic reference, "How will it look?"

This brings us to questions concerning the human universality of esthetic standards, and the cultural and other differences in such judgments.

The anthropological approach to esthetics revolves around two problems: 1) universality vs. relativism, and 2) the relation of esthetic values to other aspects of culture and the human condition. These two facets are closely related, because if there are universal esthetic criteria, then the fact that there are so many differences in taste calls for some kind of explanation. The variations in what people like must be in some way related to differences in physiology, psychology, culture or situation. If, on the other hand, esthetic taste is purely subjective and relative, then the existence of stylistic similarities calls for an explanation of how so many similarities have come to be.

Above all, it is very hard to explain why there is as much agreement as there is on what has esthetic quality, and even what is of high quality. It looks as if we need to explain both the similarities and differences in esthetic tastes, and what these are related to. We return, in this area of discussion, to the anthropological "universal question:" "In what way are all peoples alike, in what ways is any people like some but not like others, and in what ways are they unique?

Beauty in nature gives us the feeling, in the words of Browning, that "God's in His heaven, all's right with the world." This is the feeling that things are healthy, natural and in their right places; awe inspiring, perhaps, but not dissonant.

In art, even on the purely esthetic level, this means that context—the right thing for the right time and place, affects evaluations.

Contextual Influences

In one way or another esthetic response is affected by all the factors that have been discussed in previous chapters. Both the form of the work and the viewer's perception of it, and the emotional response are involved.

Esthetic quality is affected by physical setting, the immediate environment. Even under present conditions when so much is made of the work as a thing in itself, this is important. If you have ever heard the fuss painters make about where their works were hung in an exhibition, this should be no surprise to you. This being so, the original setting for which the artist prepared his work is relevant to the understanding of its esthetic quality. With works far from their original settings, information enables one to perform the act of imagination to put the object before him into the physical setting for which it was made— festival lit by torches, a clearing in the forest, or an altar lit by candles, or spread on the sands of the desert.

I said at the beginning that one of the components of art is *craftsmanship,* and this is one of the most universal and cross-culturally understandable criteria for judgment of esthetic evaluation. Listen to what people say as they look at a hand made artifact, if they are not afraid to seem naive: "Is it hard to make? How long did it take you?" Admiration for skill and effort are universal.

In our society we take for granted that *psychological* factors that make for individual identity affect what we like in art; so much so that to find another person who shares our esthetic preferences is regarded as a rare and treasured happening.

Esthetic judgment is not independent of *social* context. For example, lavish costume jewelry used in an operatic performance might get raves in that setting, but would be considered ugly and in poor taste at a conventional wedding, and a piece of junk in an exhibition of fine jewelry. The charming decorations of a festive occasion look tawdry after the ball is over, even if they are not faded; the music that was so exciting is noise the morning after. This is, of course, to say that the perception of the esthetic is situational and therefore relative. It does not follow that it is completely and absolutely relative. It does mean that the concept of pure art should be questioned, and it should not be made a criterion for "good" art. The question: "Good for What?" is not completely insensitive.

Meaning, too, affects esthetic evaluation in several ways. In a very obvious example, many works that had a satirical meaning, as in some Yoruba masks, have been regarded as simply grotesque, and people have wondered about the strangeness of the Yoruba esthetic, when, in fact, the Yoruba canons were deliberately violated for satirical and comic effect. If we used the word "taste," it becomes more clear as to the ways in which esthetic excellence depends on the meaning, because the appropriateness of the artistic means used for the whole context of the work strongly affects the response to it. This is not to say that all works must have representational or iconographic or symbolic meaning, but they cannot fail to have formal qualities, and if these qualities do not communicate something that seems meaningful and appropriate to the viewer, he will not perceive the work as esthetically valuable. Why should anyone care about the inner concerns of an artist as he projects them on canvas unless he has something to say about the human condition that in that time and place is relevant to the human condition as perceived by his viewers?

The most important thing about art in many cultures is not always esthetic quality, but symbolic meaning, ritual correctness, and spiritual essence. These may be culture specific (emic), and have no significance unless the viewer shares a feeling for the meaning of the forms. But beyond and in addition to such significance some shared humanness and spiritual awarness may relate to universal esthetic responses.

Esthetic Universals

With all these influences operating on our perception of what is esthetically valuable, the wonder is that there is any agreement at all. Many persons are so impressed by the great diversity of art forms, and the great complexities of the factors which influence esthetic appeal, that they give up the problem, say that everything is relative, and that there's no accounting for taste. In so doing they are overlooking the very obvious fact that there are also great similarities, and overlappings. If we have such complete relativism, how is it that artists have any audience at all? How is it that art museums can find so many things of esthetic worth from such a variety of cultures and periods? Why would we go to see such works if perceiving esthetic worth in alien productions is a hopeless pursuit? For

that matter, how is it there is agreement about the beauty of flowers and butterflies?

Carvings were collected until very recently first as artifacts and then as art, without concern for the name of the artist. In time these have been sifted through in various museums and by collectors, and have gradually acquired esthetic ranking. When an effort has been made to find out something of the background of the better pieces, it has been found that where oral traditions still exist, the carver is identifiable and was particularly well known and esteemed in his own society. In other words, these people had ranked the carvings very much in the same way as had collectors. Where observers have studied carvers in the field, as in the Asmat, Solomon Islands, and Yoruba cases, the local ranking of a carver's work was very much in keeping with the observer's judgment.

What kinds of similarity, and what kinds of differences can we conceptualize to get a handle on the nature of this phenomenon? It will be noted that the problem of the nature of the esthetic responses is very closely related to the problems of perception briefly discussed in Chapter 4, and the problem of form-meanings in Chapter 6, in that it is hard, even conceptually, to disentangle perceived esthetic qualities from the ways they are described and combined and the ways they are interpreted.

Esthetic tastes are probably similar in the basic ways human beings are similar—which is to say we look at visual forms with eyes that are physiologically very similar in relation to the physical phenomena. We all have rhythms of activity and repose, dislike of being off balance to the point of falling down, find red-orange stimulating and green soothing, find healthy flesh more attractive than diseased. The relation of the human organism to the physical world is an important constant. When Leonard Bernstein gave his lectures in which he sought to apply Chomsky's concept of deep structure of the human mind to music, it was not the structure of the *mind* that he in fact related to the structure of the music, but the physics—the relation of music to physical properties and phenomena. The implication, though, is there—that the human mind relates such aspects of reality through the ear, and the mind. Similarily, the deep structure of the human mind, relating through the eye, finds pleasure in things that are in tune with a physical-biological reality. But the relations are less clear.

There are some universals in human experience and in human physiology that underlie the esthetic response, in whatever way they may be combined to appeal to the needs at any one time, place, function, and mood. For example, balance and repose, motion and activity, the bilateral symmetry of the human body, and the rhythms of life, are all very fundamental sensations that relate directly to visual forms.

Furthermore, certain fundamental regularities in the natural world are so widely observable that they fit into everyone's "natural categories," and thus are sure-fire to give a feeling of natural order in art. The best known of these is the "golden mean" or perfect proportion, mathematically known as the Fibonacchi series: 1 to .618034, roughly 5 to 8; this ratio is the basis of the "golden rectangle", and many spiral forms. Such spirals as natural forms are very common, the best known being is the snail, the chambered nautilus and the ram's horn—it is a commonly recurring growth pattern. "Man can see the image of life in art that is based on the golden mean."

The work of the depth psychologists in analyzing visual productions in terms of psychological pathology, for all its limitations, provides some interesting clues concerning the nature of the meanings of visual forms and the nature of esthetic appeal. In *Visual Metaphors* I pointed out that some of the psychoanalytical interpretations did not apply to art forms because they were too unbalanced to be found in anything that could be called art. This may have been a subjective judgment on my part, but I think the implications of this deserve some thought. If, in a two dimensional form, the form consists of a small figure "clinging to the side of the page" it indicates fear, lack of self confidence, and the like. In art, such placement would be highly unlikely, and forms that "comfortably fill the space" are deemed "good." This suggests to me that many of the characteristics of art that are esthetically acceptable (which we can often accept as widespread simply because we in fact find them so often), may be beautiful because they are healthy.

In the relatively few instances where an art form, or more likely some fraction of an art form is "unhealthy," the chances are that they are part of the question, of the "problem" that is being solved in some other aspect of the work to produce a "solution." If, in times of trouble, there are an unusual number of forms speaking of disease, that speak of problems, that reject old solutions, they will probably not endure as art when the new solutions emerge.

Yet the fact that esthetic response and evaluation of art depends so much on context indicates enormous possibilities for misunderstanding, for different interpretations of how the universal perceptions can be interpreted, combined, and evaluated. One way to find out about how this is done is simply to ask people what they consider excellence in art—to collect and put together their evaluation of specific works.

The idea that people from other cultures might be able to verbalize their criteria for good art is a fairly new one, and not entirely due to ethnocentric snobbery, because it is recognized as a very difficult thing to put essentially abstract criteria into words in one's own society, for all the ink that has been spilled on it. It is, however, snobbery to laugh at the phrase "I don't know anything about art but I know what I like" without asking, "what do you like?" We are surprised that so many people, as among the Yoruba, can be so verbal in explaining why they like what they like when field workers have asked for esthetic evaluations. We have now some information on esthetic value systems. Its is particularly difficult to translate such terminologies. But some indication of the kinds of criteria used offer clues for further study (See Crowley 1966, Warren and Andrews 1977).

The Yoruba are reported by Thompson (1973) as having a fairly well defined set of esthetic canons, which briefly summarized are as follows: A carving of a human figure should look like a human being, but not be a portrait likeness; it should look believably real, but not exactly so; a person should be represented in the prime of life; emotional perspective is more important than literal proportions. (What Thompson calls "emotional proportion" includes the ideas of expressive distortion and social perspective). Sculptures should have "visibility" by means of clarity of form and clarity of line; rounded organic forms and delicacy of detail are both admired. He concludes by saying:

> "Seen as a whole, the Yoruba aesthetic is not only a constellation of refinements. It is also an exciting mean, vividness cast into equilibrium. 'The parts of this image are beautiful,' an Oyo elder once said, 'because they are equal to one another.' Each indegenous criterion is a paradigm of this fundamental predilection. Thus mimesis, as traditional Yoruba understand it, is a mean between absolute abstraction and absolute likeness; the ideal repre-

sentational age is the strong middle point between infancy
and old age; the notion of visibility is a mean between faint
and conspicuous sculpture; light is balanced by shade. . .
Yoruba artistic criticism seems to be saying that force or
animal vitality must be balanced by ethics, the moral
wisdom of the elders. Ethics in this special sense would be
the peculiarly human gift of finding the tolerable mean
between the good and the bad, the hot and the cold, the
living and the dead, to safeguard man's existence." (pp.
58,59).

It will take a great deal more information from a variety of
cultures before we can make comparative studies of verbalized
esthetic value to compare with the evidence of the objects
themselves. After all, if the art form is made and accepted in a
society, it must be judged to be reasonably good as art, and
when we have better descriptive terminologies for the formal
qualities of art we will have some basis for comparative
esthetics. Esthetic values may very well be related to each other
so as to form a system—the "logico-esthetic" integration
characteristic of a culture, comparable to and probably relating
to the kinds of symbolic systems discussed under meaning in
Chapter 6.

Often, when an expert trained in the esthetic traditions of the
Euroamerican society points out the esthetic qualities of a work
of art it never occurs to him that his is giving an interpretation
that belongs to his own system. Just as in the case of analyses of
symbolic meaning, where the scholar feels his vision is the
"real" one, so the expert assumes the esthetic qualities he
perceives are the important ones. This is not to say that it is
wrong, or that different systems of analysis cannot agree on an
over-all evaluation. What I am saying is that by analyzing in
terms of a frame of reference of another culture, the esthetic
qualities that relate to the values of the makers and users is
probably obscured. The highly developed esthetic sensitivity of
many art historians is an expertize we may draw on, as on other
expert opinion, but it is not necessary to the consideration of art
as culture. It may even be a hindrance.

But esthetic systems are not isolated constructs. They arise
from and are expressions of the way life is conceived and what
enhances the quality of life. Therefore, the more one can learn
of the lives of the makers and users, the more one can see in
what ways the art forms are or were meaningful in their origi-
nal contexts, and the deeper our esthetic perception.

On the other hand, if we are open minded we can look with appreciation, even if we know little of the context, because as Kavolis says:

> "I am assuming that it is the 'mysterious,' 'charismatic' *power of integration* of socioemotional tensions that is recognized as the ground for artistic values. There is a sense of elements that must have clashed, thus providing the 'energy' of the work of art, and of a solution that incorporated the clashing elements into a larger pattern, the 'significant form' of the work of art. The particular socioemotional tensions at the basis of a work of art need not be recognized cross-culturally and trans-historically, but rather the power of bringing together *whatever* may have been disparate must be sensed in a work of art judged to be of high aesthetic quality beyond the sociohistorical system in which it was produced." (Kavolis 1972: 159).

We are asking, because human beings need to know, what is there that makes life worth living, the quality of life that is essentially human and something more than mere survival? The arts of other peoples are part of their answers to the problem, and this opens up new possibilities, new viewpoints, for putting together our own configurations.

I suggest that we look at art in this way rather than simply as individual works labeled "art," and by catching glimpses of the ephemeral and day-by-day esthetic activity in far places, we also open our eyes to much activity having to do with the quality of life that goes on around us, the arts that are not in museums and galleries, the festival arts and household arts that are so closely woven into the fabric of life. A lifestyle is not something that is put on like a string of beads, symbolic as that may be in certain contexts; it is the whole fabric of values and emotional attitudes concerning the nature of the quality of life, and what we see as the ethos of the culture. Mills (1971), d'Azevedo (1973), Thompson (1971), and others have pointed out that to understand and appreciate the esthetic dimensions and quality of life in other cultures we need to observe these aspects of life, as life is lived from day to day, not merely as the artistic fragments are shown in museums. It is important to be aware of the significance of these statements, but it does not follow that the only way to understanding and appreciating lies in following this course of perfection. Very few persons can have the opportunity for such experience, but even knowledge that

comes to us second hand adds greatly to the enjoyment of the fragments we see.

If for whatever reason people accept different configurations more readily in art than in other aspects of life, then art is not only important for exploring potential change, but becomes important in the expansion of perception of the viewpoints of other persons and other peoples. Learning to accept and appreciate various artistic expressions sometimes helps dissolve ancient bigotries, if not the ancient hates. If it is true that there are many similarities in esthetic perception, and if it is true that art forms are affected in many ways by various facets of human life, then these fragments are important doorways into other lives and lifestyles.

There is a kind of spiralling dialog that goes on between the two aspects of the mind. The analytic part asks questions like "What did they use it for?" and "What is it a symbol of?" and the synthesizing part of the mind puts whatever bits it has together with the visual image to get a new gestalt and sudden insight that makes one feel the piece, and what it may have meant to the people, and one can ask more questions, then go look again, and ask, and look. . . . The appreciation that comes through understanding and the understanding that comes through appreciation are both needed to approach the place of art in human life.

The constant interplay between explanations of the emic and the etic, between contexts and comparisons, illuminates the fundamental similarities of human beings and their art, the conditions that bring forth some differences and similarities, and the amazing uniqueness of each human being and each work of art.

Further Reading

Altman 1973; Armstrong 1971, 1921; Child and Siroto, and Sieber, in Jopling 1971; Crowley, Ladd, Mills, and Thompson in d'Azevedo 1973; d'Azevedo 1958; Hospers 1969; Maquet 1971; Warren and Andrews 1977.

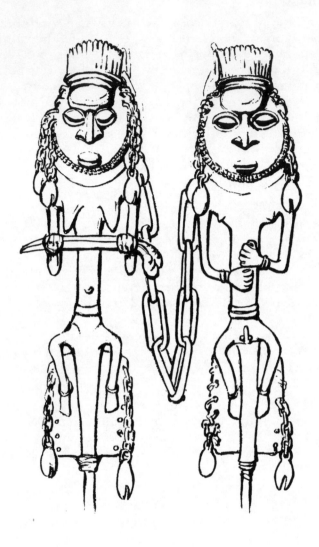

Chapter 9

The Global Context: The 15th Century

Figure 9.01. a. Merchant Prince of Florence, bronze, b. Scholar-bureaucrat of China, ivory, c. Oba (king) of the Edo, Benin city, bronze (a. National Gallery of Art, Washington, b. H.M. the King of Sweden. c. BM).

One of the things that has long interested art historians is the existence of periods of fluorescence in the arts at certain times and places. Why was a lot of art produced during these times, with so much of it of very high quality? Did many talented persons just happen to be born at such times? Which of the socio/cultural functions discussed above were present to encourage artistic activity and high quality? Only comparisons of very different societies can give clues to this phenomenon.

It is not possible to describe completely any segment of human history. One can use various devices to set some part off and treat it as an entity. One can take such a segment and give it a name, a label, and describe it in some way that seems to make sense. That's what the

human mind does. So we can take an area in a defined period of time and look for the factors within it that relate to the symbolic and esthetic productions with their characteristic styles, and gain some measure of understanding. Of course, this means simplifying the enormous complexities of life. In the comparisons sketched below, the emphasis is on what is similar in societies that are in many ways so different, because these similarities have been largely unrecognized.

One of the confusions in the various historical approaches is the tendency to not be clear about the difference between civilizations (which are in a sense culture areas) and political entities which come and go, enlarge and shrink. Thus, Chinese civilization has a very great continuity for millenia, but China as a political entity has a very checkered history. Europe once was the Roman Empire, but became a collection of little feudal states, small nations, and city states. Empires rose and fell apart again. In West Africa and in India there have been periods of large kingdoms and empires, and periods of fragmentation, of tribes and chiefdoms, and small kingdoms. Overall the historic tendency has been to larger and larger political entities, which usually seek to diminish the cultural and language differences within their boundaries, and to develop loyalty to the larger state. But there has also always been an attachment to local places and local customs, and efforts at self-determination. A similar process goes on in the arts.

In the older ethnographic literature, it was usual to try to infer and describe a society and its culture as it was just before contact with Europeans. We can use a similar device to make some comparisons between sample Old World culture areas in the 1400s before contacts all over the world increased and intensified.

The societies considered, Renaissance Italy, Ming China, and Nigeria, were very different in many ways, but there are some interesting similarities. The artistic output of the first two are well documented, and much is well preserved, but the Nigerian case is not so well known, largely because so much was either destroyed or scattered during the intervening centuries, and documentation was rare and not explored. As we rid ourselves of the ignorant and ethnocentric labels "primitive" and "tribal" we can make more honest comparisons.

Probably the most thoroughly known and written about period in art history is the Renaissance in Italy. It was part of Western European civilization, and was in a stage of quite small political entities, city states. These were in many ways very comparable to the city states

Figure 9.02. Map of 15th century trade routes; Asia, Africa, Europe.

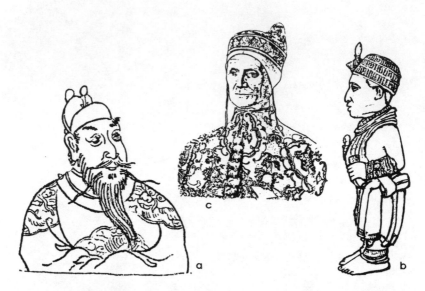

Figure 9.03. Gorgeous fabrics indicate high status in many places. a) The king of China in mid 15th century b) The Oni of Ife 14th or early 15th Century, the upper costume is of beadwork, the lower textiles c) The Doge of Venice in silk finery (a. after Levanthes b. after Eyo and Willett c. after Kent).

of the Nigerian area in pre-colonial times. In both areas each city differed from the others in politico-social organization and style, but the social functions of the arts were very similar. Both areas were part of recognizable culture areas. Nigeria was part of Western Africa, as Italy was part of Western Europe. The Chinese empire covered an area of various cultures but could be considered as approximately covering a culture area at that time.

It has been said of Ming China "it was the age of the collector and the connoisseur" but this was also true of Italy and Nigeria. (The Yoruba word for connosseur is *amewa*). In all cities, families built big houses where a variety of beautiful things were housed. Courtyards were an important feature of each. Collectors and connoisseurs, then, were part of the picture; such persons were the part of the society that supported the arts. So part of the phenomenon of artistic fluorescence probably lies in the patronage. Artists have to eat. What conditions led to the development of this amount of patronage?

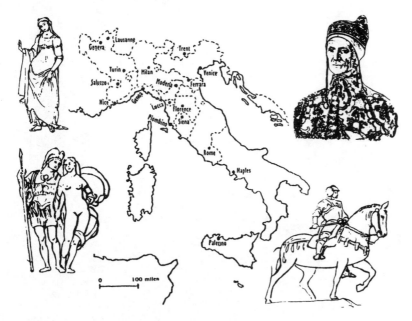

Figure 9.04. The city states of Italy in the 15th Century.

Trade and Technology

In the 15th century, increase in trade meant that in each of these three areas there were well-to-do merchants as well as royals and hereditary aristocracy.

The 15th century in China was during the Ming dynasty, and in the art histories of China it is to be found near the back of the book. This was a Chinese dynasty that had taken over in the 1300s after the reign of the conquering Mongols. The artistic emphasis was on reviving the cultural glories of the previous T'ang and Sung dynasties.

The Yongle emperor built a new capital with a great palace compound in Beijing, but it did not completely become the cultural center, in spite of the emperor's efforts. After scholar-painter-poet-bureaucrats had served at the capital, they tended to retire to Chiang Nan or one of the cities like Suchow, Yangchow or Nanking which were centers of trade. The silk, tea and salt trades built up rich families who were collectors and connoisseurs.

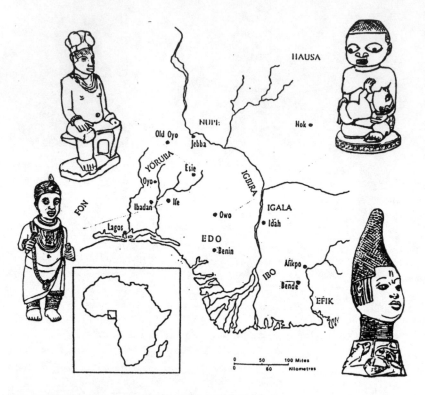

Figure 9.05. City states in Nigeria in the 15th Century.

West Africa was a culture area in many ways comparable to Europe. Most of the trade was with the north, over land and on the Niger river. Political entities became empires, empires broke up, new ones arose and spread. The area of what is now Nigeria was approximately three times that of the Italian region. There was trade all over the area. Writing (in Arabic) was part of the culture in the Northern part of the area, but not in the south.

> "By A.D. 750 at the latest, West Africa's past was dominated by the gold trade across the Sahara, and by the development of kingdoms and cities. . . . cities arose in northern Nigeria from perhaps A.D. 1000, while cities, royal residences and states are attested in southern Nigeria from A.D. 800 and later."
> (Vansina, 1984 p 11)

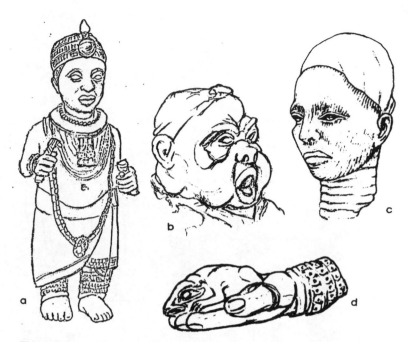

Figure 9.06. a. Bronze figure of an Ife king. b. Terra cotta portrait of an ordi-
nary citizen. c. Ife terra cotta head of a royal. d. Terra cotta fragment from Ife.
(a., d., after Eyo b. after Eyo and Willett c. MIA)

As Thornton (1992) has convincingly shown in his extensively re-
searched analysis of the early African trade with Europe, Africa in the
late 15th century did not lag behind Europe in terms of technology.
Farming was well adapted to the area, and more productive than
European farms. The Chinese reached Africa early in 15th century,
but ceased their expeditions by mid century. . . . The Portugese got to
the east coast of Africa at the very end of the century.

For more than a century "it should be emphasised, the trade was
largely one of partnership between Africans and Europeans. Both
sides gained. They bargained keenly with each other, but they also re-
spected each other" (Davidson, 1966). In the 15th century, what the
Africans wanted in exchange for the goods they sold were not tools or
necessities, but luxury goods. Their delight in new forms of textiles
has sometimes been seen as a kind of primitive childishness. But what
the Portuguese took back to Europe from Africa included as many
textiles. Why is the Silk Road called the silk road? It is not named for

Figure 9.07. Floor plan of the last traditional Yoruba palace. The smallest courtyards are impluvia, where rainwater was collected; they, too, had carved pillars. (after Willett, 1971)

any subsistence goods. The silk that was traded over so many thousands of miles was made into textiles.

Fine fabrics are to be found in all three areas and textiles were important items in trade. Chinese Emperors wore elaborate robes with the five toed dragon that was the symbol of the ruler. The elites of Nigeria wore fine cloths; Italian textiles were valued and traded abroad. They still are.

Extensive trade routes meant that not only were luxury goods transported over vast distances, but many ideas came along with them. When one looks at this period of creavitity in Italy we find that it was a time when trade was providing wealth to support the arts and also ideas from all of the Eurasian continent. By 1400 the merchants of Europe were using the new "Arabic" arithmetic. Half a century later when printing, derived from China, began, textbooks on arithmetic and nautical almanacs were printed. New ideas, new knowledge, and new materials all affected the arts, and the belief system they expressed.

In Nigeria, the kingdom of Oyo was prominent in the 15th century. Situated in the North, near the Niger river, it was active in the trade with northern Africa. The city of Oyo (now known as Old Oyo, as it was destroyed in the 1400s) was prosperous and from what

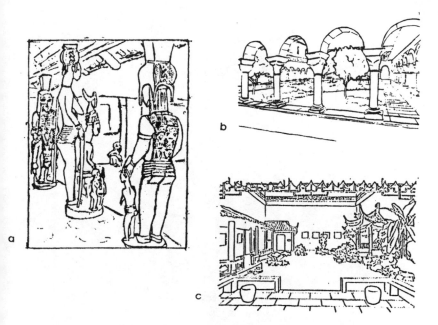

Figure 9.08. Courtyards. a. Nigeria, (Yoruba) b. Italy, (Florence) c. China, (Soochow) (a. after Delange b. after Piper c. after Howard).

accounts we have, well supplied with art. Stevens (1978) makes a good case for Oyo as the origin of the mysterious stone carvings found in a grove near Esie. No one knows who made them. In the middle of the 15th century, before the Portuguese arrived, the Oba of Benin had his city and the palace rebuilt to be an impressive capital for his expanding kingdom.

Thus the city states of West Africa gained in wealth and knowledge in a way comparable to what happened in Italy. In Benin "the town chiefs to be the *nouveaux riches* who rose to power by their own efforts, not through inherited wealth or connections" (Ben-Amos, 1980 p. 9).

Many techniques used for art works are similar in all three areas. Gold was worked by the lost wax process. Many techniques of metal working have been known in Nigeria since well before the 15th century. Iron working goes back millenia. All the basic techniques except welding and riveting were used. They could produce steel. Other metals used were copper, alloys of copper, gold and silver.

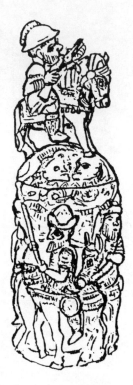

Figure 9.09. Afro-Portuguese ivory salt-cellar in the Benin style (after Ben-Amos).

The use of copper alloys goes back to at least the 9th century and provides evidence of the importance of trade because copper ore does not occur in Nigeria. The copper alloys that were used were various, and some of the fine works are technically brass rather than bronze, but considering the high status given bronze and the low given brass in our culture, I prefer to consider the artistic effect of Ife and Benin works, which is distinctly "bronze".

The bronze and terra cotta arts of Ife have been dug up and are beginning to be recognized as one of the Great Styles. The peak may have been in the 14th century, but continued into the 15th, when Benin learned from Ife. What was survived are works in copper alloy, ivory, and fired clay. Much is fragmentary.

City states in Italy and Nigeria had many things in common. The social organization was based on extended families who lived in large

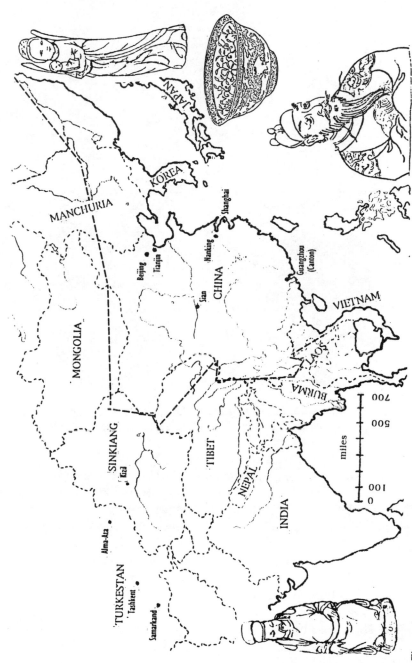

Figure 9.10. (----) China in the 15th Century.

Figure 9.11. Ming art in various mediums. a. Figure of a man, glazed terra-cotta
b. Textile. c. Cloisonne d. Porcelain bowl, blue & white. (a., b., d., after Grigaut,
et al c. MIA).

compounds in the city and owned farm land in the country. In Nige-
ria, family members, often the younger people, periodically went out
to work the farms, helped by slaves who were more like indentured
servants. The Italian families went to their country villas for vacations
and the land was worked by serfs. Cities in both areas had large mar-
ket places where a lot of lively and noisy activities went on. Money
was in use in Africa as well as Europe. In the African case it was the
women who bought and sold local goods in the market place, and
were in control of the operation. Women controlled the money they
made, and could become well to do. Men were the long distance
traders, and sold to local middlemen.

There were similarities in the palaces of the kings in the Nigerian
area and the Chinese emperor, although the scale was so different.

Figure 9.12. a. Benin Queen Mother with symbolic headdress (bronze) b. Chinese symbols of longevity (woodcut) c. Italian Renaissance lady representing Venus (painting) (a. after Ben-Amos b. from Williams c. after Black, et al.).

Figure 9.13. Sketch of a 15th century Ming landscape.

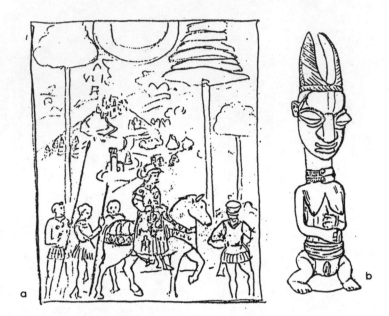

Figure 9.14. a. Sketch of an Italian Renaissance painting b. 18th century Yoruba figuine (brass) of Onile (after Gillon).

Many persons lived in the royal compounds of each: wives and children, priests and officials, eunuchs and servants. The rulers seldom left their compounds. They lived according to elaborate sets of rules of ritual and etiquette. They were dependent on reports of others for knowledge of what was going on in the kingdom, and on their bureaucracies to run the realm. But they could be arbitors and patrons of art works, and art could provide a form of escape.

A very visible difference between the areas lies in the architecture. Italy is a rocky land, and stonework is one of its artistic glories. China has a vast area to draw from, and the architecture is in both stone and wood. Nigeria is a land of rain forest and savanna, of trees, clay, and sand with only small amounts of stone to carve. The buildings were less impressive and less enduring. But in Nigeria, as in Italy, large houses and palaces were built around interior courtyards that were a focus of esthetic embellishment.

While there were similarities in many techniques, there were also differences. The Venetians and the Nigerians made glass, the Chinese made porcelain. Furthermore, different media are emphasized in

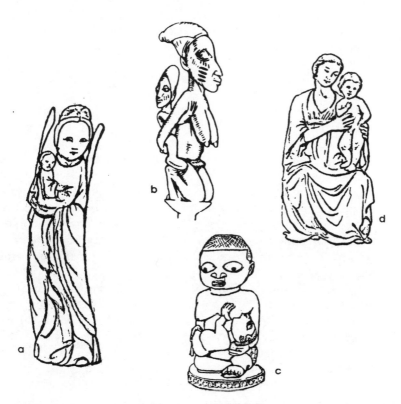

Figure 9.15. a. Kuan-yin, China, Ming period, ivory b. Yoruba mother and child, recent, wood c. Owo 15th century figurine, ivory. d. Early Renaissance Virgin and Child, Florence, Italy, glazed ceramic. (a. after Delaunes b. (PC) c. after Gillon d. after Piper)

different cultures depending on environmental and social factors. In other words, there are differences in esthetic focus. It is an ethnocentric bias to limit what is defined as Art largely to painting and sculpture that is "purely for esthetic contemplation." Carving in wood, which is today regarded in the art world as the most African of African arts and is highly prized if it is antique, must have a long history, and probably was produced in a variety of styles of great merit; but these are lost. In Africa, textiles, woven on many types of looms, were well developed, and were particularly important in the performance arts that were a main esthetic focus. Status displays of textiles at funerals are documented from the earliest contacts to this day.

Ivory carving had a long history in Africa, and there must have been a much longer period of wood carving before that. So by the time the Portuguese got there in the late 15th century they could buy the finely made and often elaborate carvings known as Afro-Portuguese ivories.

In China, painting was on a different plane than other arts, as it was so closely related to writing which was done with a brush, and so to the more elite world of scholarship. But arts labeled crafts were highly esteemed as posessions. Jade was the most precious, and given great symbolic value. The 15th century was the finest period for blue and white porcelain using cobalt imported from Persia, but there were also new ceramic wares in many colors, and there were a number of other technological innovations. Work in cloisonne (which came from Byzantine Europe) and lacquer began in this period. The latter was carved or used like paint. Later, after the end of the century, cloisonne and lacquer, as well as ivory carving and porcelain figurines became much fancier, showing off masterful techniques.

Art histories of China tend to accept the viewpoint that painting was the important art, and that the scholar-painters of the period tended to work in the styles of former, pre-Mongol times. But much creativity and innovation went into the "craft arts" in this period and one can still find some very fine small works in stone, bronze, iron, wood, ivory, jade, and ceramic. Another innovation was printing in color.

Iconography and Iconology

In all three areas the symbolic level was extensively developed. In a period when we have emphasized art for art sake, it is hard for us to realize the extent of the religious meanings, mythological references, social statements and information that were incorporated in each work of art in each of these three cultures.

The belief system of the scholar-painters of China rested on philosophical ideas that sought to bring together the various ideas of Taoism, Confucianism and Buddhism. As such a fusion, it was formulated on a very abstract level. While the great majority of the people accepted sacred figures from all these sources, most of the "gods" that are pictured functioned more as patron saints than as a pantheon. As in most societies there was a complete range from the most concrete and literal believers to the abstract concepts of philosophers.

In the Ming period the painters sought to convey the spiritual qualities that had been put forth by the pantheistic formulations of Master Chu in the Sung period: "Principle and material force are never separated but always work together as one because they are directed by the 'mind of the universe' which is the universe itself." This can be seen in the paintings as the near/far (yin yang), as the importance of silence and emptiness in the mists, and the way man's place is shown in relation to nature. The human figures are very small in the landscapes that were such favorite subjects.

In Africa the concept of the Vital Force is fundamental, and the arts symbolically represent the many ways this force is expressed in nature. The Chinese concept Ch'i is also translated as Vital Force. The Chinese and Nigerian views of humans as part of nature differs from the European view of man as apart from and seeking to control nature.

Landscape painting became more important in Italy during this period, but the landscapes were used to provide background for the human figures. The belief system of Europe was expressed in human terms, and the religious art was built of these symbolic forms. Patrons were often shown as worshipers of the sacred personages. In Nigeria, landscape is not represented pictorially, but is symbolized in a variety of ways. Figure 9.14b shows a Yoruba figure—Onile, Spirit of the Earth.

Kuan-Yin as Goddess of Mercy and Compassion has frequently been compared to the Madonna in Christian contexts. Africans also portrayed mothers with children, but they did not often make images of the deities. The figures portrayed often represented worshippers. As in China, ancestors were of tremendous importance, so the images of ancestors or ancestors as worshippers placed on altars or carried in procession were in both cases revered and sacred. The phallic emphasis in many African figures usually symbolizes ancestorhood.

Kuan-yin was considered to be the incarnation of Amida Buddha, who "listens to cries [prayers]." In earlier times, this deity was often portrayed as a man, but later usually as a woman, the protector of children. Many myths from various traditions are told about her. The Christian saint also has a varied history, and accumulated many myths. It will be noted that the symbolic functions of the two are very similar. The Yoruba mother is shown as a worshipper on a staff that is part of the ritual. We do not know the symbolism of the Owo figure, but the eyes are characteristic of the style, and so do not indicate that she is surprised to find a baby at her breast.

The histories of art in China and Northern Italy have a certain similarity in that one could consider the 1400s as a kind of Classic

period, with later works more elaborated. But looked at from another perspective, the 1400s could be considered the last flowering of the old period before the world expanded and the great oceans became highways. Which of these three areas were colonized in the 16th century?

The Ming Dynasty continued until the Manchus came down from the North, and the Europeans from over the seas in the 16th century. In the period art historians marvel at as the High Renaissance, Italy was all but devastated by French, Swiss, German and Spanish invasions, and mostly became a colony of Spain. In West Africa this was also a kind of flowering before the slave trade became devastating, and Europeans rationalized their actions by developing the theory that Africans were inferior.

These three areas and the situations of those times bring out many of the questions about the relationships of the arts to other aspects of society and especially the conditions that bring about the periods of fluorescence. Muller sums up the contradictions of the Renaissance:

> "While the humanists celebrated the wisdom and virtue of the ancients, political and economic life in Italy became more brutal and sordid. While they recommended the golden mean, men rmained devoted to medieval license and excess. The Renaissance produced the ideal of the courtier, the perfect gentleman so charmingly described by Castiglione, and it also produced the mercenary and condottiere, who were

Figure 9.16. Mars and Venus, detail of a painting from Mantua. (after Black, et al).

glorified as 'soldiers of fortune.' It was an age of treachery and devotion, brutality and civility, vice and grace, all fired by a love of gold, of beauty, of pleasure, of fame, and sometimes of God" (p 266).

Others have commented on these contradictions, and this provides us with a rather surprising hypothesis with regard to fluorescent periods in the arts, but is consistent with the ideas of Kavolis (see the end of Chapter 4). The 15th century in China was marked by a great contradiction between the expansionist, glory seeking ambitions of the eunuch faction, and the consolidation, internal development concerns of the scholar-bureaucrats. It also was a time of "treachery and devotion, brutality and civility." We do not know what the contradictions were in 15th century Nigeria, but there was warfare and elegance, and one suspects quite a lot of the rest. So, if this hypothesis is meaningful, a lot of art will be produced globally in the 21st century. The question remains concerning the factors that bring out the best in quality.

Chapter 10

Globalization: The 20th Century

Figure 10.1. Zheng He's Chinese treasure ship, 400 ft long, early 15th century; Columbus' ship Santa Maria, 85 ft long, late 15th century. (after Levathes).

At the end of the 1400s the areas of conquest became larger as the maritime technology of Europe started the global age. This might have been a Chinese expansion as the maritime trade of China was extensive, extending to India and Africa. There are early Ming blue and white porcelain shards in East Africa, and the textile trade with Indonesia was established. But China decided against colonialism.

The idea that it was superior European technology that made Europe so dominant must be tempered by the knowledge that some of the most important basic ideas—the compass, firearms, printing and paper came to Europe from the Chinese sphere. And knowledge of astronomy, geography and navigation from the East via the Muslims.

The political dimension known as the Colonial period is very much like previous political expansions but just on a wider, world-wide scale, and across the seas as well as over land. If we look at the changes that took place after 1500 without putting the emphasis on the political dimension, we can think of what happened in terms of all

229

the new contacts that were made between peoples of different cultures.

Emphasis is often put on the effects of European contacts on African, American, and Oceanic cultures, but people everywhere adapted in many different ways. The peoples that the Europeans came in contact with were not simply passive victims and recipients of the new things, new ideas and new ways that came to them. They adapted to the new circumstances as best they could. And they adapted their arts as well.

Change happened to Europe as well as to the lands the Europeans "discovered." European life changed in many ways. The Italians added tomatoes to their cuisine. Marco Polo had already brought back the idea of pasta from China. The Irish got "their" potatoes from the New World. The Chinese and the Africans got maize, areas near the equator got chili peppers.

European artists were much interested in the arts that were brought back from across the seas. Durer and other artists saw the gold work brought from Peru before it was melted down. Durer bought two Afro-Portuguese ivory salt cellars. After 1500, great quantities of an export grade Ming blue and white porcelain was brought to Europe in European ships. We still call porcelain dishes "china." Eventually China exported unglazed dishes to Holland, where blue and white Chinese style painting was added. Did they get their cobalt from Persia, where the Chinese first got theirs?

The new wealth and new ideas that contact with so many parts of the world engendered, and the problems that resulted led to the Industrial Revolution. The continuing and accelerating technological changes have meant that people and ideas get around more rapidly, and history and art history become increasingly global as we look at recent centuries.

Can we use the ideas sketched in the pages above to help us better understand the arts of large, complex societies, even post-industrial ones? And what is the role of art in an interrelated multicultural world?

The increasing contacts that occurred in the 16th, 17th, and 18th centuries have been described largely in terms of the explorations and colonizations of Europeans, and in our literature, mostly from the European point of view. In the 20th century, changes in technology have increased the pace of the interactions, and the interchanges of peoples and ideas. So in one sense, the 20th century is part of a continuing process, but it is also a very new world as a result. So there are many differences, and the arts produced are different. This leads us to

ask questions about the relationships of art to the rest of culture, and how much that we have considered in the original chapters above has any meaning for the present.

But while globalization was a continuing process, the 19th century makes for us a kind of "ethnographic present" when many traditional arts and crafts were relatively uncontaminated by the industrial revolution. In fact, much of our knowledge and many of our assumptions about "primitive" cultures come from this period. It will be noted that the Euro-American definition of "progress" rests on assumptions about Christianity, and the primacy of technology in the form of artifacts (like the plow and the frame loom).

In the European world the end of the 19th century was marked by several very different artistic movements and responses to scientific interests and industrialization. While the tradition of European representational art continued, and, some would say, reached a peak of excellence in the Victorian period, the high valuation for what was new put it out of fashion by the 20th century. So for the sake of contrast, and for the way contrasts can bring out questions with regard to art as part of the culture even in a rapidly changing world, I offer an overview, a quick sketch, of the 20th century.

Such a sketchy treatment seems impossibly simplistic to those of us immersed in our times and to art historians who have learned so much about art and artists, but the sketches of the arts and cultures of even the smallest societies treated above are also great simplifications.

The 20th Century

If we consider the arts of the 20th century in a sweeping fashion as we have those of the 15th, we can see several themes that run through it. Looking at the global picture, the most obvious changes have to do with technology, and, at least in the "developed" world, a reliance on technology for most problems that arise. A good case can be made for the proposition that this system has become a "deviation amplification system" (p.164).

Technological changes affected the arts in many ways, so change was more rapid. Artists had mixed and ambivalent reactions. The periods designated as Impressionist, Post-Impressionist, Expressionist, Modern, Post-Modern, etc. are closely intertwined with the scientific and technological changes of the times, just as the introduction of oil painting was important in the Renaissance. Scientific interest in the nature of light affected 19th century artists who became interested in

Figure 10.2 Modernist combinations of different points of view.

the effects of light outdoors. Some of the effects are direct, as, for example, when photography, film and video are used artistically, or new pigments made the vivid colors of the Expressionists possible. But some effects are very subtle and full of the contradictions, compromises and ironies that come about when humans try to deal with the problems brought by rapid change.

Modernism has been described as a period of preoccupation with and emphasis on fragmentation and discontinuity, such as subatomic particles, DNA, Pointillism, Minimalism, digitalization, individualism, etc. Post-Modernism in some ways continues this trend, but there are sporadic attempts to put things together, construct grand theory, or combine different traditions.

> "In the 20th century 'newness' was embraced wholeheartedly as a desirable quality, sometimes for its own sake. To be new meant to be modern, and to be new and modern spelled a rejection of convention, tradition, and the past. For the modern artist, feelings and personal insights provided a way out of the strict conventions taught by the traditional art academies. By looking within, artists and writers could transcend what they considered the repressive constraints of the social world.
>
> This emphasis on the subjective self fostered at least two fundamental elements of modernism—a belief in the heroic efforts of the individual, and a high value on uniqueness. As artists labored to bare their inner souls, each artist necessarily forged a new and different visual vocabulary. Personal expressiveness became the ideal."
>
> (from a gallery caption: "**Visions in early American Modernism**": in a 1994-95 exhibition of works from the

Figure 10.3 Modernist use of exaggeration and distortion to express inner feelings.

permanent collection of the Weisman Art Museum, U of Minn.)

It should be obvious that this attitude meant that communication with others and the social functions of art were not primary concerns. We were told that it was up to the viewer to learn to understand and appreciate what the modern artist was saying. What the artists were saying was that art had to change because everything else was changing so rapidly. Paris and Rome and New York were the centers of this activity, and even within the industrial world other places were regarded as regional (provincial).

Photography was interesting, even exciting, but with photography to do a realistic representation and record the visual, why should the artist do it? Interest in mathematics had affected the Renaissance artists who developed linear perspective. Linear perspective shows a scene from a particular point in space and time as photos do.

So modern artists tried showing things from several points of view, combining what one saw at different times.

An Italian version of Modernism was called "Futurism," which was marked by preoccupation with the nature of motion. This would seem to be related to the technological innovations of the period, but their stated aim was rejection of logic and rationalism as they sought to express inner emotion, much of which was a negative response to their times.

So much change in the arts lead to the questions as to what art is for, and the answer was that art was for art's sake alone, a value in itself. This led to the analysis of the formal quantities of art, the forms

Figure 10.4 Feeling communicated by the esthetic
quality of rhythm.

and colors and their interrelationships, without any subject or sym-
bols; abstract. In this, many were influenced by music, which does
not have to have a "program."

The Modern period can be looked at as a search for the pure es-
sence of the esthetic which culminated in Minimalism in all the arts.
This effort can be seen as closely related to the Western lust for abso-
lutes, the scientific efforts of the time to eliminate multiple factors in
the laboratory, and the philosopher's efforts to find pure and exact
meanings for individual words. So the analysis of the formal elements
in the visual arts led to exploring the effect of a single quality like
color or shape.

The modern art period with its stress on individual angst can be
looked at in the light of the discussions above of the artistic personal-
ity (Chapter 4) and art as feedback (Chapter 6), with regard to the re-
lation of art to perceived problems. But the relation of art to society
during this period was perceived very differently by different seg-
ments of the world society.

> "Abstract art in the Western Modernist styles became . . . a
> signifier for Western culture's claim to universal validity. Per-
> haps this is why it is still under a special taint of colonial sub-
> missiveness in much of the third world."
> (McEvilley in Vogel p 271)

In retrospect, the claim of universal validity seems a most curious
claim for a period when the emphasis was on self-expression. But the
arrogance of the Modernists was not simply ethnocentrism. They saw
the problem to be the constraints of society. One of the reactions to

Figure 10.5 Futurism an expression of motion.

this was the attraction of the primitive, which they felt was closer to nature, and freed them from traditional forms of representation, and so free to express basic human emotions rather than the superficial values of civilization. Some saw themselves as helping to create a new and better world, not realizing that industrialization might not always lead to the individual freedom they valued. This may seem a contradiction to the idea of art for art's sake, but there were many ways of looking at the world and at art in this period of change and experimentation.

But there was also an ambivalence about technological "progress" which also means an ambivalence about the "primitive." The admiration for "tribal" art has meant a lot of myths and assumptions about "traditional" societies, as the admiration means a projection of one's own desires more than a desire to understand other ways of life.

During the "Modern" period, people in small societies all over the world had become parts of larger societies. Some of the more remote ones retained much of their traditional cultures before WWII but of course they did not remain unchanged. While change was slow, we have too easily assumed that people in remote societies were slaves of custom. Many of the accounts in the body of this book come from

Figure 10.6 Paintings exploring purely formal qualities.

this period, but they should be considered as snapshots giving glimpses of the ongoing histories of each area.

However much regionalism and ethnicity were considered passe by the proponents of the International Style, many artists in many places were not only continuing their traditional arts in a variety of ways, under a variety of influences, but exploring new directions. At the same time, growth in travel increased interest in traditional arts as curios. An interesting change took place in Bali as the ancient Wayang style of painting gave way to a new—but still very Balinese style under the influence of Western artists. This new style is now referred to as the traditional Balinese style.

In West Africa a few arts, especially traditional wood carving, found a market, or rather were garnered for export. Copies of well-known carvings began to be made. Some carvers were known for their work in traditional style, but many sold (and sell) to dealers who put them on the market as old and "functional." African artists went on producing an enormous variety of textile products, and importing and modifying others. The performing arts continued, with additions of new materials.

In spite of the feelings about colonialism, many African artists were influenced by the various styles of the modernist period. Some studied abroad and worked in European styles. Traditional Yoruba style was adapted for use in Christian churches and on public buildings. Painting showed the most influence as it was essentially a new medium in the area. Many wood carvers continued to produce traditional styles, but some changed in the modern direction.

Figure 10.7 Minimalism.

China has had an extraordinarily varied history during the century. During the earlier years when China was a republic, it was largely more traditional "Western" art that influenced Chinese painting. The traditional Chinese painting styles were modified by more color and freer treatment.

In the Maoist period, "Soviet realism" with brawny workers and smiling peasants, and of course Chairman Mao himself, dominated the scene. There were, however, some interesting continuations, as when the traditional landscape paintings included smoking factories, or hoards of workers building roads and dams. The title of one work suggests the extent of the change in basic philosophy.

In spite of the perception of rejecting "the repressive restraints of the social world" the artists of the developed world were very much a part of it. They still depended on patrons, although not always so directly. Corporate skyscrapers house art as well as temples and palaces. Our museums and galleries celebrate the individualistic artist, and often the name seems to mean more than the art.

Much of the acceptance of the "modern" was for the sake of the value of newness and being "in." The emphasis on the individual and on novelty in the industrial world tied in with the concept of "progress." Styles succeeded each other very rapidly as artists explored ways of expressing feelings and relationships without representational imagery. But out of all these attempts at newness came a far greater vocabulary to be used by artists who had something to say that could have meaning for a larger part of the society.

Gradually, as the experiments of artists incorporated their various ideas of the "primitive," the eyes of art patrons became more used to

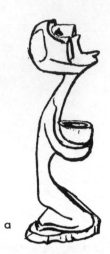

Figure 10.8. Modern influences on Nigerian art. a. A traditional woodcarving subject in a modern style. b. A small ceramic plaque made for sale combines traditional figures with a modernized lion. (a. after Mount)

other forms of representation, and so in time, more persons were able to see value in ethnic styles that had seemed so impossibly strange. Artists have been important in getting people to see "idols" and "curios" as art, not only through their own work, but by their acceptance of those arts. So perhaps one social function of the arts is a matter of helping people to accept cultural diversity.

POST-MODERNISM

With the increased pace of globalization, the awareness of the diversity of human ideas and beliefs causes questions and confusions. The rapid changes give rise to "future shock" and a variety of ways of trying to retain what is valued from the past, and what one finds attractive in the new. Appropriation became a buzzword. What are artists trying to do? What are they saying?

All the questions about the functions of art are very relevant, and even acute in this period. The psychological functions of art (Ch 4) may not have changed very much, but the social functions (Ch 8) have. The ways art served to "hold society together" do not work very effectively in a global, highly diverse society of ever increasing numbers.

The current "Post-Modern" period in the arts is marked by an enormous amount of experimental eclecticism. This means the in-

Figure 10.9. a. "Chairman Mao Walks all Over the Country," painting. b. Simplified outline of a painting titled: "Man Conquers Nature." (a. after Smith, et al.; b. after Nebiolo)

clusion of a great deal from other ethnic traditions as well as from Modernism and the more distant past. One can see examples of appropriation from many areas in Post-Modern works. Not that this is new (Ch 7). After all, there were influences from Japanese prints on Art Nouveau and Impressionism and of African masks on the "Modernists." And further back there were many influences on Renaissance art. But the extent, explicitness, diversity, and rapidity are more marked today. The result is enormously varied, making it almost impossible to pick out any kind of representative sample.

In a long term view, the late 20th century seems simply a continuation of the experimentations of the "modern" period. But keywords used indicate the kind of shift that has taken place. "Self-expression" has given way to "appropriation" as artists admittedly reached out to what others had done to incorporate in their own work.

Appropriation from the arts of any time and place depends on access to the arts of other times and places available to the artist, and with the information explosion, all artists now have easy access to art from all over. This access is not limited to the developed world.

All over the world artists trained in universities and art schools copy, imitate, or combine any and all of the 20th century and previous Western styles, in one way or another. A few years ago a show billed as fisherman's art from China proved to consist of the products of an art school in a fishing village, demonstrating a considerable range of modern styles.

Globalization is so extensive that many of the same trends can be seen everywhere. Everywhere there are traditionalists producing art in the styles of the past. Sometimes they would like to modify or change them, but many of their patrons will only buy traditional forms, whether realistic paintings of ducks and geese, African masks, or Chinese birds and flowers.

In many cases tourists have kept traditional crafts going, which has kept the craftsmanship alive. But there are also imitations of completely alien objects for the tourist trade. If something sells well in West Africa, it may be produced in Kenya, which has been done with the "akua ba"

"Post-Modern globalism is less alchemic in it's ideology than Modernist internationalism was. Instead of attempting to melt divergent things down to a Prime Matter of School of Paris or New York School homogenization, the post-Modern project is rather to focus one's particularity with as much clarity, wholeness, integrity, and intensity as one can,

Unnumbered Figure.

Figure 10.10. Sketch of a painting "Competition" by T. E. Chen . . ." [the] delib-
erately blatant mix of images and styles from different periods and cultures indicates
the cultural relativism and egalitarianism of the era" (after McEvilley in Vogel).

> while still finding a way to inject it into the international dis-
> course: a way, in effect, to make it useful to others, to make it
> readable or relevant to receptors of other ethnicities. In the
> process, all values—identity, artistic quality, cognitive
> stance—are reshuffled in a shifting and insubstantial relativi-
> zation in which all the cards become wild." (McEvilley in Vo-
> gel p 271)

One central idea in Modernism was the idea of self expression—the
"culte de moi." Post-Modernism, on the other hand, often gropes for
the connections with the mystic, and with community that is felt in
"primitive" and folk art. Furthermore, with the broadening of the
definitions of Art, cooperative craftsmanship is now coming more to
the fore. However, it is often still based on the same premise: the desir-
ability of complete freedom of individual expression, and sometimes
the belief that new and different are desirable, part of progress. It is
also a matter of rejecting whatever an older generation has taught. This
is in marked contrast to the 15th century, particularly in China.

In 1987 a Chinese artist put a copy of a book on the history of Chi-
nese art, and one on Western art in a washing machine, and showed
the result as art.

Unnumbered Figure

The Post-modern, like the Modern, often aims to throw out the past. But accounts of Chinese contemporary artists reveal a similarity with the scholar painters of the 15th century:

> "On the one hand they concern themselves with the theories of Nietzsche, Wittgenstein, de Saussure, Freud and Popper as well as with contemporary styles of art like peasant painting, happenings, installations and performance, whilst on the other hand they are also attracted by Eastern [Daoist and Zen Buddhism] elements of modern art."
> (Liu Weijian in Pohlman 1993 p 59)

Post-Modern artists in the rest of the world are not usually so conversant with philosophical writings.

Much art in this century has been some form of protest, as the ideals of "liberte, egalite, fraternite" have spread widely, but the realities have not. Of course, when the restrictions are intense, as in Maoist China and present day Nigeria, such art is not often displayed openly, but it can take a subtler form statement as in Michelangelo's "David" made when Florence was losing republican form.

One can easily interpret the Post modern appropriation of art forms from other cultures as a way of accepting diversity. The idea that art functions to provide "trial balloons" for new ways of conceiving relationships is relevant here. But there are some curious ways in which the them/us habit of thinking makes us react differently to the styles of other peoples. For one, the eclecticism of our artists is considered clever and inventive, but it is regarded as a shame for others to abandon their traditions. Such attitudes even extended to Chinese works. After the Cultural Revolution:

Figure 10.11. After a photograph in Pohlmann.

"It was argued that if modern Chinese art wished to prog-
ress, it had to learn from the West; however, as soon as these
influences began to appear, the work was dismissed as deriva-
tive or pastiche." (Elliott in Pohlman 1993 p 7)

But artists and craftspersons everywhere have access to almost as
much of the world's art as contemporary artists of the "developed"
world. They are all Post-Modern in that sense now. They cannot for-
ever be primitive and folk and let "us" be the creative, innovative
ones.

The Western European culture area, which in the early part of the
century laid claim to being the avant garde, shows some evidence of
looking more to the past as the tension between traditional identity
and globalization affects the arts in various ways.

"Modern Italian art has experienced the persistence
through many styles of a tradition which combines Classical
antiquity with Christianity, the Neo-Platonism of the Renais-
sance with effective traces of the continuing Graeco-Roman
world for which the Mediterranean and its enduring color,

Figure 10.12. "Silence," wood sculpture, Post modern protest art (Chinese), (after Pohlmann, 1993).

> light and natural redemptive power remains a central symbol."
> (Griffiths 1989)

Developments in Africa are slower to be recognized because most of the patron world wants the "primitive" and "tribal" from this area. As can be seen in any issue of *African Arts*, all the efforts of the writers of articles to consider the arts of the area as history, and as ongoing history have been until very recently completely ignored in the advertising section. Magnin says:

> "...African art is still marginal in terms of the world scene, both in the art market and in recognition from institutions that play a major role in the process of legitimization—the leading museums of contemporary art, international art galleries, the great private collections of contemporary art." (1996 p 8)

In all areas we see continuations of tradition, various combinations of art school Modern styles, appropriations of folk art, and a lot of commercial art. Looking at what I find illustrated in available sources, I am struck by the similarities and differences in these global

Figure 10.13. Broken plaster casts with string (after Griffiths).

expressions. All include forms of protest art in reaction to the various kinds of establishments. All seem to include very realistic or superrealism as if in reaction abstraction. The eclecticism of the Post-Modern period makes for an extrodinary diversity in the art scene. The craft arts that had been largely ignored by the purveyors of Fine Art are now displayed, including quilts and other fiber arts, even knitting, multimedia works and works in glass. In the "Western" world, Landscape art is back in favor after being scorned during the abstract period. This may be related to concern for the environment. The Impressionist style, long rejected as outdated, is esteemed again. It has a much wider appeal than the experiments of the Modern period, and so can be seen as part of the trend toward a more democratic approach that is evident in the acceptance of more kinds of art.

How does art function for the individual so that it improves the quality of life for the many, and so is good for the society as a whole? Will art become so globalized that there are very few differences in what is produced in Africa or China or Europe? When one considers art in terms of problem solving, it seems hardly likely, as the problems vary so much from country to country.

And there are still evidences of the long traditions in different areas. The overall effect of the Chinese work is of a very cerebral approach, and some disillusion. The African, on the other hand, is more organic, and often with a special kind of wit, as well as bitterness. Like the Chinese and European explorations, African contemporary art shows great diversity. Africa is an area of great contrasts, with modern

cites with skyscrapers, universities and hospitals, TV and internet. Paintings show a variety of styles, and the best known Nigerian ones are very complex, with many figures and detailed patterning.

One of the current trends is the use of materials that were not part of the Fine Art tradition. But African artists seem particularly inventive in the use of found (scrap) materials, and combinations. African artists also explore the uses of industrial materials. Cities are full of hand painted commercial art, in both naive and more sophisticated styles. In Nigeria the graves of important personages may now be marked with highly realistic concrete portraits, painted with acrylic.

In Africa there are also continuations of traditional styles in many rural areas. There are also fine traditional craft arts that are in some cases sold for export. For example, in Northeast Nigeria gourds are decorated in a variety of techniques and styles. Some arts, traditional in many parts of Nigeria, are new elsewhere. It would be a mistake to assume that all learning is from the "developed" world. For example:

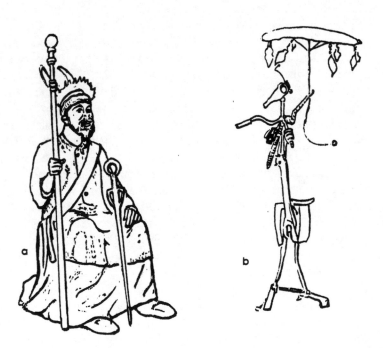

Figure 10.14. a. Realistic statue of a chief for use at his grave site. b. Found objects and mixed media (Benin) (a. after Vogel; b. after Magnin).

"In spite of a historical near absence of masking practice among the Tiv people of Nigeria, . . . the use of carved wooden masks and figures has found new and fertile expression in their contemporary puppet and masquerade theater" (Harding 1998, pp 56-67). In this example, (b), head and body are carved from a tree trunk; the sleeves are cloth.

The emphasis on diversity can be seen in museums of the developed world in Post Modern times. Ethnic is "in." This includes various forms of folk art, or, as the Chinese elites once called it, "the small skills of carving insects" (Berliner 1986). Even in the Maoist period, a variety of forms survived in China, and souvenirs for tourists have helped keep it going. Paper cutting, shadow puppets and embroidery are the best known, and some are of impressively high quality.

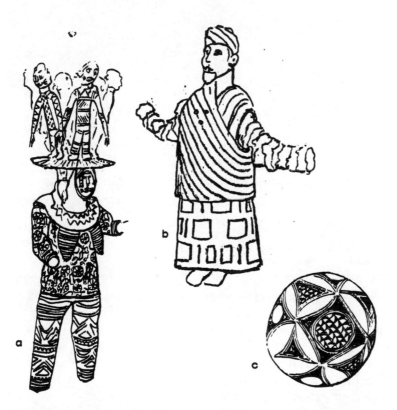

Figure 10.15. a. Odogu (Ancient Mother), headpiece and costume done in cloth applique and embroidery. b. Tiv carved mask of an elder. c. gourd decorated by pyroengraving (a. after Borgatti; b. after Harding; c. after Berns and Hudson).

Figure 10.16. a. Chinese paper cutting. b. Chinese shadow puppet. c. Chinese embroidery (a. after Menten; b. after Berliner; c. after Stalberg).

At the present time, it is often hard to make a clear distinction between folk art, tourist art, and export art. Differences in price often reflect what is at any time considered "important" or "in" as well as, or even as much as, esthetic quality. Many charming and some fine works in various mediums are being produced for sale if one looks at the art itself with an open mind.

Of course there is a lot of junk being produced everywhere—in the products of art schools as well as in bush factories making souvenirs. Experiments do not always work. There was also a lot of junk being produced in the past which has usually disappeared. But with all this

Figure 10.17. Sketch of a small colorful batik of market women recently made for sale in Nigeria, where many kinds of decorative textiles are produced.

global diversity it is not easy to determine what will pass the test of time.

Artists may become artists out of an inner need to express themselves, perhaps in response to needs in their societies. But they have to eat, and if they are going to get much done, they have to have support. An important form of patronage is the buyer of modest means particularly before the artist establishes a name.

Fluorescent periods in art depend on patronage. But why do patrons buy what they do? Of course prestige is big, and therefore the label of "important" supplied by dealers. They also respond to their inner needs. So many buyers of African art do not want contemporary African art that communicates the agonies of colonialism, nor the current problems of adapting to the modern world. That's what patrons in the modern world want to escape.

Patrons tastes have been shaped by the values of their cultures, and esthetic values are somehow related to other values, and to the metaphors, verbal and otherwise, that express them (see Ch 8). To learn about these is an aid to understanding and appreciation. The arts of other cultures can express values that some feel are lacking in their own.

As to the functions of art, there is much to be learned. In the industrial world much of the creativity goes into advertising which probably serves more to divide than unite. The communities that share synthesizing symbols now are network communities that crosscut geographic settlements. But art is being used in many places as a form of communication in the negotiations as to the nature of changes. Many innovative forms, considered in terms of what they

Figure 10.18. a. Composite sketch of Web angels b. Sketch of a T-shirt advertised by a net-work community on the Web.

communicate about relationships, can be considered as trial balloons for their usefulness in conceiving new forms of social organization, and new attitudes.

There has long been a push toward identification with a nation state and a pull of one's home town or region. With the additional effect of globalization and the increase in network communities one can see how people and art become increasingly difficult to categorize. This shows up in the arts as regional styles interacting with post-modern eclecticism. Traditional mediums such as painting in the "Western" world, and masquerades such as those of the Tiv, tend to foster local identity. But new mediums and mixed mediums tend to appropriate from past times and other places.

The new electronic media increases globalization, but also increases diversity as network communities become increasingly important, and local communities less so. The assumption that world wide access increases togetherness ignores the diversifying effects of the number of individual choices that are available on cable TV and the World Wide Web. This diversification can also be seen in the visual forms that are presented, and many different messages are transmitted in very different contexts.

The new electronic media, especially the World Wide Web, foster network communities that present a proliferation of solutions for present day problems. Here, too, the visual arts include old forms and various combinations, but the potential of the media for special effects is beginning to be an important trend. Such images can be

Figure 10.19. Commemorative works from any time or place show a resemblance to the one remembered.

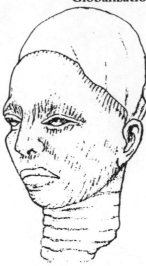

Unnumbered Figure

accepted as reality, much as in the past sacred power that has been at-
tributed to art in the form of statues.

Among the educated elites of "Western" societies the implication has
for some time been that education about Fine Art and development of
taste is good, and good for people. Many persons have given much
money, much Art, and/or devoted much time and effort to provide
museums that would further this good for the society. But the assump-
tion that exposure to the finer things would be uplifting for the masses
does not seem to have resulted in much change. In spite of all the efforts
of museum people to make their institutions more entertaining and
more accessible, the people who come are for the most part the elites
and children of the elites. This is, however changing markedly.

The museums have come to play an important role in presenting
cultural diversity as exemplified in art forms. Outsider art is in. The
arts of Africa and Oceania and native America are no longer simply
lumped in a section called "primitive art." And with the aid of video,
they are able to provide something of the contexts. I am delighted
when I see some child absorbing these things, and hear remarks like
"I didn't know they had kings in Africa." Thus museums provide an
important social function, because art opens up at least a beginning
of understanding.

But this great opening up of our definition of what is art, and the
efforts to provide context, present museums with enormous prob-
lems, and drains upon their resources in money, space, and expertise.

One of the difficulties lies in the realm of esthetic evaluation. Are we to make no judgements at all with regard to excellence? A certain amount of folk art is presented by art establishments as amusing. It is imitated by art school trained artists with a combination of nostalgia and ridicule. Naive art by minorities tends to be considered delightfully quaint.

With the new emphasis on diversity, and in discovering arts from all over, can we rid ourselves of snobbery about "the work of small insects," and the confusion between originality and esthetic excellence? But what kind of standards can be worked out that can be applied to all this Post-Modern diversity? How can we deal with an art game in which "all the cards are wild?"

Perhaps we have a new game to learn and the cards are reshuffled, but they are not all wild. There are some interesting cross cultural similarities relating to the functions of the arts that are illuminating. As noted in chapter 5, art acts as an escape and safety valve for individuals, and it provides a pleasure bond by decorating the spaces in which people gather together. Art still metaphorically and symbolically communicates values and provides trial balloons for ways to change social structures and values. There are some similarities of form and function in a great many societies, but the kinds of society have changed.

As was discussed in Chapter 8, it is by learning about the meanings of art in other times and places that we can rethink our ideas and remake our judgements. One approach to this "new game" is the one mentioned above. One can put aside one's initial esthetic reaction, no matter how acute one considers one's taste to be. For natural ability is inevitably shaped by what one experiences and what one learns. To put all this aside and try to learn all one can about the other aspects of an art form: context, ethnoesthetics, craftsmanship and all the levels of meaning, tends to give a new perspective in which the qualities of the work can be better evaluated.

Returning to Chapter one above, we can look at the components of art and ask about any work:

1) Did a high degree of craftsmanship go into it?
2) Does it have something meaningful to say?
3) Does it arouse feeling- is it "an affecting presence?"

As Grieg said about music: "What is so-called originality, so-called novelty? It isn't the most important thing. The most important thing is truth of feeling."

Ethnographic Notes and Index

The following are brief descriptions, arranged alphabetically, of the various cultures that have been mentioned in the text. The examples used have been chosen because the styles are well represented in museums, and the published material is extensive and easily available. The examples most often used are named in **boldface,** and throughout this index page and figure numbers are included to help round out the picture without too many repetitions. A few references are provided for further information.

Abelam, see **Sepik River.** Fig. 6.01

Algonkian, p. 23; Fig. 2.02, 3.10.

Algonkian is a language family widespread in northeast North America. The people more specifically referred to by that name lived north of the Iroquois; they were woodland hunters in the sub-arctic area.

Ref. Spencer, Jennings, et al 1977.

Amazon, p. 36; Fig. 2.10.

Not much is known of the prehistory of this vast area. Very little has been preserved in the archeological record, as stone is rare and organic materials quickly disappear. In some ways the numerous tribal groups were comparable to those of New Guinea, with emphasis on the ceremonies connected with feuds and headhunting. In some areas the entire village was housed in a single thatched structure. Perhaps because villages were moved with some frequency, houseposts and other wood carving does not seem to have been important. The arts were, and are, for the most part ephemeral.

Ref. Steward and Faron 1959; Meggers 1971.

Andean. p. 10, 30, 35, 36, 57, 65, 67, 78, 109, 126, 168, 193; Fig. 2.10, 2.11, 3.08, 3.10, 3.11, 3.13, 4.01, 5.07, 7.08, 7.15.

This area of South America was probably not politically unified until the time of the Inca Empire, just before the Conquest. However, like the civilizations of Mesoamerica, of India and of China, there was a cultural unity and local development of socio-cultural complexity that makes it one of the great pre-industrial

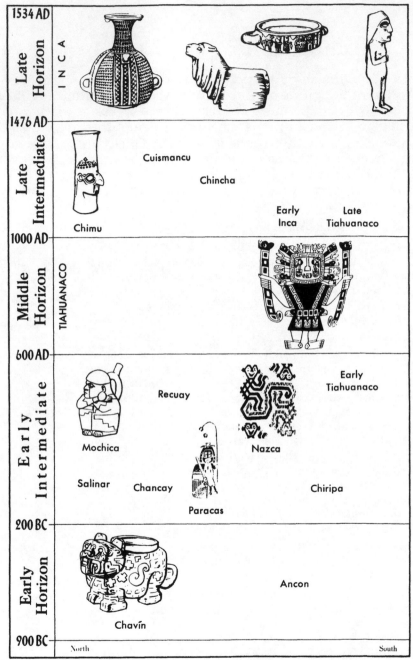

	North				South

1534 AD — **Late Horizon** — INCA

1476 AD — **Late Intermediate**
Chimu Cuismancu Chincha Early Inca Late Tiahuanaco

1000 AD — **Middle Horizon** — TIAHUANACO

600 AD — **Early Intermediate**
Mochica Recuay Nazca Early Tiahuanaco
Salinar Chancay Paracas Chiripa

200 BC — **Early Horizon**
Chavín Ancon

900 BC

Principal periods of Andean Civilization with a few styles illustrated.

civilizations. The growth in complexity from tribal culture started along the many rivers that came out of the mountains and cut through the desert to the coast. Management of irrigation systems and trade up and down the waterways and expanding populations led to the development of kingdoms as it did along the Tigris and the Euphrates, the Nile and the Huang'ho. Increasing trade and contacts continued the growth. By the time of the Inca, many pre-industrial craft techniques, except for the working of iron, were well known. Andean crafts developed more in terms of skill and knowledge than in mechanical inventions; their technically impressive works being accomplished without the use of metal tools, the potter's wheel or the pedal loom. As a result of the extraordinarily good conditions of preservation, there are a large number of fine textiles from before the time of Christ which show a range of skills and techniques unexcelled anywhere in the world. Such gold works as was not melted down by the Spanish continues to astonish us. The main periods, names and dates are summarized on the chart on the opposite page.

Ref. Stewart and Faron 1959; Keleman 1969; Dockstader 1967.

Arapesh, see **Sepik River.** Fig. 4.07.

Arnhemland, p. 4, 16, 39, 74-75, 151, 160; Fig. 1.01, 1.07, 2.12, 2.13, 4.08, 5.02, 6.08, 7.12.

This area of Northern Australia is the homeland of a number of hunting and gathering bands with various tribal names (Murngin, Gunwinggu, etc.) but a generalized description will serve our purposes here. The people of this region share the basic ways of life of all the Australian native peoples, often called "Aborigines," but with variations due to the environment and to some contact with outside peoples before colonization. This is the one area outside of the desert regions where the native life remained sufficiently intact to be described enthnographically in recent times.

In Arnhemland there is a very wet season that alternates with a dry one. The wet season is one of scarcity, the dry of plenty. This environment is reflected in the myths, as all Australian mythology is closely related to the specific homeland of each group. Rain also produces trees that provide large sheets of bark for shelters and "canvases" on which to paint. Such

paintings are less ephemeral than dancing, body paint-
ing, and other arts except rock painting, and
furthermore are portable and collectible, and hence are
particularly well known to us.

The social organization is almost entirely a matter of
kinship, with complex patterns and rules that are the
delight of social anthropologists and the despair of
students. This kinship system is oganized into
patrilineal exogamic clans which had local territories
given them in the Dreamtime. All parts of the clan land
have totemic associations. The most sacred areas are
waterholes, where the totemic ancestors, the ancestral
dead, and the unborn clan souls dwell. Another
important social principle is age grading, with the
main division being between the initiated men and the
women and children. This is a matter of the degree of
knowledge of sacred matters, and for men it is a
continuing process. A few old men become very strong
in knowledge and power before they return to the
ancestors for a new cycle.

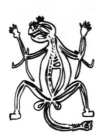

The Aboriginal peoples of Australia defined their
reality in such a way as to provide an integrated world
view, both mythical and practical, which included the
na.ural world, mythical beings, and human beings.
The stories of the Dreamtime explained the origin of all
the elements of the landscape, its resources and its
creatures and how one should behave in it, so that in
learning his religion the young person was also
learning knowledge for survival. By participation in
ordeal and ritual, a man becomes one with his people
and his land. Most of the art forms were part of such
rituals, and therefore ephemeral. But in some particu-
larly sacred places, sacred forms are shown outlined on
rocks on the ground or painted on rock walls. There
were paintings of animals on such walls too, sometimes
for magical purposes, but sometimes, as one artist told
Mountford, because "It was a good hunt and I wanted
to remember it."

In Arnhemland bark paintings were made as
illustrations of the sacred stories, but also for
enjoyment. The old way of life has not entirely disap-
peared from the area, but more and more bark paintings
became objects made for sale to tourists. In such
paintings, the style has tended to become representa-
tional.

Ref. Berndt and Berndt 1970; Elkin 1964.

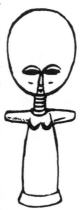

The Ashanti (Asante) live in the tropical forest area of
what was once called the Gold Coast of West Africa and
is now part of the nation of Ghana. They lived by bush-
fallowing, with a number of crops suitable for the area.
Trade has long been important, and gold dust was once
the medium of exchange. Specialization in crafts was
well developed before the colonial period, the best
known products being the spectacular work in gold and
gold leaf, the brilliant kente cloth and the little lost-wax
brasses made for the weighing of gold dust.

From the social perspective, the Ashanti are known
for the way the religious beliefs, the political organi-
zation and the kinship structure were related in a well
integrated system, with built in checks and balances
and enough centralization to make a real state. The
social organization was built on the basis of matrilineal
lineages with a male head and a senior woman. The
senior lineage provided a village headman with a
council of heads of the other lineages. This pattern was
repeated at each level. The senior royal clan of the
province (which once was a small kingdom) provided
the chief, with the Senior Lady or "Queen Mother";
there was a council, and an assembly of commoners. All
this was supported by the spirits of the ancestors, their
powers related to that which they held in life. Over all
was the Asantehene, the King of all the Ashanti, with
his Queen and Council. Important in the system were
the spokesman, or "linguists", with many important
functions, from prime minister to court reporter.

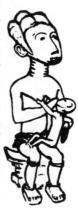

Many art forms were involved in the symbolic regalia
that went with this system; especially the carved stools
of office that became sacred items on the altars of
ancestors; ceremonial swords and their gold encrusted
scabbards; the staffs of the Spokesmen. All this regalia
was not just a matter of parading rank, but of visually
proclaiming the social contract, the constitution of the
nation.

The Ashanti have been called the "Proud People,"
and they apparently think of themselves not only as
proud, but touchy—"prickly" and nickname them-
selves the "Porcupines." This attitude may stem from
their history, for the Ashanti assimilated many refugees.

Integration involves the myth of common descent—of shared ancestors; therefore it is best if no one is nosey or gossipy about slave ancestry. Indeed, talking about something that is none of one's business is a punishable offense, even if the statements are true.

The Ashanti believe in a supreme God, the Creator, who is rather remote. Lesser deities take care of special aspects of the world and act as intermediaries. The ancestors can also bring supernatural power to bear on the affairs of men. The most powerful ancestors were once the chiefs and kings of the Ashanti, and to them their descendants appeal for help in maintaining the well being of the people and the land. The Kings and Chiefs are priests as well as rulers, and offer sacrifices of food and wine to the spirits of the ancestors. Stools of former chiefs are kept as relics, symbols, and places of contact with spirits. On ceremonial occasions the talking drums extoll the ancestors, minstrels sing historic chants, everyone joins the dancing and there is a ritual meal.

In addition to the elite forms, a number of folk arts existed, and many have persisted until the present day. Among these are a variety of textiles woven and dyed in a variety of designs. The well known Akuaba (or Akuamma) figure carved in wood was a kind of good luck charm to ensure beautiful and healthy children. Pottery and clay figures were modeled, calabashes were decorated, houses painted.

In the changes of recent times, Kente cloth appears at the United Nations—as the proud symbol extended to represent all of Ghana; calabashes are largely replaced by enameled pans; hand made cloth is still worn for dress up, and crafts serve the tourist and export market more than the royals, whose functions are greatly diminished.

Ref. Cole and Ross 1977; Service 1963; Rattray 1927.

Asmat, p. 43, 101, 202; Fig. 2.16.

The Asmat area of New Guinea in Melanesia is an enormous low alluvial plain, swampy with numerous watercourses. The people live mostly on the sago that grows wild, and sago grubs. Travel is in canoes or over fallen trees; all else is mud. Villages, inhabited by 400-500 persons, consist of a dozen or two houses on piles lined up along the river with canoes parked before them.

With stone axes obtained in trade from the distant mountains, they make their houses and canoes. All men carve wood, but certain men are recognized as artists, and they carve the ancestral figures that live in the clan meeting houses that are the centers of community and religious life.

> ". . . woodcarvings include richly carved prows of canoes made from hollowed tree trunks, often showing human figures; containers in the form of models of these dugout canoes, complete with decorated prows; paddles with carved blades and again a human figure, here crowning the handle; shields as high as a man covered with what at first sight seemed to be mainly geometric motifs; and a wide variety of human figures. And lastly. . . tall poles measuring many metres and bearing one human figure above another, and lower end often consisting of a boat, and all of them having a large open-work, pennant shaped projection at the top with distinctly pallic associations." (Gebrands 1967: 20).

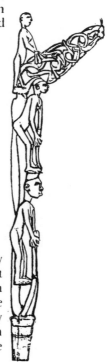

In the world view of the Asmat, humans are closely identified with trees, and women with the sago that holds life. The creativity of the sculptor is equated with the creativity of woman—she creates human life, he supernatural life. But headhunting was also necessary to life, to male potency, and as headhunters, men identified themselves with the praying mantis that the carved human figures so often resemble.

Ref. Gebrands 1967, 1968.

Australia, Fig. 2.12, 2.13, 6.08.

Aztec, see Mesoamerica. p. 70, 168; Fig. 2.08.

Bali, p. 6, 7, 11, 16, 43-44, 88, 90, 93, 107, 108, 114, 151, 164, 187, 193; Fig. 1.03, 1.07, 2.12, 2.17, 3.01, 3.03, 4.02, 4.09, 4.11, 4.13, 4.15, 5.03, 5.12, 6.05, 6.10, 6.13, 7.11, 7.12.

The Indonesian island of Bali has attracted much attention because of the high development of the arts at the village level; the elaborate ceremonials, and many temples.

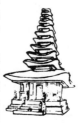

The environment is that of a tropical island about 100 miles long, mountainous in the center. Many streams flow down from the mountains to the sea, and each provides water for the rice terraces, so the terrain favors local cooperation. Intensive cultivation provided ample food with time to spare. Bali shared most of the

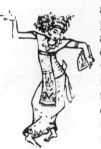

craft techniques of South Asia, practiced in the villages and in the courts of the small kingdoms. Trade provided some luxury materials such as silk and gold, and contact with many Asian styles. Social organization was marked by the corporate nature of the village (land was owned by the village, and was not transferable to non-villagers) and the extraordinary number of voluntary associations that were formed to carry out all kinds of activities. Social stratification in the form of castes has been described by observers of more a matter of pattern, of knowning one's place in an esthetically defined social order than as a matter of dominance.

The upper castes provide rulers and priests, occupation is largely hereditary. The choice in life involve forms of artistic expression, and the groups will join to carry out various activities. Caste involves various forms of etiquette, but "Satrya prince and Brapmana priest take part as equals with the rest of the village group in staging performances, rehearsing new plays or new musical compositions." (Belo 1970: 6).

The concept of higher and lower pervades the patterning of life; etiquette requires that socially higher is physically higher, and higher is more sacred, as in the terraced temple areas and the towers within them. The Gods dwell in the highest mountain and visit the temples to enjoy the festivities. The pantheon is Hindu, but interpreted in terms of ancient Balinese traditions. Reincarnation, for example, occurs within the family line, not the entire animal kingdom. With hierarchy, a concept that pervaded the patterns of life and art of Bali was that of balance and equilibrium, not climax and resolution; the idea of progress was foreign, and now the past is referred to as the time when the world was in balance. It has been noted that traditional gamelan music flows along without dramatic climax.

Conflict is avoided by physical avoidance, careful etiquette, and the control of emotional expression. The latter is channeled into dramatic productions, dance dramas that include trance states, and cock fighting.

Calendrical festivals do not follow the solar year; there is little change of season in Bali. Instead, events are scheduled by an elaborate astrological calendar. There are a number of small festivals, and every 210 days the whole population joins in a holiday season when for 10 days the high Gods are invited to come

down to earth. Everything is decorated, plays and musical entertainments are given. The elaborate food offerings are ceremonially offered to the Gods, but are then eaten by the villagers. Contests and entertainment are all offered to the Gods, but everyone enjoys them together.

In the long history of Bali, and its relation to nearby Java, one of the outstanding events, before the colonization by the Dutch, was the flight to Bali of the Hindu court and their skilled craftsmen when a Muslim regime conquered eastern Java, thus preserving many art forms lost in Java, and intensifying the art production of Bali.

In recent times, increased population and competition from imported technological items and amusements have reduced the time spent on crafts and artistic productions, and specialists in tourist and commerical fine arts have emerged.

Ref. Ramseyer 1977; Covarrubias 1950; Bateson 1949.

Bambara, p. 11, 45, 50, 187, 188; Fig. 1.05, 2.18, 6.09, 7.11.

The Bambara of Mali, in West Africa, number about 1.5 million, and are sometimes considered a tribal people because they follow their own traditional religion, but can also be classed as peasant communities because of their economic and political relations with more powerful peoples in a region that has been known as a succession of kingdoms and empires which is largely Islamic.

The Bambara raise millet and vegetable crops wherever the arid land provides enough moisture. The villages along the rocky cliffs are similar in materials and construction to the Pueblos of Arid America.

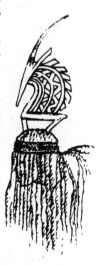

Local organization rests on a supernatural relationship between community land and the patrilineal lineage that first settled it. Each person joins an age group at adolescence. The communal work groups dance as units during the two great annual festivals. Each group has its own masks, and an individual progresses from one group and one dance to another as he gets older. The dances present animals as having behavior traits that are admired or scorned in humans, and so teach Bambara values.

The famous Bambara antelope, Tyi Wara, worn as a headdress in dances, has a male form and a female form that dance together. Once related to the importance of

hunting, this personage came to be regarded as the sacred being who brought the knowledge of farming to the people. His songs praise the virtues of good farmers. Now Tyi Wara has become the symbol of the nation of Mali. The wood carvings are famous; weaving is also highly developed.

Ref. Imperato 1975; Goldwater 1960.

Benin, p. 47, 142, 175-176; Fig. 2.19, 2.20, 3.18, 5.11, 6.03, 6.08, 7.05.

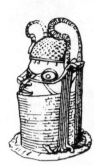

Benin is in central Nigeria, on the Guinea Coast area of Africa. One of the most famous art styles of Africa is that of the Benin bronzes. These works are made by a guild of professional craftsmen with traditions that extend back for five centuries. Bronzeworking is done in the city of Benin, woodcarving in the surrounding areas. Bronze is closely connected with the king and his court; the history of the kingdom was recorded in bronze and adorned the palace. Benin lies mostly in rain forest area. Benin acknowledges a relationship to Ife, the ritual center of Yorubaland, in that the founder of the present dynasty came from there, by request, as did the founders of the bronzeworkers guild in the fourteenth century.

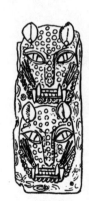

The kingdom of Benin was at the height of its power in the sixteenth and seventeenth centuries, and controlled a large area until conquered by the British in 1897, when the city of Benin was sacked and it bronzes taken away to be scattered in European museums. Under colonial rule the area of the traditional kingdom was recognized as a unit; in the modern nation of Nigeria it forms the main part of the Midwest State.

The King of Benin is called the Oba, and there is at the time of writing still an Oba of the ancient dynasty in the palace, an important symbol of the long and proud history of his people, with a number of ritual duties. Some bronzes are still made for the palace, but many bronzeworkers depend for support on the tourist trade. (The modern nation called Benin is not the same area; it is the country formerly called Dahomey).

Ref. Forman, Forman and Dark 1960; Ben-Amos 1968, 1970, 1980.

Bushmen, p. 48.

The Bushmen are gatherers and hunters of South Africa; their rock paintings have been compared to those of the Upper Paleolithic of Europe and Australia.

Ref. Lee 1979; Wilcox 1963.

Caroline Islands, Micronesia. p. 41; Fig. 2.12.

Chavín, see Andean p. 30, 35; Fig. 2.10, 7.08.

Cherokee, p. 31; Fig. 2.02.

The Cherokee of Southeastern North America were farmers and hunters living in villages and towns, with large meeting houses instead of the temple mounds of the Natchez. Ethnohistorical accounts tell of fine buckskin dyed in bright, clear colors, fingerweaving, and feather, bead and shellwork.

Ref. Gearing 1962; Swanton 1946.

Chippewa, p. 31; Fig. 5.06.

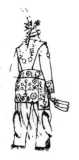

The Chippewa, spelled Ojibwa for the groups in Canada, overlap the borders of the eastern and sub-arctic areas. They were for the most part too far north for farming, and depended on a seasonal round of hunting and gathering. The best known arts are birchbark products and the handsome floral beadwork on black velvet of historic times.

Ref. Spencer, Jennings, et al. 1977.

Coclé, see Cuna.

Congo, p. 47-48, 62, 151; an area in Central Africa.

Cubeo, p. 36, 106, 107, 151; Fig. 2.10, 3.04, 4.09.

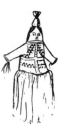

The Cubeo are manioc-growing and river fishing tribal people of the Amazon area. Goldman's account of the way the festival-ceremonial events function psychologically and socially in this society raises interesting questions concerning the functions of art events in other societies.

Ref. Goldman 1953.

Cuna, p. 35, 192, 194; Fig. 2.08, 5.06, 7.14.

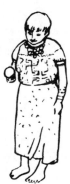

The Cuna of Panama in the Circum-Caribbean area are known both archeologically and as a living people. Archeologically they are known as Coclé, with a distinct pottery style and goldwork, organized at kingdom level, with a marked class system and wide-spread trade. After the conquest, they retired to a village tribal way of life and long retained their independence. Now, living mostly on offshore islands, they can be considered as a folk society, in touch with the outside world but maintaining their own lifestyle. Subsistence is based on farming and fishing; coconuts as well as money are a medium of exchange. Women's clothes and jewelry, made of imported materials, are status symbols

within the basically democratic system. Illness is attributed to soul loss, and is treated by shamans. Christian missionaries have made some inroads, but traditional religion persists. Beliefs have to do with a distant high God and his Wife, a culture hero, and the concept of the tree of life. There is no trace of the cult of the sun, with the priests and temple rites of pre-Columbian times.

Ref. Lothrop 1937; Stewart and Feron 1959; Salvador 1976.

Dakota, p. 29, 59, 152; Fig. 2.02, 2.06, 3.01, 3.02, 5.06.

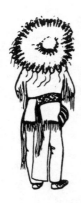

The Dakota (Sioux) roamed widely over the Great Plains in historic times, but before they took to horseback they were eastern prairie people practicing a mixed horticulture and hunting economy on the edge of the Mississippian area. They became completely nomadic about 1750.

On the plains these Siouian speaking peoples formed a number of different groups, calling themselves Nakota or Lakota or Dakota, that did not fight with each other. Collectively, they were the largest of the Plains tribes. The Yankton Dakota controlled the catlinite (pipestone) quarries in what is now southwestern Minnesota, and this and other goods were widely traded.

Fighting for glory, raiding for horses, and hunting for food were the chief preoccupations in the brief period that this lifestyle flourished. Artistic effort centered on hidework, mostly done by the women, but included representational hide painting by men.

The concept of Sacred Power which permeated the universe was important. This power could be tapped by ritual and sacrifice, and without it a person could not hope for high achievement. Individually, men sought a guardian spirit, or pledged a Sun Dance. The Sun Dance was the great ceremonial event when many bands gathered together. The circle symbolized the sun, life and the unity of the people.

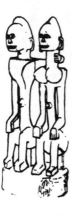

Ref. Spencer, Jennings, et al. 1977; Wissler 1904.

Dogon, p. 45, 147, 149; Fig. 2.18, 2.19, 4.08, 4.09.

The Dogon are farmers in a very arid region of West Africa, who are famous because of the profundity of their religious system and the meanings of symbolic froms which are known to us through the work of Griaule and Dieterlen.

Ref. Griaule 1965, Laude 1973, Griaule and Dieterlen 1954 (The segment of Attenborough's *Tribal Eye* film documentary devoted to the Dogon is memorable).

Eskimo, p. 23, 50, 51; Fig. 2.01, 2.02, 3.11, 4.01, 4.09, 7.15.

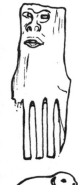

These famous Arctic hunters, spread out in small groups over the enormous boreal area of North America are known as Eskimo, but call themselves Inuit. Although all the groups were basically similar in culture, there was also considerable variation because of precise adaption to regional habitats. Religion had to do with the powerful animal spirits who had to be treated with respect, and with the ability of shamans to get in touch with such spirits to cure illness. Visual art forms did not play a large part in this except in Alaska where wooden masks were used in seances and festivities. Modern soapstone carving is derived in part from small ivory toys. Stone carving and printmaking are now important economic activities in the Canadian area.

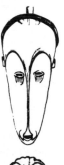

Ref. Graburn 1976; Spencer, Jennings, et al 1977.

Fang, p. 11, 12, 48, 129, 139, 154-155, 159; Fig. 1.04, 2.19, 4.09, 6.12.

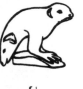

The Fang (Pangwe) are a people with a population of about 160,000 living in what is now Cameroon. Tribal dwellers of the rain forest, they practiced slash and burn farming, and lived in small villages moved periodically. Their main crops were yams, manioc and plantains. Social organization was based on a balanced segmentary lineage system, traditionally with no centralized government. Art forms were primarily dance and ritual; carving is considered incidental. The carvings for which they are best known called "biere" were used on burial bundles, and convey a sense of the continuity of the life cycle.

As in much of this area, the relations to the ancestors is not so much a personal one, as with saints and guardian spirits; it is more a matter of the whole lineage as a very special vehicle for the Life Force. "Ancestor figures" represent the whole line of humans, past and future, of which the living are a part.

Ref. Maquet 1972a, b; Fernandez 1966, 1973.

Gulf Coast, see Mesoamerica p. 25, 193; Fig. 2.09, 7.07.

Haida, p. 25, 193.

The Haida, living on the northwest coast of North America, represent the northern region of this area; the art style is less dramatic than that of the Kwakiutl, and the forms more two-dimensional, even when carved around totem poles. The elegant stylization is much admired.

Ref. Spencer, Jennings et al. 1977; Holm 1965.

Hawaii, p. 40; Fig. 2.12, 6.05.

The Hawaiian islands were organized into several kingdoms, and concepts of rank, mana and tabu centering around the royal families had become enormously elaborated. Specialized craftsmen built houses and canoes, and made fine tapa and featherwork, such as the brilliant red and yellow capes emblematic of royalty.

Temples in walled enclosures of stone held wood and stone statues of the gods. There great ceremonies were held with religious dances and ritual chants full of poetic imagery. The aggressive form of the God of war is well represented in the existing remnants of the religious art.

Ref. Buck 1957; Starzecka 1975.

Hopi, p. 27, 50, 59, 63, 99, 186; Fig. 2.04, 3.03.

The western, and until recently most isolated, group of Pueblo villages of Arid America, who maintained their traditional cultures in the face of Spanish and Anglo pressures. Dwellings were high on mesa tops, with an extraordinarily subtle farming adaption practiced in the washes below. Religion and its expression in art forms was closely involved with this adaptation. The social organization was based on matrilineal clans. In addition to the ceremonial arts, the Hopi are best known for the handshaped earthenware pottery, both prehistoric and modern. The Nampeyo women are famous for the latter. (See also Pueblo).

Ref. Forde 1963; Walters 1963; Maxwell Museum 1974.

Huichol (weechol), p. 28.

The Huichol are corn growers in a remote mountain area of Mexican Arid America who have retained much of their aboriginal culture; their religious life is climaxed by a sacred journey to gather peyote. Yarn paintings record their visions.

Ref. Toneyama 1974; Meyerhoff 1974; Furst 1969.

Iatmul, see **Sepik River.** Fig. 4.07.

Ife, see **Yoruba.** p. 175, 176; Fig. 7.05.

Ife is a Yoruba city. Ife bronzes date to the classic period, possibly the 8th to 12th centuries A.D.

Inca, see Andean. p. 119, 126; Fig. 2.10, 3.11, 3.13.

"The Inca" can mean the Inca Empire, which included a number of ethnic groups; the people of the dominant culture only; the members of the nobility; or the Emperor himself. All of which is sometimes confusing.

Indonesia, see **Bali.** p. 43-44, 67, 68, 78; Fig. 2.12, 2.17, 7.11.

As a culture area, the Malay peninsula has been included. As a modern nation state, Malaya is not included, but western New Guinea, named "Irian," is.

Iroquois, p. 31; Fig. 2.02, 3.02, 4.09.

In northeastern North America, the Iroquois confederacy originally included the Seneca, Cayuga, Onondaga, Oneida and Mohawk. While the literature on the culture and history of these peoples is extensive, a parallel art history has not yet been put together. Many of the art forms were in perishable materials, wood, buckskin, bark and shell. "False Face" masks are well known, as is the pottery from archeological contexts.

Ref. Spencer, Jennings et al. 1977; Morgan 1851; Wallace 1970.

Jalisco, see Mesoamerica. Fig. 2.08.

Jomon, Fig. 7.03.

A prehistoric period in Japan; the earliest known pottery.

Kuba, p. 48, 63; Fig. 2.19, 2.21, 3.04, 4.09, 5.04, 6.03, 6.09, 6.13.

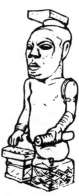

The Kuba (Bakuba) of Central Africa are a group of peoples also called Bushong or Mbala, as the chief of the Mbala is recognized as King of all the groups. The society had a recognized elite for whom crafts specialists made household objects of high quality. The commoners were farmers, grain being the staple crop. The commoners were not, however, impoverished, and accounts describe the Kuba kingdom as prosperous and the craftsmanship excellent throughout. An orally transmitted history of the reigns of kings goes back

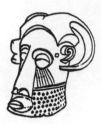

many centuries. That the record is accurate is proved by the dating of a solar eclipse in 1680. The King statuettes represent real rulers with symbols of their reigns; there is a question as to whether they are in any way portraits in the western sense.

Religion centered around the concept of the Life Force and the role of the ancestors. Many symbolic events, dances and ceremonies were connected with the court and the sacred power of the royal lineage.

Ref. Vansina 1972; Rogers 1979; Hilton-Simpson 1911.

Kwakiutl, p. 16, 25-26, 63, 82, 101, 126, 151, 160, 188, 192; Fig. 1.07, 2.02, 2.03, 3.05, 3.09, 3.14, 3.16, 3.21, 4.09, 5.02, 5.05, 5.08, 5.10, 5.13, 6.11.

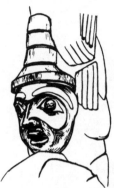

This area on the northwest coast of North America, a land of streams and fords, with forests that run down the mountains to the sea, was incredibly rich in resources, especially for peoples with the technology for fishing, sea mammal hunting, and the storage of food against lean periods. These techniques resulted in an expanding population, the development of a complex social organization, and surpluses to support elaborate ceremonial forms. However, one sees in the myth and ceremony, as well as on the value placed on the storage of food, evidences of a past history in which the fear of starvation was very real; the Cannibal Monster was a symbol of such fears. The belief system rests on acknowledgement that people depend on natural forces and animal species to survive.

The basis of economic, social and ceremonial life was the kinship group under the leadership of a headman, or "Chief" who organized group efforts and as a symbol of the group owned titles and major goods such as the great house and large canoes. The group as a whole owned fishing areas, berry grounds, and hunting territories. These chiefs and their immediate families formed a kind of noble class, but ranking was largely a matter of degree. Each village of a few hundred persons had more than one great house, and so several headmen.

Kinship groups were ranked according to the titles they held, and villages were similarly ranked. Thus rank was the important organizing principle of the society, and rank manipulation the Great Game. As a big man in Melanesia arranged for pig feasts, so the Northwest Coast chief gave potlatches organizing his people to

amass large amounts of goods, and redistributing them in spectacular ceremonies to validate titles. The carved "totem poles" declared the greatness of a kin group, displaying crests, honors and important events in its history.

Wars were fought to secure booty, to capture slaves, and to take over areas particularly rich in natural resources. They usually took the form of night raids. The position of war chief was often hereditary, but of low rank.

Supernatural beings were not remote as all elements of nature had spiritual qualities. Throughout life a man sought to gain power by ritual fasting and purification. He sought the services of a personal guardian spirit in addition to such spirits as he had inherited. The spirit world was an invisible aspect of the environment, affecting people's lives, but only rarely did one of these spirits make itself known and possess a human being. In the dancing society performances, the ancestral contacts with spirit beings were relived and dramatically re-enacted.

Winter was the ceremonial season, when activity centered around the performances of the secret societies. While membership was often hereditary, they sometimes tended to cross-cut kinship groupings. Performances had one basic scenario: the protagonist's encounter with a spirit who kidnaps him, gives him supernatural powers, then returns him to his village. There were many variations on this theme.

Beliefs were presented in very dramatic form in Kwakiutl art and ritual. The theme of the transformation—from outward and mortal form to immortal spirit, from death to life, from frenzied possession to controlled power—was used in many theatrically impressive ceremonies. Masks opened suddenly to reveal a different form, decapitated heads came to life again, a burning corpse sang in the fire—as each dance society presented its stage illusions to communicate meaningful symbolic truths with great emotional effect.

Ref. Hawthorn 1967; Boas 1927b; McFeat 1966; Holm 1965.

Lega, p. 158. A people of Central Africa.

Luba, p. 48; Fig. 2.19, 2.21.

The Luba (Baluba) people of Central Africa are an ethnic group that was once organized into a large

kingdom in this grain-growing savannah area. Their traditions remained strong and well expressed in a distinct style. To express ethnic identity, people shaved the hair to form a high forehead; the carvings of human beings are recognizable by this trait. A very distinctive sub-style, known as Buli, with skinny female figures, probably represents the work of one person and his apprentices. The Luba now live in Zaire and Zamba.

Ref. Bascom, 1973.

Mangbettu (ma-ngbe-too), p. 48, 52; Fig. 2.19, 2.22.

In the Congo area of Zaire, Africa, these forest people grow root crops, raise sheep and goats and trade with the Pygmies for forest products. There was an aristocratic ruling class for whom many fine hand-crafted household objects and musical instruments were made. The idea of witchcraft was important in this area for providing explanations of misfortune, and there were many customs to deal with it. The elongated heads, enhanced by the characteristic hairdo and represented in art forms have an elegance that reflects aristocratic values.

Ref. Baxter and Batt 1953.

Maori, p. 39, 71, 128, 181; Fig. 2.12, 3.15, 5.05, 6.09.

The Maori came to New Zealand in Polynesia as colonists from central Polynesia, adapting their culture to the temperate climate. The Maori depended on sweet potatoes and a wild fern root for starchy foods, and the fishermen of the coasts exchanged their fish for birds snared by the inland peoples. Trade was phrased as gift exchange.

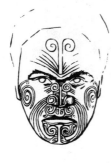

Many chiefdoms, linked by kinship but politically separate, were marked by pride of rank, elaborate etiquette in peace and war, and intense loyalty to the chief, whose mana was great.

The focus of community life and the symbol of its unity was the meeting house that was elaborately carved and painted in the men's curvelinear style, and lined with the fine mats in rectilinear styles woven by the women.

Prestige was closely connected with the concept of mana. The priest was a specialist, and so was the poet, the orator, the singer, the tattooer, the weapon maker, the architect, the canoe builder, and the teacher of dancing or music. All had mana. Mana is sacred energy

of the universe, and can be dangerous in large quantities if one is not powerful enough to handle it. Each man of rank had his face tattooed in a design that was uniquely his own.

Ref. Buck 1925; Hamilton 1896; Barrow 1969.

Masai, p. 49. Cattle herders of East Africa.

Maya, ancient, p. 33, 70, 75, 98, 119, 134, 164, 168, 176, 179; Fig. 2.08, 2.09, 3.13, 5.08, 6.03, 6.08, 6.10, 7.07.

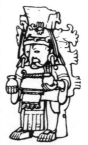

The ancient Maya of Mesoamerica are known from archeological studies, the accounts of the early Spanish missionaries, and ethnographic analogy. The most intriguing region has been the lowland, where spectacular ceremonial centers were deserted before the Spanish arrived. In this tropical region there existed a civilization with astronomical knowledge and mathematics in many ways ahead of anything known in the world at that time. Much of this knowledge was shared with other cultures in the Mesoamerican area.

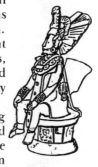

Such a civilization also depends on the development of specialists, probably full time professionals, scholars, craftsmen, traders and administrators, and these became increasingly important and numerous by the classic period.

Subsistence was based on intensive farming techniques, with maize the most important and sacred crop. Dwellings were scattered compounds, and the ceremonial centers were probably built by people from outlying farms giving periodic service in a system similar to the Cargo system of Contemporary Indian peoples of Mesoamerica.

The sculptures and pottery figurines show that personal adornment in textiles, feathers and jewelry was very important, and highly symbolic.

Ref. Culbert 1974; Coe 1980; Thompson 1954.

Maya, contemporary, p. 33, 67, 186, 187; Fig. 3.08, 7.15.

Modern Maya speakers live in Mexico, Guatemala and Honduras. Since the Spanish conquest, they have existed as peasant communities which in outward form have many Spanish features. Clothing is a combination of colonial Spanish and ancient Maya style.

The crops are largely those of pre-Columbian times; the technique is almost entirely slash and burn (milpas)

except for the use of some manure. Domestic animals such as sheep, chickens and horses are a post-Columbian addition. Some specialization in crops results from differences in local conditions, and some crafts are also localized, so trading is of considerable importance.

Each language and dialect area represents a strong ethnic consciousness, and in the highlands each village has its traditional costume and patterns of weaving. Clothing is important to the Maya in indicating the municipio of the wearer, and is symbolically meaningful in ritual contexts. It must be clean and often new. Women do the weaving, and try to have new pieces for important fiestas.

Much of the energy and resources of men go into the ceremonial system which maintains the social order, world view and solidarity of people of the same language dialect. The belief system is Catholic in form, but behind the Christian symbols lie many ancient ideas, practices and attitudes. Many beliefs have to do with the sacredness and power of spirits who have local dwelling places. The ceremonial cycle retains many pre-Columbian patterns including the practice of dedicating a year at a time to ritual duties and the support of fiestas, the "Cargo system" as part of the prestige ladder.

The highland Maya are known to outsiders as artists principally for the variety of textiles woven by women on the backstrap loom, using the wool from locally raised sheep and imported cotton, and these textiles and clothes have become popular tourist export items.

Ref. Vogt 1970; O'Neale 1945; Bricker 1981.

The Mesoamerican area was in Columbian times a civilization comparable to pre-industrial Europe. While there were regional variations in language and culture, and political entities rose and fell, expanded and contracted, there was a basic cultural unity visible when compared to other civilizations such as that of India, the Andes, or China. (See also Maya).

Ref. Wolf 1959; Coe 1977.

Mexico, Valley of Mexico, see Mesoamerica. p. 33, 179; Fig. 2.09, 4.15, 6.03, 6.05, 7.03, 7.04, 7.07, 7.09.

This was a cultural region, the part of Mesoamerica around what is now Mexico City; it included the cities of Teoticuacan and the Aztec capital, Tenochitlan.

Micronesia, p. 19, 40-41; Fig. 1.09, 2.12.

Mississippian, p. 29-30, 31-33, 198; Fig. 2.02, 2.07, 3.16, 4.10.

The nature of the incipient civilization in this region of North America is illuminating in terms of the nature of cultural evolution. Polulation pressures on the resources of the area was beginning to change the subsistence patterns and social organization in ways similar to those which led to the development of civilizations in the great river valleys of the Old World. (See also Natchez).

Ref. Jennings 1974; Spencer, Jennings et al 1977.

Mundugamor, see **Sepik River.** Fig. 4.06, 4.07.

Natchez, p. 30-31.

The Natchez of southeast North America probably had, in pre-Columbian times, a provincial version of the Mississippian culture. The society was stratified, with named rank: Sun, Noble, Honored and Commoner (called stinkers by the Nobles). A man could rise in rank by success in war. The Great Sun was a ruler with absolute power over the lives of his subjects, but he had to be without physical blemish, and had many ritual duties. In the center of each village was a plaza with two mounds on it, one for the temple, and one for the house of the Sun.

Calendrical ceremonies, such as the harvest festival, centered about the Sun, who was carried to the events in a litter. There were games and mock battles between the "Red" and "White" warriors. The most elaborate ceremonies occured at the death of a Great Sun, and include sacrifice of his wives, retainers and even volunteers to accompany him to the next world. Such practices, which occured widely throughout the world at the kingdom level of complexity, are mostly known from the archeological evidence, but in the case of the Natchez these rites were witnessed by European explorers, and so we have clues as to how they were regarded by the people themselves.

These accounts suggest some of the ideas that may
have been part of the Death Cult which marks the art
objects found in the Mississippian area.

Ref. Swanton 1911.

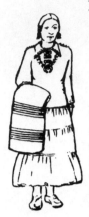

Navajo, p. 4, 14, 15, 16, 27, 57, 59, 63, 64, 76, 86, 88,
91-92, 98, 99, 108, 129, 131, 136, 141, 145-147, 148,
149, 151, 152, 161, 162, 164, 189, 191, 192, 193,
194, 195, 196; Fig. 1.06, 1.07, 2.02, 2.05, 3.01, 3.06,
3.14, 3.17, 4.03, 4.09, 4.12, 5.06, 5.09, 5.11, 5.12,
6.02, 6.06, 6.12, 6.13, 7.13.

The habitat of the Navajo, in the Southwestern
United States is in a plateau area between the desert and
the mountains; winters are cold, sometimes with
considerable snow. Usually the land is very dry; rainfall
is unpredictable and the thunderstorms of August can
cause flash floods in one arroyo when all around there is
sunshine.

The Navajo, who a few centuries ago came down
from the north as hunters and gatherers, were in the first
half of this century growers of maize and other crops in
places where there was sufficient moisture. They also
raised sheep, but were not primarily domestic
shepherds. Men farmed, women did the domestic
chores, and children herded sheep—at least this was
most usual. But the Navajo tended to pitch into what
needed doing—everybody weeded, or helped with sheep
dipping or hauled wood and water. The sexes were
regarded as complementary and equal. Men were out
front in ceremonial matters, including sandpaintings,
and men were silversmiths; women were the spinners
and weavers—these tended to be specializations.

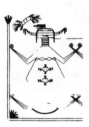

Settlements were small and scattered; sometimes the
isolation was extreme. People often traveled quite a bit
on horseback. The society was basically matrilineal and
a man went to live with his wife's people, so he often
traveled some distance to take part in affairs of his
family of origin.

Ceremonials were very important special events for
people in an area to get together to work out affairs of
common interest, visit, and have a good time, as well as
participate in religious observances. Such affairs
required social as well as symbolic harmony, and so
served social as well as psychological functions.
Usually a curing rite, they offered the one-sung-over the
support of family and friends; economically they

redistributed resources as all comers were fed. Young
men often made the rounds—looking the girls over,
gambling and singing. Some of these turned in time to
helping with the drypainting and going through the
long apprenticeship to become Chanters.

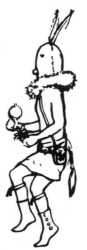

Navajo religious beliefs are complex and bewildering
to the outsider, partly because the way of categorizing in
thought and language. The sacred origin myths with
their branches and interwinings do not form a clear,
linear history; good and bad are not neatly separated.
The cultural scenario has to do with learning episodes.
The protagonists, often the Twins, or one of them, goes
through various dangerous adventures and comes
home with sacred knowledge. Part of each ceremony is
the account of how the ritual was learned.

As with most religions, it is known and understood at
various levels both quantitatively and symbolically by
various persons. Furthermore the Holy People have
multiple identities that are not clearly defined. The
Twins are sometimes four. At one level Changing
Woman is very much a good mother figure, very human
in her attributes, but she is also Mother Earth, changing
as the seasons change, mysterious and fruitful. The
Sun, or Sun Bearer, is father of the Twins, but also of
evil monsters slain by the Twins, a powerful but
ambiguous figure.

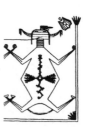

In the second half of the nineteenth century Navajo
blankets were wearing apparel, traded widely to Indian
peoples. In this century rugs have been made for sale to
whites, and only saddle blankets for Navajo use. Silver
jewelry was made both for wear and for sale.

Ref. Reichard 1939, 1950; Kluckhohn and Leighton
1962; Adair 1944; Witherspoon 1977.

New Ireland, p. 16, 41, 53-54, 115, 117, 137, 151,
 165, 188; Fig. 1.07, 1.08, 2.16, 2.23, 4.09, 5.01,
 6.01.

The name "New Ireland" refers to a long thin island
and a number of adjacent smaller ones in Melanesia.
The region for which we have the most information is
around Lesu in the northern part. Lesu lies on the
shore, but while people do some fishing, they are not
culturally oriented to the sea as in the Solomon Island
case. People depend for food on tropical root crops,
grown by slash and burn methods, each family having
several gardens in various stages of the cycle. Food is
"stored in the ground", i.e., harvested daily. Protein

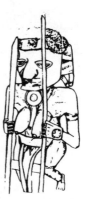

foods are pork, chicken, and fish. For traditional feasts, taro, pig and bananas are proper.

The social organization is based on matrilineal clans and subclans. Males go to live in the hamlet of the wife's family and prepare gardens there, but they do not usually marry outside of the local area. Male inheritance of wealth and intangibles is from mother's brother to sister's son, but other arrangements can be made, as people seek to find the best strategy within the rules of the game. There is a men's clubhouse where initiated males can sleep, talk, plan fishing expeditions. It does not, however, seem to have as much sacred importance as the Solomon Island canoe house or the Sepik tamberan house.

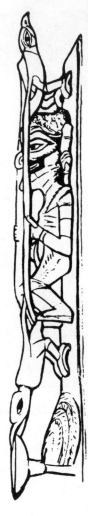

> ". . . New Ireland art is very rich in form. It is a sculptural art which features exhuberantly curving filigreed wood-carving, which is painted, along with extraordinary constructivism, i.e., the use of a host of added materials ranging from shells of marine animals to sponges, twigs, feathers and the like. In subject matter, New Ireland art features men, real and supernatural, in juxtaposition with animals, such as birds, snakes, fish and with plant forms. Its subject matter is psychologically interesting, showing genitalia transformed into fish and snakes, and with hermaphroditic figures from central New Ireland. It is a fantastic art which has been called 'surrealistic'." (Lewis 1969; 11-12).

Much of this art is from the malanggan ceremonies, and the pieces are called malanggans. (Billings says that in Lesu this is pronounced like mulligan [stew], with all the vowels slurred). Once part of the whole religious system the ceremonies are now considered to be secular, as people belong to the Christian mission churches. But the ceremonies still serve important social functions as well as deep emotional ones as people remember their dead, and the young learn the ritual and visual forms that embody tradition.

The ceremonies take place every few years after months of preparation. There are a number of rituals, dances and feasts to which people come from miles around. At the climax the malanggan figures are displayed, set up at various places within the enclosure where the artists have been working and the initiates residing. People pay a fee for the viewing, but afterwards the figures are destroyed, sold or allowed to rot.

Malanggan figures are icons of ancestors, and each
has a name. The right to make a particular named
figure is owned by an individual who commissions a
carver to prepare it for the ceremony. The proper form
exists as a vivid memory from the ceremony in which he
acquired it; it is a kind of copyright which is passed on
each time it is used.

Ref. Lewis 1969; Powdermaker 1933.

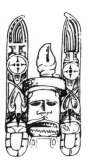

Nok, p. 175; Fig. 7.05.

A prehistoric culture of what is now Nigeria, Nok is
known for terracotta sculpture.

Northwest Coast, refers to North America. p. 25-
26, 63, 80, 128, 169, 172, 181, 191. See also
Kwakiutl.

Oaxaca, see Mesoamerica, p. 33.

Olmec, see Mesoamerica, p. 30.

Otavalo, p. 67.

Otavalo in Ecuador, South America, is noted for
weaving, and for the interesting history in which
weaving played a significant part. One of the last
conquests of the Inca, the Otavalo valley people went
through a number of vicissitudes under colonial and
later regimes. The handwoven textiles made there are
widely sold and have enabled the people to maintain
their economic and ethnic independence.

Ref. Casagrande 1977.

Papago, p. 27.

In Arid America, the Papago are desert neighbors of
the Pima, and still fine basketmakers.

Patagonia, Fig. 2.10.

Temperate area in South America in some way
similar to the Great Plains of North America, and with
a similar adaption after the introduction of horses. The
drawing on the map shows a detail from a painting on a
hide.

Pima, p. 27.

In Arid America, the Pima are irrigation farmers on
the Gila and Salt rivers, probably descendants of the
ancient Hohokam who irrigated the area extensively for
many centuries.

Plains, or Great Plains, p. 28-29, 51.

Refers to the North American culture area; like
Southwest, an ethnocentric term. If this work is

translated into Chinese or Spanish, both will be changed.

Polynesia, p. 39-40, 62, 67; Fig. 2.12, 7.01.

Pomo, p. 26, 61; Fig. 3.03.

The Pomo or California were one of the settled, prosperous food gathering peoples of central California. Acorns provided a staple food; fish, game and other wild foods were plentiful. The Pomo and their neighbors were not warlike peoples, but they occasionally fought. Each little Pomo village was permanent and had a well defined territory from which to draw its resources, and in which familiar spirits dwelt. Visiting and trading among villages was common, and athletic contests, gambling, feasting and story telling enlivened the visits. The people dressed simply and scantily most of the time, but ceremonial costumes were elaborate, with much use of fanciful featherwork. The Pomo were particularly skilled in basketry and they took delight in displaying their skill on decorated "treasure baskets" and on incredibly tiny miniature one. Men made small stone carvings.

Ref. Allen 1972; Kroeber 1925; Barrett 1908.

Pueblo, p. 13, 27, 186, 193; Fig. 2.02, 2.04, 3.14.

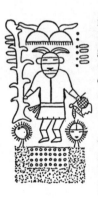

The Pueblos of the Southwestern United States include a number of villages including these of the Hopi in the west, Zuni, Acoma, and the Rio Grande group. They have been for centuries maize farmers with techniques and beliefs closely adapted to the arid environment, and tightly integrated societies. Ruins of the more numerous and larger villages, such as Pueblo Bonita, bear witness to a florescence that ended about 1300 A.D. The basic art form is the ceremonial cycle, and the costumes, masks, dances and ritual that were part of it. In addition to the Kachina dolls representing the dancers, and so the sacred beings impersonated by the dancers, pottery is the best known art. (See also Hopi).

Ref. Whiteford 1970; Colton 1959; Bunzel 1930; Waters 1963.

San Ildefonso, see Pueblo. p. 193.

Sepik River, p. 21, 43, 75, 80, 96-97, 105, 118, 125, 137, 151, 198; Fig. 1.07, 2.15, 2.16, 3.09, 3.13, 4.06, 4.07, 4.09, 4.10, 4.14, 6.01, 6.10.

The Sepik is a long river in New Guinea, Melanesia.

The focus here is on the middle region, including, among others, the groups of peoples such as the Abelam, Arapesh, Iatmus, Mundugamor, and Tchambuli.

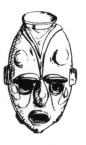

Before the contact period, the region was far from static. The Iatmul and the Abelam were prosperous and expanding, the Arapesh retiring to less desirable areas, the Mundugamor and Tchambuli rather unsuccessful and shrinking. Environmental variation encouraged local specialization and extensive trading.

The Sepik is a large meandering river, flooding widely for half the year. The Iatmul lived on the river in large pile houses, sleeping in baskets to keep out the mosquitos. Sago, coconuts, taro and other tropical foods were grown by the women. Men hunted crocodiles, and everyone got about in dugout canoes. The Abelam lived in the fertile foothills where the men grew yams and the women other crops. The Tchambuli lived by a lake in which the women fished; the men traded fish and carvings for starchy staples. The Arapesh were partly in the plains and partly in the mountains where good land is scarce; the sexes cooperated to grow yams and other crops. The Mundugamor lived on a tributary of the Sepik, the Yuat; the women processed sago. Protein food varied with habitat; fish, crocodiles, sago grubs, domestic and feral pigs were the main sources.

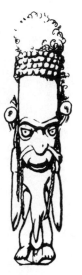

Political organization was minimal, and based almost entirely on kinship. The most common form of solidarity was a localized patrilineal lineage; head taking outside of the lineage was not only permissible, but admirable. Aggressiveness was important to maleness, and headhunting success increased the vitality of the victor's group.

Certain basic themes and postulates—the importance of the male and female principles, life stages and the importance of initiation, and bush spirits are shared throughout the area, and on these themes each group created its unique cultural scenario, and designed the sets, costumes, and props to dramatize it.

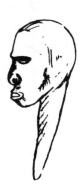

The sexual symbolism that is so important in Sepik art has to do with a world view in which the male and female principles underlie the vitality of the universe. Human males, embodying the active principle, have many ritual responsibilities to ensure the growth and well-being of people and food plants. Women's roles

are less dramatic, but necessary as the earth itself is necessary.

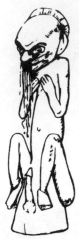

The most dramatic expression of the male ethos was through the tambaran cults. Sacred sound-making instruments were said to be the voices of supernaturals, known only to initiates. The Iatmul, the Tchambuli, and the Abelam had large highly decorated tambaran houses, sacred structures from which the brilliantly garbed figures emerged to perform dances and ceremonies for the uninitiated. Each kin-based cult dramatically stated its connection with the supernatural, but the inner meanings were hidden in ambiguity. Funeral and memorial services were elaborate. Skulls of enemies adorned the cult house, and skulls of one's own people had the flesh modeled on them in clay and were elaborately and symbolically adorned.

Often combined with other ceremonies, but separate from them in origin, were the dances using wickerwork or wooden masks. Such masks, and the way in which each was made and decorated, together with the associated magic, songs, steps and costumes were traded from one group to another, and often became all the rage and then moved on.

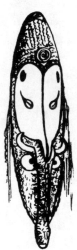

Specialization existed to the point of the hiring of recognized craftsmen from other villages and even from different linguistic groups. The art products of the area involved many techniques: wood and bone carving in the round, low relief etching, pottery and clay modeling, wickerwork and other basketry, netting, and elaborate decorations of shells, feathers, rattan, fur, fruit, leaves and flowers. Paint was used lavishly and had magical properties. Museum specimens from this region show only the more somber, permanent parts of the artistic product; in use the articles were colorful and festive. One wonders if the opposition between somber, even grim permanence and temporary ephemeral gaity is entirely due to the materials, or if this, too, had meaning.

Ref. Bateson 1958; Mead 1935; Forge 1973; Tuzin 1980; Newton 1965; Mead 1970.

Solomons, p. 11, 13, 16, 41, 50, 53, 68-69, 95, 101, 202; Fig. 1.05, 1.08, 2.14, 2.16, 2.23, 3.09, 4.01, 4.05.

These Melanesian islands present an area of considerable cultural variety within the Melanesian

patterns, especially between sea coast peoples and peoples of the interior. The culture outlined here is that of a coastal people of the eastern islands. Coconuts, yams and taro are the staples of the area, with a variety of tree and gardening crops grown by slash and burn techniques. Males clear the bush for gardens, and yams especially are under the protection of the ghosts of the kindred with rituals addressed to them. Fishing is an important activity, especially deep sea fishing during the seasons the seas are calm enough. Bonito are caught with rod and line from swift canoes with outriggers. Sharks hang around the schools of bonito, and frigate birds hover above. Most sharks are simply wild and dangerous beasts, but there are also special sharks who act as guardian spirits or unpredictable supernaturals and who figure largely in the mythology. Women may only collect shellfish, crabs, frogs and the like.

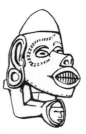

Larger canoes for fishing and overseas trading are commissioned by important men and made by specialists with the aid of the big man's kin. Such canoes require high skill both to make and to sail on the high seas. They are very artistically and symbolically decorated.

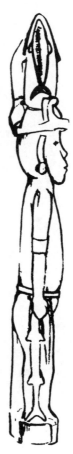

Initiation to manhood is marked by ceremonies related to bonito fishing and the supernaturals who are associated with it. The canoe house is the center of male activity; it is the largest and most decorated structure. Special stages are built before it at times when the newly initiated are adorned and presented to all the people. Feasting is an important part of the ceremonies, and men prepare feast food in pit ovens, while very large carved and inlaid wooden bowls are used to display and serve the meal.

Houses are large and well built with gabled roofs, bamboo walls, palm thatch and large houseposts that are carved. Houses are grouped and protected by the ghosts of the ancestors, if the latter are properly treated. Pigs are sacrificed to the ghosts in times of crisis.

Scarification patterns on the face indicated ethnic identity, women were sometimes tattoed by female experts, and shell ornaments were worn for important occasions. Valued shell ornaments involved a high degree of craftsmanship, and indicated the rank of the wearer.

Ref. Davenport 1968; Oliver 1955.

Tairona, p. 35; Fig. 2.08, 3.14, 7.10.

A culture of the Circum-Caribbean area known from archeological information. There were large concentrated villages with religious buildings, houses, burial mounds, stairways, roads and bridges made with much use of stone and artifacts of woven cloth, pottery and gold. From the evidence it is inferred that this culture represents one of the small kingdoms characteristic of the area in pre-Columbian times.

Tchambuli, see **Sepik River.** Fig. 4.07.

Tiahuanaco, see **Andean.** Fig. 2.10.

Tlingit, see Northwest Coast. Fig. 3.05.

Vera Cruz, see Mesoamerica. p. 33; Fig. 2.08.

Walbiri, p. 39, 137.

The Walbiri live in the most arid part of Australia, and so have been undisturbed until very recently. The art forms of the desert peoples of this region are more ephemeral and often more abstract than those of the Arnhemlanders. The sacred churingas are often maps of the homeland where the ancestors created important places such as waterholes. In this region, too, large sacred figures are sometimes outlined in rocks on the ground, and sometimes incised or painted on rock walls. Munn has recorded drawings in the sand made by women to accompany stories, using the same vocabulary forms as those used in body painting.

Ref. Munn 1971, 1973a, 1973b.

Yoruba, p. 47, 68, 74, 75, 81, 94, 123, 143-145, 148, 149, 159, 187, 201, 202, 204; Fig. 1.07, 2.19, 2.20, 3.09, 3.13, 3.19, 3.20, 4.04, 4.08, 4.09, 5.04, 6.04, 6.10, 6.11, 7.05, 7.15. (See also Ife, Ch 10)

The Yoruba are a large ethnic group in western Nigeria, currently numbering some 10 million persons. In pre-colonial times there were ten kingdoms, each with a capital city with tens of thousands of inhabitants. The area was for the most part tropical rain forest, becoming drier in the northern part, where grain crops were grown. Farming was by swidden and bush fallowing, and until this century there were forested areas between the kingdoms. Crops are similar to the Ashanti.

Yoruba cities and towns contained the compounds of the family corporations (patrilineal lineages) that also owned farm land, some of it at a considerable dis-

tance which was assigned to male members. People stayed out at the farmsteads as needed. Women were often merchants in the market place. Persons of both sexes were often specialists in crafts, and professional traders linked Yoruba towns with much of West Africa. Social life was complex, as organization by kinship was cross-cut by the cult groups, clubs, and other organizations to which the people belonged.

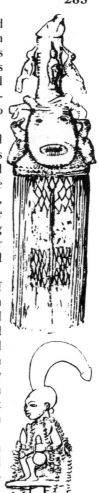

The kingdoms of Yoruba varied in political structure, but each was headed by a king selected for his abilities from the men of the royal clan. His ritual duties were of great importance. In addition to the pyramidal structure based on kinship and residence, there were palace officials and a society of elders, the Ogboni, which had a number of functions, including acting as a court in cases of murder by virtue of their association with the earth deity, for blood spilled profanes the earth.

The religious system was based on a pantheon of deities with specialized functions which has been compared to that of the ancient Greeks. Priests and worshippers were organized into cult groups dedicated to particular deities, each with a set of symbols and taboos associated with the patron. With the exception of Eshu the messenger, none of these deities is usually represented in the art forms. Figurines represent human beings, often the worshippers. Three of the cult groups use masks; Egunun, Epa and Gelede masks each have different recognizable characteristics.

Now the Yoruba are part of the nation of Nigeria undergoing rapid change in the boom times of oil exports and increased urbanization and industrialization.

Ref. Bascom 1969; Thompson 1976, 1979; Fagg 1963.

Zapotec, see Mesoamerica. Fig. 2.08.

Zulu, p. 49.

A pastoral people in the southern end of the Eastern cattle area of Africa.

Zuni, see Pueblo. p. 27.

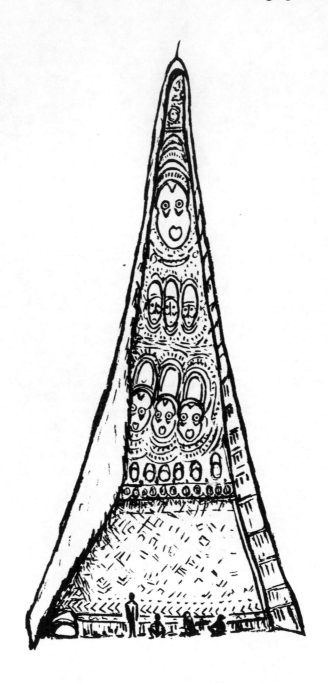

Glossary

with notes on various usages

Concepts such as "culture" and "art" are not definable in the way that objects can be defined; there are no right or wrong definitions, just more or less usual or useful ones. The definitions here give a sense of how a word is used in this book; a few comparisons with other usages may clarify the ideas behind these words, and indicate where ideas differ. A few terms not used in the text are included for reference. Terms for technical processes are omitted to keep the glossary to a reasonable length; they can be found elsewhere fairly easily.

abstract, 1) an intangible idea as contrasted to a concrete object; 2) art that uses a very few properties selected ("abstracted") to represent visible reality. Objects may, or may not, be recognizable; 3) often used for art in which there is no representational subject matter; expression is through formal qualities

acculturation, the process of interaction between two societies in which the culture of the society in the subordinate position is modified to conform to the culture of the dominant society.

ambiguity, the quality of being unclear in meaning, usually because of more than one meaning.

Anasazi, the prehistoric culture of the Pueblo Indians of Arid America, sometimes also used for contemporary Pueblos.

anthropology, the study of human beings in the broadest possible context, including the biological and cultural past, recent social and cultural diversity, and the relations of all aspects of human life to each other.

anthropomorphic, in human form.

anthropomorphism, the attribution of human form to any object.

archaic, an early phase of a style or civilization; also used for certain stylistic features thought to be characteristic of such early phases.

archetype, original model, pattern, or prototype. In the Jungian approach this idea applies to primordial human images as contrasted with culture-specific symbols.

art, there are even more definitions of the word "art" than of the word "culture"; the most usual are 1) application of knowledge and skill to affect a desired result, and 2) skill used to achieve an esthetic result.

There has been discussion as to whether all peoples have a concept of art, depending on whether they have a word for it; it is hard for academics to conceive a concept

> *without a specific translatable word, but broader understanding of the processes of thought and communication will probably remove this bias.*

artist, a craftsman who considers esthetic effect in addition to, or instead of, the uses of his product.

baroque, 1) Capitalized, a specific period in European art history, centering in the 17th century; 2) a term used to describe styles of that period; 3) styles that resemble those of the Baroque period; dramatic with "movement" of large masses of forms, impressive, grand, often rich and ornate.

binary opposition, a contrast between two qualities, things, concepts, or whatever.

canons, rules or guidelines.

cargo cults, revitalization movements in Melanesia involving the idea that proper rituals would bring a cargo of manufactured goodies.

cargo system, a ceremonial system of Mesoamerica which involves service for a year in a succession of hierarchial positions; man carries a sacred burden.

catlinite, a red clay found in parts of Minnesota that hardens when exposed to air; pipestone.

causal-functional system, aspect of society that can be observed as action and interaction without regard to how the participants conceive it. See logico-esthetic.

ceremony, a complex of rituals associated with a certain kind of occasion.

> *The use of the adjective "ceremonial" as a noun meaning a ceremony is common, and has become traditional with regard to the Navajo.*

Changing Woman, Navajo deity representing the life cycle and the earth, changing from the youth of spring through the season to the winter of old age.

chanter, a Navajo priest.

Chief, a leader. 1) in a narrow, precise sense, a leader of a chiefdom but without the authority of a head of state. 2) used very loosely for a leader; a) the Ashanti chief was more like a duke or provincial governor, b) the Kwakiutl chief was the headman of a kin group, c) the Dakota chief was simply one of the important men of the band.

chiefdom, a level of socio-cultural complexity in which there is a considerable degree of specialization, with a specialist in administration, the chief; his government does not have, however, a monopoly of force and it is not a true state; included here under kingdoms.

Child-of-the-Water, Navajo holy personage, one of the Twins. Changing Grandchild is his other self.

churinga, Australian sacred object of stone or wood seen only by initiates; often carved or painted with simple designs of great symbolic meaning.

a **civilization,** a large society of some complexity with most or all of the following cultural traits: cities, writing, monumental architecture, craft and other specialization, social stratification.

> *Where the word is used to mean a society or culture regardless of degree of complexity, then the term "high civilization" designates these more complex entities.*

> *A civilization is a term often used with the connotation of a configuration that exists through time and may cover several political and cultural entities sharing certain basic traits and postulates. A sequence of rise, climax and decadence is often assumed.*

clan, a descent group through one line—either male or female (in some usages refers to those through the female line only). Distinguished from lineage by including more distant relatives, so that the common ancestor is unknown or mythical.

classic, 1) as a period, the high point in a style or civilization. 2) as descriptive of style: a) using traditional rules, b) serenely beautiful; idealized realism.

code, a system of symbols and/or signs used in communication.

cognition, thinking.

collective representations, shared symbols of a group.

communitas, togetherness, the sense of unity among a group of people without regard for differences in status.

> *A term brought into general anthropological use by Victor Turner in his works on ritual. Myerhoff regards this as an absolute mystical state, but Turner treats it as a matter of degree.*

comparative method, the study of behavior in a variety of societies to determine the ways in which all human beings are alike, the ways they are different, and explanations for those differences and likenesses.

componential analysis, a technique for studying how people sharing a culture or sub-culture use words to order and classify some aspect of experience; gives clues to world view and value systems.

conceptual archetype, see root metaphor.

configuration theory, the idea that in a society there tends to be similarity of form in all aspects of life—that social relationships, symbolic forms, and psychological personalities are similarly patterned and congruent or analogous.

> *This idea is put forth in many terms, and is often taken for granted. Kroeber speaks of a "total cultural style"; Benedict of "patterns of culture"; Sapir calls congruence "genuine culture." Many writers equate integration of this kind with a*

state of equilibrium.

> *Geertz points out that because "causal-functional integration" and "logico-meaningful integration" are not of the same order they are not automatically congruent and tend to get out of synch where change is rapid. See p. 162-164.*

congruence, similarity of form.

content, in art, the subject plus the iconography of a work of art as distinguished from style in the narrow sense of the formal qualities of the work.

context, archeological, the precise position of an artifact when found and its relation to other artifacts and natural features; gives the information necessary to interpret temporal and cultural significance.

context, cultural, when, where, how and why an event took place, or an artifact was made and used, and especially what the meaning was.

context, social, the people involved in events at which art is displayed or performed.

cosmology, ideas and beliefs about the nature of the universe.

craftsmanship, the knowledge, skill and effort that are involved in producing an artifact.

creativity, recombining elements of any kind. Considered here as a matter of degree with regard to how novel or innovative the result.

cultural anthropology, ethnology, a term that reflects the view that the concept of culture is central to anthropological concern.

cultural relativity, or relativism, making judgments only in terms of the value systems of peoples in cultural contexts; compare ethnocentrism.

> *In moderate form, the putting aside of judgment until more understanding of a culture is achieved; some extremists have interpreted this to mean denial of all moral canons, which is absurd because of the evidence of human universals.*

> *In art, the putting aside of esthetic judgments in this same way.*

culture, the human way of adapting by the accumulation of learned ways of behaving and the use of symbols.

> *There are a great many definitions of this word, as it represents an abstract idea, a sensitizing concept, rather than any measurable phenomenon.*

> *There is sometimes a rather sterile argument as to whether artifacts are a form of culture, or whether culture is an abstraction from what is in people's minds, expressed by and deduced from actions, utterances and artifacts.*

a **culture,** the integrated sum total of learned behavior characteristic of the members of a society; the way of life, or lifestyle of members of a society, resting on a shared definition of reality.

In a large complex society there are many sub-cultures, and fewer shared beliefs and traits, so much so that the differences may seem more significant than the similarities, because the shared assumptions are subtle and unconscious.

culture, ideal, a formulation of normative patterns for behavior as stated by members of a society; what people like to think they do.

culture area, a geographical category based on similarities in cultural adaptions; many peoples and considerable diversity can exist within such areas, but they are meaningful for broad generalizations and comparisons.

culture trait or **element,** a minimal unit of learned behavior or a material product thereof.

deep structure, a set of very abstract, implicit rules about the ways in which a speaker of language rearranges the parts to form sets of meanings.

Can be extended to all kinds of thinking and is similar to the old phrase "the psychic unity of mankind". See structuralism.

depth psychology, theoretical approach involving basically the concepts of a conscious and an unconscious mind, and the interpretation of the symbols of the unconscious that reveal the dynamics of a personality.

Two relevant ideas from the depth psychology are 1) that feelings can be externalized or expressed by being unconsciously "projected" into visible forms thus revealing personality, and 2) unacceptable impulses can be redirected, "sublimated", into higher forms such as art.

diachronic, in anthropology, the study of cultures as they change through time.

diffusion, the spread of cultural ideas or traits from society to society.

diffusionism, the idea that humans are basically uninventive, so that most inventions were made only once and spread by migration or diffusion; in extreme form, from a single source.

drypainting, a design made on a horizontal surface with dry material such as colored sand, colored rice flour or dyed sawdust, etc. Navajo "sandpaintings" are the most widely known examples.

eclecticism, method of practice of selecting what seems best from various systems or theories.

ecological theory, the theory that human cultures are basically adaptions to their ecosystems, and must be to survive; this adaption includes the symbolic aspects of culture. Cultures are analyzed in this framework.

Harris's "cultural materialism" is ecological theory.

ecology, the study of relationships between organisms and their total environments.

ecosystem, a system which includes the physical environment and the organisms that inhabit it, including the human ones.

emic, the perception of phenomenon as seen and felt by a participant inside the cultural system. Icons are emic.

enculturation, the process by which the individual learns the patterns of the culture into which he or she is born. Compare acculturation.

entropy, a term borrowed from physics, and often used very loosely to mean disorganization, disintregation to inert uniformity, or a cosmic running down as entropy increases.

erotic, having to do with sexuality and sexual arousal.

> *In some theoretical formulations, notably those derived from Freudian psychology, any form that can be interpreted as analogous to sexual organs is consciously or unconsciously erotic in meaning; i.e., all pole sculpture is phallic.*

Eshu, Yoruba diety.

esthetic (aesthetic), beautiful or giving the same kind of feeling that beauty does.

ethnic, refers to a distinguishable cultural or sub-cultural tradition.

ethnic group, a group of people within a larger society, members of which identify themselves as members, who share a distinctive sub-culture because of their traditions. Example: the Ashanti are now an ethnic group in Ghana.

ethnocentric, see ethnocentrism.

ethnocentrism, the view that the values and ways of one's own group are superior; all others are judged by reference to this view. Reverse ethnocentrism, that all values and ways of one's own group are infererior to all others, is an equally prejudiced version.

ethnoesthetics (ethnoaesthetics). 1) study and comparison of esthetic standards and ideas of peoples from different cultures. 2) the study of the arts of different cultures; sometimes used to mean the study of ethnic visual arts, corresponding to the term ethnomusicology. (See Sieber 1973 for a good discussion regarding the first meaning).

ethnographic, descriptive of cultural behavior, factual rather than theoretical.

ethnology, the study of culture, including the comparison of cultures and theoretical interpretations.

ethnography, 1) the description of a culture; 2) the study of cultures.

> *"An ethnography" is comparable to "an iconography" when used in the sense of description. However, what an ethnography is about is more likely to be called the **culture** of a people while what an iconography is about is more likely to be called the **iconography** of the people.*

ethnoscience, the systematic study of the cognitive systems, or ways of classifying the experienced world of different peoples.

> *Much of this work has been done through the study of language, but some through ritual symbolism, and so is relevant to the study of art.*
>
> *Munn has dealt with the visual forms, and says: "all*

[iconographies] operate by means of relatively standardized visual vocabularies or elementary units (conveying, as in oral language, categories of varying degrees of generality) and have implicit rules of element combinations". (1973: 216).

etic, the perception of a phenomenon by an outside observer, using terminology that is applicable cross-culturally.

evolutionism, refers to the use of evolution as the principal or basic form of theoretical explanation.

fetish, a term used for an object with spirit power; often used loosely, replacing "idol" in the sense of an image in a religion not one's own.

field theory, explanation in terms of the forces or vectors operating in an event, rather than on the class of objects involved; as used here, consideration of all the factors that influence artistic events, and hence artistic form.

folk art, as this term is used, several ideas are variously combined. 1) art of common people as distinct from the elite; 2) art made by persons without professional training; 3) objects hand made for utility and not considered "fine art". "Primitive art" may or may not be included.

Folk art has often been considered in terms of lagging emulation of the elite arts, but this may be the elite view-point—witness break dancing.

formal qualities, abstract characteristics as contrasted to content; style in the narrow sense; shapes, lines, symmetry, pattern, etc.

Bateson uses the term style in this sense; he says: "I shall consider style—neatness, boldness of contrast, etc., a meta-phoric and therefore as linked to those levels of the mind where primary processes hold sway." (1973: 240).

Kroeber uses the term "technical form."

form-quality, a minimal element of form, a single formal quality.

form-meaning, meaning of a form-quality; term based on the hypothesis that form-qualities communicate more or less specific meanings or feelings.

This idea is implicit in many discussions of art, and it is used in a variety of psychological projection tests; in both cases cross-cultural validity is often assumed.

Kubler claims that the elements of form (form-qualities) have in themselves no more meaning than do the phonemes in language.

See Hatcher 1974.

Freudianism, see depth psychology.

function, how something works in a particular context; what an aspect of a system contributes to the whole.

functional art, in Graburn's terminology, art made for use within the socio-cultural context of the artist.

functional style, in art terminology, a style without ornament, designed to be primarily useful, but achieving esthetic value by elegant simplicity of form.

functionalism, a theoretical and methodological approach that emphasizes the part each unit or custom plays in the maintenance and survival of the society. In this view, all symbolic forms are explained in terms of social functions; they "hold the society together."

geometric, in the literature, this term seems to be applied to forms that are both symmetrical and done in straight lines, although it could properly be also used for designs made of curved lines.

historicism, the use of historical explanation (what happened that led up to this) as the principle or only form of explanation.

icon, 1) a culturally specific visual symbol; 2) a representational visual symbol, an image; 3) a portable image, a painting or mosaic of a sacred personage in the orthodox Christian church; 4) a sacred symbol.

> *Sense one, used in this book, is similar to Kubler's "conventional level of meaning" and Fagg's "real content of meaning." Munn uses "iconic" in sense two. From sense four comes the word iconoclast, a breaker of sacred symbols, an attacker of sacred beliefs.*

iconic, see icon. Sometimes used to mean any visual form as opposed to verbal ones.

iconography, 1) visual representation; 2) study and description of systems of visual symbolism; 3) the visual symbolism of a particular culture, a traditional system of visual representations.

> *Kubler uses this in sense two when he says: "Iconography is the study of forms assumed by adherent meaning on three levels, natural, conventional and intrinsic." (1962: 26).*
>
> *Munn uses this in sense three when she says: ". . . iconographies serve to articulate underlying assumptions about the nature of the universe; i.e., they can provide visual models for cosmic order." (1973: 216).*

iconology, 1) the study of meaning in art in general; the study of iconographies; 2) the interpretation of a visual symbol (icon) of a particular culture in terms of the cultural context; see interpretation; 3) the whole symbolic system of a society. Compare ethnology and ethnography.

idol, a representation of a sacred figure in a religion other than that of the writer or speaker.

Ifa, Yoruba divination system.

image, a visual representation or likeness.

industrial. This word is in common use for mechanization based on fossil fuels and the large scale economic systems that go with it.

innovation, something new that is accepted by enough people to be

part of a culture, whether it is invented within the society or introduced from the outside.

The acceptance or rejection of innovations, including art techniques and styles, is a complex and interesting study; what individuals, or classes or society, accept or reject what kinds of innovation? See revitalization movement, diffusion.

integration, act or process of making whole. See configuration theory, function, functionalism.

"The problem of grace [in art] is fundamentally a problem of integration and what is to be integrated is the diverse parts of the mind." (Bateson 1973: 235).

interpretation, as used here refers to the meanings that are implicit in visual forms according to various emic or etic theories; includes iconology in the second sense.

Kroeber uses the term "concept" for the deeper level of meaning and includes "emotional aura of tuning" as well as the philosophical and cognitive; Kubler uses the phrase "intrinsic meaning."

Kachina, the holy personages in Pueblo society who are represented in ceremonials by masked dancers.

life cycle analogy, theory that art styles are entities that go through stages analogous to birth, youth, maturity, decline and death.

This theory is implicit in much of art history, even if not explicitly endorsed; it rests on a basic habit of Western thought, the "root metaphor" of phenomena as entities, things, people, ideal types—the habit of thinking in terms of nouns.

lineage, a descent group (through males—patrilineage, or through females—matrilineage) where the common anscestor of all members is known.

logico-esthetic system, the way a people conceives and symbolizes their world. See causal-functional system.

malanggan, New Ireland ceremonial complex and any of the carved figures associated with it.

mana, a diffuse force or energy which is believed to reside in various degrees in objects, places and persons.

This is the Polynesian term; Africans have a concept translated "vital force" and North American Indians a concept translated "power" which are similar; a related concept is that of the Holy Spirit in early Christian belief.

matrilineal, descent reckoned through the female line.

It has been suggested that societies in which the matrilineal principle is strong encourages visual arts because art is especially needed to symbolize various forms of male solidarity (Wolfe).

meaning

The concepts behind the categories of meaning in art that

*are used here are quite common, but the number of categories
and the terms used vary a lot.*

*Perhaps the most usual is the distinction between content
and style; content includes all representational and symbolic
meaning, style the formal qualities which may or may not be
conceived as having meaning.*

*Fagg uses three levels: 1) subject matter or overt content, 2)
subject or real content or meaning, 3) style.*

*Kubler distinguishes between "adherent meaning", i.e.,
content, and "self-signal" or formal qualities of a work.*

*The reason for dividing meaning up into all the categories
used in this work are:*

*1. To call attention to complexities and possible
ambiguities.*

*2. To enable a viewer to sort out various aspects of a work,
thus deepening understanding and avoiding stupid
arguments about "real" meaning.*

3. To further the study of visual communication.

medium, (plural, media), the material used by the artist—i.e., the
means by which he communicates or through which he expresses
himself.

metaphor, some relationship, quality, form or process is seen as like
some other relationship, quality, form or process in some way, and
so one is used to suggest the other; the nature of the likeness is not
explicitly stated; an analogy.

*Metaphors are not only embedded in abstract forms, but
using the term mainly with regard to form-qualities helps to
clarify the distinction between implicit metaphors and the
more explicit symbols and analogies.*

*The term metaphor has recently become popular, and is
used in such a broad sense that it is in danger of becoming
meaningless.*

milpa, the Maya term for their fields. Milpas are important in the
religious system; maize is especially sacred; milpa is also a term for
the slash-and-burn, or swidden technique for clearing and
planting in the forest.

modal personality, a combination of those personality characteristics
that are present most frequently among individuals in a society.

*This term is an attempt to state more objectively the impres-
sionistic idea of national character or basic personality types.*

motif, (plural motifs), a design unit either formal or representational
that recurs in a style or can be traced from style to style. Analogous
to a theme in mythology or music.

multi-rhythms, superimposed or simultaneous differing rhythmic
patterns. In visual forms repetitions of colors, for example, may
repeat Red Yellow Blue, Red Yellow Blue, while the shape of the
unit may take four forms, square, triangle, circle, hexagon, so the

pattern runs Rs Yt Bc Rh Ys Bt Rc Yh Bs Rt Yc Bh, etc.

myth, an important story that usually embodies the postulates and values of a society. Often considered to be true history by members of that society. Myth differs from legend in that the latter is recognized as more or less fictional. See root metaphor.

nativistic movement, a reactive movement to remove foreign persons or cultural elements so as to restore a by-gone culture.

opposites, polar or contrastive polarities, descriptive qualities expressed in contrasting extremes: simple/complex, classic/romantic, etc. This is the fundamental device of verbal analysis, conceived, however, as a continuum rather than as purely binary.

opposition, binary, two part opposition—absolute contrast as distinct from the gradation of polar opposition: male/female, life/death. Opposition is basically semantic and the simplest form of ordering.

paradigm, a model, an ideal, a pattern. In paradigmatic theory (q.v.), an overall or basic model within which other patterns and operations are conceived.

> *Kubler's "prime object" could be called a paradigm.*

paradigmatic theory, stresses the importance of the way basic paradigms (root metaphors, conceptual archetypes, cognitive maps, religious, cultural postulates, models of reality, etc.) shape behavior, and so culture and society, and what happens with the introduction of new ones.

> *The name Kuhn is associated with this theory regarding the history of sciences; Wallace (1978, Appendix) with its application to socio-cultural processes.*

perception, awareness through the senses.

phoneme, the smallest sound unit which is used meaningfully in a language; may have considerable phonetic variation.

phonetics, the general study of spoken sounds.

postulates, cultural or basic, the unconscious assumption that underlie one's definition of reality (existential postulate) and one's values (normative postulates). See Hoebel, 1978.

potlatch, the Northwest Coast Indian institution of ceremonial feasting accompanied by a lavish distribution of gifts.

potsherds, fragments of pottery.

primitive, "of or pertaining to the beginning or origin, or to the earliest ages or period, original"—Webster. In this sense not applicable to the art of any recent peoples, all of which have equally long traditions, but applicable to the technological items resembling those known from the earliest ages. Sometimes defined as pre-literate.

primitive art, 1) the arts of non-literate, small scale societies with direct technologies; 2) art of untrained, self-taught artists in Euro-American societies, a naive style.

*The author and many others avoid this term in sense one, be-
cause it implies a them/us, primitive/civilized distinction that is
very ethnocentric. Also, there is a great problem of where, in the
levels of socio-cultural complexity, one draws the line between the
two.*

provenance or provenience, source or origin; where something came
from. For fine arts includes the entire history of the object; previous
owners, sales, exhibitions, etc. This is seldom so extensive for ethnic
arts, where sometimes the place of origin is meant, and sometimes the
source from which it was obtained by the present owner, typically to
establish authenticity.

purpose, conscious intent; distinguished here from motivation, which is
often imputed by the observer.

religion, a set of beliefs that "puts it all together" and a set of practices,
rituals, ceremonies, symbols and structures that dramatize and com-
municate the beliefs.

replica, an exact copy.

revitalization movement, the introduction, by a "prophet" of a new
or reformulated system of belief and behavior, often in the form of a
cult which if successful becomes a church. (See Wallace, 1956.)

*Innovative social movements, especially religious ones, are
communicated in changed symbolic forms and art styles.*

*The stages of a revitalization movement are seen also when
important new art styles are adopted.*

ritual, a behavior that is stereotyped, predictable, repeated on
appropriate occasions, and symbolic; differs from routine in being
non-instrumental and value-laden.

*In the current jargon of dance and the arts the term "ritual"
is very loosely used, apparently meaning metaphorical, and
is applied to something new and even unique.*

role, the customary complex of behavior associated with a particular
status.

root metaphor, an analogy, usually implicit; a model, image,
scenario or paradigm that underlies the world view of a people;
described in its cognitive aspects in terms of cultural postulates;
sometimes embodied in a synthesizing symbol. See the various
terms above, and Turner 1974.

seriation, an archeological technique based on the statistical distribu-
tion of a stylistic feature or type of artifact through time.

*Kubler is interested in such features from an art-historical
point of view; archeologists have used it largely for relative
dating.*

shaman, a religious curing specialist who has received power directly
from supernatural sources; medicine man; witch doctor; angekok.

Shango, Yoruba god of thunder.

social anthropology, comparative sociology.

A term based on the idea that social interactions are the core

concern, and that symbolic forms are important as they reflect social facts.

social organization, the actual set of patterned interactions of people in a society; compare social structure. Loosely used for social structure.

social structure, the pattern of relationships among the statuses in a society; when contrasted to social organization, implies a model or ideal as compared to an actuality.

society, a spatially indentifiable human population sharing a culture.

A society in the sense of a club is called an association in anthropology.

souvenir art, small, inexpensive, portable art objects kept as remembrances of an event or place.

stage, position in a sequence, as "tribal", "industrial" in a sequence of complexity or "archaic", "classical" in a stylistic sequence. "Age" is sometimes used in this sense; thus the native Australian were in the "stone age" or "tribal age" at a chronological period when other peoples were at other stages.

structure, a set of relationships of some kind with some kind of function. 1) In art sometimes used to mean the organization or composition of a work. 2) In anthropology, used to mean social structure (but Structuralism refers to the structure of the mind).

Structure, in Turner's terms means social organization, especially in terms of ranked status, in contrast to communitas. At times of communal rituals the structure is often replaced by what Turner calls anti-structure, and the author calls alternate structure.

structuralism, a theoretical approach based on ideas about the deep structure of the human mind, strongly influenced by linguistic analysis; the analytical approach of Levi-Strauss and his followers, especially the study of oppositions. Compare ethnoscience.

style, 1) characteristic or distinctive mode of presentation, construction or execution in any art; 2) all the elements that add up to a recognizable configuration, i.e., a style; 3) in art, often used in a narrow sense to refer to the formal qualities as distinguished from representative or iconographic content.

a **style,** a more or less arbitrary category based on selected qualities and characteristics common to a number of works and given a name.

Often loosely applied, especially in the case of tribal styles, to all the artistic products of a society.

subject, what a work of art is about; usually, but not always, refers to a representational image, often includes the iconic.

Fagg refers to subject matter, or overt content; Kubler calls this natural level of meaning. Kroeber includes representation

and iconic levels under the term subject. Each has other terms for deeper,
implicit meanings.

symbol, 1) in the narrow sense, a meaning that exists because of an
arbitrary connection with its referent, and so is culture-specific;
words such as "eye" or "hand"; 2) in the broad sense, anything that
stands for or suggests something else—almost synonymous with
the whole range of meaning—thus art and language are "symbolic
systems."

> *In art, visual symbols in the first sense are often so entwined*
> *with metaphors that the distinction is largely conceptual.*
>
> *Merriam, an ethnomusicologist defines four levels of sym-*
> *bolism: 1) representational, direct meanings; 2) culturally*
> *defined meanings; 3) reflection of social behavior and values in*
> *a particular culture; 4) universal human symbols.*

system, a set of things that interrelate or interact.

systems theory. Defining some entity, such as a society, as a system
distinct from its environment. The components of the system are
considered to be linked by feedback mechanisms so that a change in
one component will produce compensating changes in others to
maintain the total system in an operating equilibrium. If the
change exceeds the capacity of the system to respond, the system
fails.

tapu, prohibition of an act, violation of which is punishable by
supernatural sanctions.

tamberan, name for men's cults in the Sepik river area of New Guinea
and the houses associated with them.

technical qualities, physical characteristics of an artifact, such as the
kind of temper used in a pot, or the type of weave in a textile.

> *Kroeber used this in the sense of formal or abstract qualities;*
> *now we would say that technical qualities affect formal ones.*

themes, recurrent ideas, emotions or scenarios frequently encoun-
tered in the myths or other cultural products of a society;
such themes offer clues for inferring the root metaphors, etc. of that
society.

totem, symbolic association and even identification of plants, ani-
mals or objects with classes of people.

totem poles, Northwest carved poles with a variety of symbolic
associations; not totemic in the strict sense.

tourist art, art made for sale to tourists, usually of the same type as
those made for the export trade ("export art"). As used here, often
larger and somewhat more expensive than "souvenir art,"
sometimes called "airport art."

tradition, cultural elements that persist through time.

tribe, used here in the narrow sense referring to small societies with
direct technologies. The broad use of the term, meaning "a
people", a "society", or even an "ethnic group" is avoided.

Upper Paleolithic, late stone age period of "great hunters" characterized by specialized flint tools and known for the cave paintings of Europe.

use, the physical context of an object.

utilitarian, practical use; i.e. for physical survival and well-being rather than symbolic or psychological benefit.

world view, the system of beliefs, values, philosophy and ideology which characterize the members of a society regarding nature and mankind.

Bibliography

This Bibliography contains the works of authors cited in the text, and suggestions for further reading. Cited authors are listed in the Subject and Author Index.

Abramson, J. A.
 1976 "Style Change in an Upper Sepik Contact Situation." In Graburn, 1976.
Adair, John
 1944 *The Navajo and Pueblo Silversmiths.* U of Oklahoma Press, Norman.
Alkire, Wm. H.
 1977 *An Introduction to the Peoples and Cultures of Micronesia.* Cummings Publishing, Menlo Park.
Alland, Alexander, Jr.
 1977 *The Artistic Animal:* An Inquiry into the Biological Roots of Art. Anchor Press/Doubleday, Garden City.
Allen, Elsie
 1972 *Pomo Basketmaking.* Naturegraph Publishers, Healdsburg, California.
Allison, Philip
 1968 *African Stone Sculpture.* Lund Humphries, London.
Altman, Ralph
 1969 "Comments." In Biebuyck, 1969b.
Anderson, H. H. (ed.)
 1959 *Creativity and Its Cultivation.* Harper and Bros., New York.
Anderson, Richard L.
 1979 *Art in Primitive Societies.* Prentice-Hall, Englewood Cliffs.
Anton, F.; Dockstader, F; Trowell, M.; and Nevermann, H.
 1979 *Primitive Art:* Pre-Columbian, North American Indian, African, Oceanic. Harry N. Abrams, New York.
Appleton, LeRoy H.
 1971 *American Indian Design and Decoration.* Dover Publications, New York.
Archey, Gilbert
 1965 *The Art Forms of Polynesia.* Auckland Institute and Museum, Auckland.
Armstrong, Robert P.
 1980 *The Powers of Presence.* U of Pennsylvania Press, Philadelphia.
Arnheim, Rudolph
 1954 *Art and Visual Perception.* U of California Press, Berkeley.
 1971 *Visual Thinking.* U of California Press, Berkeley.
Attenborough, David
 1976 *The Tribal Eye.* W. W. Norton, New York.

Barnett, H. G.
1953 *Innovation:* The Basis of Culture Change. McGraw-Hill, New York.

Barrett, Sam A.
1908 *Pomo Indian Basketry.* Rio Grande Press, Glorietta. Republished 1970.

Barry, Herbert III
1957 "Relationships Between Child Training and the Pictorial Arts." *Journal of Abnormal and Social Psychology,* 54: 380-383. In Jopling, 1971.

Bascom, William
1969a "Creativity and Style in African Art." In Biebuyck, 1969b.
1969b *The Yoruba of Southwestern Nigeria.* Holt, Rinehart and Winston, New York.
1969c *Ifa Divination:* Communication Between Gods and Men in West Africa. Indiana U. Press, Bloomington.
1973a *African Art in Cultural Perspective:* An Introduction. W. W. Norton, New York.
1973b "A Yoruba Master Carver: Duga of Meko." In d'Azevedo, 1973c.

Bascom, William R. and Gebauer, Paul
1954 *Handbook of West African Art,* Bruce Publishing, Milwaukee.

Bascom, William and Herskovits, Melville
1959 *Continuity and Change in African Cultures.* U of Chicago Press, Chicago.

Bateson, Gregory
1949 "Bali: The Value System of a Steady State." In Fortes, 1949. Reprinted in Bateson, 1972.
1958 *Naven.* Second edition. Stanford U Press, Stanford.
1967 "Style, Grace, and Information in Primitive Art." Wenner-Gren Conference on Primitive Art. In Forge, 1973b. Reprinted in Bateson, 1972.
1972 *Steps to an Ecology of Mind.* Ballentine Books, New York.

Bateson, Gregory and Mead, M
1942 *Balinese Character.* New York Academy of Science, New York.

Baxter, P. T. W. and Butt, A.
1953 *The Azande and Related Peoples.* International African Institute, London.

Beam, Philip C.
1958 *The Language of Art.* Ronald Press, New York.

Bedinger, Margery
1936 *Navajo Indian Silver Work.* John Vanmale, Publishers, Denver.
1973 *Navajo and Pueblo Jewelers.* U of New Mexico Press, Albuquerque.

Bee, Robert L.
1974 *Patterns and Processes.* The Free Press, New York.

Beier, Ulli
1960 *Art in Nigeria.* Cambridge U Press, Cambridge.
1963 *African Mud Sculpture.* Cambridge U Press, London.
1968 *Contemporary Art in Africa.* Praeger, New York.

Belo, Jane
 1935 "The Balinese Temper." *Character and Personality*, 4: 120-146.
 Reprinted in Haring, 1956.
 1960 *Trance in Bali.* Columbia U Press, New York.
 1970 *Traditional Balinese Culture.* Columbia U Press, New York.
Ben-Amos, Paula
 1968 *Bibliography of Benin Art.* Primitive Art Bibliographies #6. The Mu-
 seum of Primitive Art, New York.
 1975 "Professionals and Amateurs in Benin Court Carving." In McCall
 and Bay, 1975.
 1977 "Pidgin Languages and Tourist Arts." *Studies in the Anthropology
 of Visual Communication*, Vol. 4, No. 2, Philadelphia.
 1980 *The Art of Benin.* Thames and Hudson, London.
Benson, Elizabeth P. (ed.)
 1979 *Pre-Columbian Metallurgy of South America.* Dumbarton Oaks Re-
 search Library and Collections. Trustees for Harvard University,
 Washington, D.C.
Berlant, Anthony and Kahlenberg, Mary H.
 1977 *Walk in Beauty:* The Navajo and Their Blankets. Little, Brown & Co.,
 Boston.
Berlyne, D. E.
 1966 "Curiosity and Exploration." *Science*, Vol. 153, No. 3731, 1 July, 1966.
Berndt, Ronald M.
 1958 "Some Methodological Considerations in the Study of Australian
 Aboriginal Art." *Oceania*, Vol. 29, No. 1. Reprinted in Jopling, 1971.
 1964 (ed.) *Australian Aboriginal Art.* Ure Smith, Sydney.
Berndt, Ronald M. and Berndt, Catherine H.
 1970 *Man, Land, and Myth in North Australia:* The Grunwinggu People.
 Michigan State U Press, East Lansing.
Berrin, Kathleen
 1979 "The Art of Being Huichol." *Natural History*, October, pp. 68-75.
Bidney, David
 1960 *Theoretical Anthropology.* Columbia U Press, New York.
Biebuyck, Daniel
 1969a "Introduction." In Biebuyck, 1969b.
 1969b ed. *Tradition and Creativity in Tribal Art.* U of California Press,
 Berkeley.
 1973 *Lega Culture:* Art, Initiation, and Moral Philosophy of a Central
 African People. U of California Press, Berkeley.
Billings, Dorothy K. and Peterson, Nicolas
 1967 "Malanggan and Memai in New Ireland." *Oceania* 38: 24-32.
Bird, Janius
 1979 "Legacy of the Stingless Bee." *Natural History*, November, Vol. 88,
 No. 9.
Bjerregaard, Lena
 1977 *Techniques of Guatamalan Weaving.* Van Nostrand, Reinhold, New
 York.

Black, Roman
 1964 *Old and New Australian Aboriginal Art*. Angus and Robertson, Sidney.

Boas, Franz
 1895 *The Social Organization and the Secret Societies of the Kwakiutl Indians*. Smithsonian Institution, Washington D.C. Reprinted by Johnson Reprint Corporation, New York, 1970.
 1909 *The Kwakuitl of Vancouver Island*. American Museum of Natural History Memoirs, G. E. Steichart, New York.
 1927 *Primitive Art*. Reprinted by Dover Publications, Inc., New York, in 1955. Page numbers refer to this edition.
 1966 (edited by Codere, Helen) *Kwakiutl Ethnography*. U of Chicago Press, Chicago.

Bodrogi, Tibor
 1961 *Art in North-East New Guinea*. Publishing House of the Hungarian Academy of Sciences, Budapest.
 1972 *Art of Indonesia*. Corvina, Budapest.

Boyer, Ruth
 1976 "Gourd Decoration in Highland Peru." In Graburn, 1976.

Bravmann, R. A.
 1974 *Islam and Tribal Art in West Africa*, Cambridge U Press, London.

Bricker, Victoria
 1981 *The Indian Christ, The Indian King:* The Historical Substrate of Maya Myth and Ritual. U of Texas Press, Austin.

Brigham, William T.
 1906 *Old Hawaiian Carvings*. Bernice P. Bishop Museum Memoirs, Honolulu, Vol. 2, No. 2.
 1911 "Ka Hana Kapa: The Story of the Manufacture of Kapa (Tapa), or Bark-cloth, in Polynesia and Elsewhere, but Especially in the Hawaiian Islands." *Memoirs of the Bernice P. Bishop Museum*, Vol. 3. Bishop Museum Press, Honolulu.

Buck, Peter H.
 1959 *Vikings of the Pacific*. U of Chicago Press, Chicago.

Buehler, Alfred; Barrow, T.; and Mountford, C.
 1962 *The Art of the South Seas*, Including Australia and New Zealand. Crown Publishers, New York.

Buhler, C. A.
 1971 *Oceanic Art:* Myth, Man, and Image in the South Seas. Abrams, New York.

Bunzel, Ruth L.
 1929 *The Pueblo Potter*. Columbia U. Press, New York. Reprinted by Dover Publishing, New York, 1972.

Burland, C.
 1973 *Eskimo Art*. Hamlyn, London.

Burland, C. and Forman, W.
 1969 *The Exotic White Man:* An Alien in Asian and African Art. McGraw-Hill, New York.

Bussabarger, Robert F. and Robins, Betty D.
1968 *The Everyday Art of India.* Dover Publications, New York.

Butzer, Karl W.
1980 "Civilizations: Organisms or Systems?" *American Scientist,* September-October, 1980, Vol. 68, No. 5.

Campbell, Joseph
1974 *The Mythic Image.* Princeton U Press, Princeton, N.J.

Carpenter, Edmund C.
1973a *Eskimo Realities.* Holt, Rinehart and Winston, New York.
1973b *Oh What a Blow that Phantom Gave Me.* Holt, Rinehart and Winston, New York.
1976 "Collectors and Collections." *Natural History,* March.
1980 "If Wittgenstein Had Been an Eskimo." *Natural History,* February.

Carpenter, Edmund and McLuhan, Marshall (eds.)
1960 *Explorations in Communication.* Beacon Press, Boston.

Carpenter, E.; Varley, F.; and Flaherty, R.
1959 *Eskimo.* U of Toronto Press, Toronto.

Carroll, Kevin
1967 *Yoruba Religious Carvings:* Pagan and Christian Sculpture in Nigeria and Dahomey. Geoffrey Chapman, London.

Casagrande, Joseph B.
1977 "Looms of Otavalo." *Natural History,* October.

Chernoff, John Miller
1980 *African Rhythm and African Sensibility.* U of Chicago Press, Chicago.

Child, Irvin L. and Siroto, Leon
1965 "Ba Kwele and American Aesthetic Evaluations Compared." *Ethnology,* Vol. 4, No. 4. Reprinted in Jopling, 1971.

Chipp, Herschel B.
1960 "Formal and Symbolic Facts in the Art Styles of Primitive Cultures." *Journal of Aesthetics and Art Criticism* 19. Reprinted in Jopling, 1971.

Christensen, Erwin O.
1955 *Primitive Art.* Bonanza Books, New York.

Coe, Michael D.
1965 *The Jaguar's Children:* Pre-Classic Central Mexico. Museum of Primitive Art, New York.
1966 *The Maya.* Praeger, New York.
1977 *Mexico.* (second edition). Thames and Hudson, New York.

Cole, H. M.
1969 "Art as a Verb in Iboland." *African Arts,* Vol.3, No. 1.

Cole, Herbert M. and Ross, Doran
1977 *The Arts of Ghana.* U of California Press, Los Angeles.

Colton, Harold S.
1959 *Hopi Kachina Dolls* with a key to their Identification. U of New Mexico Press, Albuquerque.

Cordwell, Justine and Schwarz, Ronald (eds.)
 1979 *Fabrics of Culture:* The Anthropology of Clothing and Adornment. The World of Anthropology Series, Mouton Publishers, The Hague.

Courlander, Harold
 1974 *Tales of Yoruba Gods and Heroes.* Fawcett Publications, Greenwich.

Covarrubias, Miguel
 1950 *Island of Bali.* Alfred A. Knopf, New York.

Crowley, Daniel J.
 1966 "An African Aesthetic." *Journal of Aesthetics and Art Criticism* vol. XXXIV, No. 4, Reprinted in Jopling, 1971.

Culbert, T. Patrick
 1974 *The Lost Civilization:* The Story of the Classic Maya. Harper & Row, New York.

Dark, Philip J. C.
 1967 "The Study of Ethno-Aesthetics: The Visual Arts." In Helm, 1967.
 1973 "Kilenge Big Man Art." In Forge, 1973b.
 1974 *Kilenge Life and Art:* A Look at a New Guinea People. St. Martin's Press, New York.

Davenport, William H.
 1968 "Sculpture of the Easter Solomons." *Expedition,* Vol. 10, No. 2, Winter 1968. Reprinted in Jopling, 1971.

D'Azevedo, Warren L.
 1958 "A Structural Approach to Esthetics: Toward a Definition of Art in Anthropology." *American Anthropologist,* 60: 702-714.
 1973a "Mask Makers and Myth in Western Liberia." In Forge, 1973b.
 1973b "Sources of Gola Artistry." in D'Azevedo, 1973c.
 1973c (ed.) *The Traditional Artist in African Societies.* Indiana U. Press, Bloomington.

Deetz, James
 1967 *Invitation to Archaeology.* The Natural History Press, Garden City.

Delange, Jaqueline
 1974 *The Art and Peoples of Black Africa.* E. P. Dutton, New York.

Devereux, George
 1961 "Art and Mythology: A General Theory." In Kaplan, 1961. Reprinted in Jopling, 1971.

D'Harcourt, Raoul
 1962 *Textiles of Ancient Peru and Their Techniques.* U of Washington Press, Seattle.

Disselhoff, H. D. and Linne, S.
 1960 *The Art of Ancient America.* Crown Publishers, New York.

Dockstader, Frederick J.
 1967 *Indian Art in South America:* Pre-Columbian and Contemporary Arts and Crafts. New York Graphic Society, Greenwich.
 1973a *Indian Art of the Americas.* Museum of the American Indian, Heye Foundation, New York.
 1973b "The Role of the Individual Indian Artist." In Forge, 1973b.
 n.d. *Indian Art in America:* The Arts and Crafts of the North American Indian. Promontory Press, New York.

Dondis, Donis A.
1973 *A Primer of Visual Literacy.* The MIT Press, Cambridge.

Douglas, Frederic H. and d'Harnoncourt, Rene
1941 *Indian Art of the United States.* The Museum of Modern Art, New York.

Douglas, Mary
1975 *Implicit Meanings.* Routledge and Kegan Paul, London.

Drewal, Henry J.
1979 "Pagentry and Power in Yoruba Costuming." In Cordwell and Schwarz, 1979.

Drewal, Margaret Thompson
1977 "Projections from the Top in Yoruba Art." *African Arts,* October.

Drewal, Margaret and Drewal, Henry John
1978 "More Powerful than Each Other: An Egbado Classification of Egungun." *African Arts,* pp. 28-39.

Drucker, Philip
1955 *Indians of the Northwest Coast.* McGraw-Hill, New York.
1965 *Cultures of the North Pacific Coast.* Chandler Publishing, San Francicso.

Duly, Colin
1979 *The Houses of Mankind.* Thames and Hudson, London.

Dunn, Dorothy
1968 *American Indian Painting.* U of New Mexico, Albuquerque.

Ebersole, Robert P. and Craven, Roy C., Jr.
1978 *Folk Arts and Crafts of the Andes.* U of Florida, Gainesville.

Ebin, Victoria
1979 *The Body Decorated.* Thames and Hudson, London.

Eicher, Joanne B.
1969 *African Dress:* A select and Annotated Bibliography of Sub-Saharan Countries. Michigan State University, East Lansing.

Elkin, A. P.
1950 *Art in Arnhem Land.* U of Chicago Press, Chicago.
1964 *The Australian Aborigines.* Doubleday, Garden City.

Emery, Irene
1966 *The Primary Structure of Fabrics:* An Illustrated Classification. The Textile Museum, Washington D.C.

Emery, Irene and Fiske, Patricia (eds.)
1977 *Ethnographic Textiles of the Western Hemisphere:* Irene Emery Roundtable on Museum Textiles 1976 Proceedings. The Textile Museum, Washington.

Emmerich, Andre
1965 *Sweat of the Sun and Tears of the Moon:* Gold and Silver in Pre-Columbian Art. U of Washington Press, Seattle.

Ewers, John
1939 *Plains Indian Painting:* A Description of an Aboriginal American Art. Stanford U Press, Palo Alto.

Fagg, William Buller
 1965 *Tribes and Forms in African Art.* Tudor Publishing, New York.
 1969 "The African Artist." In Biebuyck, 1969b.
 1970 *Miniature Wood Carvings of Africa.* New York Graphic Society,
 Greenwich.
 1973 "In Search of Meaning in African Art." In Forge, 1973b.
 1977 *The Tribal Image:* Wooden Figure Sculpture of the World. British
 Museum Publications, London.
 1980 *Yoruba Beadwork:* Art of Nigeria. Rizzoli, New York.

Fagg, William Buller and Elisofon, Elliot
 1958 *The Sculpture of Africa.* Praeger, New York.

Fagg, William and List, Herbert
 1963 *Nigerian Images.* Lund Humphries, London.

Fagg, William, Pemberton, J. and Holcombe, B.
 1982 *Yoruba Sculpture of West Africa.* Alfred A. Knopf, New York.

Fagg, William and Picton, John
 1970 *The Potter's Art in Africa.* British Museum, London.

Feder, Norman
 n.d. *American Indian Art.* Harry N. Abrams, New York.

Feest, Christian F.
 1980 *Native Arts of North America.* Oxford Press, New York.

Fenton, William
 1940 "Masked Medicine Societies of the Iroquois." *Smithsonian Institu-
 tion Annual Report.*

Fenton, W. N. and Gulick, J. (eds.)
 1961 *Symposium on Cherokee and Iroquois Culture.* Bureau of American
 Ethnology Bulletin 180.

Fernandez, James
 1966 "Principles of Opposition and Vitality in Fang Aesthetics." *Journal
 of Aesthetics and Art Criticism* 25 (1). Reprinted in Jopling, 1971.
 1973 "The Exposition and Imposition of Order: Artistic Expression In
 Fang Culture." In D'Azevedo, 1973c.
 1977 *Fang Architectonics.* Institute for the Study of Human Issues,
 Philadelphia.

Fewkes, Jesse Walter
 1973 *Designs on Prehistoric Hopi Pottery.* Dover Publications, New
 York.

Firth, R. W.
 1936 *Art and Life in New Guinea.* The Studio, London.
 1951 "The Social Framework of Primitive Art." *Elements of Social
 Organization.* Watts and Company, London.

Fontana, B.; Robinson, W.; Cormack, C.; and Leavitt, E.
 1962 *Papago Indian Pottery.* U of Washington Press, Seattle.

Force, Rowland W. and Force, Maryanne
 1971 *The Fuller Collection of Pacific Artifacts.* Praeger Publishers, New
 York.

Forde, C. Daryll (ed.)
1954 *African Worlds.* International African Institute. Oxford U Press, London.
1963 *Habitat, Economy and Society.* E. P. Dutton, New York.

Forge, Anthony
1965 "Art and Environment in the Sepik." *Proceedings of the Royal Anthropological Institute,* London. Reprinted in Jopling, 1971.
1967 "The Abelam Artist." In Freedman, 1967.
1973a "Style and Meaning in Sepik Art." In Forge, 1973b.
1973b (ed.) *Primitive Art and Society.* Oxford U Press, London.

Forman, W.; Forman, B.; and Dark, Philip
1960 *Benin Art.* Paul Hamlyn, London.

Fortes, Meyer (ed.)
1949 *Social Structure:* Studies Presented to A. R. Radcliffe-Brown. Clarendon Press, Oxford.

Fraser, Douglas
1955 "Mundugamor Sculpture, Comments on the Art of a New Guinea Tribe." *Man,* Vol. 55, 1955.
1962 *Primitive Art.* Doubleday, Garden City.
1966 (ed.) *The Many Faces of Primitive Art.* Prentice-Hall, Englewood Cliffs.
1968 *Village Planning in the Primitive World.* George Braziller, New York.
1974 (ed.) *African Art as Philosophy.* Interbook, New York.

Fraser, Douglas and Cole, Herbert M. (eds.)
1972 *African Art and Leadership.* U of Wisconsin Press, Madison.

Freedman, Maurice (ed.)
1967 *Social Organization:* Essays Presented to Raymond Firth. Aldine, Chicago.

Furst, Peter T.
1969 *Myth in Art:* A Huichol Depicts His Reality. Los Angeles County Museum of Natural History Quarterly Reprint #11, Los Angeles.
1973 "An Indian Journey to Life's Source." *Natural History,* April.

Gardi, Rene (translated by MacRae, S.)
1969 *African Crafts and Craftsmen.* Van Nostrand-Reinhold, New York.

Garfield, V. E. and Forrest, L. A.
1948 *The Wolf and the Raven.* U Washington Press, Seattle.

Gearing, F.
1962 *Priests and Warriors:* Social Structures for Cherokee Politics in the 18th Century. American Anthropological Association Memoir 93.

Geertz, Clifford
1957 "Ethos, World View, and the Analysis of Sacred Symbols." *Antioch Review,* Winter 1957-58. Reprinted in Hammel and Simmons, 1970.
1980 *Negara:* The Theatre State in Nineteenth Century Bali. Princeton Press, Princeton.

Gerbrands, Adrian A.
 1967 *Wow-ipits:* Eight Asmat Woodcarvers of New Guinea. Mouton,
 The Hague.
 1968 (ed.) *The Asmat of New Guinea:* The Journal of Michael Clark
 Rockefeller. Museum of Primitive Art, New York.

Gibbs, James L., Jr. (ed.)
 1965 *Peoples of Africa.* Holt, Rinehart and Winston, New York.

Gillo, Paul Jacques
 1960 *Form, Function and Design.* Reprinted in 1975 by Dover Publica-
 tions, New York.

Gittenger, M.
 1979 *Splendid Symbols:* Textiles and Traditions in Indonesia. Textile
 Museum, Washington, D.C.

Glaze, Anita J.
 1981 *Art and Death in a Senufo Village.* Indiana U Press, Bloomington.

Goetz, Hermann
 1964 *The Art of India:* Five Thousand Years of Indian Art. Greystone
 Press, New York.

Goldwater, Robert
 1960 *Bambara Sculpture from the Western Sudan.* Museum of Primitive
 Art, New York.
 1964 *Senufo Scultpure from West Africa.* The Museum of Primitive Art,
 New York.
 1973 "Art History and Anthropology: Some Comparisons of
 Methodology." In Forge, 1973b.

Goodale, Jane C.
 1959 "The Tiwi Dance for the Dead." *Expedition* 2: 3-14.

Goodale, Jane C. and Koss, Joan D.
 1971 "The Cultural Context of Creativity Among the Tiwi." In Otten,
 1971.

Gotshalk, D. W.
 1962 *Art and the Social Order.* Dover Publications, New York.

Gould, Richard A.
 1969 *Yiwara:* Forgagers of the Australian Desert. Chas. Scribner's Sons,
 New York.

Graburn, Nelson H. H. (ed.)
 1976 *Ethnic and Tourist Arts:* Cultural Expressions from the Fourth
 World. U of California Press, Berkeley.

Greenhalgh, Michael and Megaw, Vincent (eds.)
 1978 *Art in Society:* Studies in Style, Culture, and Aesthetics. St.
 Martin's Press, New York.

Griaule, Marcel
 1965 *Conversations with Ogotemmeli:* An Introduction to Dogon
 Religious Ideas. Oxford U Press, London.

Griaule, Marcel and Dieterlen, Germain
 1954 "The Dogon." In Forde, 1954.

Gross, Daniel R. (ed.)
1973 *Peoples and Cultures of Native South America:* An Anthropological Reader. Doubleday/The Natural History Press, New York.

Gunther, Erna
1967 *Art in the Life of the Northwest Coast Indian.* Superior Publishing, Seattle.

Hamilton, Augustus
1896 and 1900 *The Art Workmanship of the Maori Race in New Zealand.* Dunedin, New Zealand.

Hammel, Eugene and Simmons, William (eds.)
1970 *Man Makes Sense:* A Reader in Modern Cultural Anthropology. Little, Brown and Company, Boston.

Hanna, Judith Lynne
1979 *To Dance is Human:* A Theory of Nonverbal Communication. U of Texas Press, Austin.

Haring, Douglas G. (ed.)
1956 *Personal Character and Cultural Milieu.* 3rd edition. Syracuse U Press, Syracuse.

Harley, George W.
1950 *Masks as Agents of Social Control in Northeast Liberia.* Peabody Papers XXXIII, Harvard U.

Harlow, Francis and Young, John
1965 *Contemporary Pueblo Indian Pottery.* Museum of New Mexico Press, Santa Fe.

Haselberger, Herta et al.
1961 "Method of Studying Ethnological Art." *Current Anthropology,* Vol. 2, No. 4, October 1961.

Hatcher, Evelyn Payne
1974 *Visual Metaphors:* A Formal Analysis of Navajo Art. AES Monograph #58, West Publishing, St. Paul.

Hatcher, E.; Skelton, L.; and Ingeman, J.
1980 *Festivals:* Study Notes and Queries. Hatcher Museum of Anthropology, St. Cloud.

Hawthorn, Audrey
1967 *The Art of the Kwakiutl Indians.* U of Washington Press, Seattle.

Heine-Geldern, Robert and Ekholm, Gordon F.
1951 "Significant Parallels in the Symbolic Arts of Southern Asia and Middle America." *Selected Papers of the 29th International Congress of Americanists I.* Sol Tax (ed.), U of Chicago Press, Chicago.

Helm, June (ed.)
1967 *Essays on the Verbal and Visual Arts.* U of Washington Press, Seattle.

Herskovits, Melville J.
1948 *Man and His Works:* The Science of Cultural Anthropology. Alfred A. Knopf, New York.

Hill, Ann (ed.)
 1974 *A Visual Dictionary of Art.* New York Graphic Society,
 Greenwich.
Hilton-Simpson, M. W.
 1911 *Land and Peoples of the Kasai.* Constable, London.
Hiroa, Te Rangi (Peter Buck)
 1957 *Arts and Crafts of Hawaii.* Bishop Museum Press, Hawaii.
Hoebel, E. Adamson
 1966 *Anthropology:* The Study of Man. McGraw-Hill, New York.
 1977 *The Plains Indians:* A Critical Bibliography. Indiana U Press,
 Bloomington.
 1978 *The Cheyennes:* Indians of the Great Plains. Holt, Rinehart and
 Winston, New York.
Hoebel, E. A. and Weaver, Thomas
 1979 *Anthropology and the Human Experience.* McGraw-Hill, New
 York.
Holm, Bill
 1965 *Northwest Coast Indian Art:* An Analysis of Form. U of
 Washington Press, Seattle.
 1972 *Crooked Beak of Heaven.* U of Washington Press, Seattle.
 1974 "The Art of Willie Seaweed: a Kwakiutl Master." In Richardson,
 1974.
Holt, Claire
 1967 *Art in Indonesia:* Continuities and Change. Cornell U Press,
 Ithaca.
Horton, Robin
 1962 "The Kalabari World View: An Outline and Interpretation."
 Africa 32: 197-219.
 1963 "The Kalabari Ekine Society: A Borderland of Religion and Art."
 Africa, Vol. XXXIII, No. 2. Reprinted in Skinner, 1973.
 1965 *Kalabari Sculpture.* Department of Antiquities, Apopa, Nigeria.
Hospers, John (ed.)
 1969 *Introductory Readings in Aesthetics.* The Free Press, New York.
Hunt, Morton
 1982 *The Universe Within:* A New Science Explores the Human Mind.
 Simon and Schuster, New York.
Imperato, Pascal, Jr.
 1975 "Last Dances of the Bambara." *Natural History,* April.
Inverarity, Robert B.
 1950 *Art of the Northwest Coast Indians.* U of California Press,
 Berkeley.
Iwao, Sumiko and Child, Irvin L.
 1966 "Comparison of Esthetic Judgements by American Experts and by
 Japanese Potters." *Journal of Social Psychology* 68: 27-33.
James, George Wharton
 1909 *Indian Basketry.* Henry Mulkan. Reprinted 1972, Dover
 Publications, New York.
 1927 *Indian Blankets and Their Makers.* A. C. McClurg, Chicago.

Jones, W. T.
1973 "Talking About Art and Primitive Society." In Forge, 1973b.

Jopling, Carol F. (ed.)
1971 *Art and Aesthetics in Primitive Societies:* A Critical Anthology. E. P. Dutton, New York.
1977 "Yalalag Weaving: Its Aesthetic, Technological and Economic Nexus." In Lechtman and Merrill, 1977.

Jung, Carl G. and others
1964 *Man and His Symbols.* Doubleday, Garden City.

Kaplan, Bert (ed.)
1961 *Studying Personality Cross-Culturally.* Harper and Row, N.Y.

Kavolis, Vytautas
1965 "The Value-Orientations Theory of Style." *Anthropologica Quarterly*, Vol. 38, No. 1, January. Reprinted in Jopling, 1971.
1968 *Artistic Expression:* A Sociological Analysis. Cornell U Press, Ithaca.
1972 *History on Art's Side:* Social Dynamics in Artistic Efflorescences. Cornell Press, Ithaca.

Keeler, Clyde E.
1969 *Cuna Indian Art:* The Culture and Craft of Panama's San Blas Islanders. Exposition Press, New York.

Kelemen, Pál
1969 *Art of the Americas:* Ancient and Hispanic. Thomas Y. Crowell, New York.

Kent, Kate Peck
1976 "Pueblo and Navajo Weaving Techniques and the Western World." In Graburn, 1976.

King, Jonathan C. H.
1977 *Smoking Pipes of the North American Indians.* British Museum, London.

King, Mary Elizabeth
1965 *Ancient Peruvian Textiles* from the Collections of the Textile Museum, Washington D.C. and the Museum of Primitive Art, New York. New York Graphic Society, Greenwich.

Kluckhohn, Clyde and Leighton, Dorothea
1962 *The Navaho* (Revised Edition). Doubleday, Garden City.

Kluckhohn, Clyde and Wyman, L. C.
1940 *An Introduction to Navaho Chant Practice.* American Anthropological Association, Memoir #53.

Koch, Ronald P.
1977 *Dress Clothing of the Plains Indians.* U of Oklahoma Press, Norman.

Kooijman, Simon
1973 "Tapa Techniques and Tapa Patterns in Polynesia: A Regional Differentiation." In Forge, 1973b.

Kris, Enst
1952 *Psychoanalytic Explorations in Art.* Schocken Books, New York.

Kroeber, A. L.
1925 *Handbook of the Indians of California.* Bureau of American Ethnology Bulletin 78.
1944 *Configurations of Culture Growth.* U of California Press, Berkeley.
1948 *Anthropology.* Harcourt, Brace and Company, New York.
1951 "Great Art Styles of Ancient South America." In Tax, 1951.
1953 (ed.) *Anthropology Today:* An Encyclopedic Inventory. U of Chicago Press, Chicago.
1957 *Style and Civilization.* Cornell U Press, Ithaca.

Kroeber, A. L. and Kluckhohn, C.
1952 *Culture:* A Critical Review of Concepts and Definitions. Anthropological Papers, #47, Peabody Museum, Cambridge.

Kubler, George
1962 *The Shape of Time:* Remarks on the History of Things. Yale U Press, New Haven.

Kurath, Gertrude P.
1960 "Panorama of Dance Ethnology." *Current Anthropology* 1: 233-254.

Kyerematen, A. A. Y.
1964 *Panoply of Ghana:* Ornamental Art in Ghanaian Tradition and Culture. Frederick A. Praeger, New York.

Laude, Jean (Jean Decock, translator)
1971 *The Arts of Black Africa.* U of California Press, Berkeley.
1973 *African Art of the Dogon:* The Myths of the Cliff Dwellers. Brooklyn Musuem/Viking Press, New York.

Leach, Edmund R.
1961 "Aesthetics." In Evans-Pritchard, 1961.
1970 *Claude Levi-Strauss.* The Viking Press, New York.
1973 "Levels of Communication and Problems of Taboo in the Appreciation of Primitive Art." In Forge, 1973b.

Lechtman, Heather and Merrill, Robert (eds.)
1977 *Material Culture:* Styles, Organization, and Dynamics of Technology. 1975 Proceedings of The American Ethnological Society. West Publishing, St. Paul.

Lessa, William A. and Vogt, Evon Z.
1979 *Reader in Comparative Religion:* An Anthropological Approach. (4th Edition). Harper and Row, New York.

Leuzinger, Elsy
1960 *Africa:* The Art of the Negro Peoples. Crown Publishers, New York.

Levi-Strauss, Claude
1963a *Structural Anthropology.* Basic Books, New York.
1963b *Totemism.* Beacon Press, Boston.

Lewis, Phillip H.
1969 *The Social Context of Art in Northern New Ireland.* Fieldiana: Anthropology, Vol. 58. Field Museum, Chicago.

Linton, R. and Wingert, P. S.
1946 *Arts of the South Seas.* Museum of Modern Art, New York.

Lloyd, P. C.
1965 "The Yoruba of Nigeria." In Gibbs, 1965.

Lommel, Andreas
1966 *Prehistoric and Primitive Man.* McGraw-Hill, New York.

Lothrop, Samuel K.
1937 *Coclé.* Memoirs of the Peabody Museum, Harvard University, Vol. 7.
1961 (ed.) *Essays in Pre-Columbian Art and Archaeology.* Harvard U Press, Cambridge.

Malin, Edward
1978 *A World of Faces:* Masks of the Northwest Coast Indians. Timber Press, Portland.

Maquet, Jaques
1971 *Introduction to Aesthetic Anthropology.* A McCaleb Module in Anthropology, Addison-Wesley Publishing, Reading.
1972a *Africanity:* The Cultural Unity of Black Africa. Oxford U. Press, New York.
1972b *Civilizations of Black Africa.* Oxford U Press, New York.

Mason, Otis T.
1904 *Aboriginal American Basketry.* Annual Report U.S. National Museum for 1902, Washington D.C.

Matthews, Washington
1887 *The Mountain Chant:* A Navajo Ceremony. Smithsonian Institution, Washington.

Mauer, Evan M.
1979 "Symbol and Identification in North American Indian Clothing." In Cordwell and Schwarz, 1979.

Maxwell, Gilbert S.
1963 *Navajo Rugs:* Past, Present and Future. Desert-Southwest, Palm Desert.

Maxwell Museum of Anthropology
1974 *Seven Families in Pueblo Pottery.* U of New Mexico Press, Albuquerque.

Mead, Margaret
1935 *Sex and Temperament in Three Primitive Societies.* Wm. Morrow, New York. Reprinted by Mentor Books, 1950, page nos. refer to this.
1940 "The Arts in Bali." *Yale Review* 30: 335-347.
1959 "Creativity in Cross-Cultural Perspective." In Anderson, 1959.
1960 "Work, Leisure, and Creativity." *Daedalus,* Winter. Boston. Reprinted in Jopling, 1971.
1970 *The Mountain Arapesh:* Arts and Supernaturalism. Vol. II. The Natural History Press, Garden City.

Means, Philip A.
1930 *Peruvian Textiles.* Metropolitan Museum of Art, New York.

Meggers, Betty J.
1971 *Amazonia:* Man and Culture in a Counterfeit Paradise. Aldine-Atherton, Chicago.

Meighan, Clement W.
1974 "Prehistory of West Mexico." *Science*, Vol. 184, No. 4143, 21 June, 1974.

Mera, H. P.
1937 *The Rain Bird:* A Study in Pottery Design. Los Angeles Museum, Los Angeles. Reprinted by Dover, 1966.
1943 *Navajo Twilled Weaving.* Bulletin No. 14, General Series. Laboratory of Anthropology, Santa Fe.

Merriam, Alan P.
1964 *The Anthropology of Music.* Northwestern U Press, Evanston.

Miles, Charles and Bovis, Pierre
1969 *American Indian and Eskimo Basketry:* A Key to Identification. Bonanza Books, New York.

Mills, George
1957 "Art: The Introduction to Quantitative Anthropology." *Journal of Aesthetics and Art Criticism* 16: 1-17. Reprinted in Jopling, 1971 and Otten, 1971.
1959 *Navaho Art and Culture.* Taylor Museum, Colorado Springs.

Momaday, N. Scott
1975 "To the Singing, to the Drums." *Natural History*, February.

Morris, Charles
1946 *Signs, Language and Behavior.* Prentice-Hall, New York.

Morrow, Mable
1975 *Indian Rawhide:* An American Folk Art. U of Oklahoma Press, Norman.

Morton-Williams, Peter
1964 "An Outline of the Cosmology and Cult Organization of the Oyo Yoruba." *Africa*, Vol. 34, No. 3, July 1964. Reprinted in Skinner, 1973.

Mount, Marshall Ward
1973 *African Art:* The Years Since 1920. Indiana U Press, Bloomington.

Mountford, C.
1961 "The Artist in Australian Aboriginal Society." In Smith, 1961.

Mueller, J. (ed.)
1973 *Molas:* Art of the Cuna Indians. Textile Museum, Washington D.C.

Muensterberger, Warner
1951 "The Roots of Primitive Art." In *Psychiatry and Culture:* Essays in Honor of Geza Roheim; Wilbur, G.B. (ed.); John Wiley, New York.

Muller, Kal
1971 "Social Climbing in the New Hebrides." *Natural History*, October.

Mumford, Lewis
1934 *Technics and Civilization.* Harcourt Brace, New York.

Mundt, Ernest
1952 *Art, Form, and Civilization.* U of California Press, Berkeley.

Munn, Nancy D.
1971 "Visual Categories: An Approach to the Study of Representational Systems." In Jopling, 1971.

1973a "The Spatial Presentation of Cosmic Order in Walbiri Iconography." In Forge, 1973b.

1973b *Walbiri Iconography:* Graphic Representation and Cultural Symbolism in a Central Australian Society. Cornell U Press, Ithaca.

Munro, Thomas

1956 *Toward Science in Aesthetics:* Selected Essays. Liberal Arts Press, New York.

1963 *Evolution in the Arts* and Other Theories of Culture History. Cleveland Museum of Art, Cleveland.

Murdock, George Peter

1959 *Africa:* Its Peoples and Their Culture History. McGraw-Hill, New York.

Murra, John V.

1962 "Cloth and Its Functions in the Inca State." *American Anthropologist,* Vol. 64, No. 4, August.

Museum of Primitive Art

1959 *Aspects of Primitive Art.* New York.

1961 *Three Regions of Primitive Art.* New York.

Myerhoff, Barbara G.

1974 *Peyote Hunt:* The Sacred Journey of the Huichol Indians. Cornell U Press, Ithaca.

McCall, Daniel F. and Bay, Edna G.

1975 *African Images:* Essays in African Iconology. African Publishing Company, New York.

MacCannell, Dean

1976 *The Tourist:* A New Theory of the Leisure Class. Schocken Books, New York.

McElroy, W. A.

1952 "Aesthetic Appreciation in Aborigines of Arnhem Land." *Oceania,* XXIII, No. 2.

McFeat, Tom (ed.)

1966 *Indians of the North Pacific Coast.* U of Washington Press, Seattle.

Navajo School of Indian Basketry

1903 *Indian Basket Weaving.* Republished 1971 Dover Publications, New York.

Naylor, Maria (ed.)

1975 *Authentic Indian Designs:* 2500 Illustrations from Reports of the Bureau of American Ethnology. Dover Publications, New York.

Newcomb, Franc J.

1964 *Hosteen Klah:* Navaho Medicine Man and Sand Painter. U of Oklahoma Press, Norman.

Newcomb, Franc J. and Reichard, Gladys

n.d. *Sandpaintings of the Navajo Shooting Chant.* J. J. Augustin, New York.

Newman, Thelma R.

1974 *Contemporary African Arts and Crafts.* Crown Publishers, New York.

1977 *Contemporary Southeast Asian Arts and Crafts.* Crown Publishers, New York.

Newton, Douglas
 1965 *Bibliography of Sepik District Art.* The Museum of Primitive Art, New York.

New York Graphic Society
 1974 *A Visual Dictionary of Art.* New York Graphic Society, Greenwich.

New Yorker, The
 1976 "Talk of the Town." December 20, 1976, p. 29.

Oliver, Douglas
 1955 *A Solomon Islands Society.* Harvard U Press, Cambridge.

O'Neale, Lila M.
 1945 *Textiles of Highland Guatemala.* Carnegie Institution, Publication #567, Washington.

Ortiz, Alfonso (ed.)
 1979 *Handbook of North American Indians.* Vol. 9—The Pueblos. Smithsonian Institution, Washington.

Oster, Gerald
 1974 "The Spiral Way." *Natural History,* August-September, pp. 50-55.

Otten, Charlotte, M. (ed.)
 1971 *Anthropology and Art:* Readings in Cross-Cultural Aesthetics. The Natural History Press, Garden City.

Ottenberg, Simon
 1975 *Masked Rituals of Afikpo:* The Context of an African Art. U of Washington Press, Seattle.

Parezo, Nancy J.
 1983 *Navajo Sandpainting:* from Religious to Commercial Art. U of Arizona Press, Tucson.

Patton, Sharon F.
 1979 "The Stool and the Asante Chieftaincy." *African Arts,* November.

Paume, Denise (Ross, Michael, translator)
 1962 *African Sculpture.* Viking Press, New York.
 1973 "Adornment and Nudity in Tropical Africa." In Forge, 1973b.

Peckham, Morse
 1965 *Man's Rage for Chaos:* Biology, Behavior, and the Arts. Chilton Books, Philadelphia. Reprinted by Schocken, 1967.

Pemberton, John 3rd
 1982 "Staff: Edan Oskugbo (Ogboni)". In Fagg, Pemberton and Holcomb 1982.

Pitt-Rivers, Augustus
 1900 *Antique Works of Art from Benin.* Republication 1976 with new introduction by B. Fagg. Dover Publications, New York.

Plazas, Clemencia and Falchetti de Saenz, Ana Maria
 1979 "Technology of Ancient Columbian Gold." *Natural History,* November, Vol. 88, No. 9.

Poignant, Roslyn
 1967 *Oceanic Mythology:* The Myths of Polynesia, Micronesia, Australia. Paul Hamlyn, London.

Pokornowski, Ila
1979 "Beads and Personal Adornment." In Cordwell and Schwarz, 1979.

Powdermaker, Hortense
1933 *Life in Lesu.* Williams and Norgate, London.

Price, Sally and Price, Richard
1980 *Afro-American Arts of the Suriname Rain Forest.* U of California Press, Berkeley.

Prussin, Labelle
1969 *Architecture in Northern Ghana.* U of California Press, Berkeley.
1980 "Traditional Asante Architecture." *African Arts,* February.

Rainey, Froelich
1959 *Seven Metals of Africa.* The University Museum, Philadelphia.

Ramseyer, Urs
1977 *The Art and Culture of Bali.* Oxford U Press, Oxford.

Rappaport, Roy
1967 *Pigs for the Ancestors.* Yale U Press, New Haven.

Rattray, Robert S.
1923 *Ashanti.* Oxford U. Press, Oxford.
1927 *Religion and Art in Ashanti.* Clarendon Press, Oxford.

Rawson, Philip
1967 *The Art of Southeast Asia.* Frederick A. Praeger, New York.

Ray, Dorothy Jean
1967 *Eskimo Masks:* Art and Ceremony. U of Washington Press, Seattle.

Read, Herbert
1965 *Icon and Idea:* The Function of Art in the Development of Human Consciousness. Schocken Books, New York.

Reichard, Gladys
1934 *Spider Woman.* The Macmillan Company, New York.
1936 *Navaho Shepherd and Weaver.* J. J. Augustin, New York. Reprinted by Dover Publications 1974 with the title, *Weaving a Navajo Blanket.*
1939 *Navajo Medicine Man:* Sandpaintings and Legends of Miguelito. J. J. Augustin, New York. Republished by Dover, 1977 with the title, *Navajo Medicine Man Sandpainting.*
1950 *Navaho Religion:* A Study in Symbolism. Princeton U Press, Princeton.

Reichard, Gladys and Newcomb, Franc J.
1937 *The Shooting Chant:* Sandpainting of the Navajo. J. J. Augustin, New York.

Reid, William
1972 "Out of Silence." *Natural History,* February, p. 64.

Richardson, Miles (ed.)
1974 *The Human Mirror:* Material and Spatial Images of Man. Louisiana State U Press, Baton Rouge.

Ritzenthaler, R.
1961 *Sioux Indian Drawings.* Milwaukee Public Museum, Milwaukee.

Ritzenthaler, Robert and Parsons, Lee (eds.)
1966 *Masks of the Northwest Coast*. Milwaukee Public Museum, Milwaukee.

Roach, Mary Ellen
1979 "The Social Symbolism of Woman's Dress." In Cordwell and Schwarz, 1979.

Roach, M. E. and Eicher, J. B.
1979 "The Language of Personal Adornment." In Cordwell and Schwarz, 1979.

Rockefeller, M. C. (A. A. Gerbrands, ed.)
1968 *The Asmat of New Guinea:* The Journal of Michael Clark Rockefeller. Museum of Primitive Art, New York.

Roediger, Virginia More
1961 *Ceremonial Costumes of the Pueblo Indians*. U of California Press, Berkeley.

Rogers, D. C.
1979 *Royal Art of the Kuba*. U of Texas, Austin.

Rogers, E. S.
1969 *Forgotten Peoples*. Royal Ontario Museum, Toronto.
1970 *New Guinea:* Big Man Island. Royal Ontario Museum, Toronto.

Salvador, Mari L.
1976 "The Clothing Arts of San Blas, Panama." In Graburn, 1976.

Schapiro, Meyer
1953 "Style." In Kroeber, 1953.

Schieffelin, Edward L.
1976 *The Sorrow of the Lonely and the Burning of the Dancers*. St. Martin's Press, New York.

Schmitz, Carl A.
1967 *Oceanic Art:* Myth, Man and Image in the South Seas. Harry N. Abrams, New York.

Scott, Ian
1969 *The Luscher Color Test*. Random House, New York.

Segall, M. H.; Campbell, D. T.; and Herskovits, M. J.
1966 *The Influence of Culture on Visual Perception*. The Bobbs-Merrill Company, Indianapolis.

Service, Elman
1963 *Profiles in Ethnology*. Harper and Row, New York.

Sharon, Douglas G.
1972 "Eduardo the Healer." *Natural History*, November.

Shaw, Thurstan
1981 "The Nok Sculptures of Nigeria." *Scientific American*, Vol. 244, No. 2.

Shepard, Anna O.
1956 *Ceramics for the Archaeologist*. Carnegie Institution of Washington, Publication 609, Washington D.C.

Sieber, Roy
 1959 "The Esthetic of Traditional African Art." In Rainey, 1959. Reprinted in Jopling, 1971.
 1960 *Sculpture of Northern Nigeria.* Museum of Primitive Art, New York.
 1962 "The Arts and Their Changing Social Function." *Anthropology and Africa Today,* Annals of the New York Academy of Sciences, Vol. 96.
 1972 *African Textiles and Decorative Arts.* The Museum of Modern Art, New York.
 1973 "Art and History in Ghana." In Forge, 1973b.
 1980 *African Furniture and Household Objects.* The American Federation of Arts and Indiana U Press, Bloomington.
Skinner, Elliott P. (ed.)
 1973 *Peoples and Cultures of Africa.* Doubleday/Natural History Press, Garden City.
Smith, Marian W. (ed.)
 1961 *The Artist in Tribal Society.* The Free Press of Glencoe, New York.
Smyly, John and Carolyn
 1975 *The Totem Poles of Skedans.* U of Washington Press, Seattle.
Speck, Frank G.
 1925 "Dream Symbolism and the Desire Motive in Floral Designs of the Northeast." *The Guardian,* Vol. 1.
 1950 "Concerning Iconology and the Masking Complex in Eastern North America." *Bulletin,* U Museum, U of Pennsylvania. Vol. 15. pp. 6-57.
Spencer, Robert F. and Jennings, Jesse D. et al.
 1977 *The Native Americans.* Harper and Row, New York.
Spencer, Robert F. and Johnson, Elden
 1960 *Atlas for Anthropology.* Wm. C. Brown, Dubuque.
Spier, Robert F. G.
 1970 *From the Hand of Man:* Primitive and Preindustrial Technologies. Houghton Mifflin, Boston.
Starzecka, Dorota C.
 1975 *Hawaii:* People and Culture. British Museum, London.
Stewart, Julian H. (ed.)
 1948 *The Circum-Caribbean Tribes.* Vol. 4 of the *Handbook of South American Indians,* Bureau of American Ethnology, Bulletin 143.
Steward, Julian H. and Faron, Louic C.
 1959 *Native Peoples of South America.* McGraw-Hill, New York.
Swanton, J. R.
 1911 *Indian Tribes of the Lower Mississippi Valley and Adjacent Coast of the Gulf of Mexico.* Bureau of American Ethnology, Bulletin 43.
 1946 *The Indians of the Southeastern United States.* Bureau of American Ethnology, Bulletin 137.
Swinton, George
 1972 *Sculpture of the Eskimo.* McClelland and Stewart, Toronto.
 1965 *Eskimo Sculpture.* McClelland and Stewart, Toronto.
Swithenbank, Michael
 1969 *Ashanti Fetish Houses.* Ghana U Press, Accra, Ghana.

Sze, Mai-mai
 1959 *The Way of Chinese Painting:* Its Ideas and Techniques. Random
 House, New York.
Tanner, Clara Lee
 1968 *Southwest Indian Craft Arts.* U of Arizona Press, Tucson.
 1973 *Southwest Indian Painting.* U of Arizona Press, Tucson.
Tax, Sol (ed.)
 1951 *The Civilizations of Ancient South America.* U of Chicago Press,
 Chicago.
Thompson, Laura
 1945 "Logico-aesthetic Integration in Hopi Culture." *American
 Anthropologist,* Vol. 47.
Thompson, Robert Farris
 1969 *Àbátàn:* A Master Potter of the Egbado Yoruba. In Biebuyck, 1969b.
 1972 "The Sign of the Divine King: Yoruba Bead-Embroidered Crowns
 with Veil and Bird Decorations." In Fraser and Cole, 1972.
 1976 *Black Gods and Kings.* Indiana U Press, Bloomington.
 1979 *African Art in Motion:* Icon and Art. U of California Press, Berkeley.
Toneyama, Kojin (translated by R. L. Gage)
 1974 *The Popular Arts of Mexico.* Weatherhill/Heibonsha, New York and
 Tokyo.
Tschopik, H. Jr.
 1940 "Navaho Basketry: A Study of Culture Change." *American
 Anthropologist,* Vol. 42, No. 4.
Turner, Victor
 1967 *The Forest of Symbols:* Aspects of Ndembu Ritual. Cornell U Press,
 Ithaca.
 1968 *The Drums of Affliction:* A Study of Religious Process Among the
 Ndembu of Zambia. Clarendon Press, Oxford.
 1969 *The Ritual Process.* Aldine, Chicago.
 1974 *Dramas, Fields, and Metaphors.* Cornell U Press, Ithaca.
Tuzin, Donald F.
 1980 *The Voice of the Tambaran:* Truth and Illusion in Ilahita Arapesh
 Religion. U of California Press, Berkeley.
Ueda, Makoto
 1967 *Literary and Art Theories in Japan.* The Press of Western Reserve U,
 Cleveland.
Underhill, Ruth
 1944 *Pueblo Crafts.* Indian Handcraft Series. Bureau of Indian Affairs,
 Washington.
Vansina, Jan
 1955 "Initiation Rituals of the Bushong." *Africa,* Vol. 25, No. 2, April 1955.
 Reprinted in Skinner, 1973.
 1972 "Ndop: Royal Statues Among the Kuba." In Fraser and Cole, 1972.
Vogt, Evon Z
 1970 *The Zinacantecos of Mexico:* A Modern Maya Way of Life. Holt,
 Rinehart and Winston, New York.

Wagner, Fritz
1959 *The Art of Indonesia*. Crown Publishers, New York.

Wallace, Anthony F. C.
1950 "A Possible Technique for Recognizing Psychological Characteristics of the Ancient Maya from an Analysis of their Art." *American Imago* 7: 239-258. Reprinted in Jopling, 1971.
1956 "Revitalization Movements." *American Anthropologist* LVIII: 264-281. Reprinted in Lessa and Vogt, 1979.
1978 *Rockdale:* The Growth of an American Village in the Early Industrial Revolution. Alfred A. Knopf, New York.

Wardell, Allen and Lebov, Lois
1970 *Annotated Bibliography of Northwest Coast Indian Art*. Museum of Primitive Art, New York.

Warren, D. M. and Andrews, J. Kweku
1977 "An Ethnoscientific Approach to Akan Arts and Aesthetics." *Working Papers in the Traditional Arts* #3. Institute for the Study of Human Issues (ISHI), Philadelphia.

Wass, Betty and Eicher, Joanne
1980 "Analysis of Historic and Contemporary Dress: An African Example." *Home Economics Research Journal*, May, Vol. 8, No. 5.

Waters, Frank
1963 *Book of the Hopi*. Viking Press, New York.

Wauchope, Robert (ed.)
1967 *Handbook of Middle American Indians*. U of Texas Press, Austin.

Weltfish, Gene
1953 *The Origins of Art*. Bobbs-Merrill, Indianapolis.

Wescott, Joan
1962 "The Sculpture and Myths of Eshu-Elegba, the Yoruba Trickster: Definition and Interpretation in Yoruba Iconography." *Africa*, Vol. XXXII, No. 4.

Whiteford, Andrew Hunter
1970 *North American Indian Arts*. Golden Press, New York.

Whitten, Dorothy S. and Whitten, Norman E., Jr.
1978 "Ceramics of the Canelos Quichua." *Natural History*, October.

Willett, Frank
1967 *Ife in the History of West African Sculpture*. McGraw-Hill, New York.
1971 *African Art:* An Introduction. Praeger, New York.

Willette, Kristin
1977 "Cultural Values and Spatial Patterns." Unpublished student paper, Festival Behavior Study Program. St. Cloud State U, St. Cloud.

Willey, Gordon R.
1962 "The Early Great Styles and the Rise of the Pre-Columbian Civilization." *American Anthropologist*, Vol. 64, No. 1. Reprinted in Otten, 1971.

Williams, Nancy
1976 "Australian Aboriginal Art at Yirrkala." In Graburn, 1976.

Wingert, Paul S.
 1962 *Primitive Art.* Oxford U Press, New York.

Wissler, Clark
 1904 *Decorative Art of the Sioux Indians.* Bulletin, Vol. 18, Pt. 3. American
 Museum of Natural History, New York.

Witherspoon, Gary
 1977 *Language and Art in the Navajo Universe.* The U of Michigan Press,
 Ann Arbor.

Wolfe, Alvin W.
 1969 "Social Structural Bases of Art." *Current Anthropology* 10 (1): 3-44.

Wyman, Leland C.
 1960 *Navaho Sandpainting:* The Hackel Collection. The Taylor Museum,
 Colorado Springs.

Zimmern, Nathalie H.
 1949 *Introduction to Peruvian Costume.* Brooklyn Institute of Arts and
 Sciences, Brooklyn.

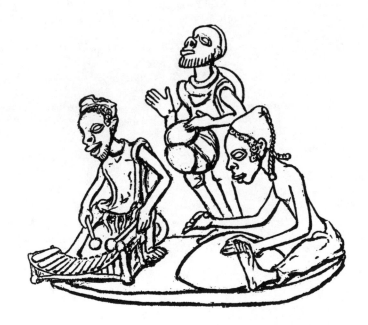

Bibliography for Second Edition

1989 *Art and Design*: "Italian Art in the Southern European Tradition." St. Martin's Press, New York.

Anderson, Richard L.
 1990 *Calliope's Sisters*: A Comparative Study of Philosophies of Art. Prentice Hall, Englewood Cliffs, New Jersey.

Ben-Amos, Paula
 1980 *The Art of Benin*. Thames and Hudson, London.

Berliner, Nancy Zeng
 1986 *Chinese Folk Art*. Little, Brown & Company, Boston.

Berns, Marla C. and Barbara R. Hudson
 1986 *The Essential Gourd*; Art and History in Northwestern Nigeria. Museum of Culture History, UCLA, Los Angeles.

Black, C. F., Mark Greengrass, David Howarth, Jeremy Lawrance, Richard Mackenney, Martin Rady, Evelyn Welch
 1993 *Cultural Atlas of the Renaissance*. Prentice Hall, General Reference, New York.

Borgatti, Jean
 1970 *From the Hands of Lawrence Ajanaku*. Museum of Cultural History, UCLA, Los Angeles.

Chipp, Herschel B.
 1968 *Theories of Modern Art*: A Source Book by Artists and Critics. University of California Press, Berkeley, Los Angeles and London.

Delange, Jacqueline
 1974 *The Art and Peoples of Black Africa*. E. P. Dutton & Co., Inc., New York.

Delaune, Philippe
 1987 *Les Ivoires*. Jacques Grancher, Editeur, Paris.

Everdell, William
 1997 *The First Moderns*: Profiles in the Origins of Twentieth Century Thought. University of Chicago Press, Chicago.

Eyo, Ekpo
 1977 *Two Thousand Years of Nigerian Art*. Federal Department of Antiquities, Lagos, Nigeria.

Gillon, Werner
 1991 *A Short History of African Art*. Penguin Books, New York.

Griffiths, John
 1989 "Mediterranean and Metaphysical: The Southern Tradition in Mod-
 ern Italian Art." In *Art and Design*.
Grigaut, Paul L. and E. P. Richardson
 1951 *The Arts of the Ming Dynasty*. The Detroit Institute of Arts, Detroit.
Harding, Frances
 1998 " 'To Present the self in a Special Way.' " African Arts, Vol XXXI, no. 1.
Helms, Mary W.
 1993 *Craft and the Kingly Ideal*: Art, Trade, and Power. University of
 Texas Press, Austin.
Holcombe, Bryceaaa (ed.)
 1982 *Yoruba: Sculpture of West Africa*. Alfred Knopf, New York.
Howard, Kathleen (ed.)
 1983 The Metropolitan Museum of Art Guide. The Metropolitan Museum
 of Art, New York.
Kaeppler, Adrienne, Christian Kaufman, and Douglas Newton
 1997 *Oceanic Art*. Abrams.
Kent, Rockwell (ed.)
 1939 *World-Famous Paintings*. Wise & Co., New York.
Law, Robin
 1977 *The Oyo Empire c. 1600-c. 1836*. Clarendon Press, Oxford.
Levathes, Louise
 1994 *When China Ruled the Seas*: The Treasure Fleet of the Dragon
 Throne 1405-1433. Simon and Schuster, New York.
Lopes, Robert S.
 1970 *The Three Ages of the Italian Renaissance*. Little, Brown & Co., Bos-
 ton and Toronto.
Magnin, Andre, ed., with Jaques Soulillou
 1996 *Contemporary Art of Africa*. Harry N. Abrams, Publishers, New
 York.
Marcus, George E. and Fred R. Myers (eds.)
 1995 *The Traffic in Culture*: Refiguring Art and Anthropology. The Uni-
 versity of California Press, Berkeley, Los Angeles.
Menten, Theodore
 1975 *Chinese Cut-Paper Designs*. Dover Publications, Inc., New York.
Morton-Williams, Peter
 1995 "Two Yoruba Brass Pillars." *African Arts*. Vol. 28, #3, Summer.
Muller, Herbert J.
 1952 *The Uses of the Past*. Profiles of Former Societies. Oxford University
 Press, New York.
Muller, Joseph-Emile
 1965 *Modern Painting IV* Cubists to Early Abstract Painters. Tudor Pub-
 lishing Co., New York.
Napier, A. David
 1992 *Foreign Bodies*: Performance, Art, and Symbolic Anthropology. The
 University of California Press, Berkeley, Los Angeles.

Nash, June (ed.)
 1993 *Crafts in the World Market*: The Impact of Global Exchange on Middle America Artisans. State University of New York Press, Albany.
Nebiolo, Gino
 1973 *La Cina dei Cinesi*: 25 Anni di Grafica Rivoluzionaria. Priuli & Verlucca, Editori, Rome.
Papdakis, Dr. Andreas C. (ed.)
 1989 *Art & Design*: Italian Art Now and the Southern European Tradition. St. Martin's Press, New York.
Piper, David
 1994 *The Illustrated History of Art*. Crescent Books, New York.
Pohlman, Wolfger
 1993 *China Avant-garde*. Haus der Kulturen der Welt, Berlin.
Rotberg, Robert and Theodore Rabb (eds.)
 1986 *Art and History*: Images and Their Meaning. Cambridge University Press, Cambridge.
Rubin, Arnold (edited by Zena Pearlstone)
 1989 *Art as Technology*: Arts of Africa, Oceania, Native America, Southern California. Hillcrest Press, Beverly Hills.
Smith, Bradley, and Wan-go Weng
 1979 *China: A History in Art*. Doubleday & Co., New York.
Stahlberg, Roberta
 1986 *Shopping in China: Arts, Crafts, and the Unusual*. China Books and Periodicals, San Francisco.
Steiner, Christopher B.
 1994 *African Art in Transit*. Cambridge University Press, Cambridge.
Stevens, Phillips, Jr.
 1978 *The Stone Images of Esie, Nigeria*. Africana Publishing Co., New York.
Sullivan, Michael
 1977 *The Arts of China*. University of California Press, Los Angeles.
Swann, Peter
 1963 *Art of China, Korea, and Japan*. Frederick Praeger, New York.
Sze, Mai-mai
 1959 *The Way of Chinese Painting*: Its Ideas and Technique. Vintage Books, Random House, New York.
Talbot Rice, Tamara
 1963 *Ancient Arts of Central Asia*. Frederick Praeger, New York.
Thornton, John
 1992 *Africa and Africans in the Making of the Atlantic World 1400-1680*. Cambridge University Press, Cambridge.
Vansina, Jan
 1984 *Art History in Africa*. Longman, New York.
Vogel, Susan
 1991 *Africa Explores*: 20th Century African Art. The Center for African Art, New York and Prestel, Munich.

Whitten, Dorothy S. and Norman E. Whitten, Jr. (eds.)
 1993 *Imagery and Creativity.* Ethnoaesthetics and Art Worlds in The
 Americas. University of Arizona Press, Tuscon.

Willett, Frank
 1967 *Ife in the History of West African Sculpture.* McGraw-Hill Book Co.,
 New York.

Williams, C.A.S.
 1941 *Outlines of Chinese Symbolism & Art Motives.* Dover Publications,
 New York. Reprint 1976.

Subject and Author Index

Page references are to both text and figures; G indicates that the term is in the Glossary.

A word stands for its singular, plural or variants.

The reference "see..." indicates another word, synonym, or term for a closely related subject.

Ethnic groups, culture areas, etc., are indexed in the Ethnographic Notes and Index, and are not repeated here.

Important and frequently used words are indexed only where concepts and basic relationships are discussed.

✳ ✳ ✳ ✳ ✳ ✳ ✳ ✳ ✳ ✳ ✳ ✳ ✳ ✳ ✳ ✳ ✳ ✳

A NOTE ON THE TYPE IN THIS BOOK

The type face of the main text is a photo typesetting machine's poor imitation of the beautiful face John Baskerville designed in 1752–4, and not the least of the distortions is the absence of ligatures. This is a common, typical failure of the technical revolution, and another is that most such machines are dedicated to an idiotic automatic justification that results in both very wide and very narrow word spacing, and even totally unnecessary letter spacing; there remain many examples of these esthetic horrors in the book. Hyphens are discouraged by this automation—the system thinks they are letters, and they turn up in the middle of words in the middle of lines when something is "automatically" reset.

There was no bold face in Baskerville's time; it is a much later adaption. That in the running heads and two figure captions are 10 and 9 point Monotype's bold version. The tabular bits and all the larger 18, 24, 36 roman were handset in Monotype. This note is handset in the best available version of the face; it is the 8 point of the American Type Founders's Baskerville Series 15. It is a duplicate of Stephenson & Blake's casting, which in turn is Joseph Fry's version (ca. 1764) of Baskerville, and is very close to the original.

About the Author

EVELYN PAYNE HATCHER is Professor Emeritus of Anthropology at St. Cloud State University and Adjunct Professor at the University of Minnesota. Her previous works published include *Art as Culture: An Introduction to the Anthropology of Art* (1985).